Odd Man In

SUZANNE MUCHNIC

Odd Man In

Norton Simon and
the Pursuit of Culture

UNIVERSITY OF CALIFORNIA PRESS
BERKELEY LOS ANGELES LONDON

The publisher gratefully acknowledges the generous contribution to this book provided by the Art Book Endowment Fund of the Associates of the University of California Press, which is supported by a major gift from the Ahmanson Foundation.

University of California Press
Berkeley and Los Angeles, California

University of California Press, Ltd.
London, England

Library of Congress
Cataloging-in-Publication Data

Muchnic, Suzanne.
 Odd man in : Norton Simon and the pursuit
 of culture / Suzanne Muchnic.
 p. cm.
 Includes bibliographical references
 and index.
 ISBN 0-520-20643-6 (alk. paper)
 1. Simon, Norton, 1907–1993—
 Art collections.
 2. Art—Private collections—California.
 3. Art patronage—California.
 I. Title.
 N5220.S66M83 1998
 709'.2—dc21
 98-2981
 CIP

Printed in the United States of America
9 8 7 6 5 4 3 2

CONTENTS

LIST OF ILLUSTRATIONS

PREFACE

When i joined the staff of the *Los Angeles Times* in 1978, Norton Simon was a shadowy giant on the art scene. His influence was pervasive, not only at the Pasadena Art Museum, which he controlled and later named for himself, but also at other cultural institutions that had shown his collection and sought his favor during the previous twenty years. He also had enormous influence in the marketplace, making multimillion-dollar purchases at auction and driving hard bargains privately with leading art dealers.

His exploits and acquisitions made for lively conversation in art circles, but his motivations were a matter of dispute. Champions of contemporary art generally viewed him with disdain, if not outright contempt, because he did not share their passion for the art of their own time. Simon had saved the Pasadena Art Museum from probable extinction in 1974. But in bailing out the financially troubled institution, he had transformed the symbol of contemporary art's rising status in southern California into a showcase predominantly dedicated to his own collection of historical art. His museum was a marvelous cultural asset for the community, but it came at considerable cost to the pride of artists and collectors who had supported the original. They had wanted a sugar daddy when they accepted his help; instead they got a pragmatic businessman who solved their financial problem on his own terms.

Simon's collecting was also something of a conundrum. He made brilliant acquisitions, but he also sold important works, sparking criticism that he wasn't simply upgrading his collection, as he claimed, but operating as a dealer and cashing in at opportune times. The turnover in his holdings and the fact that the art was owned by his private foundations, rather than the museum, also fueled speculation that the collection might be only a temporary fixture on the cultural

scene. Even people who worked closely with Simon wondered if he loved the art as much as the game of its pursuit.

As the years passed and I settled into my job, working first as a critic and later as an art reporter, Simon continued to be perplexing, but I became accustomed to his quirks. Other museums planned exhibition schedules years in advance and rarely made newsworthy acquisitions; the Norton Simon Museum frequently made surprising announcements. Occasionally one of his representatives would telephone the newspaper to say that he was installing something new and to request coverage. That would lead to a circular conversation about when the exhibition would be ready, when a critic would come to the museum, and when the article would appear. Simon was unwilling to leave newspaper coverage to chance; he wanted a commitment. But, as I eventually learned, that was partly because he tinkered with exhibitions until the last possible moment. Just before the assigned critic arrived, he would stop making changes and disappear. Occasionally he would reappear, unannounced, through a side door, saying, "I hadn't planned to talk to the press today, but since you're here," and launch into a lengthy monologue. However, I never caught so much as a glimpse of him until I had worked at the *Los Angeles Times* for twelve years.

Simon was struck with a debilitating illness in 1983. Over the next decade, although his physical condition alternately improved and declined, his collecting all but stopped, and he became increasingly reclusive. During this time, speculation about the fate of his collection escalated and took on a more urgent tone. Despite his frailty, he was completely lucid and therefore entirely capable of dispersing or liquidating the art he had so assiduously collected.

Early in 1990, when John P. Lindsay, then editor of the *Los Angeles Times*'s Sunday *Calendar* arts and entertainment section, asked me to develop ideas for stories on collectors, I decided to write about Norton Simon. At the time, an interview seemed out of the question. He hadn't been quoted at length in the press for many years; as far as I could determine, no reporter had been granted a personal interview in more than a decade. Those who had managed to make tentative appointments had been frustrated by last-minute cancellations. Still, Simon was such a mysterious figure and his story so improbable that I

felt compelled to write it. I decided to proceed even if he declined an interview. To my amazement, he accepted and we made a date: 14 June 1990.

He greeted me at the door of Bungalow 9 at the Beverly Hills Hotel, confined to a wheelchair but eager to talk and expressing delight that his wife, Jennifer Jones Simon, had agreed to join us. As the hours passed, he answered many questions, left others open, and led the conversation into a wide variety of subjects, only taking time out for a session of therapy and a few sips of sherry.

When I left I had enough information to write a lengthy newspaper article, but it could only skim the surface of his involvement with art. It would take a book to tell that part of his life story, but he was too ill to collaborate with a biographer. I had met him far too late, or so it seemed. Then, on 5 February 1992, at a lavish party held at the Norton Simon Museum to celebrate his eighty-fifth birthday, I heard his longtime friends and associates pay tribute to him and offer illuminating anecdotes. Their remembrances renewed my interest and indicated that a substantive version of his story could be constructed from secondary sources and first-hand accounts of people who knew him well.

Simon died the following year. Several months later Jennifer Jones Simon generously granted me permission to pursue a biography that would concentrate on her late husband's life as an art collector. Simon's collection is his most important legacy; what I had in mind was *a* life, a portrait of an extraordinary collector, not *the* life with all the complexities of his business, politics, philanthropy, and family. Even so, it wouldn't be a simple tale. His emergence as a collector coincided with southern California's cultural coming of age, and much of my fascination with Simon concerned his role in that evolution. My story, then, probes the passions and strategies of a paradoxical character and illuminates the cultural territory he helped to shape.

ACKNOWLEDGMENTS

I AM PROFOUNDLY GRATEFUL to Jennifer Jones Simon, without whose cooperation I would never have embarked on this book. Throughout the project Sara Campbell, the director of art at the Norton Simon Museum, was unfailingly helpful, insightful, and patient. Her assistance, support, and good humor were absolutely essential. Andrea Clark, the museum's registrar, also was an invaluable source of information as I was separating fact from fiction.

To piece together this version of a productive but highly complicated life, I conducted about fifty interviews with art museum directors, curators, dealers, and associates of Simon. Dozens of other people were consulted in briefer conversations. I am greatly indebted to all those who enriched the text with personal accounts and directed me to additional sources. In particular I wish to thank Harold M. Williams, president of the J. Paul Getty Trust and a longtime friend of Simon, Angelina Boaz, a sympathetic observer who worked closely with Simon at a crucial period, Simon's sister, Evelyn Simon Prell, and Lillian Weiner, a fount of information on many aspects of the Los Angeles art scene.

Among many scholars and librarians who aided my research, I owe a special debt to Shelley Bennett, the curator of British and Continental art at the Huntington Art Collections, and Dorothy Ingebretsen of the *Los Angeles Times,* who helped me prepare for my initial interview with Simon, long before I had considered writing his biography.

Thanks also go to my family and friends who have listened to my Norton Simon stories and expressed confidence that my fascination with his achievements would grow into a book.

1

MAN IN THE NEWS

I have not finished bidding.

NORTON SIMON
Los Angeles Times, *20 March 1965*

NORTON SIMON STRODE into Christie's auction house in London on 19 March 1965 hell-bent for victory. As he entered the lobby of the elegantly appointed building on King Street he knew this would be a day to remember. His plan of action would be all set as soon as he had touched base with Peter Chance, Christie's chief auctioneer. But there was no time to spare. It was 10:40 A.M., only twenty minutes before Chance was scheduled to open a highly publicized sale of old master paintings.[1]

When Simon emerged from Chance's office a few minutes later, the sale room was teeming with dealers, collectors, and members of the international press corps. Clients and privileged spectators were finding their reserved seats. Reporters were positioning themselves to observe the impending competition. The top lots were five pictures from a renowned collection begun in the late nineteenth century by Sir Francis Cook, who had made his fortune as a textile manufacturer. Simon took his seat on the second row beside Dudley Tooth, a courtly gentleman and longtime art dealer in London who had become his adviser and confidante.

The outcome of the sale remained to be seen, but one thing was certain: some of the most discerning eyes in the art world were fixed on the London auction that morning when works by Dürer,

Hogarth, Rembrandt, Turner, and Velásquez from the Cook collection went on the block, and Simon intended to give them something to watch. If events followed his planned scenario, he would be bidding anonymously, under a special agreement with Christie's, for the most coveted item in the sale, Rembrandt's *Portrait of a Boy, Presumed to be the Artist's Son, Titus.* But everyone who counted would soon know that the renegade California industrialist who already had established himself as a major force in the art market had won the prize at Christie's.

As Rembrandts go, *Titus* is not particularly favored by scholars. Painted in 1650 in a rather sketchy style, the portrait of a golden-haired boy is charming but appears unfinished. Portraying a single individual, it is less complex and challenging than are the artist's monumental paintings of figure groups. The sweet subject makes it less prestigious than are works with weightier themes, such as *Aristotle Contemplating the Bust of Homer,* the Rembrandt masterpiece that Simon had lost in an auction four years earlier to the Metropolitan Museum of Art in New York. Still, he knew the public would love the captivating image of an angelic youth. Not merely the progeny of a great artist, the boy is also a child left motherless when the painter's wife, Saskia, died. Although dressed in a seventeenth-century Dutch plumed hat and a tunic with a lace collar, the boy fulfills timeless popular fantasies of innocent beauty and beloved sons.

As Simon perused the morning sale's agenda, he felt confident that he would not be outbid by bigger spenders, as he had been in the auction of *Aristotle.* In 1961 he had naively plotted his bidding strategy with his corporate attorney and loyal friend, Harold M. Williams, only to be cut out of the competition as soon as it began.[2] On that occasion, for the first time in history, Parke-Bernet's auctioneer, Lou Marion, had opened the bidding at $1 million—the highest price that Simon had been prepared to pay, and one that he had expected to work up to gradually. Instead he had only been able to watch in amazement as the price soared to $2.3 million and James Rorimer, the director of the Metropolitan, purchased the picture for his venerable institution. Williams himself got his education in the high cost of fine art much later, in the 1980s and 1990s, while serving as president of the J. Paul Getty Trust in Los Angeles. But by 1965

Simon had already become a player in the art market. In the competition for a Rembrandt that was about to begin in London, he knew he was in the game.

In his pocket, he had a handwritten copy of his bidding agreement. Signed by both Simon and Patrick Lindsay, an assistant to Chance, the unorthodox pact stipulated that Simon would be considered to be bidding on the Rembrandt as long as he was sitting down, whether he gestured openly or simply sat quietly, but that if he stood up, he had declared himself out of the bidding. If he sat down again, however, and raised his finger, he was back in the competition.[3]

Bidding on the Rembrandt began at about three hundred thousand dollars and quickly rose to $1 million, with Simon and two London dealers, Geoffrey Agnew of Thomas Agnew & Sons and David Somerset of Marlborough Fine Art, pushing the price higher and higher. Simon entered the fray early but confused Chance by bidding verbally. This was permitted in the written agreement, but Chance had understood that Simon would not be bidding aloud. Thus, later in the auction, when Simon fell silent, Chance assumed that the collector, although still sitting down, was no longer bidding. Getting no further signals from Simon, Chance struck his gavel on the podium and sold the Rembrandt to Marlborough for $2.1 million.

As applause broke out, Simon leaped to his feet, shouted, "Hold it, hold it," and protested that Chance had broken their agreement. Chance held his ground, insisting the painting was sold fairly to Marlborough. Convinced that he had been wronged, Simon exploded in a tirade and confronted Chance with his sheet of instructions. "I have never seen such a look of cold anger on anybody's face," said Geoffrey Agnew's son, Julian.[4]

As the press corps rushed to the front of the room to hear the heated exchange and members of the audience struggled to figure out what was happening, Dudley Tooth read the written agreement aloud. Shaken, Chance apologized and announced that conditions of sale regarding disputed bids at Christie's required him to continue the bidding. Over Somerset's protests, he reopened the sale. The Rembrandt was sold to Simon for $2.2 million.

Simon had his trophy, and—after negotiating for two months to get an export license from British authorities—he took the painting on a victory trip across the Atlantic Ocean. He made a public appearance and exhibited *Titus* at the National Gallery of Art in Washington, D.C., appeared on the cover of *Time* magazine,[5] and returned home to southern California, where the painting went on view several months later at the Los Angeles County Museum of Art.

Rembrandt's *Titus* was not Simon's greatest artistic catch, nor was it the most expensive. But the international brouhaha surrounding the sale defined the image of a self-made multimillionaire and world-class amateur expert in art who played to win by his own rules. Just as Simon had flourished in business—parlaying a seven thousand dollar investment in a bankrupt orange juice bottling plant into Hunt Foods & Industries, Inc. and using a company known for tomato sauce and catsup as the foundation of a diversified industrial complex—he had triumphed in the rarified sphere of collecting art. Previously known primarily in business and art circles, Simon became a celebrity in the popular media after the *Titus* affair, and the story was told and retold in the British and American press. London's *Daily Express* ran a cartoon by Osbert Lancaster on its front page, showing a woman's legs straight up in the air in front of an art auctioneer's podium, the caption reading, "Don't forget that by private arrangement Lady Littlehampton is still in the bidding as long as she is standing on her head!"

Press photographs and reports at the time portrayed Simon as a restless competitor whose all-too-visible rough edges seemed to reflect inner conflicts. Seen by the camera, he was tall, lean, and vigorous. Droopy eyes gave his long, deeply lined face a sad appearance, but he was so intense that he usually appeared to be either on the attack or fiercely defensive. News pictures often portrayed him as if caught in midsentence, in the heat of an argument with his mouth wide open, or pursing his lips while impatiently listening to an adversary. When shown smiling, he seemed to be merely indulging the photographer or reveling briefly in victory before charging off to his next battle.

The pictures didn't say it all, but they offered insight into a brilliant but perpetually agitated man who thought of himself as a belea-

guered outsider. The very personification of conflict, he was secretive and insecure but driven to succeed and hungry for recognition. Although he was soft-spoken and polite, he wore down his adversaries by relentless questioning and unsettling interrogation techniques. Simon was leery of the press but desperate to be respected if not appreciated, so he would go to great lengths to protect his privacy, then reveal himself in public outbursts. A connoisseur who had exquisite taste but no pretensions, he lived comfortably below his means while seeking advice among the highest echelons of experts about building a collection that would appeal to the masses. Never satisfied, he pushed others almost as hard as he pushed himself. He was aggressive, manipulative, and ruthless but capable of expressing great tenderness to friends and employees—and thus able to inspire their intense loyalty.

Even the closest observers, though they were privy to his perceptions of human behavior and his mode of operation, rarely agree on what drove Norton Simon. He often told them that life is controlled by "the three Ps: power, paranoia, and publicity." By that measure, he succeeded on a grand scale. Endowed with extraordinary creativity and intelligence, he gained power in the worlds of business and art by amassing a fortune and using it shrewdly. Though his paranoid streak was far from being a clinical affliction, his own insecurities and fears of being bested helped him understand how to exploit similar weaknesses in his competitors. He did not employ a press agent and disdained the notion of public relations as a legitimate profession, but he came to appreciate the value of images conveyed by the media, learned to manipulate the press, and created his place as a newsmaker.

Adopted by a less complex achiever, Simon's doctrine might have been quite clear and straightforward, if fundamentally cynical. As he saw it, the road to success was paved with sudden turns, potholes, and obstacles. Any assessment of his life must take into account the force of his personality and his equivocal behavior. But there is widespread agreement on one thing: Norton Simon was America's preeminent art collector in his time. By the time he died in 1993, at the age of eighty-six, he had built one of the world's greatest private collections of art to be assembled since World War II, rivaled only by those

of two European industrialists: Peter Ludwig in Germany, whose encyclopedic holdings include few old master paintings, and Baron Hans Heinrich von Thyssen Bornemisza of Switzerland, whose collection (now in Spain) is often said to be second only to that of Queen Elizabeth II of England, which was established by her predecessors. Like the monarch, Thyssen inherited family treasures. Simon started from scratch. Long after most of the historic artworks worth having were thought to be owned by museums, he amassed twelve thousand paintings, sculptures, prints, and drawings created over seven centuries. All these works are lodged at the Norton Simon Museum in Pasadena, California, which endures as Simon's legacy and a tribute to both his artistic taste and his financial acumen.

Simon made a mark in the business world by spotting mismanaged companies, quietly buying up their stock, taking control, and making them more productive. A self-made man, his achievements were hard won, but the odds of having comparable success in art collecting were far less favorable than they had been in commerce. Simon had no formal training in art, he started collecting quite late, and he was based in Los Angeles, a cultural backwater at the time in comparison to New York, London, and Paris. But the innate qualities that helped him build his business empire served him well in the art world.

Possessed by a need to excel, endowed with the intelligence to get the best possible advice, and compelled to make his own decisions, he developed his natural eye for quality. In thousands of private transactions and dozens of widely publicized auctions, he bought old master paintings by Raphael, Botticelli, Rubens, Bassano, Cranach, and Zurbarán; impressionist and modern art by Van Gogh, Degas, Cézanne, and Kandinsky; massive bronze sculptures by Rodin, Moore, and Maillol; and prints by Rembrandt, Goya, and Picasso. After he married the Academy Award–winning actress Jennifer Jones in 1971, she persuaded him to take his first trip to India and thus inadvertently directed his collecting into an entirely new direction. Smitten by the art of regions he had scarcely considered before, he became a major force in the Indian and Southeast Asian art market.

What Simon accomplished in his collecting probably will never be matched, and not merely because the supply of world-class historical

material on the market is steadily shrinking. His particular combination of financial resources, intelligence, taste, and tenacity equipped him to go after, and get, the best. Often vilified in the business world as a corporate raider, he offended entrenched forces when he took over ill-managed companies and turned them into profitable enterprises. In cultural circles, he was accused of knowing the price of everything and the value of nothing, but he won respect for his grand acquisitions, shrewd negotiations, and unorthodox tactics.

As a collector of art, Simon set his own standards. He followed the tradition of America's nineteenth- and early twentieth-century collectors—most notably Henry Clay Frick, who bought widely and extremely well—while effectively pitting himself against such wealthy contemporaries as the uranium magnate Joseph Hirshhorn and the oil tycoons Armand Hammer and J. Paul Getty. Hirshhorn has a museum on the mall of the nation's capital, but his collection of modern and contemporary art lacks the depth and breadth of Simon's broad holdings. Hammer used his eclectic collection for political purposes and his lack of aesthetic discrimination led him to buy more trinkets than jewels; notable exceptions include pictures he purchased from Simon. Getty endowed a museum whose collection may one day be better than Simon's, but only because Getty also left sufficient funds to upgrade his eccentric accumulation of antiquities, French decorative arts, and European paintings.

The story of how Simon arrived at a position of such prominence is also a tale of the cultural coming of age of Los Angeles. When Simon bought his first artworks in 1954, the Los Angeles County Museum of Art was merely part of an undistinguished, multipurpose institution in Exposition Park, not the massive structure that has since become a fixture on Wilshire Boulevard. The J. Paul Getty Museum was open to the public for two days a week in 1954, but it was housed in a residence on a sixty-five-acre citrus ranch in Malibu. In 1974 Getty opened a new museum in Malibu, patterned after the Villa dei Papiri in Herculaneum; after his death in 1976, the J. Paul Getty Trust commissioned yet another Getty museum, as part of the massive Getty Center in Brentwood, which was opened in 1997. The Los Angeles Museum of Contemporary Art—founded in

part by initial supporters of the Pasadena Art Museum—was not opened until 1983, when Simon's collecting days were waning. The same is true of the Armand Hammer Museum of Art and Cultural Center in Westwood. Established with funds from Hammer's principal source of wealth, Occidental Petroleum Corporation, and operated by the University of California at Los Angeles, it was founded in 1988 and opened in 1990. Yet each of those institutions owes a significant debt to Norton Simon. His vision, entrepreneurial drive, opportunism, and impassioned connoisseurship were an immense force in shaping southern California's cultural landscape. Over the years, Simon flirted with the possibility of giving his collection to other institutions and occasionally talked of selling it. Yet he knew that it was his greatest achievement and that his name would live if his museum survived. He was right.

2

GROWING UP FAST

How am I going to beat this world?

NORTON SIMON
New York Times, *31 May 1970*

NORTON WINFRED SIMON was born on 5 February 1907 in Portland, Oregon, the first child of Myer Simon and Lillian Glickman Simon, who were descendants of European Jewish immigrants. A curly-haired, sad-eyed child, his appearance seemed a reflection of his intense personality and his parents' high hopes for their only son. Greatly loved by a father who would spend much of his adult life working with and for his son and adored by a mother who believed he would rule the world—or, at the least, use his extraordinary argumentative skills to become a brilliant attorney—he was a precocious boy who enjoyed the benefits of a comfortable childhood and the devotion of parents who lived a modest version of the American dream.

One of a family of five boys and two girls, Myer was born in San Francisco in 1885. His father, a scrap metal dealer, later moved his family to Portland. Lillian, the only child of a short-lived match, was born in Chicago in 1884 and raised by her father and his second wife in Sacramento. Myer was a creative, hard-working entrepreneur who labored at a variety of enterprises to feed his family and build a financial base. Most frequently, he used whatever resources he could muster to buy up job lots of clothing and inventories of bankrupt firms. When a store went out of business, he would purchase the remaining stock at distress prices and sell it for a slightly higher sum

at his own establishment, Simon Sells For Less. On any given day, thrifty shoppers there would find a changing array of groceries, clothing, and household goods at discounted prices that they could brag about.

Known as a kind-hearted, family-oriented fellow, Myer would pick up hitchhikers and remind his children that every down-and-out beggar was somebody's baby, but he also viewed himself as an outsider who had to buck the system to gain his fair share for himself and his family. Steeped in the sensitivity of Jewish immigrants who had lost any real connection with their ancestral homelands but still didn't feel completely welcome in America, Myer confronted a brand of Oregon conservatism that he labeled "mossback." It was a hidebound, backwoods attitude. Mossback conservatives weren't aggressively reactionary; they just preferred the status quo. Comfortable with the way things were—and had been for as long as they could remember—they didn't take kindly to interlopers with strange customs and entrepreneurial business practices that didn't conform to local traditions.

Norton listened to his father's description of the challenges he faced and took them to heart. Identifying with his father, the boy felt that he was up against the same obstacles. "In my early childhood I sensed the fixedness of the society that was around me," Norton told an interviewer many years later. In 1970, empathizing with rebellious college students, he spoke of "fixed things" that "block us out" and prevent a free enjoyment of life. "What right have you got to keep the world from us?" he asked, demanding an answer from the vague forces that represented the establishment. "You're not letting us in this world, and we're part of it. And I felt that when I was a kid, and I would dream, 'How am I going to beat this world?' "[1]

The question drove him throughout his life. Norton's perception of himself as an outsider seemed to propel him to greater and greater achievements in business, but none of his victories provided lasting satisfaction. He reveled in beating the odds and besting the competitor of the moment. Fighting "them" became a way of life and an integral part of his personality.

Norton's father and earliest role model was a rough-and-tumble businessman whose fortunes fluctuated in his early days. He pros-

pered during World War I, although he entered into contracts that required him to pay high prices for sugar and other goods in short supply. After the conflict ended and the market was flooded with formerly scarce products, prices fell. So did Myer's fortune. In one lucky break, he bought two hundred barracks from an army camp in nearby Washington State and sold them to families who moved the rudimentary buildings to their own lots and converted them to homes. But he was nearly wiped out by the depression of 1921, and the experience made a big impression on his adolescent son.

"I was around that store," Norton said, recalling Simon Sells For Less, "and I saw the problems he had and I saw him finally come out of that depression with very little money, losing a modest fortune he had built up. And I saw the extent of the loss and I felt it and I tried to get him to take his losses quickly and get the hell out. I encouraged it but I wasn't persuasive enough at the time."[2] He may have exaggerated his youthful insight when he recalled his father's problems many years later, but as the oldest child and only son, he had a strong bond with his parents and even when he was little more than a child thought of himself as his father's business partner.

Norton had his parents all to himself for six years. His sister, Evelyn, was born 20 April 1913. Five years later, on 22 August 1918 his youngest sister, Marcia, arrived. More fascinated than threatened by the new members of the family, he would tease the girls mercilessly as they grew up and shower them with attention and buy them lavish gifts when he began to earn his own money.

Despite the fluctuations of their financial resources, Myer and Lillian took pride in having produced a healthy, close-knit family. One of their luxuries was to spend summer vacations and weekends at a beach house they had acquired at Seaside, a small town on the Pacific Coast, about seventy miles northwest of Portland. In the summer in 1921, while the family was at Seaside, Lillian was stricken with an acute digestive disorder resulting from a diabetic condition that had caused her little trouble in previous years. She died two days later. Norton was fourteen years old, Evelyn was eight, Marcia was nearly three.

Devastated by the loss of his wife in the same year that his business had suffered a sharp decline, Myer was determined to maintain a

family life for his distraught children. He was in the process of building a fine two-story house on Westover Terrace, in a prestigious area not far from their residence on Northrup. Though he could ill afford it and was forced to build the house of wood rather than brick, as he had planned, he finished the project. Lillian's half-brother and his wife, Edward and Bess Foreman, who also lived in Portland, moved into the new house to help Myer take care of his children. About a year later he sold the house and moved his family to San Francisco to live with his sister and her husband, Jacob and Frances Reisberg.

When the Simons arrived in San Francisco, Norton was ready for his last year of high school. An indifferent student who annoyed his teachers by reading novels in class, he had a photographic memory. A gift for calculating figures in his head helped him excel at mathematics. During his year at Lowell High School, his fellow students included Edmund G. (Pat) Brown, a future governor of California, and Brown's wife, Bernice Layne, who became lifelong friends. Reminiscing about their high-school days from the governor's office for a profile of Simon published by *Time* magazine in 1965, Brown, describing his friend's competitive nature and computerlike intelligence, recalled his crapshooting talents. "It was amazing how Norton could always figure the odds. He might be playing against half a dozen others, but somehow he kept all the odds in his head."[3]

Norton was graduated from Lowell High School in 1923, at the age of sixteen. He was a year or two younger than most of his classmates, but he later claimed that school was something he did in his spare time. Since his early teens he had worked Saturdays, Sundays, holidays, and summers, fueled more by ambition than need. When he left high school he had already earned several thousand dollars as a wholesaler of paper products. In one legendary deal in San Francisco— probably inspired by Simon Sells For Less—he purchased a large quantity of Cupie toilet tissue from a fire-damaged warehouse and sold the salvageable rolls at a profit. Business was already his primary interest and financial gain was his goal, but he wasn't averse to a little self-indulgence. To flex his muscles, impress his friends, and gain a measure of independence, he bought himself a sporty little Italian S.T.A.R. car, a four-cylinder coupé.

Norton had little interest in going to college. His father insisted, so he enrolled at the University of California in Berkeley. Myer thought law was an ideal profession for a young Jewish man of superior intellect and argumentative temperament. The idea was anathema to Norton, who could see no point in going through four years of undergraduate school and taking required courses that didn't interest him before he could even enter law school. "I had no financial problems, my family would have been more than happy to pay my way through," he said, reflecting on his college days. "As a matter of fact, I had money of my own that I could have gone through college on, but I hated it. I didn't see why I had to take Italian and astronomy and a bunch of other subjects."[4]

After six weeks on campus, he fled. He was living at home while attending college, so he told his father he was going to spend the weekend and the following Monday night at a fraternity house. When he didn't show up at home on Tuesday night, Myer called the fraternity and was informed that his son "went east." Myer called the police who eventually picked up Norton in Salt Lake City. When Myer reached him by phone, Norton refused to come home unless he could quit school and go to work. Myer relented and Norton's formal education was over.

The scene had changed at home as well. In 1923, after being a widower for two years, Myer married Lucille Michaels, a Chicago-born woman eight years his junior who soon became a devoted mother to Norton, Evelyn, and Marcia. The girls were delighted with their new mother and relieved to return to a smaller family circle. Although Norton later told his sisters that the loss of his mother had created a perpetual void in his life, he developed a warm relationship with his stepmother and remained close to her until her death in 1969. She saw much of Myer in Norton and often reminded family members, "The fruit doesn't fall far from the tree."

After a shaky beginning in San Francisco, Myer established himself as an importer and exporter of surplus and scrap goods, doing most of his business with Asia. Norton worked with his father but also branched out on his own. Among other brief ventures, he invested in the Alcazar Theater, which had opened in 1911 on O'Farrell Street.

The theater was the home of the Henry Duffy Players, a popular stock company that presented tried-and-true favorites, sometimes with guest stars.

Eager to be independent, Norton divested himself of his business enterprises in San Francisco and took off for Los Angeles in 1925, when he was eighteen. His ambition was to make a lot of money, and he tried various approaches—from managing a crew of young men who hawked cigarettes on downtown street corners to carrying on family traditions of wholesaling and exporting. His most substantial accomplishment during his early years in southern California came in 1927, when he established Los Angeles Steel Products Company, a sheet metal distribution company.

Obsessed as he was with financial success, Norton was not all business when he struck out on his own. When he arrived in Los Angeles, he was a teenager living alone for the first time. A lanky young man, just under six feet in height, he spoke softly but with great determination. With time on his hands and energy to burn, he turned himself into something of a man about town—and a daredevil. He bought himself a terra-cotta and beige Nash convertible to get around in style. To his delight, he acquired yet another flashy vehicle when he bought a dollar ticket to a raffle and won an Iris D Special, a tiny car with a seat for the driver and a jump seat for a passenger. It was an amusing toy, which he loved to drive on sidewalks and show off to his sisters. On other occasions he rented a speed boat and took the girls on terrifying rides in the Pacific Ocean.

Norton also learned to fly. One of his favorite amusements was to rent a plane at a small airport on the southern outskirts of Los Angeles and persuade one of his employees to drive the Nash on the broad, flat reaches of Western Avenue while he flew just above the car. His sisters loved to hear about his escapades, and they saw enough evidence of his pranks to believe most of what he said, but sometimes he left them in the dark. "He never told us, but I think he must have crashed because he stopped flying," Evelyn said. "He stopped flying his own plane and he wouldn't even fly commercially for a long time."[5]

Norton had asserted his independence at an early age, but remained close to his family throughout his twenties. In 1929, Myer, Lucille,

Evelyn, and Marcia moved to Los Angeles to join him. Stresses, strains, and bitter estrangements began to damage their relationships as Norton became a successful businessman who had less and less time for family. He seemed to have the least patience with those who had been closest to him. Evelyn remained relatively unscathed by going her own way and keeping her distance. Marcia reached out for love and approval from her brother, but was frequently rebuffed and occasionally not on speaking terms with him. Yet, when they recalled their youth, the two women would always speak of their headstrong sibling as a wonderfully loving brother.

The balance of power also shifted between Norton and his father after the family moved to Los Angeles. Norton trusted Myer more than anyone else and needed his guidance. Myer offered it freely and provided a stabilizing force as his son set out to seek his fortune. United in the belief that they were outsiders who had to use their wits to beat the system, they became business partners. But within a few years Myer was overshadowed by his son's ambition and compulsion to control his own destiny.

3

THE EMPIRE BUILDER

Norton Simon climbed to the tin can throne by a simple formula:
don't start a business yourself; buy up those already started
and run them better.

TIME
8 October 1945

IN ECONOMIC TERMS, 1929—the beginning of the Great Depression, the year the United States stock exchange crashed, banks failed, and panic gripped the nation—was not a great year for Myer Simon, but his son was astonishingly flush for a college dropout in his early twenties. Norton had begun investing in the stock market while still in his teens, working up from penny stocks to blue-chip companies. In an early indicator of his financial genius, he put three thousand dollars into the stock market several years before the crash and emerged from the depression with thirty-five thousand dollars in stocks and business holdings.

His profit gave him a foundation for independent action, initially undertaken with the counsel of his father but financed with his own resources. In 1931, when he had turned twenty-four, Norton put up the money for the first building block of what would become his business empire. At Myer's urging, he used profits from Los Angeles Steel Products Company to invest seven thousand dollars in Vita-Pac, a bankrupt orange juice bottling plant in the sleepy Orange County community of Fullerton, southeast of Los Angeles. In typical Simon family fashion, Norton planned to sell off the equipment at a profit, but Myer persuaded him to try running the company for

a year. When the experiment was moderately successful, they changed the company's name to Val Vita Food Products Company, added other fruits and vegetables to the line of products, and switched from bottles to cans.

The key to success, as far as Norton could see, was to hold down costs and undercut competitors' prices. Processing standard-grade products, he controlled as many aspects of the business as he could manage. To save money on cans, he bought a bankrupt Los Angeles can-making plant in 1934 and moved the equipment to Fullerton. To reduce pickup and delivery costs, he used his own trucks. He devised a way to label cans on the production line and pioneered the use of pallets and lift trucks. His strategy paid off. Val Vita's annual sales rose from forty-three thousand dollars in 1932 to nearly $9 million in 1942.[1]

At a Thanksgiving party in 1932, Norton met Lucille Ellis, the daughter of a Jewish candy and tobacco wholesaler in Buffalo. A graduate of Wellesley College, she was in Los Angeles studying social work at the University of Southern California. They were married on 3 February 1933, two days before Norton's twenty-sixth birthday. He took his bride on a honeymoon combined with a business trip: a cruise through the Panama Canal and a tour of East Coast steel mills.

Returning home, they settled in Fullerton, not far from Val Vita. Their first son, Donald, was born on 6 April 1936. His brother, Robert, arrived on 23 November 1937. A typically proud new father, Norton was so excited about Donald's birth that he stayed up most of the night, celebrating with his sister, Marcia, by taking her to one movie after another. But his competitive, domineering personality was ill-suited to fatherhood. Norton continued to work seven days a week and Lucille stayed at home with the boys.

Before Donald and Robert had reached school age, Norton and Lucille bought a house in Los Angeles on Buckingham Road, a tree-lined street in a pleasant, upper-middle-class neighborhood a few miles west of the downtown business district. It was their home for fifteen years. The Simons were among the richest people in the neighborhood, one of the few families that employed a cook and a chauffeur. They also acquired a beach house on Lido Island in New-

port Beach, about forty miles southeast of Los Angeles, where they spent weekends and most of the summer, often sailing in the family sloop. Yet, despite these luxuries, which they could easily afford, they always lived below their means. They drove top-of-the line automobiles, but their houses were relatively modest and Lucille often bought the boys' clothes at Sears.

Within ten years of launching Val Vita, Norton had acquired a dozen other small food-packing plants, including a fish cannery in Long Beach and a pet-food company in San Pedro. Although he had created a new company from scratch in transforming Vita-Pac to Val Vita, he didn't repeat the exercise. Building a business that way was far too much work and too risky, so he adopted a more efficient means of expanding. His strategy was to scour the market for undervalued companies that appeared to have growth potential. Once he had spotted a likely candidate, studied it thoroughly, and satisfied himself that it was ripe for a takeover, he would quietly buy up enough stock in brokers' accounts to enable him to demand representation on the board of directors. The incumbent directors often discovered that the interloper knew much more about their business than they did and had not arrived on the scene to preserve the status quo. He was bent on doing whatever was required to increase profits. His attitude and methods implied criticism of past management and frequently entailed his stepping on a lot of toes; he insisted that he was merely serving the best interests of shareholders.

In retrospect, it seems that some of his actions in the 1930s and 1940s might have been predicted because he concentrated on the food-processing industry, often expanding into areas that would directly benefit his core business. But he was little-known, and reclusive by nature despite his flair for dramatic action. Indeed, stealth was part of his strategy. The national press reported his successes in the 1940s, but he shied away from publicity in his early days and received relatively little attention until the 1950s and 1960s.

In 1941 Simon made a silent but auspicious move when he began using some of Val Vita's income to buy stock in Hunt Brothers Packing Company, a food-processing plant in Hayward, California, south of Oakland. Hunt was a private-label company, applying the brand names of its various customers to the canned goods it pro-

duced. Norton had noticed that Hunt's sales were erratic, but that its stock appeared to be undervalued with a book value of eleven dollars and a market price of eighty-five cents a share.

Val Vita was performing well in 1941 and 1942 while Simon was increasing his interest in Hunt. But, like many small companies, the Fullerton firm was feeling the squeeze of wartime shortages. Simon—who wasn't required to serve in the military because food processing was considered a vital industry—decided to sell Val Vita to Hunt for $3 million and use the proceeds to increase his holdings in Hunt to 25 percent of the company's stock and thus gain a controlling interest in its management. In 1943, he changed the company's name to Hunt Foods, Inc. and began turning it into a more efficient and profitable operation. Private-label packing made no sense, he thought, because packers were at the mercy of their customers and couldn't distribute their products. His point of view was a serious blow to the private-label trade, which needed the goods Hunt had provided. Simon weakened its position even further when Hunt bought several private-label canneries and put Hunt labels on their canned goods.

Simon's timing was perfect. Wholesalers and grocers were unable to get enough private-label goods during the war, so they eagerly accepted Hunt products as a temporary substitute. With the products set for national distribution, Simon launched an aggressive advertising campaign. "When he bought control of Hunt in 1942, many housewives had never heard of Hunt Products," *Time* magazine reported in 1945. "Simon told them by billboard, newspaper and radio so loudly and effectively that 'Hunt for the best' became a household slogan. One result: the West Coast, all but drinking Hunt's tomato sauce like milk, now buys almost half of the 100 million cans a year they sell (nearly five cans per capita)."[2]

During the war Hunt's clients were so desperate for canned goods to sell that they accepted the company's terms of "price at time of shipment," with Hunt naming the price. But in the summer of 1946, the U.S. government stopped buying canned food; in the fall, government-established price ceilings were removed. Suddenly the market was glutted. Hunt's customers demanded that their contracts be canceled or changed to fit the circumstances. Hunt made some

adjustments but held most of its buyers to their contracts, setting off a raging controversy. Longtime members of the trade said that ethical standards and traditions required Hunt to let its clients off the hook, but Simon argued that a contract was a contract and claimed that Hunt would go broke if it honored all the demands. The company ended 1946 with a profit but gained bitter enemies in the trade. Some wholesalers vowed to stop distributing Hunt products permanently. Fortunately for Simon, Hunt's advertising had created a demand in the market that hobbled the threats, but resentments smoldered.

To bolster his business in 1948, Simon launched a costly campaign of national advertising. Instead of promoting Hunt's entire line of products, he decided to concentrate on expanding the market for a single item, tomato sauce. The massive campaign included a series of full-page color advertisements in *Life* magazine. Designed to motivate legions of housewives to pluck cans of Hunt's tomato sauce from their grocers' shelves, the ads offered simple recipes along with other enticements: "Now . . . from California a cooking sauce with spicy tomato goodness"; "He'll love you both if you cook spareribs with Hunt's tomato sauce"; "Aunt Mary may get jealous when you serve lamb chops with Hunt's tomato sauce." According to the advertisements, nearly every dish would taste better with the sauce from California added to it. In a recipe for tomato scrambled eggs, cooks were instructed to heat a can of Hunt's tomato sauce and pour it over six or eight scrambled eggs—and to put six more cans on their shopping lists. The cost of the year's campaign was $2.25 million or about 7 percent of Hunt's sales—about triple the industry average of 2 percent at the time—but the investment paid off by increasing Hunt's share of a vastly enlarged market.

The tomato sauce promotion was followed by campaigns for catsup, tomato paste, and Hunt's "heavenly" peaches, with advertising designed to appeal to particular groups of consumers. The advertisements in Life were cluttered pastiches, crammed with folksy tips on low-cost cooking; an elegantly restrained series that ran in *Vogue* in 1956 made catsup appear as chic as high fashion. Leafing through the mostly black and white pages of the magazine, readers would come across refined but rather dull appeals to buy such expensive items as

Alaskan seal fur coats, Cartier and Tiffany jewelry, Chanel perfume, and Oldsmobile Starfire 98 automobiles. Though steeped in snob appeal, the advertisements for luxury goods were designed to blend in with articles on the latest trends in gracious living and fashionable dressing. Hunt's catsup ads pushed a product that almost everyone could afford to buy, but were so striking in color and design that they resembled sophisticated artworks. Long before minimal art emerged on the scene, one double-page spread illustrated a single bottle of bright red catsup in a luxurious, pure white table setting. With the magazine open to those pages, nothing detracted from their visual impact. Another double-page spread pictured a pair of impeccably groomed women dressed in black, posed with shopping carts overflowing with white flowers. Photographed against a red backdrop of floor-to-ceiling shelves of catsup, the models selected bottles as if they were rare treasures with unique characteristics. In each *Vogue* advertisement, the single line of copy read simply: "Hunt for the best." Spending more on advertising than most of his competitors were spending, and tailoring advertisements to appeal to the aspirations of each magazine's audience, Simon all but forced grocers to carry Hunt's products.

To finance his extensive advertising campaign and sell Hunt's products cheaply, Simon had to keep costs low—a practice he had adopted early and perfected over the years, partly through strategic growth. Capitalizing on his success with Val Vita's in-house can production, he decided to make cans for Hunt's much larger operation. In 1945, he acquired control of Atlas Imperial Diesel Engine Company of Oakland and converted it into a maker of can machinery. He moved Atlas to Hayward in 1948, next to Hunt's plant, and then built a glass plant to make bottles primarily for Hunt products. In 1950 the company name was changed to United Can & Glass.

By 1945, Hunt was among the biggest food-processing companies on the West Coast. After buying out California Conserving Company, a major competitor located just across the street, Hunt owned sixteen canning plants that produced seventy products. Hunt's sales grew from $14.5 million in 1942, to $102.5 million in 1958.

Simon began looking far beyond the food-processing industry for new sources of profit. In 1944 he began investing Hunt money in

Ohio Match Company, a firm that was second only to Diamond Match Company and had holdings in timberland. His motivation was twofold: to use Ohio's matchbooks to advertise Hunt products and to gain control of the company to make it more profitable. Two years later, when it was revealed that Diamond's principal stockholders had a 20 percent controlling interest in Ohio Match and government trustbusters forced them to sell it, Simon and a friend, Hart Isaacs, were the buyers. Simon immediately began a sweeping reorganization, reducing the firm's staff and boosting annual sales from $9 million in 1946 to $20 million in 1952. With profits from Ohio Match, he bought into the Wesson Oil and Snowdrift Company and the Northern Pacific Railway Company.

Entering the match business, which consumed a great deal of wood, gave Simon a strong interest in gaining long-term contracts for timber supplies. Northern Pacific Railway owned vast white pine timberlands, but it had plenty of business and showed no interest in a competitive bid from Ohio. While studying the situation in 1946, Simon discovered that financially, the railroad was in precisely the position he always sought before making a big investment. The common stock was undervalued at about fifteen dollars per share, so he and his family bought 60,000 shares. He pressed for representation on the board, but had to work through a director who represented others as well. In November 1950, when Northern Pacific again rebuffed Ohio Match's bid for timber, he instigated a buying spree of Northern Pacific stock by Ohio. Three months later, the match company held 167,500 shares and had signed timber-cutting contracts with Northern Pacific. In April 1951, Simon attended his first Northern Pacific board meeting. Unleashing all his pent-up frustration, he opposed—among other things—routine approval of permits giving major oil companies exploration rights on Northern Pacific land. In a startling coincidence, oil was discovered the very same day on railroad land in Williston Basin, which was named for the town of Williston in northwestern North Dakota and extends into South Dakota, Montana, Saskatchewan, and Manitoba. Simon was undaunted. At his second board meeting, in May 1951, he staged his first major confrontation with the corporate establishment. Simon raged for more than an hour, covering a wide range of complaints

and proposed corrections. He continued his efforts to reform the company for a couple of years, but to little avail.

In March 1952, Northern Pacific stock shot up to ninety-four dollars a share because the railroad had mineral rights on thirty-two hundred thousand acres of land in the Williston oil field, then the nation's richest. Ohio Match owned the biggest single block of Northern Pacific stock. The combined holdings of the match company, Simon, his family, and friends equaled 14 percent of the railroad. But Simon decided he could not afford to buy enough additional stock to assure his control of the railroad, and he couldn't resist an opportunity for profit. He began to sell his stock and that of Ohio Match in July 1952. Within a year, he and his family and associates had about fifteen thousand shares left, and Ohio Match had twenty-five thousand. Simon himself made a profit of about $2 million. Ohio Match gained about $5 million after taxes on a $4.7 million investment.

Moving in yet another direction, Simon decided that the coming of television and its growing popularity had led investors to overlook opportunities in magazine publishing. In 1954 he began to acquire stock in Curtis Publishing Company, McGraw-Hill, Inc., and Condé Nast Publications, Inc., but concentrated on McCall Corporation, owners of *McCall's* magazine, *Redbook,* and a $300-million printing plant in Dayton, Ohio. In 1955 he had 35 percent of the stock, enough to give him working control of the magazine. All but ignoring the editorial content, he reorganized printing operations and poured more than $2 million into advertising and promotions. Circulation rose while revenue climbed from $13.5 million in 1954 to $17 million in 1956.

Simon's activities received occasional notice in the national press beginning in the mid-1940s. Although he had avoided publicity in his early years of empire building, he was such a controversial force in the business world that, inevitably, he became a topic of discussion in corporate offices and a subject of newspaper and magazine articles. In a long profile, "Norton Simon—Like Him or Not," *Fortune* magazine essentially introduced him to the public in December 1953. "There's someone like him in every industry—the man voted least popular but most likely to succeed. This brilliant California

capitalist is content to take his winnings from food canning, timber, matches, and railroads—and forget loving cups." The author, Freeman Lincoln, described Simon as probably "the most unpopular businessman in California" and one who was "governed by a profound disrespect for the status quo. . . . He operates on the theory that success depends not on a time-costly bolstering or patching of things as they are, but on sweeping obsolete or inefficient structures out of the way and building new. His theory has worked to bring Simon handsome returns, for although he is only forty-six, he has already accumulated for himself and immediate family a stake of some $35 million. Presumably he still has a long way to go."

Lincoln quoted Simon as saying, "Nobody believes me, but the fact is that I never have a fixed idea about where I am going. I follow the road with the unknown end. I go where the going looks best." Then the author issued an alert: "That being so, any complacent president of almost any undervalued medium-sized U.S. corporation with a wide stock distribution might do well to ponder the efficiency of his operation. He might be smart to warn himself that 'Norton Simon may get me if I don't watch out.' "[3]

In an article in *Time* magazine on "shrewd investors who snap up an undervalued company with the idea of liquidating it for a quick profit, or those who take over such firms and ram through drastic changes to improve the properties and turn in bigger profits," the writer labeled Simon a raider. Although Simon did fit into the second category, he objected to being called a raider. He did not liquidate the companies he controlled. As for effecting major changes to increase the financial return, Simon said he merely provided "a technical service to management."[4]

Simon's brilliance in business was not matched by skills in dealing with people. He frequently offended employees with his chaotic style and a personality that they perceived as mean-spirited and manipulative. Hunt was progressive in its liberal use of psychologists for hiring staff and understanding employee relationships, but it became known as a revolving-door company, where employees were pitted against one another. Simon preferred to scour the country looking for the best possible person to solve a specific problem instead of working with the staff. Then, when the high-

powered problem solver had fulfilled an assignment, he was likely to be out of a job unless he could find another niche for himself in the company.[5] The atmosphere of insecurity and instability and Simon's predilection for keeping his employees off-balance was an effective means of controlling them, but it contributed to an image of Simon as a tyrant who discarded people as soon as he had no further use for them and mowed them down when they got in the way. Upon occasion, he offered visible proof that his detractors were right. His power of concentration was so intense that once, while racing down a hall to a meeting, he ran into a secretary and knocked her off her feet. Simon didn't even slow down, much less inspect the damage.

Still, he forged long-term relationships with some employees, those who were unusually competent, able to stand up to their boss, and stimulated by working for a self-made tycoon. Young Turks were given opportunities to prove themselves, but risked humiliation when they made costly mistakes. More conservative people who needed the comfort of a predictable, bureaucratic way of doing business were doomed, as were those who showed up for meetings carrying several briefcases but few facts in their heads. "If you wanted to present a case or argue something through with Norton, you needed the facts," said Harold Williams, who went to work for Simon in 1956 as a twenty-six-year-old tax attorney. Williams stayed for fifteen years, becoming a top executive at Hunt Foods & Industries before moving on to become, successively, dean of the Graduate School of Management at the University of California, Los Angeles, chairman of the Securities and Exchange Commission, and president of the J. Paul Getty Trust. "He had an incredible memory," Williams said of Simon. "He didn't need briefcases. The computer was in his head. There are people who can crank numbers and people who are creative, but they don't usually come in the same man. They did with him. He was an enormously creative guy. He used to say to our marketing people, 'You play this game as though it is solitaire. You know you're going to make a move; what are they going to do in response? It is chess, not solitaire.' "

Simon was tough to work with on a daily basis, and even Williams found he had to keep a certain distance to function effectively. But Simon's unorthodox style created personal and professional growth

opportunities for those who weren't intimidated by his strong personality. "I'd been with him maybe three or four or five years and my job was getting very fuzzy," Williams said. "I was doing all kinds of things, without portfolio. One day I said to him, 'Norton, I think I ought to have a job description.' Norton said to me, 'You don't want a job description. Job descriptions fence you in.' That kind of perspective was Norton, taking something and turning it on its head. He had a unique way of looking at things. And I thought, 'He's right.' I never did get a job description and I have never wanted one since."[6]

In his early years in business, Simon surrounded himself with family members, but even those relationships were sometimes strained to the breaking point. His sister Evelyn's first husband, Harold Brooks, worked for him from 1931 to 1946, as vice president of marketing, then struck out on his own. They remained on good terms for the most part, sometimes working together on investments, but Norton's compulsion to be in control occasionally led to infuriating confrontations and rifts. One September Mr. and Mrs. Brooks were preparing to take an extensive trip when Norton demanded that they make the final payment on a real estate loan that wasn't due until January. "Norton called just before we left and said, 'I want the last payment now.' It was horrible, but we sold some stocks and made the last payment on the property," Evelyn said. "I was furious. I didn't talk to him for a year after that. In my experience with Norton there was more good than bad, but he did some things like that. He was always in command."[7]

His younger sister Marcia's husband, Frederick R. Weisman, joined Val Vita in 1938, at the insistence of Myer Simon, and became president of Hunt Foods in 1943, at thirty-one years of age. A tough operator who didn't seem to mind being known as his brother-in-law's hatchet man but who later complained about having worked so long for such an angry man, Weisman stayed with the company until 1958, when he made a profitable uranium investment. In 1970 Weisman set out to make another fortune, taking over a twenty-year franchise for Mid-Atlantic Toyota Distributors, Inc. that turned out to be a bonanza.

Myer worked for his successful son for nearly twenty years, but also ventured into real estate and other lucrative investments. Disappointed that Norton had refused to put him on the board of directors of Hunt, Myer retired in 1949. At the age of sixty-nine he died in his sleep 31 March 1953 in Lisbon, Portugal, while taking a cruise with his wife. Though he could easily afford to pay for his own vacations by then, the cruise was a thirtieth wedding anniversary gift from his son.

4

UNFAMILIAR TERRITORY

One should never feel safe.

NORTON SIMON
14 June 1990

BECAUSE HE WAS A self-made multimillionaire who lived unpreten-tiously and avoided publicity, Simon's success in business may have appeared to be a sudden phenomenon. When his name began to appear in the national press as a controversial power in the food-canning industry, he seemed to have come from nowhere. In fact, the business holdings and the $35 million in personal assets that he had accumulated by 1953 were the product of about thirty years work and methodical—if bold and unpredictable—steps to build an empire.

His entrance into the art world was entirely different. Although Simon had had little more formal schooling in business and finance than he had in art, he was born into an entrepreneurial family. Busi-ness was in his blood. As a collector, he plunged into completely for-eign territory at the age of forty-seven, even if in later years he didn't always admit what a novice he had been. "I didn't jump off a cliff when I started collecting," he insisted thirty-six years after he pur-chased his first painting. "I had a lot of business experience. I knew a few questions to ask, and I read a lot about it." And what if he had been on shaky ground? For a man who prided himself on running his companies by the seat of his own pants, security was not necessar-ily desirable.[1]

However defensive he may have been, he was correct in claiming that he did not knock at the art world's door without qualifications. In addition to his business acumen and willingness to take risks, he had two major assets: taste and enormous resources. As for his upbringing, his sisters liked to point out that despite family hardships during their childhood they were not deprived. One of the earliest indicators of their brother's penchant for luxury emerged in his early twenties, when he used some of his newfound wealth to impress them with gifts of beaver coats and cashmere sweaters. Although he had little contact with art during his youth and early adulthood, his stepmother, Lucille Michaels Simon, a cultured woman who was interested in opera and art museums, provided an example of how the arts could enrich one's life and surroundings.

Norton was married to a woman who took a strong interest in his collecting. Unlike her husband, who had dropped out of college after six weeks, Lucille Ellis Simon had been well educated at Wellesley. Because her interest in art preceded Norton's and she became an ardent advocate of art education, some family friends credit her with inspiring him to collect. Still, there had been no collectors on either side of the family. What's more, his living in Los Angeles did not increase the odds that he would pursue a second career in art with as much passion and energy as he had put into business.

In the early 1950s, long after the major art museums on the East Coast had become fixtures on the American cultural landscape, Los Angeles had no public museum devoted exclusively to art. The major public collections of fine arts in southern California were relegated to a multipurpose institution designed with separate wings for history, science, and art in Exposition Park. Called the Los Angeles Museum of History, Science and Art, it had been founded in 1910 under a contract between the County of Los Angeles and four organizations: the Historical Society of Southern California, the Fine Arts League, the Southern Division of the Cooper Ornithological Club, and the Southern California Academy of Sciences. The county had leased part of a state-owned agricultural park to build the museum. The four organizations were to collect and install exhibitions, the county was responsible for maintenance and operations.

A board of governors, representatives of the county and the four cooperating organizations, administered the museum.

The cornerstone of the building was laid 17 December 1910, and the leased land was christened Exposition Park. The museum opened three years later. Inaugural exhibitions of history and science were drawn from the institution's collections. The museum owned no art, so all the artworks on display—including 68 old master paintings and 150 examples of local artists' work—were borrowed. As the exhibition program evolved, it consisted largely of traveling shows organized by museums in the eastern United States, displays of local artists' work, and membership exhibitions sponsored by the California Art Club, the Photographic Salon, the American Federation of Arts, and other art associations.[2]

The institution's name was changed to the Los Angeles County Museum of History, Science and Art in 1931, in an attempt to end confusion about whether the institution was a city or a county facility. But in 1939 the county Board of Supervisors relinquished some control by establishing a nonprofit group, the Associates of the Los Angeles County Museum of History, Science and Art, to receive gifts without needing the county officials' approval. Joseph B. Koepfli, who had long been involved in the establishment of the art museum, commented that, before the Associates came into being, "if the museum wished to receive donations of money or art or gifts in kind, or to trade or sell a work of art, the board of governors had to get formal action by the Board of Supervisors, which was unwieldy."[3]

Art had never been important at the museum in Exposition Park, or so it seemed in the mid-1950s to those who were offended by the notion of housing paintings, stuffed bison, and animal skeletons from the La Brea Tar Pits under one roof. Art aficionados would point out that the director of the museum was Jean Delacour, a French ornithologist, botanist, and naturalist who had been appointed in 1952. He retired in 1960, but his successor was Herbert Friedmann, another ornithologist. Although some earlier directors were educated in art, the highest position at the museum to be occupied by an art specialist was that of a department chief.

Nonetheless, the museum acquired tens of thousands of artworks during its first four decades. The first move to establish a serious art

collection came in 1931 when William Preston Harrison began to collect French and American paintings from the nineteenth and twentieth centuries with the intention of donating them to the institution in Exposition Park. The appointment in 1946 of William R. Valentiner as head of the museum's art division gave the collection an enormous boost in garnering academic respect and gifts of considerable worth. A German-born Rembrandt scholar, museum expert, and prodigious author, Valentiner had directed the Detroit Institute of Art for twenty years with great distinction. During his eight-year tenure at the Los Angeles County Museum, it acquired a broad spectrum of objects representing art history from ancient Egypt through modern times. The groundwork was laid by gifts from several patrons: Old master works were donated by Paul Rodman Mabury and Allan Balch, medieval and Renaissance pieces by the publisher, William Randolph Hearst, impressionist paintings from George Gard De Sylva, and European paintings, tapestries, and decorative arts from the oil magnate, J. Paul Getty.

Los Angeles was a relatively young city, its youth apparent in the weaknesses of its cultural institutions. But its aspirations were equally apparent in its efforts to develop educational and aesthetic resources. Fortunately for art lovers, the County Museum was not the only resource in the 1950s. The University of California at Los Angeles developed a distinguished exhibition program under the direction of Frederick S. Wight, who presided over the galleries from 1953 to 1973. A dozen or so commercial galleries maintained active exhibition schedules, showing the work of internationally known artists as well as that of local heroes. Southern California also was home to privately funded institutions with world-renowned collections, most notably the Southwest Museum, one of the nation's foremost repositories of Native American art and artifacts, and the Huntington Library, Art Collections and Botanical Gardens, a gracious complex endowed with a fine collection of British paintings.

The city had not, however, established traditions of private collecting and public cultural philanthropy, nor could it even hold onto what it had or attract gifts that might logically have come its way. Before Norton Simon had bought a single painting, Los Angeles had

lost its greatest private collection to Philadelphia. It was amassed by Walter C. Arensberg, a poet and scholar known for promoting the theory that Francis Bacon wrote the plays ascribed to Shakespeare, and Arensberg's wife, Mary Louise Stevens Arensberg. The couple lived in New York from 1914 to 1921, where their apartment was a high-spirited salon for the dada movement. The star of the frequently wild and drunken scene was the French expatriate artist, Marcel Duchamp, but on any given night the cast might include the artists Man Ray, Francis Picabia, and Beatrice Wood, the dancer Isadora Duncan, and the poets William Carlos Williams and Wallace Stevens. Walter Arensberg soon exhausted the financial support he received from his father, a Pittsburgh steel executive, but Louise inherited a fortune from a textile business in New England, which paid the couple's living expenses and provided enough money to buy Duchamp's work in depth, together with avant-garde pieces by sixty other artists, and furniture, rugs, and ethnic artifacts.[4]

After several sojourns in California, the Arensbergs settled permanently in Hollywood in 1927 and adopted a quieter lifestyle, but they continued to collect and to entertain artists and intellectuals. Visitors encountered such landmark modern paintings as Duchamp's *Nude Descending a Staircase* and Salvador Dali's *Premonition of Civil War,* along with a large group of sculptures by Constantin Brancusi, twenty Picassos, and work by Georges Braque, Fernand Léger, Henri Rousseau, and Joan Mirò. As the years passed and the collection grew to about fifteen hundred pieces, paintings completely covered the walls of every room of their house and rugs were piled several layers thick on the floors.

Ensconced in Los Angeles and aware of the city's lack of a museum devoted exclusively to art, let alone one that concentrated on the modern period, the Arensbergs decided that their collection should remain in southern California. During the late 1930s they looked into the possibility of building their own museum, either on a lot next to their home or in Beverly Hills, and joined a short-lived community effort to add an art wing to the Los Angeles County Museum. After the end of World War II, they tackled the problem again, talked with representatives of more than thirty institutions,

and developed a plan to donate their collection to the University of California at Los Angeles. In return for the gift, the university was to provide a building for the collection and to display it as a unit for a substantial period of time. To make his offer more attractive, Arensberg persuaded Galka E. Scheyer to bequeath her collection to the university. A German emigré collector and dealer who also had settled in Los Angeles, Scheyer represented a group of artists she called the Blue Four—Wassily Kandinsky, Paul Klee, Lyonel Feininger, and Alexei Jawlensky.

In 1944, the president of the university, Robert G. Sproul, announced to the press that the board of regents had accepted "the most intelligently and beautifully chosen collection of twentieth-century art in the world."[5] But a suitable building did not material-ize. Several years before the deadline in 1950, the Arensbergs had begun talks with Philadelphia Museum of Art, to which they gave the collection in 1951. Their demand for a building was dropped and the terms of agreement required the Philadelphia museum to exhibit the artworks as a unit for twenty-five years after receiving them. "I am deeply sorry," said Arensberg, "that they must leave Los Angeles where I feel they are needed, but I am glad that they will, with other collections, make Philadelphia a unique center for the study of modern art."[6]

Scheyer died in 1945, but her bequest to the university was contin-gent upon the Arensberg gift. Her will provided that, if the university did not erect a suitable building on its campus, the fate of her collec-tion would be determined by a committee she had appointed, her own preference being "that the permanent home of the Collection shall be in Los Angeles, California."[7] In late 1951, the committee gave the collection to the Pasadena Art Institute, a small community museum that had had a history of displaying oriental and nineteenth-century European and American art as well as modern material.

Apart from the Arensbergs, the city's most active private collectors tended to be affiliated with the film industry. Most of them had little inclination to support museums and those who did rarely made substantial gifts of art to local institutions. An exception was the actor Edward G. Robinson and his wife, Gladys Lloyd Robinson. In

1941 they lent fifty French impressionist and post-impressionist paintings from their collection to the Los Angeles County Museum, raising hopes that some or all of the works might be donated there. Seventy pieces from the Robinsons' holdings were displayed at the museum in 1956, but by then the couple was in the process of divorce. The following year, to pay his ex-wife's share of their community property, the actor sold most of the collection for $3 million to the Greek shipping magnate Stavros Niarchos.

As a widely traveled, well-read businessman, Simon was aware that wealthy people sometimes spent large sums on artworks and put considerable energy into building collections, but he had no close contact with other collectors who might have served as mentors. As he later told the story, what turned his attention to art was a new house. In 1954, he and Lucille purchased a lot on north Hudson Avenue adjacent to the Wilshire Country Club in the affluent Hancock Park district, about two miles north of their longtime home on Buckingham. Still living well below the level they could afford, the Simons built a comfortable, unpretentious ranch-style house with a back garden and a swimming pool.

"I don't think I was very interested in art until we moved into a new house and started putting contemporary art in it," Norton said. "A decorator brought in some paintings. I didn't like them, so I went to some dealers to see what was available."[8] He wasn't thinking beyond buying a few artworks to hang on his walls, but he became interested in the process. If there were to be art in his house, it would be something he liked and he would choose it. His first stop was at Dalzell Hatfield Galleries at the venerable Ambassador Hotel on Wilshire Boulevard. It was an obvious choice because he passed Hatfield's showcase every Saturday when he had his hair trimmed at the hotel barbershop.

At first, Simon had little knowledge and no grand plan. "At the time looking around for art was not a terribly serious endeavor for me, as it became later. In those days I bought anything that had a personal aesthetic appeal to me," he said.[9] He consulted with Lucille and rarely purchased anything she actively disliked, but he soon became the driving force behind a burgeoning collection.

Simon paid sixteen thousand dollars on 22 December 1954 for his first major acquisition, a late work by the French painter Pierre-Auguste Renoir. Completed in 1918, the year before Renoir's death, *Andrea en Bleu* is a sixteen-by-twenty-inch oil portrait of the wife of the artist's son, the film director Jean Renoir. It was the first of many Renoirs acquired by Simon, but it was not a superior example of the artist's work and he soon tired of it. Winding up his financial affairs at the close of 1956, he donated the portrait to Pomona College, where the art historian Peter Selz was chairman of the art department. "The old Renoir, then in his [seventies] had already achieved wealth and fame as a painter," Selz wrote in a college bulletin announcing the gift, "but *Andrea en Bleu* still retains a youthful freshness of discovery and reflects an obvious pleasure in painting a beautiful woman. By this time Renoir had rejected impressionist theories and now, in his post-impressionist period, was more interested in large, solid form."

A month after buying the Renoir, Simon made a smaller purchase at Hatfield, *Corbeille des Fruits,* a still life measuring 9½ by 13 inches by Pierre Bonnard, bearing a price of thirty-five hundred dollars. The colorful portrayal of a fruit basket had considerably more staying power for the fledgling collector than the larger Renoir had had. Simon kept the Bonnard until 1969, when he traded it to Paul Kantor, a dealer in Los Angeles, as partial payment for a more imposing painting by Georges Braque, *Nature Morte à la Serviette.*

Curious to see what New York had to offer, Simon began to visit art galleries there on his frequent business trips. On one occasion, in the spring of 1955, he met the artist Helen Frankenthaler, who had just seen an exhibition of Hans Hofmann's abstract-expressionist paintings and showed Simon a brochure. Simon began asking her why she liked the paintings and why she thought they were good, took her to lunch, and then accompanied her to a few galleries. The experience was stimulating for Simon, but its most lasting effect was that Frankenthaler later called the New York dealer Ben Heller and asked him to help her new acquaintance. Her request initiated a long professional and personal relationship between the two men.

Caught up in Frankenthaler's enthusiasm for Hofmann, who was

among the most prominent artists in New York at the time, Simon purchased his painting, *Floral Composition,* on 7 March 1955 from the Samuel M. Kootz Gallery in New York, for twelve hundred dollars. Almost immediately, Simon received a request to lend the painting to a traveling retrospective of the artist's work organized by the Whitney Museum of American Art in New York and the University of California at Los Angeles. He agreed to have the painting reproduced in the exhibition catalogue, but restricted his loan to the Los Angeles venue because he feared it would be damaged in transit. The exuberant abstraction didn't fit his collection as it evolved in the next few years, so Simon sold it at auction at Parke-Bernet in New York in November 1971 in one of many efforts to prune his art holdings. If the Hofmann had long since fallen out of his favor when it went on the auction block, the painting served him well in financial terms. It was sold for fifteen thousand dollars, more than twelve times its original price.

Simon's next two acquisitions, both made on 22 March 1955 at the New York branch of Wildenstein & Company, a prestigious international gallery, elevated Simon to a more rarefied echelon of collecting. With Lucille's encouragement to go for quality, he bought not only names, but also superior examples of the artists' work and paid higher prices. He purchased *Pointoise, Bords de l'Oise* a river landscape painted in 1872 by Camille Pissarro, for twenty-eight thousand dollars, and *Swineherd, Brittany,* Paul Gauguin's 1888 portrayal of a peasant and two yellow pigs in a richly colored landscape, for sixty thousand dollars. Wildenstein had tried to sell the Gauguin in Los Angeles about fifteen years earlier, through the Los Angeles dealer Al Stendhal, who had offered the painting to the film producer Jack Warner for eight thousand dollars. Warner declined, protesting, "I don't want pigs in my parlor."[10]

Simon's interest in art coincided almost precisely with the arrival in Los Angeles of Richard Fargo Brown, a bright young scholar who would serve as a catalyst for a public art museum. A native of New York and a great-grandson of William George Fargo who founded the Wells-Fargo Express Company, Ric Brown was slight of stature but enormously energetic. He had been a bantam-weight boxer in

his college years, done graduate work at New York University's Institute of Fine Arts, and earned his doctorate in art history at Harvard University. He started his career as a research scholar at the Frick Collection in Manhattan, then became a visiting professor of fine arts at Harvard. Charismatic, ambitious, and highly respected by his peers, Brown was named chief curator of art at the Los Angeles County Museum in 1954. He succeeded Valentiner, who had laid the groundwork for a separate art museum but resigned to direct the first J. Paul Getty Museum in Malibu.

Brown had been recruited by William T. Sesnon Jr., a museum trustee who was eager to enhance the institution's art program and collections. Although Brown hadn't been hired specifically to build the museum of Valentiner's dreams, it soon became obvious that he hadn't come west to preside over art in a multipurpose institution—particularly one that placed greater value on historic documents and scientific specimens. But Brown was an outsider who found it difficult to rally the energies of the board members, most of whom came from the conservative communities of Pasadena and San Marino and had little interest in major changes. He needed new blood, big money, and the energy of the city's art collectors, many of whom were Jewish and had not been invited onto the board, either because of prejudice or simply because their lives were circumscribed by the enclaves of Beverly Hills and Hollywood. As it turned out, the suave young curator was perfectly qualified to inspire the newly rich citizens of the city who were eager to distinguish themselves as leaders of a new cultural elite. Handsome, eloquent, and passionate about art, he spoke with evangelical zeal about the future of Los Angeles and soon became an indispensable guest at the best dinner parties.

At the same time as Brown began preaching to the wealthy, Simon realized that, if he continued to buy art, he would need the advice and counsel of experienced professionals. On a visit to Wildenstein & Company in New York, he asked if there were anyone in Los Angeles who might help him and was told that Brown was his man. A serious art historian whose doctoral thesis was titled "The Color Technique of Pissarro," Brown was also something of a ham who loved to

indulge in theatrical gestures. When he walked into Simon's house and saw the Pissarro landscape, he fell down on his knees as if he had arrived at a shrine. His dramatic entrance was the beginning of an intense and largely satisfying relationship that lasted for ten years as Simon transformed himself into a world-class collector and Los Angeles gained a major public art museum.

5

A WORLD-CLASS COLLECTION

*He works seven days a week, surrounded both at home and in
his office by perhaps the best private art collection in California—
from Rubens and Rembrandt to Picasso and Hans Hofmann.*

TIME
23 August 1963

LIKE MANY BEGINNING art collectors of our day, Simon was initially
drawn to the French impressionists. Their work had not been widely
appreciated during the artists' lifetimes, but by the mid-1950s they
had found an enormously receptive audience. As modernism took
hold of the avant-garde and spawned abstract modes of expression
that mystified and perplexed the lay audience, impressionism
appeared eminently comprehensible and refreshingly pleasant.
Although the work of Édouard Manet, Claude Monet, Edgar Degas,
Camille Pissarro, Pierre-Auguste Renoir, and other pioneering
impressionists actually marks a moment of profound, forward-look-
ing change in art history, unschooled observers tend to view
it as a connection to the past, reflecting a simpler time and an unen-
cumbered lifestyle that seems quite idyllic. The pastel colors, shim-
mering surfaces, light-filled spaces, and benign, everyday subjects of
the paintings are deeply satisfying to those who approach art in search
of enrichment rather than intellectual stimulation or emotional
confrontation.

Simon was probably moved by the appealing aura of French
impressionism that attracts many devotees. But in the work of lead-
ing impressionists and post-impressionists he also found a theme that

provided a continuity in his collection as it grew and branched out in different directions. While amassing both European and Asian art encompassing seven centuries, he was most frequently drawn to pieces that convey a strong concern with the nature of human form and existence. Although Simon acquired artworks of surpassing beauty and many that epitomize classical aesthetic and religious ideals, more often than not the human images that intrigued him were imperfect or burdened and the messages they conveyed were often equivocal if not troubled. He himself was a restless, introspective man who kept his employees and colleagues on the run and frustrated those who tried to second guess him. Known for considering every possible pathway to every goal and withholding decisions until the last minute, he described himself as an existentialist who was perpetually "in the process of becoming."[1] When he began to look seriously at art, he naturally gravitated toward works that not only embodied a high level of aesthetic quality but also resonated with complex, humanistic meaning.

Degas, whose sensitive portrayals of women are so unflatteringly realistic that he is often said to have been a misogynist, was an early and continuing favorite of Simon. The first work by the artist to enter his collection was a bronze sculpture, *Dancer Rubbing Her Knee.* Purchased in the fall of 1955 for $1,800 at Knoedler & Company in New York, the statue depicts a lithe young nude in an unguarded moment, stretching her legs and back while leaning forward and massaging her left knee. Instead of performing for an audience, she is getting in touch with her body and examining its physical limits. Almost by accident, it seems, her natural gesture makes an attractive composition.

About a month after he bought the bronze Simon paid a visit to Dalzell Hatfield in Los Angeles and purchased a pastel drawing of a ballerina by Degas, *Dancer in Green,* for $20,850. Here again, the subject is no dainty personification of feminine grace, but a celebration of closely observed life. The muscular ballerina is caught in the rather ungainly act of leaning over and grasping one leg in each hand as she stretches her limbs. The following year, Simon made his first purchase from Sam Salz, a dealer in New York. It was another Degas, *Study of a Man,* a painting measuring 13½ by 8 inches and

thought to depict a friend of the artist. The study was executed in preparation for *Interior*, a mysterious, narrative painting of an estranged couple on opposite sides of a bedroom. The small study is a dark, full-length portrait of a bearded man. He stares off to one side as he leans against a wall with one hand behind him and the other in a pocket. Lost in thought, he silently invites viewers to speculate about his situation.

In the next few years Simon continued to buy the works of Degas. In 1957 he paid forty-five thousand dollars to the New York dealer Paul Rosenberg for *Portrait of Madame Dietz-Monnin*, a pastel study for *Portrait after a Costume Ball. Madame Dietz-Monnin*, a painting owned by the Art Institute of Chicago. The commissioned portrait depicts the wealthy mother-in-law of a friend of the artist who had lent him money. Apparently paying off his debt, Degas portrayed the middle-aged woman wearing a low-cut dress, floppy hat, and feather boa, but her expression and body language speak of fatigue and dis- appointment. In typical Degas fashion, the artist seems to have caught his subject off-guard, slumping on a bench and wistfully waving a gloved hand at an unseen friend across the room. She is all dressed up for the ball, but she's on the sidelines. In the image of the dejected woman who hates to admit she's past her prime, Degas sums up the depression that often lurks just below the surface of gaiety.

Women Ironing, a richly expressive portrayal of two exhausted women, one yawning, the other hunched over their ironing board, is a far less subtle evocation of female misery, but a profoundly com- pelling image of lost youth and beauty. Pulling off something of a coup, Simon snapped up the painting in 1959, just before it went on the auction block. *Women Ironing* had been in the collection of Chester A. Beatty, an American mining engineer who moved to Lon- don in 1911 and became well known as a collector of European and Asian art. The provenance would probably have helped bring a hefty price at auction, but Dudley Tooth, who headed the firm of Arthur Tooth & Sons in London, bought it from the owners first and sold it to Simon for $260,000.

Honoré Daumier, a satirical observer of the human condition, also caught Simon's eye when he began looking at art. But instead of buy-

ing a typical caricature or political commentary, his first Daumier was *Mountebanks Resting,* an introspective painting of traveling performers sitting at a table, purchased in 1955 from Wildenstein for $85,234. He later bought and sold several of Daumier bronzes that portray bourgeois men as poseurs and fools, but the more complicated *Mountebanks Resting* continued to interest him. He acquired the study for the work and included a reproduction of the painting in his museum's picture book, *Masterpieces from the Norton Simon Museum.*[2]

Édouard Manet and Paul Cézanne also joined Simon's collection early on, when he owned fewer than a dozen pieces of art. And in each case his earliest purchase was a portrait. Cézanne's *Portrait of a Peasant,* purchased in 1956 from Rosenberg & Stiebel for $70,000, is an archetypal piece by an artist whose painting formed a bridge between impressionism and cubism. A late work, executed between 1900 and 1906, it portrays a pensive man seated in a chair outdoors, with flickering light breaking up the surfaces of his clothing and the surrounding landscape. The Manet, acquired in 1956 from Wildenstein for $54,000, is a portrait of the artist's wife, painted in 1866. Lowering her eyes as she patiently sits for her husband, Madame Manet has a soft, thoughtful face that illuminates the center of an otherwise dark canvas.

Simon had taken the painting to his home on approval in December 1955, when Ric Brown was interviewing James Elliott for a curatorial position at the Los Angeles County Museum. Although Simon hadn't yet joined the museum's board of trustees, Brown was eager to have him meet the young man who would likely be joining the staff and might consult with him on his collection. Simon viewed the meeting as a chance to size up the new recruit while picking his brains about a potential acquisition. "It is a breathtaking painting" said Elliott of the Manet "but the subject matter isn't conventionally pretty. We got into a discussion about what made it a profound and subtle view of a not entirely happy woman. And we decided that whatever sadness was being expressed was a sympathetic observation of the human condition. There is such poignancy about the picture that looking at it is like reading a poem about sadness and realizing that life is like that."[3]

Simon continued to buy works by Cézanne, Renoir, and Pissarro

during the late 1950s, consulting with Brown and a growing number of scholars and dealers but always making his own decisions. As his collection grew, he enhanced his holdings with jewels such as Monet's shimmering landscape, *The Artist's Garden at Vétheuil*. Foretelling the breadth of his collection's future scope, he bought a few pieces of contemporary art in his early years as well as Greek vases and statuary and an ancient Egyptian sculpture of a priest. Moving forward in time from the impressionists, he purchased paintings by Georges Braque, Henri Matisse, and Pablo Picasso. Retreating into European art history, he acquired a seventeenth-century Dutch portrait by Frans Hals and French works by the pre-Revolutionary painter Jean-Antoine Watteau, the romanticist Théodore Géricault, and the neoclassicist Jean-Auguste-Dominique Ingres.

Adding a piece to the collection could be a long process. Simon took more than a year to decide in favor of Rembrandt's *Portrait of Hendrickje Stoeffels,* a family favorite that occupied a place of honor in the living room and exemplified the humanistic qualities Simon appreciated. The painting depicts a housemaid who became the artist's devoted companion after the death in 1642 of his wife Saskia. A rather plain but sweet young woman in the portrait that Simon acquired, she was Rembrandt's most frequent model during his later years, appearing as her own unpretentious self and as the goddesses Venus and Flora.

The portrait came from the venerable firm of Duveen Brothers in New York, where it had been in the inventory for more than twenty years. Unbeknown to Simon, the gallery's owner, Edward Fowles, had offered it to the Rijksmuseum in Amsterdam for $105,000 in 1953. The director general of the museum, David Roell, declined, saying that he greatly admired the painting and would happily display it, but did not "feel the inner conviction that it is entirely by the hand of Rembrandt" and therefore "could not consider paying a Rembrandt price for it."[4] Attributions of Rembrandt's work have long been a subject of scholarly debate and many museums display paintings ascribed to him that have been questioned, so Fowles didn't consider Roell's judgment a fatal blow. His subsequent offers to prominent European private collectors, at $120,000 and $150,000, failed, however, to produce a buyer.

When Fowles saw that Simon was seriously interested in the painting, he raised the price to $200,000. They arrived at an agreement in June 1956, but it was far from a sure thing. Six months later they made a second, more complicated arrangement that involved two Rembrandts and a lesser price for the Stoeffels portrait, which was to be cleaned by Billy Suhr, a conservator in New York. Yet another year passed before Simon agreed on 31 December 1957 to purchase the Stoeffels portrait for $133,500 and take an eighteen-month option on another painting by Rembrandt, *The Philosopher*, at a purchase price of $100,000. One month before the option expired, Simon notified Fowles that he was not going to buy *The Philosopher*.

Simon was spending a considerable amount of money in the late 1950s for someone so new to the field, but except for the Rembrandt and the $260,000 he paid in 1959 for *Women Ironing*, by Degas, all his purchases were under $100,000. That changed in 1961, when he bought a portrait by Frans Hals, thought to be of the painter Jan van de Cappelle, for $142,500, and more than twice that sum for each of two paintings by Vincent van Gogh. Both were painted in 1889, the year before the artist died, during the most highly valued period of his work. One painting, *St. Paul's Hospital at Saint-Rémy*, purchased from Rosenberg for $380,000, depicts the hospital where Van Gogh was treated. The long, low building is screened by a row of wiry trees that reach up into a turbulent sky, their leaves forming clumps of greenery. The other painting, *The Mulberry Tree*, a vibrant yellow and blue landscape that came from Marlborough Fine Art in London, was priced at $300,274. Its centerpiece is a tree with corkscrew foliage that looks so powerfully agitated that it might be electrified. "It's a hell of a dynamic painting," Simon said toward the end of his life, when looking back over his experiences as a collector and singling out favorite pieces.[5]

But in a sense he was tricked into buying it. Frank Lloyd, the co-owner of Marlborough, presented the Van Gogh to Simon on a trip to California. Following a common practice of visiting dealers, Lloyd took a room at the Beverly Hills Hotel and invited collectors to see a selection of items he had brought with him. Simon was the primary reason for Lloyd's trip, and he had judged his client's tastes

well. Simon immediately gravitated to the Van Gogh. But he knew that some superb paintings by Degas were coming up at auction in New York within a few days and was torn between the two artists. Tipping his hand to the dealer, Simon couldn't resist grilling Lloyd about the quality and value of the Degases. Lloyd soon figured that Simon was making a choice. When Simon left the hotel room without committing himself to the Van Gogh, Lloyd immediately called his assistant in New York and instructed him to bid on the Degas lots to insure that Simon wouldn't buy them instead of the Van Gogh. The plan worked. Lloyd got the Degases for his inventory and Simon bought *The Mulberry Tree*.

As Simon began to buy art at a faster pace and pay higher prices, dealers quickly realized that an important new player had arrived on the art scene. Little by little, he made the rounds of distinguished galleries, becoming acquainted with long-established dealers and seeking out younger ones who were particularly knowledgeable and pleased to be of service. Eager to have his business, the dealers began to keep Simon in mind when something unusually good appeared on the market and they looked for prime material to offer him.

Eugene Thaw made his first sale to the Californian collector in 1963. "I came back from a buying trip to London," he said in an interview thirty-two years later. "I was not a very powerful dealer then, but I had taken a gamble on a big, wonderful painting by Corot, *Site in Italy with the Church at Ariccia,* and brought it back to New York and cleaned it. I sent a photograph of it to Norton and he bought it. It was seventy thousand dollars, nothing like today's prices, but it was a lot of money at the time. After that I would just simply send him material on anything very good that I got, and as I prospered I got better things."[6]

As Simon gathered information about artists and dealers and became more knowledgeable about the art market, he asked more and more questions, and every answer seemed to lead to a new line of inquiry. Determined to make smart decisions, he sought professional advice from a variety of specialists. Before long he became infamous for telephoning museum directors, curators, conservators, and dealers at any time of the day or night for counsel, and for keep-

ing them on the phone for hours. In his view, the reason was simple. "They had information I didn't have," he said.[7] And he was determined to get it.

Simon also queried his friends and employees who had little if any knowledge of art, to gain insight into unschooled reactions to artworks. "You can have a lot of knowledge and still be wrong," he said in defense of his unconventional strategy.[8] Convinced that the best way to get to know a work of art is through frequent, casual contact, he liked to take potential purchases on approval so he could live with them before making a decision. As paintings and sculptures arrived at his home and offices, nearly everyone who encountered them would be asked for an opinion or to weigh one work against another. Those who were well acquainted with Simon knew it was unwise to try to figure out his preferences because he was unpredictable. But they also had to be prepared to defend their opinions.

Most dealers had never encountered a collector quite like him, and as they became accustomed to working with him, they sometimes found him a frustrating client. "The thing about Norton is that he couldn't made up his mind," Thaw said. "Also, Norton had a weakness as a buyer in that he was always thinking of the public's reaction. If a piece was too obscure, too specialized, or too art historical, he thought it didn't have the power to get the public response he wanted. He tried to overcome that and he did buy some very scholarly things, but in the early days of his collecting you couldn't get a picture sold to him unless his butler and chauffeur and housemaid and what-have-you liked it. That was part of the gauntlet you had to run."[9]

Simon didn't completely shift gears as he moved between business and art—a tendency that galled aesthetic purists as well as dealers who couldn't fathom his tactics—but that was the only way he knew to proceed. When he started collecting art, he couldn't turn off the inquisitive nature that had helped make him a successful businessman, nor did he have any desire to do so. "The fact that I started collecting rather late in life may have been a help because of the broad knowledge I got in living," he said.[10] Indeed he often attributed his success in both business and art to his ability to ask questions. "I take nothing for granted. Before I buy a painting I raise questions about

its authenticity, condition, history, and ownership. In the business world I always raise serious questions about the status quo."[11]

Harold Williams, who worked for Simon from 1956 to 1970 and remained close to him until his death, became a seasoned observer. "Norton had a strange mixture of the kind of self-confidence that enables you to ask what sound like stupid questions but at the same time, a kind of self-doubt that causes you to want to ask those questions, because you are really not sure of yourself, not sure of your own judgment," Williams said. "He was a consummate brain picker. In a museum he would just stop people and ask what they liked about a painting. He would just walk up to people and do that. But of professionals, he would ask and ask and ask."

Art buying fulfilled his acquisitive instincts, but Simon's friends contend that his collection assumed a profound personal and spiritual importance for him. "He would say, 'Harold, art is my religion,'" Williams said. "It was not just an intellectual experience. He felt the art. In a strange sort of way, the fact that he felt it caused him to push the intellectual side to be sure he wasn't just reacting emotionally. That was typically Norton. He'd go back and forth that way. But if he didn't feel it, all the intellectual arguments in the world wouldn't do it for him."[12]

6

A COUNTY MUSEUM FOR ART

*We may not have as many of the greatest masterpieces of art as
some eastern and European museums but we will have the most
beautiful buildings and facilities for exhibiting them. This county is
moving ahead faster than any other in the nation in a dynamic
growth of cultural facilities.*

EARNEST E. DEBS
Los Angeles Times, *1 November 1962*

THE NOTION THAT LOS ANGELES needed a public art museum had
been bandied about since the 1920s and seriously discussed during
Valentiner's tenure, but it didn't catch fire until the 1950s when a new
cultural elite began to emerge. Enlightened leaders understood that, if
Los Angeles were to achieve more than a modicum of respect in
national and international intellectual circles, the city must have arts
institutions that symbolized its new sophistication and embodied the
aspirations of its cultural leaders. The old Philharmonic Auditorium,
built downtown in 1926, didn't measure up to more modern facilities
for presenting music and dance in America's other big cities. The rele-
gation of art to a mere department of a multidisciplinary institution
had become an embarrassment.

Several forces fueled the change of attitude. Wartime and postwar
industries, including aerospace, oil, and savings and loan companies,
brought a higher level of prosperity to southern California and
attracted more skilled workers and professionals to the region. New
immigrants were better educated, upwardly mobile, and eager to
enrich the quality of life in their new home. At the same time,

boundaries between the city's two traditional centers of power were ready to fall—or at least to bend for a good cause.

The old-money, old-business establishment, which was overwhelmingly Protestant and conservative Republican, had long been entrenched downtown, to the west in Hancock Park and to the north in Pasadena and San Marino. Beverly Hills and the vast area known as West Los Angeles were home to a younger, brasher, more liberal element that encompassed the film industry and much of the Jewish community. There was little to bring the two factions together. Residents of each area shopped, socialized, patronized restaurants, and conducted business in their own sections of town. The Los Angeles Country Club was located in West Los Angeles, but for a long time it admitted neither Jews nor actors. They were equally unwelcome on the boards of many cultural institutions.

These patterns were already changing when Simon began collecting art. Although he was the epitome of a Jewish, self-made entrepreneur, he had built his new house in Hancock Park, an old-money neighborhood. At the same time, Ric Brown had arrived in Los Angeles, sized up the lethargic state of philanthropy, and decided that any campaign to build a new museum would require the help of southern California's arrivistes. Most of the energy and promise seemed to belong to people who were not involved with the museum.

Only a few years earlier, Dorothy Buffum Chandler, who was married to Norman Chandler, the publisher of the *Los Angeles Times,* had reached a similar conclusion during a successful effort to save the Hollywood Bowl, an open-air theater threatened with destruction. In 1954 she took on the far more daunting challenge of raising funds for a new music center. The campaign began with a $4-million goal for a new auditorium but grew to an $18.5-million complex for the performing arts. While buttonholing and browbeating everyone she encountered—and schemed to meet through her considerable connections—she effectively forged an alliance between the two enclaves and added formerly isolated ethnic communities to the mix.

Establishing the Amazing Blue Ribbon 400, an elite group of fund-raisers for the music center, and using the newspaper's society pages to publicize the activities of people who helped her cause, Chandler was a catalyst for a new social order. Having money and

donating it—rather than belonging to the right family, church, business, or political party—was the primary criterion for acceptance and public recognition.[1]

Her activities did not go unnoticed by Brown, although the charming young curator would have pursued a similar course even without her example. He already had gained a powerful ally, one who happened to be a friend and admirer of Buff Chandler. When Brown began to talk about his dream of transforming the County Museum's art department into a separate museum, one of the first people he consulted was Norton Simon, who endorsed the idea and offered to donate a million dollars toward the effort.

Another wealthy businessman captivated by the possibility of building a public art museum in Los Angeles was Edward William Carter, the president of the Broadway-Hale Stores, a retail chain in southern California that he took over in 1946 and transformed into the largest group of department stores in the western United States. Carter had much in common with Simon. Although Simon's empire was much larger than Carter's when they met in the 1950s, both men had attained positions of wealth and accomplishment from modest beginnings. Carter, who was four years younger than Simon, got his first job at age ten as a printer's devil in a Los Angeles print shop to help support his widowed mother and sister. After graduating from Hollywood High School, he attended the University of California at Los Angeles while working forty hours a week at Silverwoods menswear store on Wilshire Boulevard.

Both Simon and Carter were driven by enormous ambition but they were too introspective and intense to be charismatic. Still, the differences between them were striking. Unlike Simon, who had dropped out of college after six weeks, Carter had not only earned a bachelor's degree at UCLA in 1932, but also had gone on to the Graduate Business School at Harvard University, whence he graduated cum laude in 1937. Simon was a far more creative thinker, but his circular style of questioning and reasoning was unfathomable to many people he encountered. Carter presented his ideas in a clear, logical order, as if he were a college professor reading from an outline. Simon was soft-spoken, but his nervous mannerisms and incisive mind kept him in a state of agitated animation. Carter, handsome and meticulously

groomed, appeared perfectly controlled and contained. In keeping with his personality and training, Carter toed a narrow path in art collecting. He built an extraordinary collection of relatively prim seventeenth-century Dutch landscapes and still lifes; Simon's probing curiosity and eclectic taste compelled him to pursue art representing a wide range of periods, styles, and nationalities.

The two men were thrown together in the effort to finance and build the museum. Carter, who was chairman of the Southern California Symphony Association, had been involved in the early phase of Buff Chandler's campaign for the music center, but he wanted to play a bigger role than she was willing to give him. As support for a separate art facility grew, leaders of the museum's board of governors approached Chandler and asked if she would lead a fund-raising drive. She declined, saying that she was just beginning a campaign for the music center, but suggested Carter. When he became aware of the project Brown and Simon had envisioned, he saw an opportunity. Carter joined the museum's board of governors in 1958 and became chairman of the fund-raising committee. He hired McCormick and Associates, an advisory firm, to study the feasiblity of raising money for a new museum. The report was optimistic, so Carter agreed to lead the effort provided three conditions were met: Land must be donated for the museum, as it had for the music center; the museum's operating expenses must by underwritten by Los Angeles County or another government entity; and the museum must be operated by a private, self-perpetuating board, independent of public agencies.

All three provisions became realities. The most desirable site was on Wilshire Boulevard, a parcel of county land valued at $8 million. Known as Hancock Park, like the residential area just east of it, the area was also the location of the La Brea Tar Pits. The Los Angeles County supervisors granted permission for the property to be used as a museum and agreed to pay operating expenses, then estimated at $1 million a year. A new group, the Museum Associates, was established as a private board of trustees for the projected art museum, and Carter became its first president.

Carter didn't win county support without an argument. One supervisor, Kenneth Hahn, initially opposed the new museum, say-

ing that "private capital may build an art gallery but it will be up to the county to maintain it and this, in the long run, is the larger item of expense."[2] But within a few months Hahn had been persuaded that the museum was needed, if only to provide more space for collections housed at Exposition Park and exhibits of scientific and historical materials. Hancock Park was a logical, centrally located site, and the supervisor had been assured that powerful community leaders would back up their verbal support for the museum with big donations to the project.

As 1958 drew to a close, two major donors to the museum were announced: One was Norton Simon, the other, Howard Ahmanson, the chairman of Home Savings and Loan Association. (Their early support for the museum united them in a community cause, but they were frequently at odds over its development.) After a long period of deliberation, Simon had been appointed to the board of governors in August 1957. Brown had repeatedly urged the governors to invite Simon to join them, so early in 1957 Joseph Koepfli, who was the chairman of the nominating committee, began to look into the possibility. Even though the board members were private citizens, the board was itself subject to public scrutiny because of the county's support of the museum. Making discreet inquiries about Simon to determine his acceptability, Koepfli repeatedly heard that Simon had an unsavory reputation in the business community because of his aggressive tactics. Some people who had dealt with Simon even accused him of being a crook. Sensitive to the charges but not convinced they were based on fact, Koepfli—a scientist at the California Institute of Technology who was well connected in the business and banking community in Los Angeles—spent eight months conducting a quiet investigation. "I satisfied myself that he was not a crook," Koepfli said. "He was sharp as hell, but he was not dishonest."[3]

Shortly after his appointment, Simon reiterated his earlier pledge to Brown by telling the trustees that he and Lucille would donate $1 million for a separate art facility if the rest of the money could be raised. Asked if the gift were contingent upon other conditions, Simon said he didn't want the building named for him; he wanted only to participate in the choice of architect. In his view, the Solomon R. Guggenheim Museum in New York, designed by Frank Lloyd Wright

and distinguished by its spiral plan, didn't work well as an art museum. He wanted to avoid a similar problem in Los Angeles.

With his million-dollar offer, Simon had made a spectacular entrance on the Board of Governors, but it soon became clear that he had serious competition in Howard Ahmanson, who had pledged $2 million. Public notice of the two gifts kicked off a long fund-raising campaign that began with a goal of $5 million and brought in $11.5 million by the time the museum opened in 1965.

Simon had initially made his offer to Brown, who would become director of the proposed museum. Ahmanson had been solicited by Carter, and they had struck a verbal deal in private. Several months later, Ahmanson signed a contract making his gift official, and stipulating that the museum and every addition to it be called the Ahmanson Gallery of Fine Arts. It was a bold move that signified Ahmanson's clout with the Board of Supervisors and Carter's political savvy. The supervisors were in debt to Ahmanson's bank, and he chose the moment to call in his chits. At Ahmanson's urging, the supervisors agreed to pay the salaries of the proposed museum's staff and maintain the building and grounds at a level commensurate with that of major public cultural institutions in other cities. In exchange for Ahmanson's persuasive services, as well as his financial pledge, Carter promised the museum would be named for him.

Simon was furious when he learned of the agreement. Not only had he been upstaged, a situation he found nearly intolerable, but also he felt that Carter was selling off the museum piecemeal, a development Simon believed was both reprehensible and destructive. He argued that naming buildings and galleries for a few patrons would undercut the public-spirited nature of the project and deter other potential donors who wouldn't get credit for their generosity. Then he proved the point by reducing his own donation to one hundred thousand dollars. Simon wasn't the only museum supporter who was offended by the Ahmanson deal. Judge Lucius Peyton Green, who had planned to bequeath his collection of old master paintings and financial assets to the new museum, donated them instead to the Fine Arts Museums of San Francisco.

In an open letter to the County Board of Supervisors, the art critic Jules Langsner credited the success of National Gallery of Art in

attracting gifts of major collections to the fact that the Washington institution was not named for its founding patron, Paul Mellon.

> I sincerely believe it is in the best interest of all parties concerned that matters at issue be renegotiated in such a fashion as to properly honor Mr. Ahmanson for his splendid generosity while at the same time protecting the future of this museum so vital to the cultural life of Southern California.
>
> If matters at issue are not resolved intelligently, I fear that the intentions of all parties concerned to create a major museum of art are doomed to failure. Mistakes in judgment made today will be inflicted on the community for decades. In years to come, major collectors can be counted on to give their monies and collections to museums in other cities. A museum housing mostly second-rate works of art is a second-rate museum, no matter how impressive its physical structure.[4]

Eventually Brown came up with a compromise that Ahmanson and most of the other trustees accepted. Instead of building a single structure, the new museum would consist of several buildings, only one of which would bear Ahmanson's name. The compromise apparently helped the fund-raising efforts. On 30 June 1960, Carter announced that $4.85 million had been raised toward the museum's goal, which had now risen to $5.5 million. Enough money had come in to start making preliminary studies for the building, Carter said. In an overly optimistic projection he speculated that ground would be broken around the middle of 1961 and the museum would be completed in 1962. "This museum, together with the music facility, will set the stage for our achieving eminence comparable with the other great cultural centers of the world," he said, echoing the fund-raising refrain that he had found most productive.[5]

Bringing the press up to date on the campaign, he said that Ahmanson's $2-million gift would be used for a $3.5-million building to house permanent collections, to be known as the Ahmanson

Gallery. Bart Lytton, the chairman of Lytton Financial Corporation and Lytton Savings and Loan Association, had promised to give $500,000 toward a $1-million building for traveling exhibitions, to be called Lytton Center. Another $1-million building that would house an auditorium, restaurant and education facilities was unnamed and awaiting a donor, Carter said. He made no mention of Simon, who eventually raised his sharply reduced pledge of $100,000 to $250,000, for a sculpture plaza that bore his name.

Funds continued to come in, but—partly because of the decision to erect several separate buildings—the estimated cost of the project escalated steadily and dates of its beginning and completion were repeatedly pushed into the future. On 5 January 1961, the County Board of Supervisors officially approved the site for the museum at Hancock Park. By then the projected cost of the buildings had grown to $6.5 million and the campaign goal had jumped to $7 million. Carter had secured about $5.3 million in gifts and pledges. Construction was now expected to start in 1962, and the opening date was tentatively set for 1963. Expectations for the museum's status also were rising. Henry J. Seldis, the art critic for the *Los Angeles Times,* predicted that, "because of the fine permanent collection it already has and because of the difficulty and cost of acquiring major art works at the present time, the Los Angeles County Art Museum will be the only institution in the Southwest that has the possibility of becoming a major general and comprehensive museum of art encompassing all ages and media."[6]

In the late fall of 1961, Carter had secured more than $6 million for the museum, but its cost was now set at $7.5 million, and the fund-raising goal was $8 million. Franklin D. Murphy, the chancellor of the University of California and a trustee of the Los Angeles County Museum of Art, accepted the new post of general community campaign chairman with the challenge of raising $750,000 in relatively small gifts from public subscription. Progress was being made on other fronts as well. The Board of Supervisors divided the Los Angles County Department of History, Science and Art into a History and Science Department, and a separate Department of Art Museum. Another encouraging development was that a donor, Anna

Bing Arnold, had been found for the third building. A resident of Los Angeles who had been a Broadway actress before her marriage to Leo S. Bing, a real estate magnate and art collector in New York, she agreed to fund the building in honor of her late husband.

To avoid political entanglements, the governors had agreed that no local architect would be considered. Eager to present an adventurous new museum to the art world, Brown lobbied hard for an internationally renowned modernist who would design a functional but distinctive monument. His choice was Mies van der Rohe, a German who was a leading figure in the development of modern architecture. Brown invited him to Los Angeles, showed him the site, discussed possibilities, and championed him to the board of trustees. Two other architects were on a short list of candidates. One was Eero Saarinen, a prominent Finnish modernist and urban designer, who was working on the Dulles Airport in Washington, D.C. Invited to make a presentation to the governors, Saarinen showed a film of his work that greatly impressed his hosts and seemed to give him an edge. The third contender was Edward Durell Stone, a relatively conservative American who had worked with other architects on the Rockefeller Center, Radio City Music Hall, and the Museum of Modern Art in New York.

Ahmanson's choice was Stone, who in 1961 had designed Ahmanson's Home Savings and Loan Association building in Beverly Hills and whom he had commissioned to build two other offices. Brown was appalled. In his view, Stone was by far the least interesting choice. Furthermore, Brown feared that Ahmanson's man would be influenced by Millard Sheets, a politically adroit but architecturally reactionary artist in southern California, who was the financier's principal artistic adviser and would probably be Stone's partner in the museum project. The board reached an impasse because Ahmanson effectively had veto power by virtue of his economic clout. If he were not satisfied, he would withdraw his gift. As a compromise the trustees decided to give the job to a local architect, William L. Pereira. A decision that would surely be perceived as provincial was exactly what Brown had tried to avoid, but he had to admit defeat and accept the complaints of leading members of the art community about a missed opportunity to gain a major architectural landmark. Simon did not

object to Pereira, who had built his corporate facility in Fullerton, but Ahmanson's control galled him almost as much as the practice of naming buildings and galleries for donors did. "The museum had too many bosses," he concluded.[7] The long-delayed ground breaking took place 8 November 1962, when Carter announced that the campaign's goal—now set at $8 million—had been reached.

7

THE ART DEALERS

I think most of the best collectors are difficult people,
but he was on the far side of difficult.

JULIAN AGNEW
23 May 1994

He had a reputation for chewing people up and spitting
them out, but I thought he had great charm. His restlessness was
a sign of his brilliance.

STEPHEN HAHN
27 May 1994

SIMON'S BUSINESS STYLE was legendary. A writer for *Newsweek* characterized him as a man "with the tact and subtlety of a bull-dozer," and fleshed out the picture with quotes from anonymous associates of Simon. "What the hell, he's a personal entrepreneur in the grand style. Any guy who tries to bump other people off company boards, rip out the deadwood, and improve the balance sheet is bound to make enemies." "He's just not that good at tea parties."[1] When Simon turned his attention to the art world, he made an equally strong impression.

Eugene Thaw described Simon as "the kind of person who intrudes on your life. I suppose I was motivated by a combination of flattery—that a man of that importance and brilliance thought

it worthwhile calling and consulting me—and by commercial interest in staying in close touch with him. Also he was fascinating. He was exasperating, but he had such a complicated mind, it was fascinating to deal with him. He would call me at least once a week and talk for two hours or so, almost always at an inconvenient time. I was on the phone with Norton more than with any other person in my life, ever."[2]

When Simon wasn't talking to Thaw, he was consulting other dealers, among them, Dudley Tooth, Martin Summers, and Geoffrey Agnew in London, and William Acquavella, Ben Heller, Paul Rosenberg, Stephen Hahn, and Jeffrey Loria in New York. Or he was badgering specialists in the auction houses about artworks in upcoming sales, or querying art historians and conservators about the finer points of pieces he was considering adding to his collection. Some of the professionals he approached couldn't handle his time-consuming tactics, but few could resist the stimulation of working with Norton Simon or afford to ignore his buying power.

"He managed even from the beginning to have an aura about him because he committed in the end," said Summers, who worked with Simon first at Arthur Tooth & Sons and later at the Lefevre Gallery. "You knew that if he didn't buy from you, he was going to buy from somebody else. Everybody was dancing up and down, and he was the piper playing the tune. If you walk into a market with dollars sticking out of your pockets, everybody is going to take notice."[3]

Teaching himself art history and looking for information about a wide range of artworks and their value, Simon hired his own curators but also contacted renowned experts on particular artists and shrewdly sought out the young, talented, energetic, people who stood to gain by working with him and were more than willing to take on the challenge. "One of the things that really impressed me was that he was in his sixties when I met him and I was in my twenties, and yet he really valued my opinion," said David Nash, who resigned as worldwide head of Sotheby's impressionist and modern art division in 1996 after working with the firm for thirty-five years. "He would argue, but it was pretty heady stuff to have the leading collector in the United States listen to you and pay attention to you and want to do deals with you. It really gave me a lot of confi-

dence and sharpened my ability to make a deal, and I have benefitted from it."[4]

Summers, also in his late twenties when he met Simon, was similarly smitten: "I was in awe of him. When he rang you at home at 11:30 at night, even though you knew you would be trapped into a difficult conversation, you were flattered to have your opinion asked. He made it sound as if what you said was far more interesting than what anybody else had told him. He made you feel fit, as if you knew what you were talking about and, thank God, he'd now got the truth."[5]

In Stephen Hahn, Simon found a bright young man who would take time to talk to him about building his collection and work with him at auctions. Strolling unannounced into Hahn's gallery in New York in the early 1960s, Simon introduced himself and struck up a conversation. "He was wearing baggy pants and his tie was askew, but he didn't look like the monster I had heard about," Hahn said. "Apparently he had been looking for someone who was known for having a good eye and knowledge but wasn't a celebrity, and I had been recommended to him." Simon asked if Hahn would be interested in bidding for him at auctions. Simon wouldn't pay the commission customarily charged by dealers for such services, but he persuaded Hahn that the arrangement would give him valuable publicity and enhance his reputation.

The unexpected visit was the beginning of long relationship involving many auctions and extended conversations. Whenever Simon traveled to New York on business, he would stop in at Hahn's gallery, always unannounced. Hahn, too, received his share of ill-timed telephone calls at home, generally during dinner: "I would say, 'Norton, can I call you back in forty-five minutes?' He would insist that he only had a couple of quick questions, but the calls never took less than an hour and a half. By that time my soup was cold and my children had gone on to other things."[6]

Simon's conversations ranged from rapid-fire barrages of questions about art prices to serious examinations of art historical material to rambling, philosophical discourses. His line of discussion could be circular and difficult to follow, but it was rarely dull. "When you would discuss philosophy, he would be extraordinarily pragmatic,"

Heller said. "When you would discuss business, he could be extraordinarily philosophical. He would bring different perspectives to a conversation. I found it exciting to talk to him because we both loved to toss ideas around. Once at a dinner party we were discussing whether he should buy an exquisite little Watteau painting or a gorgeous early Chola bronze. The thrill for him and the enjoyment for me was not comparing apples and apples, but discussing apples and oranges, two completely different worlds, cultures, economic values, you name it. Of course he ultimately bought both the Watteau and the bronze, but the fun of it was to discuss the two."[7]

Simon's calls to dealers frequently concerned the art market. He would ask about the value of pieces already in his collection as well as that of potential purchases, often putting dealers in a difficult position. "He would constantly ask people what his things were worth, which was worrisome because he was capable of selling," Summers said. "If you quoted too low a price for a picture, then you weren't going to get it. He would give it to your competitor. And if you quoted too high a price, then he would want you to offer that much for it."

Queries about possible acquisitions could be even more perplexing. "You knew he was a potential buyer for virtually anything you had," Summers said. "He could take anything on a whim, and sometimes did. But he loved making a deal. You would know there was going to be a negotiation and you would have to arm yourself for the battle. You might put the price up in order to come down, but if you put the price up too much or brought it down too much, you'd blow the deal out of the water before you started. You were trying to figure out how to get him to pay as much as you could, but he knew what you were doing far better than you knew yourself."

Simon's calls came with increasing frequency just before auctions of first-rate material. "Before every sale he would ring up and say, for example, 'What are the Renoirs worth? How much do you think they'll bring?'" Summers said. "You didn't really know what to say. Or he would say, 'I've been offered a Degas in the auction. What do you think I should pay for it?' If you said too little, it was as bad as saying too much. If you said too high a price, he would want to know how much a Degas he already had was worth. And if you

quoted a higher price than he had paid, he would say, 'Well then, what would you give me for it?' You were hung either way. It was very exhausting when a big sale came up. All he wanted to do was glean information. He would then pit your information against a colleague's information, and you couldn't win." And his energy never seemed to wane. "It was as if every deal was a new deal, every sale was the first that he'd ever been to. 'What's it worth? How do I know? If it's worth that, what's mine worth?' It was very important to him not to overpay."[8]

Simon bought many impressionist and post-impressionist works and an occasional modern piece at auction, frequently with Hahn placing bids from the audience. Acting on Simon's behalf, Hahn made winning bids for several important pictures: Pissarro's street scene, *Place du Théâtre Français, Soleil d'Après-Midi en Hiver,* purchased in 1964 for $155,000, Degas's *Répétition de Ballet,* bought in 1965 for $410,000, a record price for a pastel work by the artist, and Henri Rousseau's *Exotic Landscape,* bought in 1971 for $775,000. Simon always gave Hahn a limit, but he went a bit higher than the authorized sum to get Wassily Kandinsky's abstraction, *No. 263: Open Green,* for $155,000, in the same sale as the Rousseau. Hahn feared that Simon would be displeased, but he was actually delighted that Hahn had persevered.

Simon generally guarded his anonymity at auctions, putting Hahn or another dealer in the spotlight, but he also indulged his penchant for devising and participating in complicated strategies. "It was great fun," Hahn said, recounting auctions at which he would bid up to a certain point and then drop out to throw Simon's competitors off-track while Simon himself continued to bid behind the scenes. Word of his purchases usually leaked out soon after the sales. Simon often announced new acquisitions, but he loved to keep his competitors guessing while the heat was on. For Vincent van Gogh's portrait of his mother, sold for £115,000 ($275,354) at Christie's in London on 28 June 1968, the press reported Hahn as the buyer. Noting that he frequently bid for Simon and other American collectors, a writer for the *New York Times* ventured that Hahn planned to sell the painting.[9] In fact, Simon was the proud new owner of the Van Gogh, which had been consigned to Christie's by the Reverend Theodore Pitcairn, a

distinguished collector who was a son of one of the founders of Pitts-burgh Glass Company.

By most accounts, Simon was a good student both of art and the market. "What impressed me was how quickly he moved from being a neophyte collector to someone who knew what he was doing," Nash said.[10] But even as Simon's expertise developed, he would make inexplicable moves. He missed a chance to buy Claude Monet's *La Terrasse à Sainte-Adresse,* a major early impressionist work from the Pitcairn collection that was sold in 1968 for $1.4 million to the Metro-politan Museum of Art in New York. Yet a few months later, he paid $1.5 million at Parke-Bernet in New York for Renoir's *The Pont des Arts,* another early work by an Impressionist master but one that is generally less highly regarded by scholars. In the wake of this pur-chase, he tried to persuade impressionist experts that it was, compara-tively, more important to the development of Renoir's oeuvre than *La Terrace* was to Monet's development.

Before the sale of the Monet, Simon repeatedly called David Bathurst, who was the impressionist expert at Christie's in London, to ask how much he thought the painting would fetch and who else would be bidding on it. He also tried to cajole Bathurst into with-drawing the painting from the auction and selling it to him privately. Simon seemed determined to have the Monet, but when the sale came he conceded it to the Metropolitan. For the Renoir, Simon spent several weeks plotting his strategy. When *The Pont des Arts* went on the block, Hahn bid for him, but stopped at $1 million to make it appear that Simon had reached his limit. Then Simon himself took over, but the audience couldn't see him. Standing behind a curtain with Peter Wilson of Parke-Bernet London, he continued to bid, with Wilson waving his arms to signal the bids to the auctioneer John L. Marion.

Simon also worked with other dealers at auction. Geoffrey Agnew, a specialist in old masters, occasionally bought pieces for him in London, sometimes with special provisions. "There was a tremen-dous amount of to-ing and fro-ing about things that came up in the auctions," Julian Agnew said. "What Simon particularly liked was to have rather loose arrangements by which if a dealer bought something, he had a right to buy it from the dealer afterwards at

the same price plus a fixed percentage. That had merits of fixing the price at a level he thought was suitable on the market but at the same time giving him the option not to buy it if he decided he didn't want it or if the price was too high. He liked those sorts of arrangements that were deeply complicated."[11]

On other occasions, Simon changed his mind after an auction. He had a rare chance to buy all six of Giovanni Francesco Romanelli's full-scale cartoons for a seventeenth-century tapestry series on 25 March 1969 at Sotheby's London. Three complete sets of the eight-tapestry series, illustrating the story of Dido and Aeneas from the *Aeneid* by Virgil survive. Two of the eight original drawings for the tapestries have been lost, but the six remaining cartoons were in surprisingly good condition. Although executed in gouache on fragile sheets of paper, the drawings had been mounted on stretched linen so they could be displayed on walls. Interested by the possibility of adding the set of monumentally scaled cartoons to his collection, Simon commissioned Robert M. Light, a dealer in Boston, to bid on his behalf. The cartoons were offered as separate lots at the auction, but Simon authorized Light to purchase only four, for a total of about fifty thousand dollars. Agnew, who competed with Light on all six lots, bought the other two works and, four months later, after an intense round of bargaining, sold them to Simon for about thirty-six thousand dollars.

Simon drove dealers to distraction by proposing dozens of private trade and purchase arrangements, or by imposing unusual conditions on a sale. "It was a real strategy to get Norton to come to a decision because his whole mode of thinking was never to close any door, never to close off an option," Thaw said. "So as long as he could keep a thing on reserve, string it out, play it along, or say, 'How much is it with this?' or 'How much are these four together and that one alone?' he would keep going. Then he would come back six months later and start again. It was a real sparring match, and you'd have to try to keep your mind clear to remember what you had told him before because his mind was like a computer. There were many times when I don't know whether I came out with a loss or a profit because it became so convoluted with trade-ins and combinations."

In one typically complicated transaction, in 1977, Simon bought Rembrandt's *Portrait of a Bearded Man in a Wide-Brimmed Hat* from Thaw for $1.15 million and paid for it with $430,000 in cash and four works from his collection: Rembrandt's *Dido Divides the Oxhide,* valued at $200,000, *An Extensive River Landscape,* by Philips de Koninck, a follower of Rembrandt, valued at $350,000, Francesco di Stefano Pesellino's *The Madonna and Child,* valued at $85,000, and Watteau's *Head of a Man in a Wig,* which was valued at $85,000.

On another occasion, in 1972, Thaw persuaded him to buy a rare Renaissance painting, *Shepherd with Flute,* by Giovanni Savoldo for $500,000, but Simon insisted on retaining the right to return it for up to a year after the purchase. Two and a half weeks after the year had passed, Simon called Thaw saying he wanted to return the painting and insisted that the dealer honor their agreement. "It was a real strain financially because it came at a time when things were going badly for me, but I did it," Thaw said. "I took the picture back and put it in a closet, as a sort of bad luck charm." A couple of years later Thaw sold the painting for $700,000 to another private collector who later sold it to the J. Paul Getty Museum. Toward the end of his life, Simon apparently regretted returning the Savoldo, saying that he hadn't fully understood its importance.[12]

As well as pushing dealers to frustration almost routinely, Simon was quick to take legal action if he believed he had been wronged—or even outwitted. In the summer 1977 he took an option to purchase *Danae under a Shower of Gold,* a seventeenth-century painting by the Italian, Orazio Gentileschi, from T. P. Grange, a dealer in London, for £300,000. Grange shipped the painting to California for Simon's approval and waited hopefully. When the option expired with no decision from Simon, Grange repeatedly requested the return of the painting. Eventually Simon sent the painting back to Grange, who agreed to extend the option until an expert, Denis Mahon, could examine it in London. Informed that Mahon had endorsed another scholar's judgment that the *Danae* in question was an earlier version of a similar work in the collection of the Cleveland Museum, and thus the more valuable of the two, Simon sent a telegram to Grange stating that he would exercise his option to

buy the painting. But—as was often the case with Simon—the deal wasn't that easy.

The extended option expired at midnight on Saturday, 29 October 1977. Simon dispatched his telegram from California at 5:41 P.M. on Saturday, California time; owing to the time difference, that was 1:41 A.M. on Sunday, 30 October in London. Simon was unaware that Richard Feigen, a dealer in New York, had approached Grange about buying the painting. Grange had told Feigen he couldn't sell it at the time because Simon had an option on it. Feigen kept in touch with Grange, hoping it would become available. When the expiration date approached and Simon hadn't acted, Feigen flew to London. Late on that Saturday night, long after the gallery was closed, and assuming that the option was no longer effective, Grange sold the painting to Feigen. When Simon's telegram arrived, Grange telephoned him and said he was sorry but he had sold the Gentileschi after the option had expired.

Angry, Simon accused Grange of collusion. After a month of allegations, investigations, and discussions with his attorneys, Simon sued both Grange and Feigen, claiming breach of contract and demanding that he be granted title to the painting or paid damages. Grange died while the suit was pending, but Simon pursued his widow, Marie-Thérèse. In December 1978, more than a year after Simon's claim was filed, the three parties reached a settlement. Feigen kept the painting, but he and Mrs. Grange paid Simon £100,000 in damages.

Exasperating as Simon could be, most dealers put up with him because of his taste and buying power. "In the pantheon of collectors you hoped to deal with or interest in something, Norton Simon was the bee's knees," said Michael Findlay, the senior director of impressionist and modern art at Christie's New York. "He was the first person to whom one went with anything of significance. His strong point was an enormous passion for the object and almost equal passion for the chase. I was amazed at how accessible he was. Most of your captains of industry nowadays won't take a phone call from a dealer they don't know very well, even if it's a dealer with a big reputation. They'll say, 'Send a transparency to my curator.' Norton Simon would take a call and he would pile drive. 'Well, what is the

painting? What's it worth?' He enjoyed this. It was an important part of his day."

Making himself available to dealers and proving himself a serious buyer, however difficult, meant that Simon had access to superb material. "I tell new collectors this, that if they remain anonymous they can come to auction and buy good pictures, but they will never be offered great paintings," Findlay said. "Norton Simon was offered the best because he wasn't afraid to declare himself in the market. You can't have it both ways. When Gene Thaw has a great Van Gogh, there are five people he can call. You won't even be on that list if he doesn't know you."[13]

But once Simon had received an offer that interested him, he could drag out the decision-making process so long that it was destructive to the very dealers he needed. He became infamous for keeping transparencies and artworks for months, preventing dealers from offering the pieces to other clients while he made up his mind. If he decided against a purchase after holding a piece for several months, and the word got around, the value of the piece could be tarnished. Once that had happened, Simon was not above negotiating a lower price, knowing full well that the dealer would have difficulty selling the piece to any one else. "You did have to be incredibly patient," Agnew said. "He had the reputation for getting things out on approval, showing them to forty-five people, and then sending them back, which was bad for the paintings. So things were not by any means easy going. I think most of the best collectors are difficult people, but he was on the far side of difficult. He liked having all the options. He liked making decisions and he liked even more not to have to make decisions."[14]

Simon didn't hesitate to use his clout in the art world. "He was acutely aware of the power he had," Findlay said.

> He was also acutely aware of the time difference between Los Angeles and New York, and the advantage that gave him. If he picked up the phone at 11 o'clock at night in Los Angeles and called you up in New York, it was 2 o'clock in the morning. He would say, 'Oh, listen, about the Degas. Look, you said $1.2 million. Well, I think that's ridiculous. Here's what I want to do. I'll give you $300,000 now, and

half of the balance up to 70 percent of the price in sixty days, but you've got to tell me right away or the deal is off. He's calling late in Los Angeles, waking the dealer up, and making a pitch, and he doesn't give him any time. There's no way to get hold of somebody else or talk to your partner. Then you'd lie awake, wondering how much money you had lost on the deal.[15]

In his compulsion to get the best of the art market, Simon worked out complicated billing and art-trading agreements with dealers, buying through his foundations and making gifts of artworks to the foundations at greatly appreciated values to claim income-tax deductions. He also dreamed up outrageous schemes to cash in on undervalued art, just as he had done with undervalued companies. Upon noticing that gold-ground paintings were not in demand while drawings by the same old masters commanded high prices, Simon devised a plan and presented it to David Nash in a discussion that went on for hours. When he eventually got to the point, Simon suggested scraping the paint off the undesirable works to reveal the underlying drawings, which could then be sold for larger sums. "It was nuts," Nash said. It never came to pass, but the idea was vintage Simon.[16]

After years of being bombarded with questions and having learned that Simon made the same queries of their competitors, many dealers grew weary of the process and felt used or offended. "It is a kind of curious anomaly that someone who is so independent, so driven personally, so secure in his ability to take a position, needed to poll everybody," Heller said. "And it got worse later. As he got more contacts and more people got in touch with him, he had more people he could call. And these were not short conversations. After a while, when you began to see that he would call everybody, you would think, what's the difference what I say? Now he's polling the delegation. What does he do, take seven out of ten, six out of ten? When does it swing? But I always gave it my best shot."[17]

Some people who did business with Simon judge him harshly. "He bought art by consensus," Paul Kantor, a dealer in Los Angeles, charged.[18] But most dealers insist that he made his own decisions in

the end. They learned to accept his unorthodox methods as the price of doing business with a man with enormous resources, and they defend him because of his accomplishment. "There's a certain amount of truth in saying he bought by consensus," Summers said. "But I think that judgment is a little unfair because by consensus you never arrive at the best. You always end up with soft decisions and Norton bought tough pictures. He did eventually put his money where his mouth was, but his ear was everywhere."[19]

8

BUYING DUVEEN "LOCK, STOCK, AND BARREL"

*"I don't want any Duveen to come after me," Lord Joseph Duveen once
said, rebuffing a suggestion that his nephew be trained to carry on
his great art gallery. As usual, Duveen got his way. A year before his
death in 1939, his gallery passed to a group of associates and
employees. Last week, 79-year-old Edward Fowles, the only surviving
owner and a Duveen veteran of 66 years, went his old boss one better.
He made sure that nobody would come after him by arranging
to sell Duveen's to Norton Simon, a California tycoon,
collector, and philanthropist.*

NEWSWEEK
4 May 1964

IN APRIL 1964, THE NORTON Simon Foundation issued a three-page
press release to announce the biggest acquisition of Simon's entire
collecting career: "the firm of Duveen Brothers, the gallery made
world famous by the most fabulous art dealer of all time—Joseph
Duveen." In case members of the press didn't understand the full sig-
nificance of the announcement, it was explained that "the firm
brought to this country many of the world's most magnificent art
treasures. Major portions of the outstanding Mellon, Widener, and
Kress collections at the National Gallery; the Morgan, Altman,
Rockefeller, and Bache collections at the Metropolitan Museum of
Art; and the exquisite collection at the Frick Museum once passed
through the hands of the House of Duveen."

Lord Joseph Duveen had indeed been immensely successful at
acquiring artworks from European collections and persuading Amer-

ica's wealthiest businessmen and industrialists to buy them. He took over Duveen Brothers, a family firm established in 1879 by Dutch immigrants in England. The company, which operated galleries in London, Paris, and New York, originally dealt mainly in furniture and objets d'art. Joseph Duveen transformed it into one of the world's leading fine-art dealerships.

Reportedly a brash, unprincipled supersalesman, Duveen understood his newly rich American clients' thirst for cultural prestige and figured out how to slake it. Paying unheard-of prices to European collectors, he sold his booty for even higher sums to Americans who believed that they were purchasing social cachet along with art of the masters. Duveen collaborated with the scholar and art critic Bernard Berenson to authenticate his inventory. At the time, Berenson's stamp of approval was considered irreproachable. Many of his judgments have subsequently been proven incorrect or dubious, and his reputation has been tainted by the revelation that his attributions for Duveen were not those of a disinterested scholar but those of a paid consultant. Both men have been accused of placing profit above ethics and scholarship, but they played a crucial role in America's golden age of art acquisition. Sending a flood of cultural riches westward across the Atlantic Ocean, Duveen was, with Berenson's help, enormously influential in building America's greatest collections.[1]

At his death in 1939, Duveen willed 90 percent of Duveen Brothers in equal parts to his nephew Armand Lowengard and an employee, Edward Fowles, who had joined the company at its London gallery in 1898, at the age of thirteen. The remaining 10 percent was divided between John Allen, Duveen's financial comptroller, and Bertram Boggis, a former merchant seaman who had become Duveen's close friend and confidant. Shortly after the end of World War II the galleries in London and Paris were closed, so Fowles moved to New York where Duveen Brothers was housed in a five-story, eighteenth-century-French-style mansion at 18 East Seventy-ninth Street, near Madison Avenue. When other Duveen owners died, Fowles bought their shares of the company and continued the business.

Simon met Fowles in 1955, on one of his initial visits to New York galleries. By that time Duveen Brothers was a shadow of Lord Joseph

Duveen's operation, but it was swathed in the mystique of its history and luxurious premises. Simon found many pieces that interested him in Fowles's inventory and dropped by the gallery several times each year. One of his earliest purchases there, made in 1957, was Rembrandt's *Portrait of Hendrickje Stoeffels.*

Late in 1963, he told Fowles that he was interested in buying a group of paintings from him, including Bernardo Daddi's early four-teenth-century painting, *Madonna and Child Enthroned with Saints John Gualbertus, John the Baptist, Francis, and Nicholas,* valued at $40,000, an Italian Renaissance work, Botticelli's *Madonna and Child with Saint John,* priced at $100,000, and *The Princess of Orange,* by Sir Anthony van Dyck, a seventeenth-century Flemish work with a price tag of $50,000. Fowles was eager to make the sale but reluctant to part with all the works Simon wanted because the transaction would strip him of his best material, the very pieces that helped maintain some of the luster of the gallery's days of glory. When Fowles hesitated, Simon had a better idea. "Why don't I buy the whole thing, lock, stock and barrel, including the building?"[2]

Fowles was surprised, but at the age of seventy-nine, he saw a golden opportunity to tie up his business affairs and provide for himself and his wife, Jean. The deal would mean closing the business that had consumed most of his life, but Simon assured Fowles that he would continue to need his services as a consultant. On 19 February 1964, Fowles and Simon signed a two-page document giving the Norton Simon Foundation a ninety-day option to buy Duveen Brothers, Inc. for $4 million, to be paid in sums of $400,000 a year. The art inventory had cost the gallery about $3.5 million, but its market value was set at more than $14 million. A twelve-thousand-volume art library, included in the agreement, was valued at $250,000.

Simon never publicly disclosed the purchase price, but in his press release said that the collection was valued at more than $15 million. As the story of Simon's coup was told and retold in the press, some publications mistakenly reported he had paid $15 million for the entire firm, inventory, library, and building; it seemed a reasonable sum. At the actual price of $4 million Simon got a bargain, and within a few years he recouped his entire investment. Following the

strategy that had served him so well in business, he kept the pieces he wanted and sold the rest.

Simon knew he was getting an eclectic assortment of fine and decorative arts that covered a broad sweep of history and varied greatly in quality, and that the attribution of many pieces was questionable. The collection contained more than four hundred artworks including 146 paintings and an array of objects from the thirteenth through the eighteenth centuries. Among the earliest pieces were Gothic polychromed wood figures from the School of Rheims. Numerous tapestries included fifteenth-century Flemish panels depicting Helen of Troy and a set of four rose damask works commissioned from the painter François Boucher by Louis XVI and made at the Gobelins workshop. There were Chinese porcelains, French portrait busts, ornate decorations, and antique furniture. The paintings—the primary objects of interest to Simon—included "some by major and some by lesser masters," as the press release diplomatically put it. Among the best was a cache of Italian fifteenth- and sixteenth-century interpretations of religious themes by Francesco Bissolo, Vincenzo Catena, Il Francia, Bernardino Luini, and other artists. The inventory also gave Simon a gem of French rococo painting, *The Happy Lovers* by Jean-Honoré Fragonard, and a dramatic example of Spanish baroque painting, *The Sense of Touch* by José de Ribera.

Duveen Brothers closed its doors on Friday, 18 April 1964, three days before the sale was announced. All was quiet outside but there was a buzz inside the elegant building as Simon's staff and various scholars assessed the enormous acquisition. Simon sent Barbara Roberts, his trusted and capable assistant, to oversee the operation. A diplomat with a talent for expressing herself gracefully, she had facilitated many difficult transactions, often smoothing over difficulties and reporting back to her boss with insights into the personalities and feelings of people involved. But this assignment was entirely different. "The Fowles," she said, "belong to a bygone era, with roots firmly implanted in nineteenth-century Europe."

A sympathetic listener and keen observer, she sent Simon a perceptive account of the situation. Jean had complained that "there's no excitement in our lives now that we're not talking to Mr. Simon any more." Noting that the marriage, a second for both, was "less

than an ideal match," Roberts remarked that "Mrs. Fowles is rather taken with you, and Edward is a bit annoyed, if not jealous." Jean, it appeared, was tired of working six days a week at the gallery and relieved that it would be closing; Edward was fearful. He equated the impending closure with his own death: "The hours spent at the gallery have become his payments for life insurance, and he dreads the consequences of nonpayment."[3]

Returning to New York in April, Roberts again reported back:

> A prolonged visit at Duveen's is the nearest I've come to being "through the looking-glass." All the characters are a little bit mad, albeit delightful, and the setting lends credence to one's feeling of otherworldliness. Edward Fowles, despite his frailties and infirmities, rules autocratically and impartially. None but his wife dares to question him—and she exercises great tact and prudence at every approach. Yet his employees, submissive in his presence, are blithe spirits on their own. Alec Silver, a sixty-nine-year-old, white haired sprite with the slight frame of a twelve-year-old boy, is virtually ubiquitous. No matter where you are, if you will just look into the shadows, or open a door quickly, or turn a corner lightly, there is Alec, disappearing into the gloom of unlighted halls. (Lights are never kept on. From first floor to fifth, there is darkness, relieved only in the presence of a visitor.) Alec has been at Duveen's for fifty-one years. For the first decade of his employment there, he traveled to and from work on a bike. From Jersey City! Now he commutes more conventionally, but not without stopping for two or three double Manhattans before getting on the Hudson Tube.
>
> Andy Warcholic is a year younger. In my judgment, he is the most useful employee—an expert craftsman, furniture repairer, restorer, etc. Andy's two difficulties are his extreme deafness and his painful sensitivity to criticism. Bill Bywater is known as the youngster among the male employees. He is only sixty-four. His hearing, too, is poor but not sufficiently impaired to prevent his conducting his own enterprise on the premises. Bill is an art dealer in his own right (specializing in nineteenth-century American artists) who numbers

men like Robert Lehman as his customers. "He uses our light, our phone, and our wrapping paper to conduct his business," laments Mrs. Fowles.

Mr. Bywater, the authoritarian accountant (I am a CPA!) is lame; he sits in his fifth-floor office beneath a lurid South Sea oil painting from nine to six, undisputed ruler of the books. He vehemently refused to defer billing two accounts as Mrs. Fowles had asked. "Can Mr. Simon do anything with him?" she plaintively asked.

Molly is a large, pleasant-faced Irishwoman with a delightful brogue when she is able to speak.[4] She has chronic laryngitis. Molly spends her days sitting in a dark cubbyhole by the second-floor landing ready to turn on lights in the two large furniture rooms. She feels rather left out of things since she's been there only twenty years, but she has recently found a position as the protector and confidante of Gavin, Mrs. Fowles' son.

Roberts expanded upon the Fowles's lifestyle and relationship—a marriage that had "very little 'our' in it—everything is either 'his' or 'hers.' . . . The absence of any 'community property' in their home makes it quite difficult to compliment [them on] any of their possessions. They keep a running mental tab of the number of compliments each receives, and if the score is uneven, there are apt to be wounded feelings. I was once forced to choose between—of all things!—Jean's cloisonné ashtray and Edward's silver ashtray. At the rate I smoke, it was not hard to fill both, impartially. But it does make one feel like Solomon."[5]

Simon's purchase ended the gallery's life and dispersed the cast of characters. But once he owned the vast inventory, he had to figure out what to do with it. The most obvious answer was to ship the pieces he wanted to keep to Los Angeles and display them at the new museum that was to be opened the following year. But he had taken on an enormous responsibility that required the services of numerous conservators, curators, and consultants, as well as the museum's staff. Simply assessing the condition, value, and best use of the pieces was a task that continued for years.

The Clark Art Institute in Williamstown, Massachusetts, bought

the Duveen library in 1965 for four hundred thousand dollars, a price well above Fowles's estimate of its market value and more than four times the ninety thousand dollars that Simon had paid for it. Four years later, Simon also divested himself of the building. After a tentative agreement to sell the building to Acquavella Galleries for $425,000, to be paid in cash six months later, was not consummated, Simon traded the building to Acquavella for two paintings, *White and Pink Mallows in a Vase,* a sparkling still life painted in 1895 by Henri Fantin-Latour, who worked at same time as the French impressionists but considered himself a realist, and *Woman with a Rose,* a late work by Renoir, painted in 1916, depicting a dark-haired model holding a rose next to her face. As the years passed and the price of prime New York real estate escalated, Simon's associates occasionally chided him for selling the building too cheap. But he always insisted that the artworks he acquired were infinitely more valuable.[6]

Writing to Simon after her husband died, Jean Fowles remarked:

> Edward loathed people who looked at his paintings coldly and he was afraid you would cheapen them by asking too many people to look at them. But he could explode and then forget about it and it never changed his fundamental affection and admiration for you.
>
> I am deeply grateful for the fact that you made Edward's last years peaceful. You took a load of responsibility off his shoulders and in tranquility, free of all financial worries, he devoted himself to his memoirs. In helping him with them, I learned a great deal about my husband, who was modest and self-effacing. As the active buyer and discoverer for Lord Duveen, it seems to me he was the backbone of the business and his quiet temperament and intelligence were invaluable to the firm.[7]

9

―――――――

A NEW MUSEUM AND A NEW DIRECTOR

*Notable less for architecture than for some remarkable works of art lent
to its opening, California's latest splendor augurs promise.*

ARTNEWS
March 1965

TEN YEARS AFTER RIC BROWN, a catalyst for the project, had been
appointed curator of art, and $11.5 million dollars later, Peter Bart
was able to tell the readers of the *New York Times* that

> The . . . Los Angeles County Museum of Art will open
> officially Wednesday amid a numbing succession of banquets,
> receptions and other rituals of civic self-congratulation. The
> new museum, which fills a gaping cultural void in this city,
> will be the largest west of the Mississippi and the biggest to
> be constructed in this country in 25 years. Opening only
> four months after a $33.5-million Music Center, the museum
> represents an impressive achievement for what is essentially
> a newly emerging cultural establishment in southern
> California. The leaders of this new establishment, repre-
> senting an alliance of California's "old families" with the
> "new tycoons" of the postwar boom, managed to introduce
> an active philanthropy in an area distinguished mainly for
> its cultural miserliness.[1]

The museum consisted of three pavilions, positioned at right
angles to one another. Built on a plaza above a pool, the buildings
appeared to be floating. They were surrounded by concrete columns

and clad in white marble tiles. Aluminum-frame promenades topped with clear plastic domes provided covered walkways between the separate pavilions.

As visitors approached the museum from Wilshire Boulevard over a causeway, they faced the two-story Lytton Gallery. It opened with an exhibition of works by Pierre Bonnard, organized by the chief curator, James Elliott. To the east of the Lytton Gallery was the Leo S. Bing Center, housing a six-hundred-seat auditorium, a cafeteria, a forty-five-thousand-volume research library, a children's gallery, and a members' lounge.

The principal unit of the complex, the Ahmanson Gallery, lay to the west. It was a four-story building designed around a central, sixty-foot-square atrium. On the lower level, galleries displayed oriental, classical, and medieval art; those on the plaza level offered European art from the Renaissance through the eighteenth century; on the third floor were paintings and sculpture from the nineteenth and twentieth centuries; and the fourth floor was devoted to costumes, textiles, and decorative arts.

In their rush to see the new buildings and exhibits, few visitors noticed the inscription on the wall, just to the right of the entrance to the Ahmanson Gallery. It began with the words, "This museum was conceived by Norton Simon and Richard F. Brown," then listed major donors. Throughout the three buildings, names of individual patrons, couples, and groups also could be found on twenty-four galleries, the library, the members' lounge, and the board room. Simon was affronted by all the "naming opportunities" provided to contributors. In a none-too-subtle dig at donors whose names were attached to parts of the museum, he ran a full-page advertisement, under the auspices of his business conglomerate, Hunt Foods & Industries, Inc., in the *Los Angeles Times*. Below the image of a twelfth-century French sculpture of the head of a king, ran the legend: "This Gothic masterpiece is a monument to an unknown sculptor. The new County Museum of Art is a monument to thousands of people, many of them anonymous, whose generosity has helped create this museum for Los Angeles and for America."

But if the significance of the message escaped most newspaper readers and if Simon's name appeared only on a little-noticed slab

of marble, his presence resonated throughout the galleries. The Ahmanson building was erected to display the museum's permanent collection, but in terms of monetary value, almost half of the art on view there belonged to Simon or his foundations. That art covered a broad swath of history, from the twelfth to the nineteenth centuries. Late Gothic pieces included the Burgundian limestone head illustrated in Hunt's advertisement, a French fresco portraying Saint Anthony Abbot, and a painting of the Madonna by Bernardo Daddi. From the Northern Renaissance were the Flemish painter Gerard David's *The Coronation of the Virgins,* and a set of four large Brussels tapestries illustrating legends of Helen of Troy. Italian Renaissance works included a painting, *Madonna* by the Venetian master Giovanni Bellini, a large allegory, *Fidelity,* by the Sienese artist Francesco di Giorgio Martini, and a Florentine marble relief carving, *The Beauregard,* Madonna by Desiderio da Settignano. Jean-Honoré Fragonard's painting of *The Happy Lovers* and Gobelins tapestries based on drawings by François Boucher hung with French rococo furnishings. Thomas Gainsborough's double portrait, *The Cruttenden Sisters,* distinguished a group of English eighteenth-century works. Even the modern section had a Simon touch. Kurt Schwitters's seminal collage of 1919, *Construction for Noble Ladies,* was purchased by the museum with funds matching a donation from Simon.

The most notable of Simon's loans came from the Duveen inventory. Although far from the only borrowed objects in the museum's inaugural installation of its so-called permanent collection, there was no doubt the Duveen pieces were the guests of honor. When he had bought them, Simon had announced his intention of placing them on long-term loan to various museums. But the opening of the Los Angeles County Museum of Art was a prime opportunity to show off his new acquisitions, demonstrate his influence, and get maximum recognition. The event illustrated his command of two of "the three Ps"— power and publicity—that according to Simon, ran the world.

The third P—paranoia—came into play behind the scenes. Simon worried about so many valuable pieces on view in such a public forum; he also loved to plot scenarios that might be useful to foil the thieves he feared were watching. Shortly before the museum was due to open he hatched a plan to transport the bulk of the Duveen prop-

erty from the New York gallery to the museum. Brown had become infatuated with the work of the German sculptor Norbert Kricke and had decided that one of Kricke's abstract metal pieces would be just the thing to place in a central fountain on the museum's causeway. Although the curators did not share his enthusiasm for Kricke's work, Brown persuaded David Bright, a trustee and collector of modern art to purchase a Kricke piece for the museum. It was packed in a crate in New York awaiting delivery to Los Angeles at the same time as Simon was planning to move the Duveen inventory. Hearing about the impending shipment of the Kricke, Simon orchestrated a ruse. Enlisted as a courier, Henry T. Hopkins, the museum's chief of educational services, flew to New York, ostensibly to accompany the Duveen shipment to Los Angeles. Instead, following Simon's plan, he returned on a Flying Tiger plane, taking the Kricke and traveling with the armed guards while the Duveen collection was shipped on another airline with no security. "It was one of those wonderful cloak-and-dagger schemes Norton would dream up," Hopkins said. "It was insane, but it was indicative of the extraordinary lengths the museum would go to, to help Norton—and the kind of paranoia he dealt with."[2]

The effect of Simon's loans on the museum's collection did not go unrecognized by visiting art critics. Alfred Frankfurter, writing for *Art News,* considered that the "most notable aspect at [the Museum's] opening [was] the breadth of the Foundation's multiple loan, including its items from the ex-Duveen collection, which alone gives the event true significance on a national basis. Without the presence of what this extensive loan comprises, there would be little need for an art historical critique of the new Museum—for, thus deprived, it would amount to no more than simply nonvintage wine in shiny modern bottles."[3]

John Canaday, the critic for the *New York Times,* although enthusiastic about Simon's contributions, set the stage with a bit of historical context:

> The most impressive thing about the new Los Angeles
> County Museum of Art may be that it exists at all.
> Interest in art in Los Angeles is a postwar phenomenon

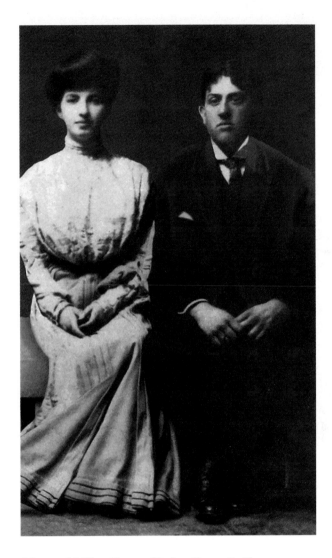

Myer and Lillian Simon. (Evelyn Simon Prell)

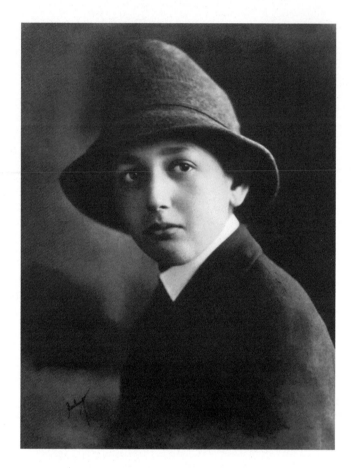

Norton Simon as a child. (Evelyn Simon Prell)

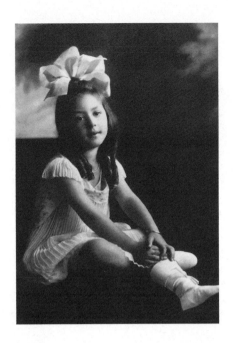

Evelyn Simon. (Evelyn Simon Prell)

Marcia Simon. (Evelyn Simon Prell)

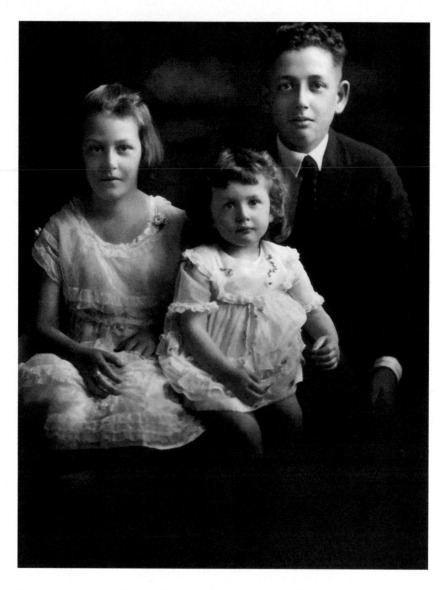

Evelyn, Marcia, and Norton Simon. (Evelyn Simon Prell)

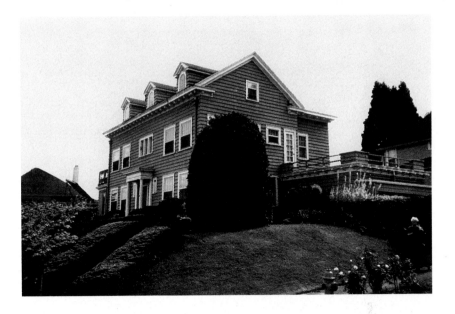

The Simon family's house on Westover Terrace in Portland, Oregon. (Evelyn Simon Prell)

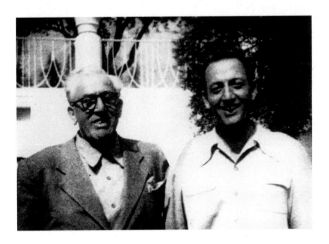

Myer and Norton Simon. (Evelyn Simon Prell)

Norton Simon and his wife, Lucille, at the Los Angeles
County Museum of Art in December 1965, when
Rembrandt's painting, *Portrait of a Boy, Presumed to be
the Artist's Son, Titus,* was on loan there from the Simons.
Right, Sidney Brody, a trustee of the museum. (*Los Angeles
Times* Syndicate)

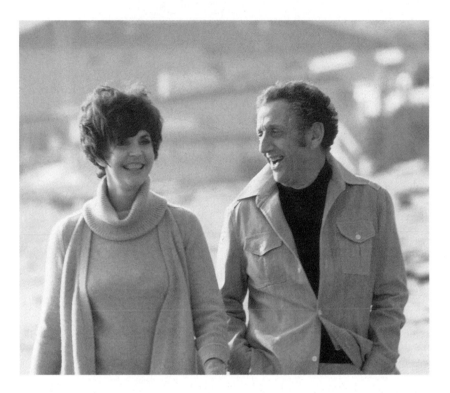

Norton Simon and Jennifer Jones Simon on the beach near their home in
Malibu, Calif., 1974. (Norton Simon Museum, Pasadena, Calif.)

Norton Simon in 1989. (Norton Simon Museum,
Pasadena, Calif.)

The entrance to the Norton Simon Museum in Pasadena, California. (Norton
Simon Museum, Pasadena, Calif.)

that gathered real momentum only about ten years ago.

Actual plans for the museum, which meant separating the art collections from a ragtag-and-bobtail general museum and giving them a proper home of their own, were drawn up in 1961. And even as late as two years ago, with ground broken for the new building, a survey of the collections suggested that there might be a lot more building than there would be art worth displaying in it.

Happily, this turns out not to be the case. Los Angeles is still a long way from the position of Washington, Philadelphia, Boston, Cleveland and Chicago, cities that compete in claiming second place to New York's Metropolitan for their museum. But Los Angeles has made a good start toward disproving the contention that the market, especially the depleted market in old masters, just doesn't offer the material for another major art museum today.

The collections run from pre-history on up to the moment, and if you go through them looking for holes, the place is a sieve. But the general usefulness of a public museum depends not on what it doesn't have, but on what it does have, which is not quite the same thing.

Loans from the Norton Simon Foundation, even though the museum does not have title to them, have so enriched the new galleries that you can not only eke out an adequate summary art history, but must keep finding numerous pieces . . . that can make any museum director, in America or Europe, regret they are no longer obtainable.[4]

In the atmosphere of self-congratulation and praise from afar, the new museum appeared to be an enormous success. Both the staff and trustees had reason to be proud of their accomplishment. The museum's registrar, Frieda Kay Fall, had overseen the packing and transport of five hundred thousand objects from Exposition Park to Wilshire Boulevard with only one casualty. The handle and lip of an ancient jar were broken, but not beyond repair. Membership jumped from three thousand to twenty thousand before the museum opened its doors and grew by an additional nine thousand before the end of the year. After the opening round of exhibitions of paintings by Bon-

nard, drawings by the seventeenth-century Italian artist Agostini Mitelli, and contemporary ceramic sculpture by Peter Voulkos, the public could look forward to a schedule that included New York school paintings, David Smith's sculpture, a seven-thousand-year survey of Iranian art, Japanese national treasures, drawings by John Constable from the Victoria & Albert Museum in London, and a mid-career survey of Edward Kienholz's assemblages and tableaux.

But the stress and power struggles involved in the long process of raising the funds, planning, and opening the new museum had taken a toll. Brown was far too charismatic, popular, and forceful a personality for Carter and other trustees who considered themselves much more accomplished administrators than the director was. When *Time* magazine considered putting Brown on the cover of its magazine, Carter objected that a mere art historian was being given credit for work he didn't do. The cover story did not develop, but the feud that had been brewing for several years gathered steam.

About two years before the new museum opened the trustees had begun to pressure Brown to hire a deputy director to take care of administration while he oversaw the art program. Brown resisted repeatedly, pounding his fist on the boardroom table and insisting that the museum be run by an art specialist, not a manager. But in 1964 he knuckled under and picked his own man as deputy director, Kenneth Donahue, a specialist in Italian baroque art who had worked with Brown at the Frick Collection and had moved on to Sarasota, Florida, where he directed the Ringling Museum of Art. Brown had hoped that Donahue would smooth out conflicts, but the appointment only paved the way for his own demise. With a cooperative staff member who could take charge, at least for an interim period, the trustees believed they could weather a stormy transition.

Within a few months of the museum's spectacular opening, Carter, Ahmanson, and other trustees began to press for Brown's resignation. As a civil-service employee, whose salary was augmented by Museum Associates, he could not be fired without a full review by the county's Civil Service Commission. In the end Brown decided not to take his legal option. He had lost support of the trustees, including Simon whose vote was part of a unanimous board decision to ask for Brown's resignation. Although Simon defended Brown for the

rest of his life, he too had reasons for wanting a more malleable director. Like other trustees, Simon had quarreled with Brown about attributions of works in his collection. More important, Simon knew that so acrimonious a climate was unlikely to improve. One day he took a walk with Brown in the park behind the museum and told him he would have to go.

Brown took Simon's advice, but he did not leave quietly. At the beginning of November, only seven months after the museum had opened, Brown signed an agreement providing that he would resign no later than 31 January 1966 and that a public announcement would be made before 1 January. Then he issued a press release announcing his departure and charging the board with destructively meddlesome behavior and castigating Ahmanson, without naming him, for a mediocre design.

> Individual board members have forced decisions and taken
> unilateral action not consistent with good museum admin-
> istration, which requires the full-time efforts of trained
> specialists, and which cannot be handled by part-time
> laymen regardless of their devotion or attainments
> in nonrelated fields. Recently, this tendency has disrupted
> normal day-to-day professional operation and has mitigated
> [*sic*] what could and should be an ideal program of acquisi-
> tion, care, maintenance, exhibition, and interpretation of
> art for the public good. The Director is not permitted to
> operate the museum on the proper level of professional
> standards nor to maintain his personal integrity without
> conflicting with the individual board members concerned.
>
> Along with a justifiably proud community, I am proud as
> one of those who brought the new museum into being. But
> it was, and still is, my firm opinion that the museum could
> have been substantially greater in layout and design but for
> the unfortunate decisions in which professional recommen-
> dations were overruled in favor of a generous but misguided
> donor's understandable refusal to sufficiently compromise
> his desire for a monument rather than build the finest
> community institution possible.

Brown attached a copy of his press release to a memorandum to all staff members, thanking them for their loyalty and pouring out his emotions:

> The greatest unhappiness of all that I feel is because I soon will no longer be working with you. Together we have accomplished something that, just a few short years ago, was considered something that could only happen by a miracle. We did it. And we did it in a spirit of mutual respect, friendship and love that is unique in the annals of institutions. This experience is now a part of us as human beings, and it can never be taken away from any of us. Whatever happens, I shall always treasure my association with you.
>
> We may not be the most worldly and sophisticated staff in the world, just the best. The best because everyone has given himself or herself to a high purpose unselfishly. Continue to do that, and not only will this institution and the world be better for it, so will you.
>
> Ars longa, vita brevis.

Proving that he was not disgraced in the art world, Brown also used the press release to announce his acceptance of a new position "among a number of other flattering offers." He would direct the Kimbell Art Foundation in Fort Worth, established by the will of K. Kimbell, a noted industrialist in Texas. In his new job Brown would oversee the extensive collection already owned by the foundation and make significant additions to it. He would also assume administrative responsibility for the design and construction of a new museum building. As it turned out, Brown got his revenge against Ahmanson and Carter. As one of his last major commissions, Louis Kahn, the well-respected architect, designed the Kimbell Art Museum. One of the world's most beautiful art museums, distinguished by an extraordinary orchestration of light and space in a concrete, vaultlike construction, the building works unusually well.

Brown had considerable support in the art community, so his forced departure unleashed a torrent of critical coverage in the press. As the museum board's president and official spokesman, Carter said that Brown had been asked to resign because of his "demonstrated

inability to deal adequately with the administrative problems of a major art museum." No examples were publicly cited. When pressed, some trustees anonymously complained to the press that Brown had difficulty in making decisions and delegating authority. Others thought he had contributed to the board's factionalization. "Ric Brown or Sandy Koufax, it's the same thing. It's all very well to have the best player in the league, but it's the team that counts," Sesnon said.[5]

With Carter remaining tightlipped and Brown eager to talk, the press was overwhelmingly sympathetic to the dismissed director. "Dr. Brown's resignation statement, in effect, put every self-respecting museum official on notice that they could expect nothing but compromise, humiliation, and mediocrity in the now vacant job at the Los Angeles County Museum of Art."[6] A local Save the Museum committee emerged and presented the board with demands for changes in the museum's governance. In press accounts of the debacle, Ahmanson was accused of being Brown's most vigorous adversary. Ahmanson was said to bear a grudge about Brown's resistance to his choice of architect and to Millard Sheets, who had been Ahmanson's principal artistic advisor. What's more, the financier was reportedly outraged that Brown had refused to hang paintings from his collection at the museum.[7]

Donahue was appointed as acting director of the museum and five of the trustees, Franklin D. Murphy, Anna Bing Arnold, Sidney F. Brody, Joseph B. Koepfli, and Taft B. Schreiber, were charged with the responsibility of recommending a candidate for the permanent directorship. They soon selected Donahue, who served as director until 1979.

10

THE *TITUS* AFFAIR

A bizarre auction room dispute ended dramatically today
when Rembrandt's portrait of his son, "Titus" was sold for $2,234,000
to the Norton Simon Foundation of Los Angeles.

NEW YORK TIMES
20 March 1965

IF THERE WERE ANY DOUBTS that Norton Simon had emerged in public as a major art collector, his purchase of Rembrandt's *Portrait of a Boy, Presumed to be Artist's Son, Titus* dispelled them. He had a reputation as a reclusive businessman, but the circumstances of his acquisition of that painting put him in the brightest of spotlights. Stardom occurred so dramatically—and through such an irregular turn of events—that his relationship with the painting appeared to be a sudden affair. For all the public knew, he might have first encountered the portrait as lot 105 in Christie's catalogue for its sale of old master paintings on 19 March 1965. His acquaintance with *Titus* actually began eight years earlier and continued as an on-again, off-again courtship typical of the collector who often delayed purchases for months or even years in an effort to consider potential acquisitions from every angle, get the best deal, and keep all his options open.

The *Titus* affair began in March 1957 when Simon called Claude A. Partridge of Frank Partridge & Sons Ltd. in London about a Cézanne he was considering. In the course of the conversation, Simon mentioned that he was also interested in acquiring a late

Rembrandt. Replying that "there are now very very few of these left in private hands," Partridge noted that "the Cook picture of his son Titus does not seem to be for sale."[1]

Partridge was referring to a painting that had been watched by dealers for many years but was part of an estate that would be heavily taxed when its assets were liquidated. According to a legend circulated in the press shortly before Christie's sale, the portrait was brought to England around 1815 by George Barker, a dealer and restorer who often performed services for Lord Spencer at Althorp in Northamptonshire. In the Netherlands on business, Barker was returning home to England when he missed his boat and had to spend a night at a farmhouse near The Hague. He was enchanted to find *Titus* hanging above the bed in his room. When Barker told his host how much he liked the painting, the farmer included it with the price of bed and breakfast, one shilling. Back in England, Barker gave the portrait to his patron, Lord Spencer, whose wife Lavinia immediately fell in love with it and declared that it must never leave the house.

Her wish was broken 100 years later, in 1915, when the Spencer collection was dismantled. Sir Herbert Cook, the son of Sir Francis Cook who began acquiring old masters in 1871 and eventually formed one of England's finest collections, purchased the painting for £35,000 ($170,000) to keep it in the country and displayed it at Doughty House in Richmond. When Sir Herbert died in 1939, the artworks were passed to his son, the second Sir Francis Cook, who dispersed some of them, lent a few pieces to museums, but kept a group including *Titus* at his house in Jersey in the Channel Islands.

Although Partridge couldn't offer *Titus* to Simon, he indicated its market value by telling him that an offer of £120,000 ($333,600) had been made by another suitor. Simon responded in a letter, saying that the painting appeared to be "outstanding" in photographs, but he would have to see the real thing to judge its quality. Expressing further reservations, he told Partridge "the price is rather high for this relatively small picture." (It measures 25½ by 22 inches.) Simon also said that he was interested only in "outstanding pictures and if they are for sale." He had no wish to have "to go to someone with a completely unreasonable price in order to interest them in selling."[2]

The subject seemed to be closed, but in 1963 Simon was thinking about *Titus* again. A group of dealers, including Geoffrey Agnew of London, obtained Sir Francis Cook's permission to try to sell the picture. Agnew offered it to Simon for £550,000 ($1.5 million) plus commission. Despite the price rise, Simon requested an opinion about the painting from Edward Fowles of Duveen Brothers in New York. Fowles said he hadn't seen the portrait in many years, but forwarded to Simon notes he had made when it had been exhibited at the Royal Academy in London in 1929. He told Simon that most Dutch critics doubted that the subject of the painting is actually Titus because in later pictures the boy has brown hair and brown eyes and in this one he is a blue-eyed blond. But "it is a fine and beautiful picture . . . charming and decorative and full of colour" and "certainly a picture worth buying today." He said that it would fetch over half a million dollars and advised Simon to buy it.[3]

Simon was reluctant to take his advice without seeing the picture and negotiating a lower price. He wrote to Agnew saying that it might be possible for his frequent adviser, Ric Brown, to travel to London on his behalf and inspect the condition of the painting, but only if "we could settle on a definite price with the owners that would be somewhat below the price you indicated."[4]

Agnew replied that the picture was at Sir Francis Cook's house in Jersey, about an hour's flight from London, and that it would be necessary to go there to examine it. "In my opinion, which is, I think, universally shared among connoisseurs and experts, there is no problem about this picture as to its authenticity, condition, aesthetic quality, attractiveness, desirability and importance. The only problem is one of price." Reiterating that he thought £550,000 a fair price, Agnew said he would make any reasonable offer Simon cared to advance, but making a direct offer was "the only way to achieve success" with the Cook family.

"To sum up," Agnew said, "I think it comes to this. You must make up your mind whether you think you would be prepared to buy the picture if, after seeing it, you (a) like it sufficiently, (b) had been satisfied by Rick [*sic*] and myself of its condition, (c) are prepared to pay the sort of price I have indicated. If you feel that there is this possibility of wishing to own such a uniquely beautiful example

of one of the greatest of all artists at the height of his powers, then come over and we will see if we can buy the picture. We may not of course succeed, but I think we have a very good chance of doing so. Personally I feel it is a picture which would give you enormous pleasure to own; this is why I am giving you the opportunity, but I think we must take some action fairly soon."[5]

Simon stalled, saying that if he and Brown could have seen the picture together he might have been willing to pay the suggested price. "As much as I would like to, I just cannot feel that I want to pay this price for the picture (beautiful as it is) without both of us getting a good look at it at the same time."[6]

Agnew may have been frustrated and he was certainly disappointed, but he didn't give up. A year later he wrote to Simon regarding an "important development" about the Cook Rembrandt. Sir Francis Cook had given the picture to his seventh and current wife, presumably for tax purposes. Legal questions had been raised as to whether she could sell it and keep the proceeds or whether the Cook Trust had a prior claim. The matter had been settled in Lady Cook's favor, she was ready to sell the painting, and was prepared to accept the reduced price of £500,000 ($1.4 million).[7]

Simon replied that he was still interested in *Titus,* but that traveling to Jersey was too great an inconvenience and even if he took the trouble, he feared that the light there would not be good enough to permit him to examine the painting properly.[8] The indefatigable Agnew wrote again, insisting that the painting could be seen in good light in Jersey,[9] but Simon replied that he was "not too interested in pursuing the Cook Rembrandt."[10]

The following year, when the Cooks consigned *Titus* and four other paintings to Christie's and Simon faced what appeared to be a now-or-never situation, his attitude changed dramatically. He first heard the news in an express letter from Agnew. "The Cook Rembrandt is coming up at Christie's. If possible, you should come and see it and, once again, I recommend it with all my heart and all my head."[11]

Having learned of Simon's past interest in *Titus,* Robert M. Leylan of Christie's also wrote to Simon, advising him that the auction house planned to sell "a small group of capital pictures from the

famous Cook collection" on 19 March and that Christie's had estimated the selling price of *Titus* at about $1.5 million.[12] In fact, to secure the consignment, the auction house had guaranteed the Cooks that sum. If bidding didn't rise to at least $1.5 million, Christie's would buy the picture and sell it privately after the auction.

Within a few weeks, Simon's attorney Milton Ray was checking into British export laws and Christie's had reserved a suite for Simon at Claridges, but not under his name.

Simon's plane was more than twelve hours late and it was past midnight when Simon arrived at Christie's. He perused the artworks quickly before informing Patrick Lindsay of his proposed bidding arrangements. Twenty minutes later, they each had a hand-written copy of the agreement, signed by both men. Autolycus, Simon's *nom de vente* (a fictitious name assigned, in auction house practice, to protect the privacy of special clients), was printed across the top of two small sheets of the auction house's letterhead. His taking the name from Greek mythology was a private joke, known only to Simon and a few people at Christie's. Autolycus, the son of Hermes, was a notorious thief and the Olympian god of wealth and good fortune and patron of commerce and larceny. As events evolved, Simon's tactics at the auction later that morning would be interpreted as high-handed stealing, but the irony of the secret moniker was lost in the international commotion. Simon thought he was setting up a system enabling him to make the purchase in secret and announce it at an opportune moment. "When Mr. Simon is sitting down he is bidding. If he bids openly when sitting down he is also bidding. When he stands up he has stopped bidding. If he then sits down again he is not bidding until he raises his finger. Having raised his finger he is continuing to bid until he stands up again."[13]

Lindsay told Simon that his procedure was too complicated—the auctioneer was likely to have the various bidding strategies of several clients to remember and watch for during the sale—and that he should discuss the arrangement with Peter Chance, the auctioneer, the next morning. At their brief meeting before the sale, Chance, too, told Simon that his tactics would be too confusing and suggested that he let the dealer Dudley Tooth bid for him. Simon refused, but Chance thought that they had at least agreed to simplify

the arrangement by determining that Simon would not be making any open bids on *Titus.*

Titus was the last lot in the sale. With television lights blazing, cameras poised, and the audience on edge, Chance opened the bidding, in guineas, at about $300,000 and soon doubled that sum. Confusing the auctioneer, Simon made a verbal bid of about $900,000 and continued with bids that raised the price to about $1.9 million. Then he fell silent. He had remained seated and merely changed his tactics to confuse observers, but Chance thought he had dropped out. In what appeared to be the last round, Geoffrey Agnew was pitted against David Somerset of Marlborough Fine Art, who was representing the Greek shipping magnate Stavros Niarchos. The price edged up to about $2.1 million, with Somerset making the last bid.

Concerned, Chance solicited a further bid from Simon but got no response. Chance banged his gavel on the podium and said, "Marlborough Fine Art." Simon then jumped up, demanding that Chance abide by their written agreement. Chance reopened the sale, took one more bid, Simon's, for $2.2 million, and sold the painting to the Norton Simon Foundation.

Victorious, Simon rushed out of the room and down a back stairway, followed by the press. Outside he was surrounded by reporters who demanded to know why he had set up such an odd bidding arrangement. "I wanted to buy it anonymously," he said. "I wanted to avoid the publicity." His statements sounded ludicrous in the circumstances, but Simon had hoped that, having switched from bidding openly to bidding silently, he could keep his purchase a secret until he returned to Los Angeles, where he had planned to make a dramatic announcement of his latest acquisition.

The incident became a source of controversy and speculation in the art world as observers tried to account for Simon's behavior. Martin Summers, a young associate of Tooth who had accompanied him to the auction, suspected that Simon had planned the whole scenario: "He got the picture and he made himself a name that day. That might easily have been his intention, to nail his colors to the mast and let the world know, 'I am a collector to be reckoned with.' "[14]

Simon had been advised that the British Board of Trade had three

months to make a decision about granting him an export license, but that the normal wait was only about three weeks and his chance of success was between 90 percent and 95 percent. His application could be rejected "in the national interest" if a review committee determined that the nation had a shortage of good Rembrandts, which was not the case. Even then, a British buyer would have to match Simon's price to keep the painting in the country, and that seemed unlikely.

But obtaining the required license didn't proceed as smoothly as had been expected. The National Gallery in London had attempted to acquire the Rembrandt from the Cook collection in 1929, in 1939, and again in 1945, and it remained on the gallery's list of desirable acquisitions. A group of prominent figures in British art circles attempted to persuade the license review committee to declare the painting a national treasure and refuse the license. The discussion dragged on for nearly a month. Then Simon astonished the British by announcing that, if they really thought the painting should remain in the country, he would help them. He would open a public sub-scription drive with a donation of between $150,000 and $300,000. His gift would, however, require that a substantial part of the total $2.2 million come from the general public and that no single donor contribute a higher sum than he himself had. If the money were raised in that way, the picture would remain in the possession of the British, but it would have to be in the permanent collection of the National Gallery in London and occasionally lent to the Los Angeles County Museum of Art. He also suggested that the people of Los Angeles might match his own gift in a gesture of good will.

The trustees of the National Gallery issued public thanks to Simon but declined his offer. It was too soon to mount a public subscription drive after a campaign in 1962 that had raised more than $2 million to prevent the export of *The Virgin and Child with Saint Anne and John the Baptist,* a charcoal drawing by Leonardo da Vinci. Lord Rob-bins, the chairman of the National Gallery, wrote to Simon, thanking him for his "exceedingly sporting offer" and expressing the hope that "the picture will come to rest in your splendid Los Angeles gallery."[15] The license was granted.

Instead of taking the painting directly to California, Simon

stopped off in Washington, explaining that "the painting has such great beauty and universal appeal that the foundation has a special obligation to exhibit it in the most favorable circumstances for the widest possible enjoyment."[16] Henry Seldis, the art critic for the *Los Angeles Times,* smelled a rat. "It is no mere speculation to report that Simon's decision to bring the famous canvas to Washington first has to do with his growing dissatisfaction with developments within our new museum." Quoting Simon as saying, "I would like to see the majority of my current loans stay in the County Museum of Art for good," Seldis outlined Simon's unhappiness with "the lack of developing an overall acquisitions policy, with the relatively small number of art-minded members on the museum board, and with incomplete separation of the County Museum of Art from other county museum branches" and issued a warning of the possibility that Los Angeles might lose the Simon collection.[17]

Michael Green, Christie's shipping manager, sat alongside the four-foot-square padded box containing *Titus* during the nonstop flight from London to Washington. A contingent of armed guards escorted the crate to the National Gallery of Art. Asked about the tight security, the gallery's assistant director J. Carter Brown said that the portrait was "one of the most valuable paintings ever received in the National Gallery" and "the precautions were commensurate with its value."[18] *Titus* was installed for six months in a lobby where the *Mona Lisa* had hung during a visit from the Louvre the previous year.

With the American debut of *Titus,* Simon and the painting appeared on the cover of *Time* magazine, 4 June 1965.

> The man who bought *Titus* . . . is perhaps the only man in
> the world who could and would execute such a coup. As
> head of California's rapidly expanding Hunt Food &
> Industries, Inc., Norton Winfred Simon is the ruler of a
> business complex that embraces two dozen companies in
> fields as diverse as publishing and steel. A comfortable
> millionaire—about $100 million at latest count—who grew
> rich primarily by canning tomato products, Simon in recent
> years has leaped from catsup to culture by assembling a
> $45-million assortment of art that ranks as one of the U.S.'s

most impressive private collections. He is thus not only one of the few individual collectors with the money and desire for a first-class Rembrandt, but also that even rarer creature: a man who pursues great paintings and additional companies with equal vigor, thereby establishing a collector's reputation in both business and art.[19]

After a six-month exhibition at the National Gallery of Art, *Titus* was to be shipped to the Los Angeles County Museum of Art in early December. But how? Simon would never allow the painting to travel without maximum security—or the appearance of it—and a plan that would outwit potential thieves. Frieda Kay Fall, the energetic and enterprising registrar who had overseen the move of the museum's collection from Exposition Park to Wilshire Boulevard, offered to fly to Washington, wrap the painting as if it were a Christmas gift, and bring it back with her on the plane.

At the National Gallery, Fall had to produce a stack of identification cards to persuade the museum's legal counsel that she really was Frieda Kay Fall. She inspected the painting, watched while it was packed to her specifications, and then covered the package with Christmas paper, tied a ribbon around it, and attached a gift card, inscribed "To Mother with Love, Your Son." The museum provided an armored truck for the painting and a limousine for her. The two vehicles circled the airport, then pulled up to a Trans World Airlines plane parked a long distance from the terminal. Boarding the plane before any other passengers, she took her assigned seat and just across the aisle, the painting sat on its side on the floor, resting against two seats. An observant flight attendant plied Fall with questions about the package. The stewardess persisted, asking if it might be a painting. Fall responded that her son couldn't afford a painting and had probably given her a framed mirror.[20]

Titus went on public view at the museum the day after Christmas in a prominent gallery equipped with new partitions and special lighting. Commenting on the value of the artwork to the museum and the public, Seldis saw it as a symbol of lofty goals.

It will serve as an example of unquestioned quality in a new institution still largely filled with mediocre works. It may possibly inspire the long-overdue formation of an aggressive acquisitions policy that would insure the museum its just and proportionate share of the ever-shrinking supply of truly great art objects of all periods before the prices become even more astronomical than that paid for the *Titus*. It is even possible that the wide public gratitude already evidenced for this loan will move Norton Simon and his foundation to make its loan and that of so many of his possessions which are now the qualitatively most important displays in the museum, permanent.

Noting that the portrait appeals to children as well as scholars, Seldis said that it demonstrates that the museum's function is educational, not social or political. He concluded with a message to the museum's trustees: "It may be too much to expect from such a small canvas, no matter how great its creator and how high its monetary value, but on the threshold of a new year we must hope that *Titus* will serve as a beacon for a less divisive and more constructive year."[21]

11

LIVING WITH ART

*We are constantly reshuffling things here because I am always looking
for a better relationship between the picture or sculpture and me.*

NORTON SIMON
Los Angeles Times, *23 July 1967*

THE SIMONS' HOUSE GRADUALLY evolved into a domestic gallery. As
the years passed and one piece of art after another was delivered to
the residence on Hudson Avenue, it became a private museum.
While Simon was buying art with what he called "soft money" for
his foundations and exploiting their tax advantages by making the
collections available to the public through educational and cultural
institutions, he spent vast quantities of "hard money" to amass a per-
sonal collection that he and Lucille displayed at home. At first they
put their new possessions in obvious places of honor, in the living
room, dining room, and other areas that visitors would see. But as
Norton's new interest became a passion, they installed art in hall-
ways, bedrooms, bathrooms, and even closets.

Despite the frenetic pace of Norton's business, the Simons main-
tained a quiet private life in Hancock Park. Still, the collection was
far from secret. Art dealers from Europe and the East Coast, visiting
scholars, and members of Los Angeles's cultural elite were fre-
quently invited to the house. The press noted Norton's purchases at
auction, and every new addition was fodder for the art world's gos-
sip mill. Lucille was uncomfortable with public attention, but Nor-
ton developed a taste for publicity and periodically indulged it to
the hilt. He was eager to be portrayed as a culturally enlightened

industrialist and to have his foundation collections seen as an educational resource.

It was difficult for reporters to gain access to his private life, but in 1964 *Time* magazine introduced his personal collection to the public in a four-page color spread. In the accompanying text, Simon was hailed as "the most discriminating art collector on the West Coast," an assessment that pleased him enormously. After years of getting little more than grudging respect from the press for his accomplishments in business, he was hungry for unadulterated praise. Drawing an analogy between Simon's habits of collecting both companies and art, the writer said that the industrialist added luster to artworks when he purchased them, just as he improved companies he bought. "By hanging it in the company of centuries of masterworks, even Simon's Rembrandt gains character as a personal choice, and returns the compliment to Simon's spread from Lorenzo Monaco to De Kooning. It is no coincidence that Simon speaks like an existential philosopher and terms himself an abstract businessman: he seeks man's fulfillment of self in art and business."[1]

On Simon's taste in art, the writer quoted Ric Brown: "Simon's primary consideration is esthetic quality without regard for periods. And he lives with it just that way, hanging a Van Dyck alongside a Gorky in his office, a Memling alongside a Degas at home. This takes courage and taste, because it means holding the bat full length, not shortening up." Commenting on Simon's penchant for difficult subject matter, Brown said the collector had "a sympathy, an understanding, a desire to recognize agony in life." Simon himself was quoted as saying "the facts of life and cold reality" are "bona fide subjects of art."[2]

The magazine's readers glimpsed the range of Simon's interest in a photograph of his office in which a stately, early-seventeenth-century portrait of the Marchesa Lomellini Durazzo of Genoa by Sir Anthony Van Dyck was displayed alongside two exuberant twentieth-century pieces—*Plumage Landscape,* a buoyant painting by the abstract expressionist Arshile Gorky and Ernst Barlach's chunky, stylized figurative sculpture, *Singing Man.* In photographs of Simon's home, *Women Ironing,* a depiction by Degas of weary laundry maids, hung in the living room near an elegant Egyptian bronze sculpture of a cat. The study, where Simon often considered

potential purchases, offered more proof of Simon's inclination to mix periods and styles. Memling's 1478 devotional painting, *Christ Giving His Blessing,* and Giorgione's 1509 *Bust Portrait of a Courtesan* hung on walls alongside nineteenth-century pieces by Degas and Daumier. On the floor and leaning against two couches were a dozen old master and impressionist drawings. A picture of the bedroom presented a more predictable assembly, with Matisse's *Odalisque with Striped Dress* over the brick fireplace and works by Degas and Renoir on walls near the bed. But a picture of another bedroom revealed a small marble Grecian Venus sitting on the top of an electric organ, with *The Virgin Annunciate* by a Renaissance painter, Lorenzo Monaco, on the nearby wall.

Before the house and the collection were ten years old, the ranch-style dwelling that once seemed spacious was cramped for wall space, but the Simons weren't eager to move. Friends and visitors may have wondered why such a splendid collection was so unpretentiously housed, but the Simons had little interest in acquiring a showy palace or adopting a more ostentatious lifestyle. They had become accustomed to many of the comforts and services that wealth provided, but Lucille was inclined to be frugal and Norton never developed an interest in real estate. Living in a relatively ordinary house that blended into a tranquil, affluent neighborhood suited them fine. Space was an acute problem, however, so in 1964, when a neighboring property went on the market, the Simons bought it, knocked down the house, and built an addition to their own. They doubled the size of the house, and gained a vast room designed as a gallery. With wood-paneled walls, built-in shelves for art books, and a steeply pitched ceiling, it was an impressive space that would accommodate about a hundred works of art, including small sculptural pieces installed in glass-covered cases and arranged on tables.

The gallery's most distinctive feature and its dramatic centerpiece was a compact storage and display unit consisting of sliding screens built into a recessed space along one wall. Paintings hanging on the front screen were visible all the time, but the panels behind it could be rolled out one by one to reveal treasures for visitors seated on a long, gold-colored upholstered couch and orange chairs facing the changing exhibition. The Simons often rearranged the display for

themselves and close friends, revealing their latest acquisitions. When well-connected visitors made appointments to see the collection, a servant would pull out one rack at a time to show off particularly fine pieces.

A year later, when Simon and a new acquisition, Rembrandt's *Titus,* were on the cover of *Time,* Simon's business career and collecting activities were described, but the collection at his home was barely mentioned. Among tidbits about his lifestyle, readers learned that he frequently swam after dark and smothered his food in catsup that was kept in silver containers. There was only a brief reference to the recently completed addition to his house and Simon's security measures: "An elaborate alarm system protects the art, and Simon's household staff includes regular guards."[3] The only photograph of the house was of the exterior.

Although reluctant to show the world what was in his house—and understandably concerned about security—Simon was proud of the new addition. In 1967 he opened his door to Henry J. Seldis, the art critic for the *Los Angeles Times,* and accompanying photographers. "Here at home the emphasis is on late nineteenth- and twentieth-century masterworks because the expressions of these great artists suit our modern living environment," he told Seldis. "They are all works that have stood up to the composite judgment of thirty or forty years."[4]

Most of the works were those of impressionists, post-impressionists, and other artists of roughly the same period—for which Simon had a particularly sharp eye. Seven Cézannes hung in the bedroom alone. Among them was *Still Life with Blue Pot,* purchased at auction three months earlier for $406,000. The masterful work is one of a group of late watercolors by Cézanne that are highly regarded by scholars for their scale, fluidity, and brilliance.[5] Simon described it as "one of the most colorful and complete of [Cézanne's] watercolors."[6]

Grass-cloth-covered walls of the plainly furnished dining room held three Picassos of different styles, depictions of women over a twenty-six-year span of time: *Head of a Young Woman* (1906), from the artist's rose period; *Woman with Guitar* (1915), a late-cubist work in which the fragmented figure all but disappears, and *Woman with a Book* (1932), a voluptuous abstraction of the artist's mistress, Marie-

Thérèse Walter. But any notion that Simon collected programatically was quickly dispelled by pictures in the newspaper. Gauguin's *Tahitian Woman and Boy,* painted in 1899 and purchased by Simon in 1965 for $365,500, had a prominent place in the gallery, but so did old master works including the Van Dyck portrait and an oil sketch by Rubens. Van Gogh's *Mulberry Tree* hung in the living room, along with Lucille's favorite painting, Rembrandt's portrait of his second wife, Hendrickje Stoeffels.

In the article Seldis had pictured a neat, organized environment, with every piece of art in its place. Simon consistently portrayed his collecting as a journey of self-discovery as well as a quest for quality at the best price. "Before you can communicate with others, you must learn to communicate with yourself," he told Seldis. "This is only one of the central lessons great art teaches us.[7] . . . We are constantly reshuffling things here because I am always looking for a better relationship between the picture or sculpture and me. Putting them in different positions gives new life to them and takes away any tendency to become static. As different pros and cons become evident in each work as it is moved around, I am better able to identify with a particular artist's vision. Each artist sees life in a different way and eventually you are able to share that vision to some extent. Looking out of the window one projects these personal manners of seeing even to nature, thinking of a 'Sisley cloud' or a 'Van Gogh field.' "[8]

Lucille, too, also had a strong interest in art as education. She fulfilled it, in part, by opening her home to graduate students in the art department at the University of California at Los Angeles. The painter William Brice and other members of the art faculty took classes to the Simons' house to see a private collection that would have been extraordinary in any city and was unsurpassed in Los Angeles.[9] Simon's foundation collections could be seen at the Los Angeles County Museum of Art and several other museums around the country; the sprawling house on Hudson Avenue presented a different, but equally impressive sight in 1968: an array of art, in sometimes amazing quantity—twenty-three works by Degas, fifteen sculptures by Maillol, fourteen Picassos, twelve Cézannes, eleven Daumiers, eight Matisses, and pieces by other artists ranging from Goya to Toulouse-Lautrec.

In the foyer were still lifes by Bonnard and Braque and the *Portrait of Madame Dietz-Monnin* by Degas. In the living room were four bronzes by Daumier, three works by Dégas, a Matisse, a Pissarro, Rembrandt's portrait of Henrickje Stoeffels, and the Egyptian bronze cat. The gallery housed nearly one hundred pieces, about two dozen of them—by Boudin, Braque, Chardin, Corot, Courbet, Degas, Delacroix, Fantin-Latour, and Fragonard—hung on the sliding screens. Nothing was off limits to the students, and those who wandered into Robert's bedroom found a dozen etchings and engravings there by Breugel, Daumier, Dürer, Géricault, Goya, Manet, Rembrandt, and Rubens. Outside in the back garden were nine larger-than-lifesize bronze nudes by Aristide Maillol, sold to Simon by Dina Vierny, the artist's model and lover who, after his death in 1944, became an entrepreneurial dealer.

12

CULTURE FOR FULLERTON

*Here in Fullerton, we have one of the great museum opportunities
in the country. I want to find out just how we can make the
most effective use of these art objects. How can it be used to enhance
the culture of the area? This will take study.*

JAMES M. BROWN
Los Angeles Times, *14 January 1968*

ENTRENCHED AS SIMON HAD become at the Los Angeles County Museum of Art, he had deeper roots twenty-five miles to the southeast, in Fullerton, Orange County. It was only natural that his collecting would become entwined with his business.

In 1954, the year he began his personal collection with Renoir's *Andrea en Bleu,* Simon established the Hunt Foods Charitable Foundation, which evolved into a tax-exempt vehicle for building a corporate art collection. Despite his own abbreviated college career and apparent disdain for formal training, his company's charitable activity initially focused on education, providing funds for college scholarships for children of Hunt employees and grants to universities attended by the scholarship winners, among other causes. The emphasis of the foundation's philanthropy shifted from education to art as Simon's collecting became more serious. The foundation's name also changed—four times in its first twenty years of existence—reflecting Simon's fluctuating business interests and his growing commitment to fine art.

The first name change came in 1959, after Hunt Foods had mushroomed into Hunt Foods & Industries. Simon merged two other

corporate foundations with Hunt Foods Charitable Foundation, under the name of the Hunt Foods & Industries Foundation. Around the same time he began to carve out a new image for himself in Fullerton as a cultural patriarch. The first public evidence of his aspirations arrived in the form of a library, built at a cost of $485,000 on land owned by Hunt Foods & Industries with money from the foundation. It was presented to the City of Fullerton in 1962. Simon envisioned the twelve-thousand-square-foot building, designed by William L. Pereira, as the "first step in the development of an important cultural center and landscaped park area in Fullerton."[1] Turning part of the library into an art gallery and study center, he donated a collection of art books worth $5,800 in 1963 and soon began installing artworks from his collections on the walls and in the grounds.

The library was a local showpiece, but it was only a symbol of Simon's more ambitious goal. Simon and his representatives began talking to civic leaders about building an actual museum in Fullerton. After several months of discussions Herman Hiltscher, the Fullerton city administrator, was asked to find out "if the city and the people of the community would be responsive to [a museum] and would provide a reasonable level of community support for such a cultural endeavor." Summarizing Simon's thoughts about the museum, Carl Kalbfleisch, the executive vice president of Hunt Foods & Industries, Inc., wrote:

> It is our opinion that a fine arts museum plays an important role in the cultural life of any community and that such a facility would add to the City of Fullerton's stature and reputation as a progressive city, an educational center of the county, and as a fine place to live and conduct a business. So that an art museum can become a reality in Fullerton, on a faster timetable than would be feasible if the project were to depend entirely upon city funds, the foundation is considering making a major gift to the city for this purpose . . . not less than half a million dollars for construction of the art museum. Recognizing that it will take time for a new museum to acquire an art collection, Mr. Simon has indicated that he personally, as well as members of his family, the Norton Simon Foundation, and the Hunt Foods

& Industries Foundation plan to loan works of art to the museum and also, from time to time, may make donations of art objects to the museum.[2]

If the plan appeared to be bold and innovative for Fullerton, it was essentially a modest variation of the scheme that had launched the Los Angeles County Museum of Art: an art museum built with private funds on public land, the institution run with a combination of public and private support. In Fullerton, where Simon was by far the biggest businessman, he would not have to deal with the likes of Ed Carter and Howard Ahmanson. There would be no competition among donors and no question about who deserved credit for the project. Simon's foundation would provide all the private funds for the building's planning and construction. The museum would not bear his name, but it would be near his corporate headquarters and be called the Hunt Foods Foundation Museum. Simon was determined to have his place in southern California's rising cultural sun, but only on his terms. That meant providing Fullerton with a cultural asset while getting the most for his money and assuring himself that the city's leaders and residents thought the museum important enough to merit their financial support. The city's donation of land and its promise to maintain the museum, along with a show of popular support, would provide the proof he needed.

As usual, Simon had done his homework and had reason to believe his dream would be realized, but he had underestimated the difficulties of working with a city bureaucracy and local politicians. By mid-November 1964 the museum plan was bogged down in other proposals for land swaps and confusion over zoning and a road providing access to the museum. The school district had refused to exchange the land Simon originally requested for the project. The foundation accepted a piece of city property nearby, but instead of moving forward, the project became mired in meetings and political power plays.

While watching his dream disappear into a bureaucratic muddle, Simon became offended by innuendoes that he had ulterior motives for the proposed gift, such as gaining additional access to Hunt

property, enhancing his corporate headquarters, and getting free public land for a private museum. The foundation issued a press release attempting to clear up misconceptions and answer questions. "When the first stage of the art museum construction is completed, full title will be given to the city. The foundation would expect that whatever governing body the city might establish for the art museum would have full responsibility for determining the policies under which it would be operated and would determine what art would be exhibited, etc. The foundation and the company, at this point, would be involved only in terms of continued interest and support of the museum's programs." The tone was neutral, but the release contained a bombshell, calmly phrased as a warning. If the project became disruptive to the community and its relationship to Hunt, if the city and community had only nominal interest in supporting the project, and if problems could not be solved promptly, the foundation would retract its offer.[3]

Simon proceeded in good faith. In December 1964 the Internal Revenue Service authorized the foundation to accumulate income in the amount of five hundred thousand dollars in a reserve fund for contribution to the City of Fullerton toward the construction of an art museum.

Progress was fitful in 1965, but the project seemed to be on its way. That year the foundation invested more than three hundred thousand dollars in the museum, the bulk of it to buy a dozen houses that were to be cleared away for a road. The balance was spent on art for the museum and a deposit in the reserve fund. Meanwhile, Simon won the community support he wanted. Thirty-four local civic organizations endorsed the project and the North Orange County Fine Arts Association prepared a brochure, effectively supporting the museum by explaining it to the public in the foundation's language.

Behind the scenes, the picture was far less encouraging as relationships between the city and the foundation deteriorated. City officials worried about making a long-term commitment to maintaining a museum and paying for security for a valuable collection. Arguments about the school district's and the city's potential need for the museum land presented one obstacle after another. Exasperated over

more than two years of delays, Simon asked the Internal Revenue Service for a new ruling, one that would change the foundation's name to the Hunt Foods & Industries Museum of Art and redefine its activities. Instead of giving a museum to Fullerton, the foundation would construct and operate its own art museum and lend works of art to public museums. The ruling was granted in October, and the foundation promptly announced that funds previously reserved for the Fullerton museum would be used to buy art.

The press release announcing Simon's withdrawal from the museum also revealed the foundation's acquisition of Picasso's 1920 cubist painting, *Open Window in Paris*. He bought the painting for $225,000, exhibited it at the Fullerton library from 1967 to 1969, and then lent it to *The Cubist Epoch* exhibition at the Los Angeles County Museum of Art and the Metropolitan Museum of Art in New York in 1971 and to Princeton University's Art Museum in 1974. While it was at Princeton, he sold the painting to Eugene Thaw in New York for $1 million, more than four times the sum he had paid eight years earlier.

Picking up a cue from the foundation's announcement of its revised mission, other cities in Orange County proposed sites for the museum while supporters in Fullerton hoped that Simon would change his mind. More than a year after Simon's withdrawal, some city officials in Fullerton insisted that the museum plan was still viable. Publicly Simon talked about exploring the possibility of building a museum to house the collection, but did no more than that. The foundation spent $2.4 million on art in 1967 and $4.7 million in 1968. In keeping with Simon's taste, the Hunt collection focused on nineteenth- and early twentieth-century works by such well-known painters as Henri Matisse, Pablo Picasso, Pierre-Auguste Renoir, Gustave Courbet, Eugène Boudin, and Piet Mondrian. The foundation's growing stock of sculpture included bronzes by Auguste Rodin, Alberto Giacometti, Aristide Maillol, Henry Moore, and Wilhelm Lehmbruck.

To maintain the tax-exempt status of his foundation, Simon was required to make the foundation's art collection available to the public and use it for educational purposes. When the leaders of Fullerton did not appear to appreciate his offer of a museum partnership that

would have fulfilled his obligation, he considered other options: He could enhance the art program at his corporate office, he could build his own museum, and he could lend groups of works in his collection to museums and educational institutions. Initially, he decided to share his riches with nearby universities. *A Selection of Nineteenth- and Twentieth-Century Works from The Hunt Foods and Industries Museum of Art Collection* traveled to University of California galleries at Irvine, Davis, and Riverside and to the Fine Arts Gallery of San Diego, from March to October 1967. The thirty-one-piece show consisted of a dozen paintings, ranging from Courbet's dark, realistic landscape, *The Forest Pool*, painted in 1865, to Willem de Kooning's brash, abstract-expressionist interpretation of *Two Standing Women*, painted around 1949, figurative sculptures by Jacques Lipchitz and Maillol, various drawings and watercolors by Arshile Gorky, Marcel Gromaire, Édouard Manet, and Jules Pascin, and prints by Picasso.

Art history students at the University of California at Riverside wrote entries on the artworks for the illustrated catalogue and John Coplans, the director of the gallery at the University of California at Irvine, provided an introduction: "At this stage of the collection's growth the emphasis is on acquiring important works of art as they become available on the market. Obviously the purpose of this flexible approach is to not lose opportunities that very often occur only once in a lifetime." Coplans seemed to be struggling to justify a rather incoherent exhibition, but he did argue for the quality of individual pieces and indirectly praised the man who bought them. "The establishment of the Hunt Foods and Industries Museum of Art Collection is representative of a highly developed sense of cultural and social responsibility."[4]

Rumors that Simon would yet build a museum were still to be heard and gained credence late in 1967 when James M. Brown, the fifty-year-old director of the Oakland Museum, was hired to head the Hunt Foods & Industries Museum of Art. Until then, Simon had depended on Barbara Roberts, executive secretaries, and administrators. Although he supported education through his foundations and sent his sons to the University of California at Berkeley, Simon prided himself on being self-taught. His employees found that one

of the hazards of working for him was being pushed to perform tasks beyond their expertise. Hiring his first trained and experienced art professional was out of character for Simon, but it was interpreted as an indication that he intended to build his own museum.

When Brown's appointment was announced, he denied the existence of plans for a museum but left the issue open. "It will be my first task to recommend *if* and *where* we should build, and to find how we can give the collection the greatest overall utility," he said in an interview with Henry Seldis. "It is certainly Mr. Simon's intent to supplement rather than to compete with existing cultural facilities."[5]

Seldis was a newspaperman with a deadline and a firm conviction about what he felt was inevitable. Noting that Simon's personal collection and his two foundation collections had an estimated total worth of close to $100 million, Seldis said that a museum of the Hunt collection could receive gifts of art from the other two collections. Given that situation, the nonexistent museum had "the potential of becoming the greatest art treasure house in the West." And in choosing Brown, Simon had hired a veteran who knew how to develop a museum and facilitate productive relationships between art and business, Seldis said. "Had Simon merely wanted to extend the scope of his corporate collection, the first Hunt Foods & Industries Museum director would have been an eminent art historian. Take a collector embarked on assembling one of the great art collections of modern times, add a professional museum builder, and the realization of a full-blown, Simon-controlled art museum in the Los Angeles area emerges as a near certainty."[6]

Such optimism was understandable. Simon had acquired so much good art so quickly that he had become the nation's most active collector. His holdings had occupied much of the exhibition space in the Los Angeles County Museum of Art since it opened in 1965. An additional display of twelve modern sculptures from Simon's collection was installed on the plaza in the summer of 1968. In Fullerton, his art was in Hunt's offices and the Hunt library contained works by Gorky, Mondrian, and Fernand Léger, along with a pair of fourteenth-century limestone Madonnas from the Duveen collection. Outside on Hunt's grounds were two pieces by Giacometti,

Tall Figure I and *Tall Figure II*, Lipchitz's *The Bather*, Rodin's *Monument to Balzac*, *Adam*, and *The Walking Man*, and Moore's *Reclining Figure* and *Standing Figure: Knife Edge*. Maillol's *River* reclined in a rectangular pool. The changing and growing assembly looked like that of a museum, and it was treated as such by local schools and colleges whose students visited on field trips and art study sessions.

Indeed, Brown was so busy with the foundation collection that Simon authorized him to hire an assistant after he had been on the job for six months. Help arrived in the form of Darryl Isley, a bright, personable, fun-loving young man who had been born in Fullerton and had studied art history at the California State University in San Jose. As he had in years previously, Isley returned home to Fullerton in the summer of 1968 to work in Hunt's canning factory; he planned to enter Columbia University in the fall. While at Hunt he saw a notice on the company bulletin board advertising a position for an art researcher. Isley submitted an application along with one of his college art history papers. Brown hired him and Isley embarked on an adventure he could scarcely have imagined. Instead of spending the summer as a factory laborer and pursuing a doctorate in art history at Columbia, he was thrown into the business of art collecting with an extremely unconventional and demanding taskmaster.

Brown stayed with Simon for less than two years, supervising the foundation's loan program, known as a museum-without-walls. Apparently weary of the unpredictability in the operation and eager to return to a more conventional institution, he resigned in September 1969 to become director of the Virginia Museum of Fine Arts in Richmond. The parting was amicable but not surprising. Simon, who couldn't bear to relinquish control, really didn't want a director. He preferred relatively inexperienced people who were up to the challenge of learning to work his way to professionals who had adopted traditional methods of dealing with the art world and expected to make independent decisions. When Brown left and another art position opened—though not for a director—Isley sent word to Sara Campbell, a close friend and former fellow student at

San Jose. Persuaded that a job at the moment was better than another degree in the future, she joined the staff late in 1969, arriving just as Simon had given up trying to bring culture to Fullerton. With a talent for riding the waves of Simon's demands and changing interests, Campbell worked for him until his death twenty-four years later. She served as his chief curator during the last decade of his life and became the director of art at his museum after he died.

13

RULING THE COUNTY MUSEUM

*If Norton finds this exercise not to his full satisfaction, I am convinced
he will never find any exercise to his full satisfaction.*

FRANKLIN D. MURPHY
16 June 1972

WHEN THE LOS ANGELES County Museum of Art threw open its
doors in the spring of 1965, it was easy to see the essential role Simon
played at the new institution. Other people's names might have been
all over the place—on buildings, galleries, the members' lounge, and
the library—but his artworks were the core of what was wishfully
called the permanent collection. Displayed on the plaza level of the
Ahmanson building, Simon's loans—which numbered more than
one hundred—were among the first works of art that visitors saw
and, as a group, the most valuable. More than half the total value of
the art on view was vested in works from his collection. The space
and prominence given to Simon's holdings implied that he would
give his collection to the museum. It was only a matter of time and
diplomacy, or so it seemed.

The public saw Simon as merely a provider of artworks; insiders
knew that his connection with the museum concerned much more
than the installation of his treasured possessions. The possibility that
he would endow the museum with a fabulous collection had earned
him a place of power, and he used it to influence the institution's
programs and operations. For instance, applicants for curatorial and
administrative positions, mostly funded by the county, had to win
his approval, initially a fairly benign procedure. When James Elliott
visited Los Angeles at the end of 1955 to interview for the position of

chief curator, he was accompanied by Ric Brown to Simon's home and there engaged in a thoughtful discussion about a proposed acquisition to Simon's collection. Nine years later, when Donahue was being considered for the post of deputy director and Maurice Tuchman, a young curator from the Solomon R. Guggenheim Museum in New York, had been approached to become the founding curator of the museum's department of nineteenth- and twentieth-century art, the candidates discovered that they were subjects of, as Tuchman saw it, an inquisition.

> I came to interview in February or March of 1964, after several discussions on the phone with Ric Brown and Jim Elliott. I was at the Guggenheim, and I talked about the idea to Tom Messer, my boss, who taught me the museum business. He said Los Angeles was already the second city for art in the country and this museum was going to be a major operation. He thought I should take it seriously.
>
> So the discussions continued and eventually Ric and Jim invited me to come out to interview. They said I would come out for a weekend and meet a few people, but the main thing was just to talk with Ric and Norton Simon. I checked with a few people to find out who Norton was and what his reputation was. On all fronts I was told, "You have to beware. The guy is a ferocious shark. You are out of your league. You are a kid and the guy is going to eat you up. You have to prepare."
>
> I had never been on an airplane going west of New York; I didn't even know which city was Los Angeles and which was San Francisco. This was very typical of New Yorkers of my generation. So I decided to come out a day early, and I told Jim my plans. I went to the airport directly from the Guggenheim, dressed in jeans, took an afternoon flight, and arrived in the evening. To my chagrin and shock I was met at the airport by Jim and another individual who said they were taking me right to Norton Simon's. I said, "Wait a second, wait a second. I'm in jeans. I'm hungry and tired. I came out a day early." I couldn't speak openly to Jim because this other guy was clearly Norton's boy, but I said, "This wasn't the plan."

Jim sort of patted me on the back and we went directly to Norton Simon's house. When we walked in Jim said, "I'll wait here in the foyer." I said, "What? The chief curator waits in the foyer?" I was already in a rage. I was a chain smoker, so I took out a cigarette and lighter, and I was told there's no smoking in the house.

Then I was led into an oval room, very deliberately suggestive of the White House. I sat alone there for awhile and then in walked this Tweedle Dum Tweedle Dee kind of fellow whose name was Kenneth Donahue. He said he was being considered for an assistant director. I said to myself, "Well, what am I in for?" And I asked Ken, "You mean they are having a joint interview?" He said he didn't know, and I thought, "Let me out of here."

At that point, in walked Taft Schreiber, the vice president of the Music Corporation of America, who was a trustee at the museum and Norton Simon's hatchet man in museum affairs. He was dressed in a gray suit, the uniform of the trade. He said, "Mr. Simon will be out in a few minutes and he wants to talk to both of you. Why don't you tell me a bit about your backgrounds." You had to talk to Taft in order to talk to Norton Simon.

I just wanted to get out of there, but Ken went completely into it, as if he were a subservient job applicant. He was completely straightforward about who he was and what he had done and why he thought he would be a great assistant to the director—completely the lackey he was doomed to become. Then Taft turned to me. I was very young and inexperienced, and I was rather terse and curt. He pressed me about my studies with Meyer Schapiro; which at least allowed me to show some affection. Again I took out a cigarette and Taft said, "You can't smoke here." I said, "Can I get a drink or something? I'm really hungry." He said, "We'll do that later on." He didn't offer a drink or anything, not even water. The message was, this is interrogation time. You are in the hot seat and let's just do business.

Then Norton came in and asked Taft to brief him on what he had learned. Taft gave him a very short version and Norton asked, "Would you like to see part of my

collection?" I said, "Sure." So he led us to the living room and allowed us to walk around for maybe thirty seconds, and look at the Manets, Pissarros, Sisleys, and Courbets and some seventeenth-century art, which I didn't pay attention to. He didn't say a word. Then we walked back into the office. He said to me, "I have certain of these paintings on reserve. Do you think I should buy the Monet still life or the Manet figure painting?"

I said, "Mr. Simon, these are both terrific paintings, but that's like comparing oranges to apples." He said, "There are lots of people who can separate oranges from apples for me. I need you to tell me which one to buy." I wouldn't answer directly. I just talked about the strong points of each one. I wouldn't play his game. It wasn't pleasant; it wasn't fun. But talking about art was better than dying for a cigarette or a drink.

Then he said, "Now Mr. Donahue, did you notice the seventeenth-century painting? What do you think of it?" And Ken started to sweat. He perspired and faltered and stumbled, and finally said, "I think it's a really wonderful painting. It has all the qualities a work by this artist should have for a painting of this period." He was behaving as if the guy owned it and he had to like it.

Norton turned to me said, "Mr. Tuchman, what do you think of that painting?" I said I really hadn't paid much attention to it. He said, "What if I told you the authorities in the field of seventeenth-century Dutch painting regard that painting as a fake? What would you say then? Mr. Donahue here thinks it's an outstanding masterpiece." His whole schtick was to play one person against the other—not to get at the truth, but to get at the truth of the dynamic of the relationship. He wanted to know how we would react and how he could control us. Even though I was young and naive, and I had never seen an operation like this, I still felt what was going on. He was trying to get me to contradict Ken. He would set traps and pitfalls, and I hated every second of it. The questions were overblown and grandiose and insubstantial. They were all designed to see what kind of a person you were. I reacted with anger and frustration. I didn't have a cigarette, and it was midnight, my time.

And then it was over, just like that. Jim was waiting outside in the foyer the whole time, and he took me to the hotel. I didn't say too much to him because I was embarrassed for him, and I was just worn out and strung out and wrung dry. When I walked into my hotel room the phone was ringing. I picked it up and a voice said, "It's Ric. How did it go?" I hadn't even met him, but I said, "Terrible. It was terrible. I really don't understand. I don't get you guys out here. This is not the way you treat someone who comes here to interview. I can't stand it. I hate this guy Taft Schreiber and I can't work with a guy like Simon. Let's call the whole thing off. I'm going home tomorrow."

He said, "Will you calm down? Just calm down. Norton loves you. He just loves you. He has interviewed fourteen people. He hates them all, but he loves you. You're his kind of guy." The next morning Ric put the whole thing in perspective. He was up for challenges, and he had a great sense of humor.[1]

Tuchman took the job and stayed at the museum for thirty years, retiring in 1994 after weathering several changes in administration. Earl A. Powell, a young administrator from the National Gallery of Art in Washington, D.C., succeeded Donahue in 1980, presided over a twelve-year period of prosperity and growth, and then returned to the National Gallery as director. He was succeeded by Michael Shapiro, who had been curator at the St. Louis Art Museum. An inexperienced and inept director, he tried and failed to have Tuchman demoted; he left the museum after less than a year on the job. Although Tuchman and Simon did not work closely together and Simon had no interest in the contemporary art championed by Tuchman, he apparently appreciated Tuchman's spirit. In Donahue, Simon found a useful director who was pliable and eager to do his bidding.

As Donahue soon discovered, Simon was nearly impossible to please. He served as a trustee at the County Museum for fourteen years, but during the last six years of his tenure—after the new building opened on Wilshire Boulevard—he was perpetually engaged in a tug-of-war over his collection and embroiled in arguments about its

treatment. Laboring under the belief that Simon would donate his collection if the museum measured up to his standards, his fellow trustees and Donahue generally tried to accommodate him. When Simon talked, people at the museum listened. At board meetings he and Carter would sit at opposite ends of the table and argue heatedly while Franklin Murphy acted as a conciliator. On one occasion, when Simon threatened to remove his collection if he didn't get his way, Murphy called an intermission to let tempers cool. They never came even near to blows, and their friends suspected that Simon and Carter secretly relished their battles, but they continually antagonized each other.

At evening meetings of the board's art acquisitions committee, chaired by Joseph B. Koepfli, the acrimonious discussions would continue far into the night. As other committee members deliberated about how to build the collection with gifts and purchases, Simon would interrupt impatiently. Demanding a framework for making decisions and a concensus on the big picture, he would ask, "What's our policy? What's our policy? What kind of museum are we?" Accustomed to being in charge while comporting himself as an outsider, as he had in business, Simon couldn't bear to be an agreeable member of a committee. He was torn between his desire to lead the museum and his reluctance to commit himself completely to an institution that he knew he could not control. Koepfli would call Simon after one of his outbursts and implore him to formulate the kind of policy he thought the museum should follow. "He never did," Koepfli said. "One thing you could never get out of Norton Simon was a piece of paper. He wouldn't put anything down on paper."[2]

Simon gave financial support to the museum, but he got much more than he paid for in storage, insurance, shipping, cataloguing, photography, conservation, and curatorial advice. To improve the chances that his collection would end up at the museum, resources that might have been used for art acquisitions were applied to Simon's needs. The hoped-for gift "would be the greatest thing that ever happened to the museum and to Los Angeles," Donahue said in 1969 during a period of rapprochement.[3] But the troubled courtship continued with no resolution of differences.

Soon after the museum opened, Simon's friends reported seeing visitors carrying umbrellas dangerously close to his valuable loans and touching artworks. He reacted immediately by removing some pieces and demanding more guards. The museum hired ten more security officers. A few months later Simon dispatched Barbara Roberts to survey the situation and report back to him. She offered little reassurance. Although the shortage of guards had been alleviated, the museum failed to marshall crowds, control unaccompanied children, prohibit smoking, and provide adequate protection for the artworks, she said. Roberts also reported problems with the care that Simon's art was receiving. Tapestries had been hung without proper support, she said, and a vase had been broken. She had had trouble finding objects in storage or research areas and complained that insurance had been allowed to lapse during the museum's installation and opening.

Murphy became chairman of the board of trustees, his primary goal being to secure the Simon collection for the museum. He and Simon had developed a friendly relationship, so his hopes were not entirely unfounded. But Simon continued to find fault with the museum and insisted that the changes he wanted were for the good of the entire museum, not just for his collection, as some trustees and staff members had intimated. Meanwhile Murphy tried to persuade skeptics that making the museum the permanent home of the Simon collection should be the institution's top priority.

Adding weight to his demands, Simon solicited John Walker, a board member and formerly the director of the National Gallery of Art in Washington, to consult with him on upgrading the new museum. In mid-1970 Simon submitted a lengthy list of "suggestions for museum improvement," among them some drastic measures— nothing less than bringing in a new architect to redesign the entire museum complex and modify existing structures: remove the Kricke sculpture and fountain, replace the reflecting pools with lawns, add greenery to the Simon Sculpture Plaza, remodel the Ahmanson building to create more floor space, and install an escalator in the Hammer building (the former Lytton building, which housed temporary exhibitions and had been renamed for Armand Hammer after Lytton failed to make promised payments and Hammer emerged as a major

patron). In addition, Simon wanted to move the conservation center out of the museum, put the contemporary art in the Hammer building, and ship the costumes and textiles collection off to another, unnamed museum.

He also listed items that needed immediate attention. All graphics and major paintings should be covered with nonreflective glass or Plexiglas; several works in his collection were in need of conservation; bases for the artworks in the Simon Sculpture Plaza should be replaced. Indeed, Simon's "suggestions" called for everything from eliminating entire departments to cleaning the museum storage areas, supervising the guards so they wouldn't talk so much, and making less expensive meals available in the cafeteria. The ground floor of the Ahmanson building was too dull, cold, and lifeless, he thought. There should be a new building for special exhibitions, contemporary art, and costumes—none of which interested him—allowing existing structures to be devoted entirely to the permanent collection. Few of the changes were made immediately, but many were effected over the next twenty years, particularly when the museum prospered and grew in the 1980s under the direction of Powell.

In the meantime, the so-called suggestions exacerbated the tension. In a gesture of conciliation the trustees in late 1970 agreed to underwrite the cost of a two-volume catalogue of Simon's collection and distribute it as a benefit to members before the opening of a major exhibition of the collection planned for 1972. Walker was appointed general editor and charged with recruiting authoritative scholars to write about artworks in the collection. A casualty of an ever-deepening rift, the catalogue was never published.

Simon's presence at the museum loomed larger than ever in 1970, when he moved out of his corporate office in Fullerton, bringing his art staff with him to Los Angeles. He conducted his business affairs from his longtime office on Wilshire Boulevard, while three of his employees—Barbara Roberts, Darryl Isley, and Sara Campbell—were installed at the museum. Assigned as assistants to members of the museum staff, they were in the awkward position of ostensibly working for the museum, but at the behest of Simon. The situation, though short-lived, would have been justified if Simon's collection

had eventually gone to the museum. But early in 1971 Murphy confirmed long-standing fears about Simon's commitment. Simon let it be known that he had decided to sell decorative arts items from the Duveen collection ("except those which the museum feels it desperately needs") and pictures from his private collection at auction.[4] It wasn't an empty threat. He put seventy-four paintings from his collection on the block on 5 May and sold 243 items from the Duveen inventory on 7 and 8 May at Sotheby's in New York. Around the same time, Isley and Campbell returned to Simon's corporate offices and Roberts moved on to become the first director of West Coast operations for Christie's auction house.

In August 1971, after being informed that the museum could not afford to continue packing and shipping works from his collection to exhibitions at other institutions, Simon resigned from the museum's board of trustees, ending a fourteen-year tenure. Dismayed and discouraged as he was, Murphy didn't give up. Two weeks later, Donahue submitted a detailed proposal to Simon about his collection. The proposal provided for the creation of a Norton Simon Collections Committee with Simon as chairman and four members appointed by him. The president of the board of trustees and the museum director would be ex-officio members of the committee without voting privileges. The committee would establish policies for all matters relating to the exhibition, installation, storage, loan, sale, and trade of works in the collection. A curator, paid by the county but mainly responsible to the committee, would be appointed. In addition, a secretary, an assistant to the registrar, two preparator-packers, and a conservator would be assigned to the Simon collection. Programs for conservation, photography, and publications were outlined, and it was suggested that the plaza and upper levels of the building that were currently used for special exhibitions be allotted to the collection. Donahue was, in effect, proposing a Simon museum within the confines of Los Angeles County Museum of Art.

Apparently attempting to placate Simon, the museum had hired Charles Millard late in 1970 as its first curator of nineteenth-century painting and sculpture, the primary area of Simon's collecting. Millard stayed until June 1974, but Simon did not take

Donahue's proposal seriously. Meeting with Murphy in October 1971, Simon said he couldn't make a commitment to the museum until he saw results. As far as he could see, there was little evidence that the museum would be upgraded to his satisfaction. He told Murphy he didn't like the idea of putting his collection in the special exhibitions building, and furthermore he wasn't sure that the exhibition planned for 1972 would happen. He declared that he had been so unhappy with the museum that he had considered getting rid of his entire collection. That impulse had passed, he said, but the pieces he had sold in May were not the last; he informed Murphy that he intended to sell others as it suited him.

The sales were a blow to the curators who had advised Simon on acquisitions and researched his holdings. Ebria Feinblatt, curator of prints and drawings, confided to Isley, "I love Mr. Simon; I always have and I always will," but said she felt betrayed by the sales. In Simon's view, he was only refining his collection, but pieces Feinblatt was fond of and had diligently researched, expecting them to end up in the museum's collection, had been sold off, in pique it seemed. Her comments were a gentle indication of a much wider disenchantment with Simon that had spread throughout the museum. At the same time, Simon himself began to pull back. He hired Robert S. Macfarlane, an ordained Presbyterian minister who was the son of an old family friend, to represent his interests at the museum. The Wilshire Boulevard institution was no longer special; it was just one of many museums that received loans of his artworks. For their part, the county museum's staff and trustees began to face the inevitable loss of his collection.

The long-planned exhibition of objects from Simon's foundation went forward, however, and included paintings, drawings, tapestries, and sculpture spanning five centuries. One of the highlights was a collection of sixty drawings from an album by the French seventeenth-century artist Claude Lorrain. Just before the opening on 16 June 1972, Simon issued a statement saying that he had launched a new program of long-term loans. The show in Los Angeles was one of four exhibitions around the country that would rotate among the participating museums.

The exhibition had been precarious right up to the opening. Assembled at short notice, it required a rearrangement of the entire permanent collection, but that augured well, Murphy said in a letter to Macfarlane, thanking him for his help, "for future exhibitions of whatever kind [which could] be carried out as successfully [at the Los Angeles County Museum] as any place in the country—given comparable firm agreements, deadlines, and quite as importantly, lead times—that are somewhat better than the ones we have had to work under. . . . In any event, I doubt if any museum could have done any better within the time allotted than we have done. If Norton finds this exercise not to his full satisfaction, I am convinced he will never find any exercise to his full satisfaction. I earnestly hope that this is not the case, however."[5] The appearance of cordiality was maintained but, despite the niceties, the struggle continued. Within two weeks Macfarlane had sent a memo to Simon. Entitled "Small Victories," it consisted of one line of text: "Starting today all pictures in the LACMA exhibit will be dusted daily."[6]

14

THE MUSEUM WITHOUT WALLS

It was a sight surely as remarkable in its own right as the newly arrived three-million-dollar Raphael painting on display at the Princeton Art Museum. Formally dressed early arrivals hung over the second-floor railings, shoulder to shoulder—ignoring some twenty million dollars worth of financier Norton Simon's art treasures—at the opening of the year-long exhibition Saturday night. . . the most smashing party Princeton has seen in many a year. It was left to Norton Simon to sound the note of the most genuine emotion in one of the most brief of speeches. "Art to me is only the basis for starting the art of human relations," he said. "I thank you for letting me have this experience tonight."

THE EVENING TIMES
Trenton, New Jersey, *4 December 1972*

THE PRIMARY MISSION of Simon's art foundations—and the rationale for their tax-exempt status—was to make the collections available for educational purposes. Initially he satisfied those requirements by displaying his art in Fullerton and at the Los Angeles County Museum of Art. But, having abandoned his plan for a museum in Fullerton and become increasingly disenchanted with the County Museum, he needed other showcases. He found them by developing a nationwide lending program. Instead of being an occasional, secondary activity, long-term loans and traveling exhibitions became the foundation's most visible undertaking.

Simon wanted his art to go to the best places, to be seen under optimal conditions, and put to good use in high-minded programs.

He knew that colleges, universities, and many museums would seize an opportunity to display his art holdings. Even the nation's best museums would welcome the cream of his collection. A major lending program requires coordination and painstaking effort, and moving the artworks would increase the risk of theft and damage, but the rewards could be considerable. Once again the three Ps—power, publicity, and paranoia—came into play. Simon had acquired the power to play the role of a beneficent but demanding patron. A national lending program would publicize his collections far more extensively than a permanent museum would. As for paranoia, the directors of potential borrowing institutions would, as Simon broadly conceived it, be motivated by fears of being bested by their competitors, so they would do everything possible to please him. Museum directors and curators would know all too well that if they failed to treat the collection properly, it would go elsewhere. The subtext of all the gallery renovations, scholarly symposia, and lavish dinner parties that accompanied the exhibitions was the largely unspoken hope of receiving a donation of art from Simon or initiating a beneficial, long-term association with him.

When planning ways to put his collection on public view all across the country, Simon considered many options, typically plotting what he called "scenarios" to decide which approach would be most beneficial. He did not collect art to achieve social status, but he did demand recognition and respect for his collection. As a pragmatic businessman, he wanted others to know that he had spent his money well. As a self-taught aesthete, he needed professional reassurance that the art he chose was of the highest quality and made sense within the context of his varied collection. His fervent desire was for the art to speak to other people as it did to him. More than anything, he wanted an enthusiastic public response to the art he had so carefully chosen. If financial concerns often motivated his generosity and he sometimes spoke of exploiting the foundations' assets, Simon was also driven by his own need to share his treasures. "He never used the world *stewardship,* but he felt an obligation toward the art. In a sense he felt the art wasn't his," said Robert Macfarlane, who administered Simon's foundations and played a key role in the lending program in the early 1970s.[1]

James Brown started working for Simon in Fullerton after the lending program began, but it took off under his direction. Under the foundation's new name, the Norton Simon, Inc. Museum of Art, groups of artworks began to travel to distant cities in 1968. The Nelson Art Gallery in Kansas City exhibited ten impressionist and post-impressionist paintings. The Minneapolis Institute of Art exhibited a dozen northern European and Italian paintings from the sixteenth and seventeenth centuries, among them Rembrandt's *Titus,* five panels from Bernardino Luini's *Torriani Altarpiece,* acquired with the Duveen inventory, and Francesco Bissolo's *Annunciation,* another Duveen painting.

A larger exhibition, *Recent Acquisitions by the Norton Simon, Inc. Museum of Art,* consisting of twenty-three pieces by eighteen artists, opened at the Portland Art Museum on 12 November 1968. Van Gogh's painting, *Portrait of the Artist's Mother,* was reproduced on the cover of the brochure published for the show. Among the most valuable works were *Dance Rehearsal in the Foyer of the Opera* by Degas, purchased for $400,000, and Matisse's *Seated Woman in Blue,* acquired for $160,000. Simon was welcomed warmly in his hometown, where he had served on the board of trustees for Reed College since 1962. The exhibition opening was preceded by a special dinner party and followed by the groundbreaking for the museum's new wing, which undoubtedly had space for potential gifts from the Simon collection.

In 1969, the year opened with an exhibition of nineteen European paintings from the seventeenth century at the Brooklyn Museum and smaller loans to the Museum of Modern Art in New York, Wellesley College, and the University of Pittsburgh. Later in January the Philadelphia Museum of Art offered *Recent Acquisitions by the Norton Simon, Inc. Museum of Art.* The show contained only fourteen pieces, but several of the paintings exemplified Simon's taste for French impressionism and early modernism: Renoir's *The Pont des Arts,* Cézanne's *Uncle Dominique,* and Picasso's *Nude Combing Her Hair.*

The Phoenix Art Museum had become a regular showplace for a changing array of the Simon foundations' new acquisitions, which were displayed there for three months after purchase to avoid California state taxes. In mid-1969, the museum had forty-two pieces on

loan from Simon including ten sculptures by Maillol, six works by the German expressionist Emil Nolde, and four pieces each by Matisse, Edvard Munch, and Picasso.

By 1972, the peripatetic collections of the Norton Simon Foundation and the Norton Simon, Inc. Museum of Art (which had evolved from the Hunt Foods Charitable Foundation) were known as a museum-without-walls. In directing the "museum," Macfarlane said that the purpose was "to avoid the major pitfalls encountered in building a museum with its enormous costs of construction and bureaucratic structure, and with its usual personnel and board difficulties. Along with Norton Simon, who is the museum's president, our curator Darryl Isley, and his assistant Sara Campbell, I tried to figure out how to use the art assets of these foundations in a manner most beneficial for the largest possible number of people across the country. . . It became obvious that we could be more helpful by filling four galleries of five museums with parts of our collections than by filling twenty galleries of one museum with Norton Simon loans. In making one-year loans, with one-year renewal options, to a number of museums, we have come into what psychologists call a 'win-win' situation, where both the foundations and the museums find their needs fulfilled." Macfarlane also expressed the hope of building long-term relationships with a few museums, "but always on a clearly understood loan basis," and he suggested that a group of museums might work together, rotating loans and giving each institution's audience a chance to see the entire collection.[2]

When a year-long loan of thirty-five pieces of modern sculpture opened at the Pasadena Art Museum in August 1972, Simon commented: "It is my belief that with the best of intent we have in this country given more attention to building museums than acquiring art. I feel the foundations are indeed fortunate in not having gone ahead some years ago with a building. If our present plan is unsuccessful, I presume a museum can still be built. However we are hoping to serve the cultural life of this country more effectively by the several exhibitions now planned."

The breadth of Simon's collections made them adaptable to a variety of exhibitions and educational programs. In early 1972, as part of a festival examining the cultural milieu of the Dutch artist Marten

van Heemskerck, the Henry Gallery at the University of Washington borrowed four of Simon's paintings: *Allegory of Nature* by Van Heemskerck, *The Marriage of Mars and Venus* by Cornelis Cornelisz. van Haarlem, *An Extensive View of the Molo, Venice, Looking Towards the Riva degli Schiavoni* by Luca Carlevarijs, and *Venice, The Piazzetta: View from the Riva degli Schiavoni* by Jean-Baptiste-Camille Corot.

In a much larger presentation, the Museum of Fine Arts in Houston devoted three newly decorated galleries to *Masterpieces of Five Centuries: Forty-eight Paintings and Sculpture from the Norton Simon Foundation,* a year-long exhibition that opened 3 October 1972 and included *Titus* along with paintings by Fra Angelico, Botticelli, Tiepolo, Zurbarán, and Braque. The museum's director, Philippe de Montebello, reported to Simon that art history professors from the University of Houston and Rice University held classes at the museum to make use of the collection and assigned their students to write papers on specific works. That was exactly the sort of validation that Simon was seeking.

Serious as many of these presentations were, none could measure up to Simon's experience with Princeton University's Art Museum. His exhibition there took two years to organize, but it proved enormously beneficial to both the university and the collector. The relationship began in 1970, when Simon visited the university for a meeting of the Institute for Advanced Study, which he served as a trustee, and requested a tour of the campus. Acompanied by university development officer, Simon made a stop at the museum, which had been built four years earlier. There he remarked that he might be willing to lend some works from his collection. The remark was recorded in a memo that, because the museum's administration was in a period of transition, became buried in a pile of unread mail.

It was unearthed by David W. Steadman, a Harvard-educated art historian who had been a lecturer at the Frick Collection in New York, was working on his Ph.D. at Princeton, and had been appointed assistant director of the museum in 1970. "Sometime in August, when I was about three-quarters of the way through the pile [of mail and interoffice correspondence that had been accumulating

for four months], I came across the memo," Steadman said. "I remember staring at it and thinking, 'My God, what this could do.' Then I high-tailed it over to the president's office to talk about this incredible possibility."[3]

Steadman soon contacted Simon and went to Los Angeles to meet him in the fall. Having assured Simon that students would have access to the collection and the faculty would be involved in the project, Steadman began working on the exhibition with Isley and Campbell. Macfarlane, who happened to be a Princeton alumnus, oversaw opening events and public relations. The university's exhibition, *Selections from the Norton Simon, Inc. Museum of Art,* consisted of more than 100 objects—about a third of the foundation's entire holding and by far the largest assembly of Simon's art outside the Los Angeles County Museum of Art. European paintings, sculptures, and watercolors from the late fifteenth to the early twentieth centuries were chosen for the show. And for the first time since the lending program's inception, a complete catalogue was published. Faculty members and scholars affiliated with other institutions contributed essays on the periods and schools of art represented in the show. All the objects were reproduced in photographs.

It was a coup for Princeton, which had only recently built its museum and had been slow to develop its program. Making the most of the opportunity, members of the faculty remodeled their courses around the exhibition. Simon's partnership with Princeton allowed him to play his favorite role, that of an enlightened and generous patron. In the foreword to the catalogue, Wen C. Fong, the chairman of Princeton's department of art and archeology, called Simon's collection "the greatest single group of works of European art still without a permanent home today" and placed him in the company of the "great tycoon collectors—Morgan, Freer, Kress, Mellon" whose collections stocked America's finest museums.[4]

The catalogue also afforded Simon a dignified opportunity to express his philosophy.

> One of the most profound means of human communication is the visual arts. By establishing a meaningful dialogue

between an artist's vision of the world and our own perceptions, art can help us to understand ourselves more fully. Moreover, art at its finest gives us a deep sense of history, tradition, and the true potentialities of man's creativity. In today's world where oftentimes scientific development is regarded as the highest goal and where the individual frequently feels alienated from himself and those around him, the role of art becomes increasingly important in keeping open the lines of communication."[5]

The exhibition received extensive coverage not only in newspapers, but also in art magazines.[6] Simon had arrived in the Ivy League. But even then, he couldn't resist a last-minute announcement that threw the Princeton staff into a tizzy and turned an academic celebration into a popular sensation. A few weeks before the opening, and long after the catalogue text had been sent to the printer and the installation planned, Steadman got a call from Simon. "How would you like it if we added a Raphael?" Steadman was planning to give the museum's place of honor to Bassano's masterpiece, *The Flight into Egypt.* The Raphael was the painting, *Madonna and Child with Book,* an icon of Italian High Renaissance art purchased for $3 million. The Princeton show would be the perfect place to unveil it. Steadman went to New York to see the painting ten days before the opening and reported to Isley that he was "ecstatic about the picture" and considered the purchase "a real coup." Anticipating the excitement that was sure to accompany news of the acquisition, Steadman told Isley, "I'm absolutely in orbit."[7]

On 2 December, both the *New York Times* and the *Los Angeles Times* ran front-page stories announcing Simon's acquisition of the Raphael. According to Frederick Hartt, a Raphael scholar, the painting was "one of the most significant art works to come to an American collection in many years."

After seeing the exhibition and the Raphael, Thomas Hoving, the director of the Metropolitan Museum of Art, wrote an exuberant note to Simon: "Congratulations on a splendid show *and* (damn it) a magnificent acquisition! It's a triumph. I *wish we* had it. Am green with envy."[8]

Simon became fanatical in his quest for art that would satisfy his taste for quality while capturing public attention. "What," he would ask Eugene Thaw, "is the best picture on the market right now? What's the best picture you could buy anywhere in the world?"[9] Trying to accommodate his demanding client, Thaw would think of things he had seen in other galleries or knew other dealers had, but it was difficult to come up with an answer. In desperation, Thaw decided to ask Mario Modestini, an art conservator in New York, who routinely worked on the finest paintings and had an insider's view of the art market. It was Modestini who told him about the Raphael, which was owned by Wildenstein & Company but stored in an underground vault in upstate New York. The Wildensteins had purchased the painting at auction when it was thought to have been the work of a lesser artist. Raphael's preparatory drawing for the painting, found later, proved that the painting was actually the work of the Italian Renaissance master.

Simon immediately telephoned Daniel Wildenstein and made an appointment to see the Raphael on his next trip to New York. The Wildensteins were in no rush to sell it, but Simon persisted until it was his. Then, for one of the museum's press releases issued shortly before the Raphael was to be exhibited at the Los Angeles County Museum of Art, Simon described his gratification: "To have found and acquired a High Renaissance painting by the young master Raphael is the highlight of my collecting activity, both personally and as president of the Norton Simon, Inc. Museum of Art and the Norton Simon Foundation. Beyond this, to have the condition of this picture from the hand of such a gifted talent almost five centuries back so beautifully preserved is remarkable. The simple, straightforward beauty expressed here, from a time when the spiritual feeling in art was at its height, only makes one appreciate great art more than ever."

15

AN EMPIRE FOR POSTERITY

I take a profound interest in what is around the corner,
and it really doesn't matter which corner you're talking about.
It could be business, or art, or education.

NORTON SIMON
Business Week, *14 May 1966*

SIMON BECAME ONE OF THE world's most prominent art collectors during the 1960s, but that aspect of his life was only a sideline. What pushed him out of bed at the crack of dawn every morning and financed his collecting was his business empire, which became increasingly diversified and complicated. Early in 1960 he began to consider a merger of Hunt Foods & Industries, Inc. with the Wesson Oil and Snowdrift Company, Inc. of New Orleans, a producer of cottonseed oil and its byproducts. The merger created a food company with more than $300 million in sales annually. In the preceding fiscal year Hunt and its subsidiaries had nearly $137.5 million in sales, a net income of more than $6 million, and assets valued at $174 million. Wesson had $160.5 million in sales, a net income of about $43.3 million, and $1.2 million in assets.

It was Hunt's biggest merger, but only one in a series of aggressive acquisitions. By 1965 Hunt Foods & Industries, Inc. had either merged with or obtained large holdings in twenty-seven companies, giving the conglomerate a 72-million investment portfolio equal to some mutual funds of that period. With its most substantial equity in McCall Corporation, Canada Dry, Knox Glass, Wheeling Steel, and Evans Products, Hunt also had three operating divisions: Hunt-

Wesson Foods, Fuller Paints, and an industrial section that produced can-making machinery and metal and glass containers. There appeared to be no pattern to Simon's acquisitions, but most of the companies were prestigious firms whose assets had been undervalued in the market prices of their stock. "The idea," Simon said, "is to expose the negatives in these situations, so that the positives can shine through."[1]

Antagonistic to the establishment and unwilling to play what he derisively called "the corporate game," Simon was characterized in the press as a brilliant but cantankerous maverick. Reporters who attempted to explain him and his actions to their readers quoted Simon calling himself an existentialist or an "abstract businessman."[2] An unnamed friend defined him as "a kindly, ruthless man, broadly influenced by the belief that he's doing a public service, and utterly determined to do it."[3] Franklin Murphy, who had become closely involved with Simon while trying to persuade him to give his art collection to the Los Angeles County Museum of Art, likened him to an artist: "Most businessmen tend to be rather traditional and representational in their approach, but I think of Norton as a Cézanne or a Picasso—unconventional, constantly probing and testing, constantly dissatisfied."[4]

In a cover story in which Simon was described as "one of the nation's leading collectors of companies—and art," a reporter for the magazine *Business Week* said: "More than almost any other man, he represents in a single image both the old and new of American corporate life—both the secretive individual builder of investment empires who flourished decades ago in the country, and the modern renaissance businessman who sees capitalism not only as a way of survival, but as a path toward the betterment of human beings." Simon was quoted as saying, "You exist in a state of growth or you die. Frankly the things that I do are done out of a sense of learning and growth. You must be interested in things or go stale. I take a profound interest in what is around the corner, and it really doesn't matter which corner you're talking about. It could be business, or art, or education. . . . And every company that I go into is an education in itself . . . and a growth experience," he said. "I'm not talking about growth in the sense of

dollar terms, but in the education and breadth of the individual."[5]

Enlightened as he may have sounded, Simon was not always successful, and the growth he spoke of so glowingly could be extremely painful. In acquiring Wheeling Steel Corporation, he found himself pitted against the hidebound establishment of a relatively unfamiliar industry in the foreign territory of West Virginia. Wheeling, which had evolved from a coalition of family companies, had always been poorly managed, but it made money as long as there was a demand for its products. By the late 1950s, when modern technology and foreign competition had forced America's steel industry to revitalize itself, Wheeling was in trouble. (The company was so antiquated that it still employed lamplighters to trim the wicks of the kerosene lamps on railroad switches and then to snuff them out, many years after other steel companies had eliminated that job and updated the lamps.) In 1960, its facilities were outmoded, overstaffed, and inefficient.

Simon was not a complete novice in the steel industry. He had founded Los Angeles Steel Products Company in 1927, soon after he moved to southern California, and he had visited Wheeling Steel on his honeymoon with Lucille, while inspecting can-making operations. He began buying into the company in 1962, as its stock, with a book value of $81.51, sank to about $25 a share. His broker discovered that Wheeling had designed a modernization plan and was negotiating a $120-million first-mortgage loan and an additional $20 million in bank loans.

Modernization was desperately needed, but Simon objected to a plan that had been designed without the benefit of outside advice and loans that were being negotiated without notifying stockholders. He tried to stop the loans, threatening to take his case to the stockholders. But in 1963—when Hunt's holdings increased to 11.8 percent of Wheeling's common stock, the largest block owned by a single entity—Simon agreed to drop his objections in exchange for a place on the board and a promise that the modernization plan would be critically reviewed.

Earning a reputation as a brash outsider with no respect for experienced steelmen at his first meeting,[6] Simon objected to the timing of the loan and contended that Wheeling, which had fallen from sixth

to eleventh place in the industry, would not benefit from new facilities unless it gained a larger share of the market. He also warned against impending labor problems and advocated more progressive policies because the company could ill afford a strike. At his second meeting he made himself even more unpopular by challenging Wheeling's power structure. Each of the fourteen other board members was an officer or former officer of the company, a local businessman, or a vendor who sold products to Wheeling. Simon asked pointed questions about conflicts of interest. Speaking as the only independent person on the board, the sole director who was not beholden to management or predisposed to do its bidding, he proposed reconstituting both the board and the four-man executive committee, which made all the key decisions on policies and operations. Older members and vendors should be dropped, he said, and the company should hire an executive vice president with marketing experience to succeed William A. Steele, a former blast-furnace superintendent who had moved up through the ranks of the company's operations to the position of president and chairman. Steele had no intention of retiring, despite his lack of experience in finance and administration.

Hammering away at the company's problems, Simon characterized himself as a corporate Robin Hood, justifying his actions as a service to the shareholders. He also recited his familiar them-against-us refrain, likening his opponents to evil national leaders. "Fundamentally the corporate system is much like Nazi Germany or the Communist countries," he said. "There's only one slate and the vote is always 99 percent in favor of it."[7]

Simon succeeded in disbanding the executive committee and spearheading a search for an executive vice president. He demanded and obtained another seat on the board for Hunt, choosing his longtime friend, Jack R. Clumeck, an investor in San Francisco, but Simon's opposition to Steele's re-election as both president and chairman failed. The power struggle continued until the end of 1964, when, in the face of Simon's increasing power and the obvious merit of many of his complaints, Steele was persuaded to resign. A report by the management consulting firm of McKinsey & Company, commissioned by Wheeling in response to

Simon's criticism, had revealed that Wheeling was poorly managed. The consultants recommended changes in the composition of the board, a mandatory retirement age of sixty-five, and a reduction in the number of vendor directors. Francis Rich, Wheeling's vice president of marketing, became president and worked closely with Simon, who assumed the position of chairman in November 1964.

Attaining a position of power, he found little comfort. The company was in even worse shape than he had imagined when he won a place on the board. Wheeling's profits had dropped by almost half in 1964, despite a modest growth in sales. It looked as if the company would lose as much as $8 million during the following year, and dividends would have to be suspended indefinitely. Reciting a litany of problems to his fellow directors, Simon did not let Steele go gracefully. He told the retiring executive that he was "not even a good vice president" and that Steele's $140,000-a-year salary was "preposterous."[8]

Simon soon found out that he had taken on more than an ailing steel company: He was perceived as an enemy of the entire industry. His criticisms alienated Wheeling's management, most of his fellow board members, and the banks that lent money to the company. So bad was Simon's reputation that he had difficulty in recruiting the kind of experienced help he needed inside the industry. He had accepted Rich as an interim president but soon began looking for a stronger leader. In June 1965, after a lengthy search, he chose a man with no steel experience, Robert M. Morris, who was vice president of Monsanto Company and general manager of its organic-chemicals division in St. Louis.

Anyone selected by Simon probably would have offended steel industry moguls and workers. Morris's lack of experience and dictatorial style compounded the problem and doomed him from the start. He made a conscientious effort to reduce Wheeling's operating costs and labor force, but met opposition at every turn. At the same time, expensive mistakes and bugs in new equipment installed during the modernization sent costs soaring. With Morris pushing to raise production levels, the company inadvertently shipped damaged steel to longstanding customers, resulting in costly returns and a loss of confidence and business.

In November 1966, the Metropolitan Life Insurance Company, which had helped to finance the modernization, offered to buy out Simon's interest in Wheeling. Then Pittsburgh Steel made a better offer. In 1967 Simon sold all but a hundred thousand shares of Hunt's stock in Wheeling to Pittsburgh—losing about seven hundred thousand dollars on the sale—and resigned as chairman.

A red flag bearing the single word "Hustle" flew over the company's headquarters in Wheeling during the last year of Simon's tenure. Dreamed up by Morris to contrast the firm's energetic approach with lethargic elements of the steel industry, the flag won an advertising award, but it came to symbolize the bitter antagonism between the interloper from California and the industry establishment. "Simon's first mistake was buying 8,000 Wheeling shares in the summer of 1962," *Fortune* magazine reported in a postmortem.[9] Simon blamed his problems on inherited mistakes—including the modernization plan, which was intended to increase Wheeling's production by 33 percent—but he was fighting considerable odds and probably contributed to his own demise by his rude and relentless opposition. An industry insider reportedly told Morris, "We don't like you or Simon because we don't want any outsiders in this industry. You won't get any help from us in any way. Even a magician can't cure Wheeling's problems in five years and you won't get five years to try."[10]

Simon took the Wheeling setback in his stride, but his years as a public figure in the business world were winding down. In July 1968 he consolidated Hunt Foods & Industries, Inc. and the companies it controlled into Norton Simon, Inc., forming a $1 billion sales empire. At the same time, relinquishing his administrative position and staying on only as a director, he set up a three-man group to run the new company. His longtime colleague Harold Williams was chairman of the finance committee, the position from which Simon at Hunt had run his empire. David J. Mahoney, who joined Hunt early in 1967 as president of the ailing Canada Dry Corporation and turned it around by decentralizing operations and selling off the bottling division, became president of Norton Simon, Inc. The chairman and chief executive was William McKenna, a finance specialist brought in from Litton Industries in 1967. All three men aspired to the top job, so they worked in a tense environment.

McKenna abruptly left in July 1969 and became chairman of Technicolor. Williams took over as chairman, but Mahoney became the chief executive and emerged as the company spokesman. Williams left early in 1970.

After establishing Norton Simon, Inc. in 1968, Simon moved his personal headquarters from Fullerton to Los Angeles. "It makes it clear that I have left," he said. In December 1969, he resigned as a director, severing his last managerial tie with the conglomerate he had built but remaining a major stockholder. "Business isn't as intriguing to me as it once was," he said. "This is my final move away. I don't want it [business] any more."[11] He would devote his time to art and education.

Mahoney, the man who had inherited Norton Simon's empire, was the ambitious son of poor, first-generation Irish Americans who lived in the Bronx. He began on Madison Avenue, establishing his own advertising agency. Then he became president of Good Humor Products Company, an ice cream company, and later, executive vice president of Colgate-Palmolive Company. Before his stint at Canada Dry Corporation he was mainly known as a supersalesman. The least-seasoned executive of the triumvirate established by Simon, Mahoney apparently got the nod at Norton Simon, Inc. because of his success with Canada Dry. Some of Mahoney's associates thought he might turn out to be a mere pawn for Simon, but in 1970 Mahoney moved Norton Simon Inc. to New York. "I wanted to get away from Norton," he said.[12] The company continued until 1983, when it was taken over by Esmark Inc. The following year, Beatrice Companies acquired Esmark Inc. in a $2.7-billion deal.

Simon was sixty-two when he completely let go of the business that had consumed most of his waking hours for thirty years. "So long as I had a string on the company, it had one on me," he said.[13] He claimed that he never looked back and that he was glad to be free of his longstanding obligation.

16

EVER THE OUTSIDER

You have to understand my strange style of working . . . I'm not operating from the position of being "one of the boys."

NORTON SIMON
Los Angeles Times, 23 June 1974

ANNOUNCING HE WAS RETIRING from business to pursue his interests in art and education, Simon might have made himself sound like a typical wealthy dilettante in search of pleasant hobbies that would bring intellectual, spiritual, and social rewards. But he was already so deeply embroiled in both fields that they were akin to secondary careers. By the late 1960s he was one of the world's leading art collectors, an occupation that required an enormous investment of both time and money. At the same time, he was a trustee of Reed College in his hometown of Portland, Oregon, and of the Institute for Advanced Study in Princeton, New Jersey, and a member of the Carnegie Commission on the Future of Higher Education. But his most demanding commitment to education was his sixteen-year term on the Board of Regents of the University of California.

The twenty-four-member board, consisting of sixteen rich and powerful gubernatorial appointees and eight ex-officio regents, is charged with governing the state's university system. The irony in the invitation was not lost on Simon, a college dropout, who had fled—after only six weeks—the University of California at Berkeley, the largest and most distinguished institution in the state's vast university complex. Simon's short and troubled history at Berkeley had

been a sticking point when the governor, Edmund (Pat) Brown indicated his intention in 1960 of naming his old friend as the successor to Thomas M. Storke, the publisher of the *Santa Barbara News-Press*. Some regents and university officials privately expressed doubts about Simon's suitability for the position, but Brown was determined. "Norton was a very close friend of Pat Brown. They grew up together," said Charles E. Young, who became an assistant to Franklin D. Murphy, the chancellor of the University of California in Los Angeles in 1960. "In many respects, Pat was the best governor the university ever had, but he wasn't so certain about the university when he came into office. He probably wanted someone he was close to, someone he could trust, to assume that role."[1]

In a formal introduction, Brown welcomed Simon to a group in which the most powerful players were Edwin W. Pauley, an oilman from Los Angeles and a supporter of the Democratic Party, and Edward Carter, the man who raised the funds for the Los Angeles County Museum of Art. Simon, the self-described outsider—who always attributed his abbreviated college career to a failure of the university's academic program and teaching methods, rather than to any lack of discipline on his part—had become an insider. His gaining a place at the table of the university's supreme governing body was an enormous personal victory, but it did not change his attitudes. Neither did it turn him into a conformist. Simon still had something to prove, so he cast himself in the familiar role of the maverick and gadfly, constantly questioning and upsetting the majority opinion. Entirely aware that there had been quiet resistance to his appointment, he plunged into the regents' deliberations, effectively giving notice that he would be an outspoken member of their group.

His agenda was exactly what it had been in business: to effect more efficient, productive, and economical operations. In education as in business he wanted to get the most for the least money, but as one of sixteen politically appointed regents, his motivations were sometimes clouded by politics. As his term progressed, Simon was also seen as a loose cannon or a grandstander because of his inclination to follow his own muse and promote himself as an independent thinker and man of action.

Before joining the board of regents he had done some homework on a situation that he would follow through much of his tenure, a plan for a new university campus at Irvine in Orange County that would open its doors to students in 1965. The University of California at Irvine had been conceived in the 1950s as part of a master plan providing for three new campuses. A site on Irvine Ranch, formerly used as grazing land, had been selected and deeded to the regents. The surrounding property was slated for development by the Irvine Company as a planned community. Suspecting that some of the regents had an interest in the Irvine Company and might reap financial rewards from development of the property adjacent to the planned campus, Simon fired his opening salvo at his first meeting. He made no accusations but, by advocating a thorough investigation of the company's plans for leasing and developing the land surrounding the university site, implied the possibility of a conflict of interest.

In subsequent meetings he lived up to his reputation as a financial genius and a relentless critic of what he called the status quo by persistently scrutinizing the university's financial operations. Often sparring with his more fiscally conservative colleagues, he set himself up as the perpetual adversary of Pauley and Carter. "He loved twitting them," said William Coblentz, an attorney from San Francisco, who joined the board in 1964 and observed the long-running battle with amusement. It wasn't just that Carter and Pauley were too conservative in managing the university's money. "They were too 'old school' for Norton," Young said. Although both Carter and Pauley had come up from modest circumstances and worked their way through the University of California as students, they embodied the establishment that he so thoroughly detested. "Their differences were more a matter of style than [of] substance," Young said. "I think Norton liked to be in conflict, so he overemphasized some of their disagreements beyond what they really were. I think Norton liked Ed Carter as a foil and probably, in his way, Ed liked Norton as a foil."[2] With his patrician air and orderly manner of conducting business, Carter could feel superior to Simon, who rarely stood on ceremony. Simon could revel in the role of a populist who represented the best interests of students and taxpayers. Pauley, a fellow supporter of Pat

Brown, chaired the regents' committee on investments, Simon's primary area of expertise and interest.

Simon's sensitivity about being Jewish added to the tension. Although neither a religious Jew nor a frequent supporter of Jewish causes, Simon believed that Pauley had an anti-Semitic streak and he resented the fact that Carter, who had a Jewish grandmother, was often thought to be a quintessential WASP. "Ed Carter is one-sixth Jewish and he won't admit it," Simon complained to Coblentz. "Oh come on, Norton, you're 100 percent Jewish and you won't admit it," Coblentz responded, reminding Simon that his Jewishness was more a matter of his own perception than of his public image. As far as Coblentz could see, what Simon really objected to in Carter was his powerful position in the Los Angeles establishment.

Coblentz and several other regents—among them, William Roth, who was based in San Francisco as a representative for trade negotitions in the State Department, Frederick G. Dutton, an attorney in Los Angeles who had served as assistant Secretary of State and Brown's state campaign chairman, William E. Forbes, the president of Southern California Music Company, and Elinor Heller, a Democratic Party national committeewoman from Atherton—gravitated toward Simon and often took his side in disagreements. Admiring his spirit and honesty, Coblentz found Simon to be an irascible but enormously likable character who was "direct, full of energy, and had no pretenses." But as the friendship grew, Coblentz discovered annoying traits as well. "He always felt he was right. Even if you presented him with facts that proved your point, he would argue very forcefully that you didn't understand the situation." In the face of obvious defeat, Simon was inclined to take the moral high ground with a withering expression and an accusatory tone. When Coblentz investigated Simon's claim that Carter was profiting from being a regent because one of his stores was located on property owned by the Irvine Company and near the university, and found nothing amiss, Simon bluntly told his friend: "You sold out."[3]

The University of California system was teeming with student unrest during the 1960s and early 1970s as the Free Speech Movement, protests against the Vietnam War, and racial tensions exploded in one drama after another. As a Jew, a college dropout, and a busi-

nessman who prided himself on promoting capable women, Simon professed a "community of spirit" with the angry activists.[4] Still, he was relatively calm as long as Brown was governor. Although Brown didn't agree with all of Simon's complaints, he managed to stay out of most of his friend's arguments. The atmosphere changed in 1966, when Ronald Reagan defeated Brown. Instead of supporting the governor, as he had when Brown was in office, Simon developed a deep distrust of the conservative new leader and made it his mission to prevent Reagan from using the university to promote his political agenda. "Norton was one of a group, including Bill Coblentz, Bill Roth, Fred Dutton, and Ellie Heller, who tried to keep Reagan on track," Young said.[5]

It wasn't easy. During his campaign Reagan had promised to fix the university's troubles and get tough with dissident students. Clark Kerr, the president of the entire University of California system, was his primary target. A mild-mannered economist and industrial relations consultant, Kerr was a master conciliator who had spent several successful years at the university, which had expanded to nine campuses and eighty-seven thousand students by the time Reagan took office. But Kerr had come under heavy fire in 1964 during student demonstrations in Berkeley. His attempts to smooth things out backfired and he was accused of being too soft on the agitators. Conservative regents who had had not favored Kerr's appointment in 1958 were particularly incensed when he opposed Governor Brown's decision to call in police to arrest demonstrators at the height of the Free Speech Movement. Reagan believed that Kerr had to go but didn't plan to take action immediately. The regents who had opposed Kerr for several years saw no point in delay. At the first regents' meeting that Reagan attended, in January 1967, Kerr was asked to leave the room so that a personnel matter could be discussed in an executive session. The ensuing debate led to a vote on his dismissal. Fourteen regents were in favor of firing Kerr; eight were opposed. Simon, along with Jesse M. Unruh, the Speaker of the State Assembly and a Democrat, Samuel Mosher, an oil man, Elnar O. Mohn, the director of the Western Conference of Teamsters, and Heller, Dutton, Roth, and Coblentz, voted against the dismissal.

In the national press, the affair was largely seen as a matter of par-

tisan politics. "It is a bad precedent to fire a university president concomitant with a change of political party in the state administration," Unruh said.[6] The former governor, Pat Brown, viewed Kerr's ouster with "utter contempt." It was nothing short of "a tragedy" to fire the man who had "built the University of California into the greatest university of our land," he said. "The reactionaries of the State of California are really taking over. It's just too bad."[7]

A few months later, the liberal regents suffered another setback. The state legislature reduced the university's $264-million request for state support in 1967–68 to $257.1 million and then Reagan cut it down to $251.5 million. At their meeting in July 1967, soon after the cuts had been announced, Simon discovered that his colleagues seemed unwilling to face painful facts or to do anything to improve the situation. Indeed, he thought that they seemed oblivious to the problem as they dutifully followed a prearranged agenda, listening to reports on a long-range fiscal program that outlined costs of new campuses. Incensed and incredulous, Simon said that in light of the budgetary cuts, the university would be forced to reduce—not expand—its size to maintain quality. Furthermore, it would be irresponsible of the regents to commit any more funds toward future physical expansion, he said. No more property should be acquired for that purpose until the current crisis were laid to rest.[8]

Adopting a folksy, fatherly tone, Reagan attempted to assure Simon and his colleagues that he was committed to the university and to maintaining its quality. "I may be foolish in a lot of things, but I'm not darned foolish enough to start out as governor of California and try to destroy the university, which is one of the greatest assets the state has," he said.[9]

Unimpressed, Simon said he planned to recommend using the regents' discretionary funds to restore the budget. An hour or so later, he did exactly that. His plan called for allocating $3.5 million from the regents' funds to make up the difference between the 5 percent faculty pay raise that Reagan had approved and the 7.5 percent raise approved by legislature, to increase the number of waivers of out-of-state tuition, and to replace more than $300,000 in library support deleted by the governor. Most of his colleagues wanted to

defer action on his recommendation, but Simon pressed for a vote, saying that an allocation from the regents would be an important expression of faith in the university. The motion was defeated by fifteen votes to three. Forbes and Roth voted with Simon, but the fifteen other regents in attendance opposed him.

To Simon's intense annoyance, the regents carried on after the vote as if nothing had happened, approving various financial commitments and capital improvements. He refused to go along with the pack and became increasingly agitated about what he interpreted as a lack of concern. "We are going ahead with business as usual, but this is not business as usual," he fumed. "We have no assurance of adequate state support for the future."[10] The meeting continued, with Simon persistently voting against capital outlays and calling for a reassessment of priorities.

A few months later, when the regents were considering the imposition of higher student fees to balance the budget, Simon arrived at the meeting with a nine-page statement on the regents' investments that he offered as a solution to the problem. Pauley was furious because Simon had acted independently and circumvented his authority. He reminded Simon, a member of Pauley's investments committee, that his recommendations should have been submitted to the committee for consideration before being brought to the entire board. Pauley attempted to prevent Simon from distributing the prepared statement, but to no avail. Simon passed copies of the document to the regents, and submitted an additional copy to be filed with the minutes of the meeting.

"I should like to present to the Regents some comments concerning the Board's investment policies and some possible steps for strengthening those policies and obtaining a greater gain for the University," the statement began. Then Simon reviewed what had become his struggle to wrest control of the investments from a small group and seek higher returns on the money. He contended that the university's investments of more than $450 million were handled in an outdated, conservative manner. Its failure to take sensible investment risks cost the university millions of dollars a year, he claimed. Part of the problem, as he saw it, was that a few stodgy

committee members made investment decisions without the benefit of professional advice or the knowledge of other regents and administrators. Simon called for a committee of inquiry and asked to be its chairman.

The controversy had been brewing for years, but now that Simon, seizing on the long-simmering dissatisfaction with the way the university's investments were handled, had made his complaints public, Pauley fought back. Simon, he said, was not only being "unsportsmanlike" in ignoring protocol, he was being "totally inconsistent" in his request to head a committee because he had long voiced opposition to the committee system. Simon was "a square peg in a round hole" because "he never comes to a committee meeting, or seldom does."[11]

More than a year later, Simon gained a partial victory when the regents announced liberalized investment policies. An independent report, commissioned by the regents at Simon's urging, recommended changes that were adopted. One major shift was that up to 10 percent of the university's $528.8-million endowment and pension funds could be invested in speculative securities emphasizing market growth. Formerly, only about one-sixth of one percent of the funds were invested in such securities. Among other changes, the treasurer, Owsley B. Hammond, was authorized to buy or sell up to five hundred thousand dollars worth of common stock without permission from investments committee members, and a faculty committee was set up to offer advice on scientific advancements that might affect investments.[12]

Meanwhile, another personnel matter blew up in the regents' meetings and became news across the nation. The conflict concerned Angela Davis, a brilliant young black philosophy scholar and activist, hired by the philosophy department of the University of California at Los Angeles in spring 1969. She had worked as a researcher during the summer and was scheduled to begin teaching in the winter quarter. But before she entered the classroom Davis was exposed as a member of the Communist Party. Under pressure from the regents, Charles Young, now the chancellor, asked her to confirm or deny the allegation. Soon after Ms. Davis confirmed her

membership of the party, the regents fired her, citing a prohibition, which had been established in 1950 and not rescinded, against the hiring of members of the Communist Party as university faculty. Simon and Dutton were the only two members of the board to oppose the firing.

Davis was subsequently allowed to lecture, though not for academic credit, while her case was pending in court, and she became a cause célèbre. Young came under attack from the regents for supporting Davis, but he refused to back down. He decided to reappoint her for the next academic year after a judge of the Los Angeles Superior Court set aside her dismissal and she was allowed to teach. "This is not an isolated case," Young said. "At some point there has got to be a time when somebody in this university stands up and says 'I've had it, I've had enough . . . I don't mean I'm going to quit, but there are times when decisions have to be made that are right for the university and I believe very strongly this is one of those times. This is a real case of academic freedom because Angela Davis is an undesirable character to much of the public . . . the place where you find out whether the system works is in the tough cases, not the easy ones everybody agrees with."[13] One month later, the regents overruled Young and by fifteen votes to six, decided not to rehire Davis. By then she had further alienated her adversaries by making inflammatory speeches off campus in defense of two black prisoners, George Jackson and W. L. Nolen, known as the Soledad Brothers, who were incarcerated in Soledad, California.

A year later, Simon was still angry. He characterized his opponents on the board of regents as "representative of the hypocrisy and duplicity of the establishment—the real reason the kids are so upset today. The entire American education system is endangered. Men like these, with the bad examples they set, are far more responsible for what's happening on campus—and what could ultimately happen in society—than all the SDSers [Students for a Democratic Society] and Black Panthers combined."[14]

While the Angela Davis affair festered, Simon continued his long campaign to cure the university's financial problems. In April 1970, he submitted an economy plan that, he claimed, could save the uni-

versity $70 million a year. He advocated year-round use of educational facilities, higher returns on university pension and endowment funds through high-interest-rate bonds, and a modification of the academic program to allow average students to complete their undergraduate degrees in three-and-a-half years.

"I believe California should lead the nation in putting the financing of education at all levels on a sound basis and substantially updating the actual instruction of our young people. We simultaneously need to achieve major savings and make some basic improvements. Education is costing too much money and has too great a potential for good or ill in our society to put up with the inefficiencies and lack of imagination which now pervade so much of the field," he stated.[15] A special committee was appointed to consider his proposals, but no action was taken.

Despite—or perhaps because—he had so little visible effect on the board, Simon escalated his ten-year-old crusade against the new City of Irvine. Claiming that the development would have damaging effects on the rest of Orange County and the university's campus, he pushed for a review of the Irvine Community Plan and accused unnamed regents of profiting from a conflict of interest. "We are ducking an issue because people have been caught with their hands in the cookie jar," he charged.[16]

Simon refused to name the offending regents, but it was clear that he was talking about Carter, a member of the board of directors of the Irvine Foundation, which owned majority stock in the Irvine Company, and William French Smith, who had been appointed by Reagan, and whose law firm of Gibson, Dunn, and Crutcher represented the Irvine Company. Smith denied the allegations and challenged Simon to either produce evidence of wrongdoing or retract his charges. He did neither.[17]

Simon's relations with his opponents on the board grew increasingly strained. He and Dutton became known as persistent troublemakers, frequently spouting off in the press for no apparent good reason. In October 1970 Dutton accused the board majority of postponing a discussion of the Irvine Company land for political reasons; Reagan was running for re-election. "You're a lying son of a bitch,"

Reagan shouted at Dutton, immediately after the meeting. Simon, who had been baiting Reagan about the Irvine plan during the meeting, stepped in, but Reagan pushed him away. "You've been using [the university for political purposes] for three and a half years and you finally got caught at it," Simon said. "You got caught with your pants down this time." Reagan was then whisked away by his press secretary and bodyguards before the argument went any further. Later at a press conference, Reagan said he was "very angry" because Dutton and "more recently Simon, once he discovered politics," had begun accusing the governor of "injecting politics into the affairs of the regents. Just the opposite is true," Reagan said. "They have made it very apparent that they are using the regents . . . in the gubernatorial campaign. They are outright liars on the most recent remarks they made."[18]

As the university struggled to get along with less and less state support and levied student tuition, Simon periodically presented sweeping new plans for saving money—most of which were rejected as impractical or ill-conceived. If he were disappointed, he appeared to be undaunted. Near the end of his term he claimed credit for liberalizing investment policies, decentralizing the university administration, preventing unfunded expansion, and guarding against commercial encroachment at the Irvine campus.[19] But he left the board as he joined it—complaining about investment practices and policies. At his last meeting, on 20 February 1976, he presented Elinor Heller, his fellow retiring regent, with a pillow inscribed "God Bless the Bureaucracy" in needlepoint. Heller, who had become known as a voice of moderation and understatement, responded, "I have to say that Regent Simon remains unique to the end."[20]

As his parting shot, Simon distributed a nine-page report outlining issues that particularly troubled him. "Numbers provide man's most universally understood language," he wrote. They are indicators of national health and welfare, and at the university, "the numbers cause many reasons for concern." He contended that university pensions were overfunded and that resources were unwisely invested in low-yielding common stocks. Investment activities should be removed from the treasurer's department to a separate investment

department that would implement a "yield-improvement" program, he said. Conscious that he was wrapping up his term, Simon concluded his statement with a polite challenge:

> I wish to make it clear that these statements are meant to be unequivocal. I do not mean to criticize any individual Regent, committee member, or any of the staff. All have done a decent job with the type of organization structure and policies that we have permitted to exist. But the policy structure and staffing has been completely inadequate. I know the Regents, with the Treasurer and his staff's cooperation, can appropriately restructure these activities so that the University can perform at the quality level it should.
>
> I have made strong statements today and I want them implemented. The University can take pride in setting a model in this area, as it has in so many others. We have a new Governor. There will be new Regents. This will be a period of great opportunity for updated priorities and methods. As I said in starting this statement, "Financial realities cross the spectrum of world affairs." Others have said, "As the University goes, so goes California; and as California goes, so goes the Nation." I expect that the University will perform adequately.[21]

17

A PLUNGE INTO POLITICS

*I should have quit my business and gotten
into politics five or six years ago.*

NORTON SIMON
New York Times, *31 May 1970*

CONVINCED THAT THE WORLD ran on power, paranoia, and public-
ity, Simon also had a long-standing interest in a fourth P—politics.
Government is a form of power that regulates and controls society,
and the process of gaining access to that force was a continuing
source of fascination for him. But Simon was such a determined
loner, independent thinker, and mercurial personality that he was
not strongly identified with either major political party. Going along
with the party line, whatever that party might be, was completely
contrary to his personality. His battle against "them" was fed by
his compulsion to be in control and his consummate skill in keeping
other people off balance. Although perfectly capable of being charm-
ing and displaying his gracious side to associates, friends and
strangers, he did not suffer fools gladly. He was a leader even if he
was not easy to follow.

Simon affiliated himself with the Republican Party as best repre-
senting the interests of business, but at heart and in fact, he was a lib-
eral Jew who despised the party's conservative element. His friendship
with Pat Brown, dating back to high school, further confused the
issue of Simon's political allegiance. At Lowell High School in San
Francisco, Brown was a student leader, a good Catholic, and the only
non-Jewish member of Sigma Delta Kappa, Simon's fraternity.
Brown, who became California's most powerful Democrat, first ran

for public office as a Republican in 1928. He changed his party affiliation in 1934, in the midst of Franklin D. Roosevelt's New Deal.

As Brown rose in politics, he could count on his fraternity brother for substantial financial support. In 1950, Simon's ten-thousand-dollar check contributed to a remarkable bipartisan campaign in California that won Brown the position of attorney general with the blessing of Earl Warren, the incumbent Republican governor who was running for re-election. Angered by charges that he was a power-hungry kingmaker, charges made by Edward Shattuck, the Republican nominee for attorney general, Warren approved an advertising campaign that linked his gubernatorial bid with the Democratic candidate. Brown was the only Democrat elected to statewide office that year. He was re-elected attorney general in 1954, and then served two terms as governor of California, from 1958 to 1966.

When Ronald Reagan succeeded Brown as governor, in 1967, Simon became deeply disturbed about the growing power of the right wing in the California Republican Party. On the University of California Board of Regents, Simon, who had been appointed by Brown, allied himself with Democratic colleagues. Perpetually at odds with Reagan, whom he called "deceptive, dogmatic and destructive," Simon was wary of Reagan's as-yet-undeclared presidential aspirations, saying that he was "potentially the most dangerous man in America."[1] Critical of conservative forces in the statewide political scene, Simon chafed against the political power wielded by George Murphy, a former actor who was elected a U.S. senator in 1964. As the 1970 election approached, liberal Republicans made a strong appeal for Murphy to step aside in favor of Robert H. Finch, who had frequently tangled with Reagan while serving as his lieutenant governor and had moved to Washington as Secretary of Health, Education, and Welfare in the administration of his old political ally, Richard Nixon. Finch wanted the senatorial job and he was considered a much better vote-getter than Murphy, but he would not challenge the incumbent.

Murphy's physical fitness for public office had been questioned in 1967, when he underwent surgery for throat cancer. Physicians found no recurrence of cancer when he ran for re-election in 1970, but nine days before the filing deadline for the primary election, he

suffered a different kind of threat to his political viability. Before taking public office Murphy had received an annual salary of $40,000 as a vice president of Technicolor, Inc. and was frequently active in right-wing political causes supported by Patrick J. Frawley, the corporation's president. Although it was widely assumed that Murphy had severed his connections with Technicolor when he became a senator, Jack Anderson revealed in his syndicated column, "The Washington Merry-Go-Round," that Murphy was receiving $20,000 a year as a consultant to Technicolor, as well as a free air-travel card and $260 a month toward rent on his $520-a-month apartment in Washington.

Because of Frawley's identification with political issues, the corporation's financial support of Murphy was interpreted as a means of buying influence. Murphy protested that he voted independently and only spent about one percent of his time working on Technicolor business, leading an editorial writer for the *New York Times* to observe: "At the rate he is paid, his advice must be extraordinarily valuable—or Patrick J. Frawley, president of Technicolor and promoter of right-wing causes, finds it worth-while to keep a very conservative man happy in his Senate seat."[2]

But as the filing deadline approached, Murphy had no serious opposition in the primary. Considering that situation deplorable, Simon had quietly discussed the possibility of entering the competition himself. He had contributed to John Tunney's campaign for the Democratic seat, saying he liked Tunney's ideas and thought he could beat Murphy.[3] But apparently Simon was merely waiting for a bit of encouragement at the right moment. It came from Ronald Gordon, a young attorney who called Simon to remind him it was the last day to file a Declaration of Candidacy and Nomination if he were to run against Murphy and urged him to enter the race. "I was very sensitive to the appeal because I'm quite concerned about where we're going in both the state and the nation," Simon told a reporter later that day.[4]

Simon immediately called Robert Finch's office in Washington and was told that Finch's name would not be on the ballot. Simon decided to file, called his staff to prepare the paperwork, and went off to a meeting of the Board of Regents of the University of

California. When the papers were delivered to him at the meeting, he discovered that his aides had taken out the papers in Los Angeles County, but to get the required signatures of sixty-five sponsors as quickly as possible, they had gone to Simon's former offices in Fullerton, which is in Orange County. He couldn't use the sponsors' signatures unless he took out a new set of papers in Orange County. Simon rushed down to Orange County, signed the papers, and filed them, with less than an hour to spare before the deadline.

It was the climax of a day filled with disruptions, new challenges, and comic obstacles. At the regents' meeting Simon had requested a thorough discussion of the university's financial operations. Objecting to the university's austere budget, he argued that more creative management of resources could increase income and presented some examples: year-round usage of facilities, more imaginative management of the investment portfolio, the development of income-producing property owned by the university, and studies to find new sources of support for and savings of university funds. Simon set off a heated discussion, but it ended abruptly when he departed to meet the filing deadline. Before leaving the meeting, the novice candidate—who was worth more than $100 million—borrowed $200 from his fellow regents and frequent opponents to pay the $850 filing fee.

Earlier in the day two of Simon's attorneys, Milton Ray and William Randolph, were charged with making sure the last-minute filing got through all the right channels. Political novices, they asked for advice and assistance from Tom Rogers, the Republican Party chairman for Orange County. Rogers cheerfully smoothed the way because he thought Simon was a Democrat and helping him would only increase competition among the Republicans' opponents. Learning that Simon was a Republican, Rogers realized that he had been an unwitting accessory to a split in his own party. He was horrified, but it was too late.

At first Simon was telling reporters that his campaign was somewhat "symbolic," and left them free to speculate. "You never know what symbols turn into," he said.[5] But within a few days he decided to wage a serious campaign and to finance it generously. "Contributions should only come from people who understand that this is not going to be the normal type of grass-roots campaign where

candidates ask for donations because they 'just have to have the office.' In the sixty days left, I won't be able to attend many of the meetings I've been asked to attend. I want to get around the state, but there isn't much time," he said.[6]

Simon said he didn't mind being an underdog. Unlike most businessmen who were criticized for failing to participate in the political process, he had decided "to stand up and be counted," he said. "California and this country have been very good to me over the years. I have made all the money I want. I retired completely from the company [Norton Simon, Inc.], and I want to try to give back to the society in which I was brought up." Promoting capitalism—which he defined as "initiative and incentive, freedom and individualism, enterprise and vision"—was his primary goal, but education was a primary concern, he said. Claiming that he wouldn't have entered the race without his experience on the Board of Regents, he said, "I've seen politics on the board since the first day I got on."[7]

No one was more surprised than the people who knew Simon best. The man who had always guarded his privacy—confining his statements in the press to comments about his business endeavors and art collecting or issues facing the board of regents—had willingly thrown himself into the public spotlight. "I should have quit my business and gotten into politics five or six years ago," he said in a burst of enthusiasm several days before the primary.[8] But members of his family, friends, and associates could hardly believe their ears.

The prospect of being in the public spotlight was appalling to Lucille, who recoiled from the seamy side of politics and the grandstanding generally required of successful candidates. Even Norton's unflappable sister, Evelyn Brooks, said that she was "absolutely shocked" when he announced his candidacy. Later she decided that his latest venture shouldn't have surprised her. "He'd done everything there was to do in business," she said. "What was left—make another million? For a man who always enjoyed fighting for a cause, why not politics?"[9]

As the campaign proceeded, Angelina Boaz, who had been Simon's administrative aide since 1964, couldn't stop shaking her head in disbelief. "Until that time he was an extremely private person," she said. "He really gave very few interviews. It just amazed me that when he

decided to run for the Senate, that completely changed. He was giving speeches everywhere."[10]

Simon set up his campaign headquarters in his office on Wilshire Boulevard, taking over an additional floor of the building. He persuaded Frederick Dutton, a fellow regent and Democratic Party insider who had been Brown's executive secretary and campaign manager and who was closely associated with Robert Kennedy, to share his expertise—but only behind the scenes. Demanding anonymity if he were to work for a Republican, Dutton was assigned the code name Percy. Sanford Weiner, a professional political manager who had once worked for Murphy, agreed to run the campaign. Charles Guggenheim, a filmmaker in Washington who also had worked for Kennedy, took charge of advertising. Seeking help from people he trusted, Simon also turned to longtime employees. Boaz had submitted her resignation when Simon moved his offices to Los Angeles because she lived in Orange County and didn't want to commute, but he persuaded her to stay through the race.

Not unexpectedly, in light of their antagonistic relationship on the board of regents, an attempt to win the endorsement of Governor Reagan failed. About a week after joining the race, Simon traveled to Sacramento to try to win Reagan's support. When he emerged from a half-hour meeting with the governor, he told reporters Reagan had refused to take sides. "If he was really objective he couldn't be neutral. He'd have to be for me," Simon said. Reagan had previously announced his position at a news conference, but threatened that he might change his mind if Simon violated the party's eleventh commandment, that against criticizing a fellow Republican in a primary campaign. Simon responded that the eleventh commandment was only viable if the twelfth—"being honest with the people of California"—were observed. Having asked Reagan who he thought could give the most competent, able, and vigorous support to the state of California and the United States, Simon received no answer. "Senator Murphy is not as vigorous nor as able as I and the governor knows it," he said.[11]

Simon had entered the race extremely late and he was little known outside the business community. Six weeks before the election the

campaign went public on television and radio and in the newspapers. One full-page newspaper advertisement posed the question, "Can Norton Simon, a businessman, be elected to the United States Senate?" It was followed by a series of answers and statements about Simon's agenda:

> The politicians doubt it. The public opinion polls say the
> odds are against it. But Norton Simon has been fighting and
> upsetting the odds all of his life. And he expects to win the
> Republican nomination for the United States Senate. He
> believes that Americanism is free enterprise. He believes that
> most Americans have lost patience with the inefficiencies
> in government. He expects to win because he believes that
> his proven skills and substantial business experience can
> uniquely serve President Nixon in his determination to
> restore fiscal integrity in Washington. Norton Simon has
> spent most of his life putting corporations on their feet—
> converting losses to profits—creating tens of thousands of
> new jobs. Norton Simon is a man who gets things done."

Another advertisement followed the same format: "Why is Norton Simon (a capitalist) running for the United States Senate?" The answers: "He owes a debt to his country, to Republicanism, to the capitalist system—to individualism. He believes that with dynamic capitalism you can innovate, you can break new ground. He has done these things and they have worked. He has made a lot of money, and is not ashamed of that at all. He believes that a Republican must win next November in the crucial race for the United States Senate seat in California. We cannot afford to have two Democratic Senators from California. He doesn't owe any one person anything. The only allegiance he has is to his principles."

While the advertisements promoted Simon as an unabashed capitalist, political reporters tried to understand what had motivated him to run. One result was that Simon revealed more of himself than ever before. "I'm very much Jewish, although not in a religious sense," he said, discussing a subject that rarely came up in talks with his friends. "And I just don't believe that it's feasible in this world for anybody that's Jewish or even part Jewish not to have some chip on their

shoulder someplace, somehow. I think they can only do themselves a service by finding out where it is. It's just part of a Jewish person. You can't be born a Jew without that, and you have to find it. Mine was awfully difficult to find. It can hide awfully well."

Simon also exposed his interest in psychology and offered a bit of self-analysis. "I think", he said, commenting on his perception of himself as an outsider,

> that the origin of my feeling "blocked out" was more Jungian than Freudian. It was not me alone, not me and my parents. It was the generations before me, the Jewish traditions, the psychological framework of our ancestry— the ancestral theory of Jung rather than the parental relationship of Freud. There is a hereditary pattern that makes one feel something. It was also a factor that my family was only one or two generations in this country. . . .
>
> So this would create my positive drives, but my positive drives are not the kind of positive drives I have today. They were competitive in a destructive sense. And so I would compete within the framework of the society as destructively as necessary for me to get ahead. Then as I achieved more and more success I didn't have to worry as much about me, because I felt more secure. I felt that I had broken my way through. They hadn't blocked me out to the degree that I couldn't have my sense of comfort.[12]

As for his political views, Simon had difficulty staking out clear positions. In his advertising campaign he supported the Nonproliferation Treaty as an important step to end the arms race and favored steady withdrawal of American troops from Vietnam. He also spoke out for environmental standards, consumer protection, federal assistance to public schools, and reforms in fiscal accounting. But in public speeches he felt he had to restrain his most liberal views to avoid alienating conservatives, and his innate tendency to espouse apparently contradictory positions made him sound muddled or indecisive. "I don't know whether he is a vegetarian or a prohibitionist or what," complained a party worker.

Simon was also hampered by his superior intelligence, which had

led him to develop convoluted modes of reasoning that few people had the patience or ability to follow. More important, in terms of mass communication, he lacked the talent—or the inclination—to deliver opinions in sound bites. When Nixon announced that he was sending troops into Cambodia, reporters wanted to know only if Simon did or did not support the president. Refusing to put it as simply as that, Simon essentially said he was for the move if it would help to end the war, but against it if the involvement of Cambodia would broaden the conflict. Upset by reporters' persistence in expecting him to boil his answer down to a simple yes or no, Simon said, "Dammit, I take more time buying a picture than they'll give me to decide about Cambodia. I don't give instant answers. Not to be thoughtful is to be promiscuous."[13]

About two weeks before the election, Simon's own poll gave him about 20 percent of the vote to Murphy's 40 percent. When election day arrived, Simon's standing had risen significantly, but so had his opponent's. Murphy won easily, garnering 447,454 votes or 68 percent; Simon racked up 192,366 votes, or 29 percent. Summing up the race with a favorite phrase, "You don't have to win every battle to win the war," he contended that his opposition to a right-wing Republican was an important step in shaping the direction of the party. "The point is to learn from experience, and that's where I've gotten a great deal of satisfaction from this race. Because I know that win or lose, I've learned something new."[14]

As usual, his aides who had been catapulted into yet another venture they felt unqualified for, also learned something new. Their efforts did not go unnoticed. In a show of affection that few people ever witnessed, Simon dispatched hand-written letters of thanks. "I couldn't let any more time fly by without my expressing to you my appreciation for your saving me so many times during the Senate campaign," he wrote to Boaz. "I know the extra strain of all the commuting. One never would have guessed it by the graciousness of your actions and the way you handled all the prima donnas and nice people too. I will never forget your help. Many, many thanks and much love."

Simon's 1971 New Year's card was illustrated with a reproduction of a painting from his collection, a self-portrait by Rembrandt. The

image, he said, was "my way of saying that the new year is a good time for introspection, for looking inside yourself, instead of blaming the kids for our problems. It would have sounded too pedantic and presumptuous to actually say that; I'm just afraid the Rembrandt was too subtle for the people who needed the reminder the most."[15]

Simon did not run for public office again, nor did he emerge as a political kingmaker, a fact that did not surprise his old friend Pat Brown. "Norton won't go very far, as a candidate or behind the scenes," Brown said. "Politics is a team game, and Norton is constitutionally unable to play on a team. He has to be the loner, the individual, at all costs. If I ran for president and he was helping me, he'd have a separate 'Simon for Brown for President' campaign."[16]

Pat Brown's son, Edmund G. "Jerry" Brown, had succeeded Reagan as governor when Simon left the board of regents, but the animosity continued. On 2 June 1976, Simon took out a full-page advertisement in the *Los Angeles Times*. Under the caption, "Why Ronald Reagan should vote for President Ford in the California primary," and a list of Ford's qualifications, Simon provided the reason: "Mr. Reagan has demonstrated how easy it is to offer glib and simplistic solutions to complex problems in a sensitive nuclear world. It is easy—but also self-serving, divisive, and reckless."

Although Simon had opposed a Republican incumbent in his primary race for the Senate, he argued against Reagan's challenge of the sitting President. "There is more than an election at stake. It is no exaggeration to state that the future of the two-party system may well hang in the balance," he went on.

"This Tuesday, Republicans have a clear choice. We can rally behind the President who can unite us. Or we can split the party and suffer another defeat.

"This is a time for deep thought and deliberate action.

"If Mr. Reagan really believes in keeping the Republican Party from becoming a house divided, if he really believes in keeping America strong, he would join with me in voting for President Gerald Ford on Tuesday, June 8.

"Thank you, Norton Simon."[17]

18

TRAGEDY AND CHANGE

*I've never really been at ease with people, it's hard for me to
let myself go. I believe there are two sides to a man—to be
able to live alone and to be able to live in the world. And I have
been alone more, perhaps, than I would have liked.*

NORTON SIMON
New York Times, *31 May 1970*

THE PERIOD FROM 1969 TO 1971 brought stimulating challenges to
Simon as he wrapped up the business career that had consumed
much of his energy, made a brief but intensive foray into politics,
and devoted more time to his art collection. Changes in his private
life were even more profound. In one traumatic event after another,
his family life was ripped apart, leaving him alone for the first time in
thirty-seven years.

Norton and Lucille and their two sons had been a close-knit family,
almost reclusive, while the boys were young. Raised under a strict dis-
ciplinary code, Donald and Robert did what was expected when they
left high school, going on to obtain liberal arts degrees at the Univer-
sity of California at Berkeley—and then going into business with their
father. It was taken for granted that Donald and Robert would have
the formal education Norton lacked and that they would be business-
men. He told them not to bother with business courses; in his view, he
was more experienced and better equipped to teach them what they
needed to know than any college professor.

As might have been predicted, Norton's relationship with his sons
grew strained when they came of age, went to work for him, and

tried to gain a measure of independence. Working for Norton Simon wasn't easy for anyone because of his compulsion to control every aspect of his business and his chaotic style. As sons of the boss, Donald and Robert seemed to have an inside track to the seat of power, but they found it nearly impossible to make their own mark, much less please their father. Donald worked for Norton from 1957 to 1964, but eventually decided that the only way he could have a satisfying professional life was to leave. In 1965 he went to Paris with his wife, Linda Van Ronkel, and their three young children, Douglas, Eric and Pamela. They returned to California after about a year, but went back to Paris again and lived there from 1967 to 1975. With stock inherited from his grandfather, Donald established his own business in international investments.

Robert had a closer relationship with his father, partly because he was less independent. But he, too, left the company and became involved in several entrepreneurial ventures in southern California. His first marriage, to Gail Popkin, failed in the early 1960s. He then met a young Swedish woman, Sylvia Lundgren, who was working in Los Angeles. They were married in 1966 and moved to Sweden in 1968, but returned to Los Angeles in September 1969. Robert had developed emotional problems and had psychiatric counseling, but his wife and parents were probably the only people in his circle of friends and family who had an inkling that he might be seriously disturbed. Norton knew that Robert had purchased a gun after he had returned to Los Angeles and feared his son was suicidal, so he persuaded Robert to give him the gun. But Robert apparently bought another gun. At home on 29 October 1969, at the age of thirty-one, he shot himself fatally in the head. Sylvia, who found him, was expecting their first child.

Robert's death came as a horrifying shock to his family and wrenched Norton away from his wife and remaining son. When Lucille called Norton at his office to tell him what had happened, he let out a scream that his associates couldn't forget. "That was the only time I ever saw Norton cry," said Harold Williams, recalling his visit to the Simons' house that evening when he walked in the garden with his old friend. "His son's death had a very profound effect on him. I think it really was a turning point."[1]

Simon had already consolidated his business empire into Norton Simon, Inc. and had begun to remove himself from its administration. When Donald had gone to Paris, Norton had persuaded him to stay on the board of Hunt Foods & Industries, Inc. But, back in Paris after his brother's funeral, Donald resigned from the board. Despite their estrangement, Donald's action was a painful blow to his father. In cutting his last formal tie to the business empire, Donald seemed to reject his father's achievement. Apparently the symbolism was harder for Norton to accept than his troubled relationship with his son was. A few days later, Norton himself left the board. Then, yet another chapter of Simon family history ended in December, when Myer's second wife, Lucille Michaels Simon, died in her sleep in her Wilshire Boulevard apartment, at the age of 76.

Norton and his wife had begun to have marital difficulties more than ten years before Robert's death. Even before they lost their son, they had become rather distant partners. Lucille, an avid reader and a stimulating intellectual companion, developed glaucoma, and as the disease progressed, grew increasingly fearful of blindness and profoundly depressed. Although Norton had suffered from asthma and ulcers for years, he had not much tolerance of physical ailments in other people and offered little sympathy or comfort to his withdrawn wife. She was increasingly inclined to stay at home, while Norton kept up a heavy travel schedule. Among various business associates who accompanied him on trips was Stella Russell, whom he had promoted from a secretarial position to that of executive vice president of Hunt Foods & Industries, Inc. They got along so well and were together so frequently that some family members and business associates assumed that they were romantically involved. That may or may not have been true, but it didn't help the Simons' troubled marriage.

Robert's death pushed Norton and Lucille farther apart in 1969 as they tried to come to terms with their loss. Then in 1970 Norton's political campaign thrust him into the public eye and consumed most of his time and energy for an intense two months. Shortly after Norton was defeated in the California primary election, he and Lucille separated and were divorced later that year. Lucille kept the house on Hudson and part of their personal art collection, including

her favorite painting, Rembrandt's *Portrait of Hendrickje Stoeffels.* Leading a quiet life while maintaining a few ties to the art community, Lucille has served as a trustee at the Los Angeles County Museum of Art and has given the museum one of the Simon's earliest and most important purchases, *Swineherd, Brittany,* a large landscape by Paul Gauguin. In 1991, in honor of the gallery's fiftieth anniversary, she donated *The Three Nymphs,* a lead sculpture by Aristide Maillol, to the National Gallery of Art in Washington, D.C.[2]

Single again, Norton became known as an eligible bachelor. Early in May 1971 he had been invited to attend a reception and dinner for Osborn Elliott, the editor-in-chief of *Newsweek,* who would be visiting from New York. The celebration was to be held at Chasen's, a formal restaurant and favorite haunt of movie stars, tycoons, and writers. Simon was asked to attend as the escort of Jennifer Selznick, the widow of the film producer David O. Selznick. Better known to film buffs as the actress Jennifer Jones, she had won an Oscar in 1943 for her role in *Song of Bernadette* under Selznick's direction. Jones had also starred in more than a dozen other movies, including *Madame Bovary, Ruby Gentry, Tender Is the Night, Love Is a Many-Splendored Thing,* and *The Man in the Gray Flannel Suit,* but she had retreated from the limelight after Selznick died in 1965. Involved mainly with social causes, she lived quietly in Malibu with her teenage daughter, Mary Jennifer.

Simon's staff had expected him to decline the invitation because the party was scheduled on the same night as a widely publicized auction of seventy-four paintings, drawings, and sculptures from his personal collection was to be held at Parke-Bernet in New York. He had traveled to New York to confirm details of the auction but was not, in any case, planning to be present, so he decided to fly back to Los Angeles.

The irascible sixty-four-year-old tycoon and the glamorous movie star twelve years his junior seemed unlikely to have anything in common. Simon was smitten by Jennifer Jones's beauty, but it was her social conscience that added a dimension that he had not expected, and he found her company stimulating. "That's where we connected," he said. "She was fighting the same sociological battles I was."[3]

For a year and a half before she met Simon, Jones had been work-

ing with the Manhattan Project, a group of Salvation Army residential treatment facilities for young people addicted to narcotics. Named for the project's first location, on Manhattan Place in Los Angeles, the program had expanded into three more buildings in Los Angeles and one each in Fresno, California, and Salt Lake City, Utah. Participants lived in the facilities while attending school or working. Attempting to develop a drug-free life, they sometimes spent weekends at the homes of volunteers, Jones included.

The dinner for Osborn Elliott started a whirlwind courtship. Apparently by chance, Simon and Jones saw each other the very next night at another social occasion, and he invited her to dinner the following evening. They were both planning trips to Europe, so they decided to go to Paris together. They stopped in London on the way home and decided to get married there. It was the Whitsun holiday weekend, so they couldn't get a marriage license. Simon presented his problem to a well-connected old friend, Peter Wilson, head of Sotheby Parke Bernet in London. Happy to pull a few strings for a good client, he arranged for the couple to get married on a yacht, five miles off the south coast of England.

Simon and Jones drove to Folkestone, boarded the boat, and set out to sea. It was already late, and the trip took longer than expected. They were married at 4 A.M. on 30 May 1971—three weeks and four days after they met—by Eirion Phillips, a Unitarian clergyman. "It was great fun," Simon told a reporter when they arrived back on shore. "We were bobbing about in the sea and in the early morning light. I could just make out the white cliffs of Dover. It was very romantic."[4] Phillips had a different memory of the event. "The boat was lurching so much that I could hardly stand up to perform the ceremony," he said.[5]

Back in London, Simon was euphoric. "We are both in great shape. To say we are tremendously happy would be the understatement of 1971," he told a reporter who caught up with the couple as they emerged from their hotel the day after the wedding.[6] Simon told another reporter that he and his new wife liked to think of themselves as being about thirty years younger than their actual ages. That made him "about thirty and Jennifer going on twenty-five, not too old for love at all," Simon said.[7]

The early-morning wedding off the coast of England was not, it transpired, valid in California. Another ceremony, performed by the superior court judge Steven S. Weisman, a brother of Simon's brother-in-law, Frederick Weisman, was held at the Los Angeles County Courthouse.

Simon and Jones bought a pair of houses at the beach in Malibu and commissioned the architect Frank O. Gehry to refurbish the two and connect them. They settled in, leaving their old lives behind. Enormously pleased with himself, Simon took to calling his marriage to Lucille "the former management."

19

THE ART OF ASIA

Stolen Statue of Shiva Bought by Simon

NEW YORK POST
11 May 1973

Simon Denies He Admitted Buying a Smuggled Statue

LOS ANGELES TIMES
13 May 1973

NORTON SIMON AND JENNIFER JONES were married so suddenly that they didn't have time to plan an extended honeymoon. After returning to Los Angeles they decided to treat themselves to a relaxing trip to Hawaii, but Norton soon became bored with swimming and tropical scenery. Jennifer, who was interested in yoga and eastern philosophy, suggested that they travel on to India.

As soon as they arrived in New Delhi, Norton did what came naturally: He picked up the phone and called an expert for advice. He knew that Pratapaditya Pal was the man to consult, even though they hadn't met. A young but extraordinarily gifted and well-educated scholar, Pal was born in Bangladesh and educated in India and England. Upon completing his formal education at Cambridge University in 1965, he had assumed a prestigious position as keeper of the Indian collection at the Museum of Fine Arts in Boston. While working there in 1969, Pal had been consulted by Kenneth Donahue on a large acquisition contemplated by the Los Angeles County Museum of Art: 345 pieces of Indian, Nepalese, and Tibetan art from

the Nasli and Alice Heeramaneck collection. Nasli Heeramaneck, an Indian collector and dealer who had studied at the Victoria & Albert Museum in London and opened a gallery in New York in 1929, had played a major role in building the Asian art collections of America's best museums. The Los Angeles County Museum of Art had purchased five massive Assyrian alabaster reliefs from his collection in 1966. The second acquisition from the Heeramaneck collection— made with Pal's enthusiastic approval—had immediately established the fledgling West Coast institution as a serious collector of Indian art. The landmark purchase also had made it necessary for the museum to hire a specialist to head its newly created department of Indian and Islamic art. Pal was offered the job.[1]

Although his colleagues in other American museums advised Pal against leaving the venerable institution in Boston for an upstart in California, he thought Donahue's purchase of the Heeramaneck collection indicated a commitment to Indian art. The young curator was even more encouraged by the support of Franklin Murphy, then president of the museum's board of trustees. While interviewing for the position in Los Angeles, Pal had informed Murphy that the museum needed an Indian art library as a resource for the prospective curator. When Murphy asked how much the necessary books would cost, Pal made a guess of fifty thousand dollars and got a surprising response: "Fine. On the day you join us, I will send you a check for twenty-five thousand dollars and when you have spent it I will send you another check." Murphy's decisiveness was hardly typical of his fellow trustees, who had waffled and stalled for two years before buying the Assyrian reliefs for $306,000, but Pal was impressed. "Any institution that could make decisions that quickly seemed like a good place to be," he said.[2]

The new curator's expertise was in Indian and Southeast Asian culture, rather than in the European art that Simon collected, and Pal's brief acquaintance with American collectors was based largely on his experience with East Coast residents who shared his interests. Indeed, before joining the staff, he had barely heard of Simon. Even after Pal moved to Los Angeles, the museum's most prominent collector initially had no effect on his professional activities. Simon was a trustee when the Heeramaneck collection was acquired, but he had

indicated no particular interest in the purchase, or in the fabulous cache of material after it arrived at the museum. As far as Pal knew, Simon might even have been opposed to the deal. Having had no contact at all with Simon during his first year in Los Angeles, Pal was astounded to receive his call from India. At that point, Simon was merely in pursuit of tourist advice from a knowledgeable native. Simon and his bride had followed a whim to India, with no itinerary, and he simply wanted to know what they should see.

Because Simon was on his honeymoon, Pal advised him to go to Agra to see to the Taj Mahal in the moonlight. He also suggested a visit to the National Museum in New Delhi, where he could see one of the world's best collections of Indian art. Simon followed both tips. He was duly impressed with the Taj Mahal, but the museum visit changed his collecting life. Simon had never been a single-minded collector; he had purchased a few pieces of Chinese and Egyptian art early on, and his interests in European art were quite eclectic. But Indian art had been almost completely outside his purview. He had never seriously considered its aesthetic merits, nor had he been thrust into a situation that encouraged him to learn about it. His trip to India changed that.

At the National Museum he saw masterpieces of sculpture that might have seemed quite foreign to him. Both the cast of characters and the complicated iconography of the artworks were unfamiliar, but elements of Indian art that tend to baffle most western novices posed no obstacle to his appreciation. Simon was swept away by the sensuality and voluptuousness of the art and by its classical beauty. Instead of focusing on differences between Indian and European modes of artistic expression, he saw formal similarities. Indeed, he apparently felt quite at home with Indian art, once he really looked at it. "At the National Museum he saw Indian sculpture in its context, and it hit him with a bang," Pal said.[3] Here was a different way of portraying the human figure, a subject that had always intrigued him. The deities, saints, and heroes depicted in Indian art were imbued with spiritual strength instead of human imperfections, as was frequently the case in the art he had collected. But in physical terms, Indian sculpture offered the same qualities of classical form and refinement that Simon valued in European art.

He had purchased some Indian artworks on his trip and on his return wanted to show them to the curator. When Pal went to Simon's home and saw the objects—an ivory Shiva and Parvati group and a chess set, purchased at the Ivory Palace in New Delhi— he asked Simon if he wanted to hear the truth. Simon assured him he did, so Pal gave him good and bad news. The Shiva pair was modern, though well crafted, he said, but the chess set was genuine and very interesting. Made in northern India in the early nineteenth century, the Mughal-style set consisted of carved ivory Sikhs and Afghans on a wooden board inlaid with ivory. Having just met Simon, Pal was unsure about how the collector would react to his assessment. Much to Pal's surprise, Simon was delighted with the mixed review. "He said, 'You know, that's fantastic. One out of two. That's not bad.' "[4] Simon had paid three thousand dollars for the chess set, and he never sold it. In 1978 he gave the set to the Norton Simon Foundation, at an appreciated value of ninety thousand dollars.

With one successful purchase in hand, Simon was ready for more. He had already decided to concentrate on Indian sculpture, not painting. But he knew he needed help. Pal traveled to New York several times a year to look at possible purchases for the museum and keep abreast of the market. The museum had little money for Indian art acquisitions after buying the Heeramaneck collection, so Simon asked Pal to reserve good pieces that the museum could not purchase. The request presented Pal with a rather delicate situation that could be perceived as a conflict of interest, but he agreed. Although Simon had resigned as a trustee, Pal knew that there was still hope, however slim, that he would give part or all of his collection to the museum. Before long, as Pal made his rounds and Simon himself began to show up in galleries he had not visited before, New York dealers in Asian art realized they had a new and serious client. "Once he had made up his mind, Simon was like a bull in a china shop," Pal said. "Over the next year or two, he was relentless in purchasing not only Indian sculpture, both in stone and bronze, but also sculptures in both media from Nepal as well as Thailand and Cambodia. Apart from acquiring individual masterpieces, he also purchased large groups from individual dealers."[5]

Doris Wiener, who had a gallery on Madison Avenue, first met Simon in late fall 1971.

> Pratap and I were in touch a lot so he called me and said, "There's a man coming over to see you. He just came back from India. He's married to Jennifer Jones and his name is Norton Simon." At that moment, someone buzzed me on the intercom and said, "Norton Simon to see you," so I told Pratap I would call him back. Of course I had heard of Norton Simon because he would hit the newspapers with the wonderful things he bought, but it was really very exciting to meet him.
>
> For me it was fascinating. I was particularly rich in early Nepalese bronzes, ninth- and tenth-century pieces, and I had very good Chola bronzes. He started at square one. He wanted to know about Hinduism as compared to Buddhism, for example, and he wanted to know everything right away. He began to compare Asian antiquities to European art in terms of prices. He had questions about why things were priced as they were. Why was a twelve-inch bronze worth much more than a stone piece three or four feet tall? It sounded as if he was interested in money most of all, but that wasn't really true. The questioning was his way of learning. He was very, very complicated and as a result I think people misunderstood him. He sent out very many messages. In retrospect I think he was sending these messages to himself as much as to others.[6]

The first piece he purchased from Wiener, in December 1971, was an eleventh-century Central Indian sandstone sculpture of Surasundari (Beautiful Woman of the Gods). Forty inches high, it was one of the larger pieces in Wiener's inventory and an accurate indicator of Simon's penchant for the monumental in Indian art. Priced at forty-five thousand dollars, the Surasundari was considerably more expensive than the chess set had been, but it cost far less than he was accustomed to paying for art. A month later he purchased two other works from her gallery: another eleventh-century sandstone sculpture of a female figure, roughly the same size as his earlier purchase but priced at fifteen thousand dollars, and a sixteen-and-one-half-

inch-tall bronze Buddha from the sixth-century Gupta period, for which he paid three hundred thousand dollars. He had taken a bold leap into a new field of art, but it was only the beginning of a ten-year adventure that would put him at the forefront of the Asian art market and add a major holding of Indian and Southeast Asian material to his already renowned collection of European art.

Like other dealers before her, Wiener became an adviser and confidante of Simon, as well as an occasional adversary. He acquired dozens of artworks from her, becoming a major client, but she was far from his only source of Asian material. In 1972, his first full year of collecting in the field, he purchased thirty pieces from J. J. Klejman of New York, fifteen items from Oriental Antiquities of London, and smaller quantities from three other dealers in New York, William H. Wolff, Robert H. Ellsworth, and Ben Heller. European dealers began to work with Simon as well. On trips to Paris he stopped in to see what Yvonne Moreau-Gobard had in stock at Arts d'Asie and purchased several Cambodian pieces from Beurdeley & Cie. A serene ninth-century sandstone Buddha from Thailand came from Spink & Sons, Ltd. in Zurich. Purchased in 1972 for $210,000, the monumental figure—which stands more than seven feet tall and is said to be the largest Thai Buddhist sculpture outside Thailand[7]— was the first of dozens of pieces Simon bought from Spink's galleries in Zurich and London.

Simon introduced himself to Robert Ellsworth in the summer of 1972.

> I'd heard through the grapevine that he had been out there buying in the Indian world, and I guess he heard about me through the grapevine and came to see what I was up to. I don't think he'd been at it for very long, but if you are a serious collector and you come to Oriental art later on, the accumulated knowledge gained from old master paintings or manuscripts or whatever gives you a jump ahead because you have trained your eye. If he hadn't, he wouldn't have gotten as far as he did.
>
> He had a very good eye. He could pick out quality very rapidly. At our first meeting, the sculptures he was interested in and later purchased were all lying on their backs

covered with brown wrapping paper and probably an inch of plaster dust. I just uncovered one and showed it to him and moved on to the next. His selection was that of someone who understood quality, rarity, and—above all, in Norton's life—importance.[8]

Simon's first three purchases from Ellsworth came from south India: a twelfth-century bronze Buddha, about thirty inches tall, priced at $120,000, and two monumental statues of the Hindu god Vishnu, dating from around the tenth century and priced at $45,000 each. Carved as figures attached to blocks of stone, they were probably made for niches of temples as symbols of divinity and power.

By the end of 1972, only a little more than a year after Simon had purchased the chess set with ivory figures in New Delhi, he had amassed nearly a hundred pieces of Asian sculpture, primarily from India, but also from Thailand, Nepal, Tibet, and Cambodia. Paying as little as $793.46 for a tiny, fifteenth-century Tibetan bronze at auction and as much as $360,000 for a thirty-nine-and-one-half-inch-tall Chola bronze in a private deal, he had made an astonishing entry into the market. But he had spent less than $5 million on his new collection. "He had moved from a world of painting where most everything had price tags on them to a world where I don't think most people in his position knew exactly what anything was worth or what it would cost," Ellsworth said. "I think the voluptuous quality, the bosoms in Indian art, may have been part of his first inspiration to collect it, but I think he also knew he was playing in a ball park where, if he held the art long enough, he couldn't lose a nickel."[9] Having made his fortune in large part by discovering and investing in undervalued companies, Simon had found a field of art, too, that was undervalued. His activity in the market certainly raised prices, but compared to the sums he had been paying—and continued to pay—for European art, his Asian art was a bargain.

Once Simon had declared his interest in the field, he was offered the best examples. In one notorious case the price was extremely high—not only in dollars but also in time, research, international diplomacy, and legal expertise. Simon first heard about the bronze *Shiva Nataraja* (Lord of the Dance) from Ben Heller in November

1971, after Simon had returned from India but before he began buying Indian art in New York. Heller told him the forty-four-inch-tall figure, made about 950 A.D., during the Chola period, was one of three great *Natarajas* in the world. The other two were in museums in Amsterdam and Madras.

The gregarious dealer may have been making extraordinary claims about the work he wanted to sell, but his enthusiasm was warranted. The worship of Shiva reached its height of popularity under the Cholas, and the most important images made during that period depict the Hindu god as Lord of the Dance. A summation of religion, philosophy, and culture, this *Nataraja* is dynamically posed within a ring of fire. He stands on one leg, the other leg stopped in motion, and holds a drum and a flame in his hands. His dance represents five manifestations of eternal energy: creation, destruction, preservation, salvation, and illusion.

Although *Nataraja* images are commonly seen in Indian art, the example in Heller's hands was of unusually high quality. The day after talking to Simon, Heller sent him a letter, reinforcing the point. The statue in his possession was nothing less, he said, than "the finest rendition of the most important subject in Hindu art." Heller had put the *Nataraja* on the market for $1 million, but did not mention the cost. In the same letter, he also offered Simon ten other pieces, bearing price tags of between $120,000 and $200,000. Simon did not leap at the *Nataraja,* but he bought ten other Indian sculptures from Heller in 1972, at a total cost of more than $1 million. The purchases included a first-century B.C. sandstone pillar portraying scenes from the life of Buddha, three Chola bronzes, depicting Shiva's consort Parvati, a Somaskanda group portraying the couple with their infant son, Skanda; and the elephant-headed god, Ganesha, who bestows success upon his worshippers.

Meanwhile, discussions about the *Nataraja* continued. Simon was excited about the prospect of acquiring such a perfect piece of Indian art, but he was unsure of its provenance; he wanted to be certain that Heller had clear title to the work. As Heller had told him, the sculpture had been unearthed in the early 1950s on temple grounds in the village of Sivapuram in the state of Tamil Nadu and displayed in the temple for several years. The *Nataraja* subsequently

had passed into the private collection of Boman Behram, a dealer in Bombay and then into other dealers' hands. But its former association with a temple could raise questions about private ownership—and indeed it did. In May 1972, after Indian officials learned that the sculpture had been exported and was on the market, it was reported that the Indian government might make claims on the *Nataraja*. Simon's attorney, Helen A. Buckley, called William Wightman, an agent for the U.S. Customs Department, requesting confirmation that the statue had entered the country legally. Wightman told her that it had, and added that United States law does not recognize Indian law holding that all alleged cultural property removed from India is deemed to be stolen. Still, other dealers warned Simon against buying the *Nataraja*. "I just knew there was something wrong," Wiener said.[10] Six months after Heller had made his initial offer, Simon felt he needed more time for research, but he was afraid of losing the statue. The solution was a six-month option.

On 15 June 1972 Simon wrote to Heller, agreeing to buy two other Chola bronzes, the *Somaskanda* for $225,000 and the *Parvati* for $150,000. Like the *Nataraja,* the *Somaskanda* had been unearthed in Sivapuram, displayed at the temple and transferred to Behram's collection. In the agreement Simon required Heller to guarantee that he had full legal title to the two works, that they had been legally and properly cleared through U. S. Customs, "and that there is no detriment, impediment, or condition of any sort whatsoever [that] would result in denying to this Foundation full use, possession, and enjoyment of the items within the United States. . . . Both parties acknowledge that they are aware of the fact that the *Somaskanda,* formerly in the collection of Mr. Boman Behram of Bombay, now deceased, was for a time standing in the temple of Sivapuram."

Simon went on to outline an agreement that the Norton Simon Foundation would have an option to buy three other artworks: the *Nataraja* for $900,000, two Cambodian pieces for $220,000, and a stone head of Surya for $175,000. The option could be exercised until 15 December 1972. The same stipulations about title and importation set forth on the items purchased outright applied to the optioned works and the same declaration about the provenance of the most valuable piece was included: "Both parties acknowledge that they are

aware that the Nataraja formerly was for a time standing in the Temple of Sivapuram." Simon and Heller signed the agreement.

During the next six months Simon and his staff talked to Asian art specialists in an attempt to discover the whole story of the *Nataraja,* compile critical assessments of the piece, and determine if it could be safely purchased by the Foundation. Accounts of the sculpture's history and travels varied. Everyone agreed that villagers had dug up the *Nataraja* along with several other artworks while building a new temple in Sivapurum to replace the old one that had fallen into disrepair. The sculptures had been taken to the elders who installed them in the temple, where they remained for several years. At one point the *Nataraja* was thought to be too valuable to display in the temple, and it was transferred to the Government Museum in Madras. But later, when the elders requested it back, the idol was returned, with an informal understanding that it was merely on loan from the museum.

Accounts of the statue's leaving the temple permanently varied. According to one widely circulated story, Lance Dane, a photographer with an interest in sculpture—possibly working with an accomplice or an intermediary—had purchased the *Nataraja* from the temple elders for somewhere between one and two thousand dollars, a high price in India at the time. Part of the deal was that the sculpture was to be replaced with a replica, cast from a mold made from the original. Another popular version of the tale held that Dane had persuaded the temple elders that the *Nataraja* and the other three sculptures should be treated to arrest bronze disease, a malignant corrosion generally attributed to the effect of chlorides on metal. He took the bronzes to Raja Swami Sthapathi, a restorer in Madras, and replaced them with replicas—possibly without informing the elders.

Most of Simon's sources concurred that the *Nataraja* had contracted bronze disease, which would have consumed it, and that temple authorities had authorized treatment. Sthapathi was said to have cast the replicas, but there was disagreement about whether he had exchanged them with the originals surreptitiously or with the elders' knowledge and approval. Still another version of the tale made Sthapathi a hero. Unable to pay for the restoration, the elders told the

restorer to melt down the original and use the metal to cast a copy. He had made a replica, but kept the original, thereby saving it.

At the end of six months, all Simon knew for sure about the affair was that Sthapathi had been arrested, but not for his involvement with the *Nataraja,* Dane was in prison, but hadn't been charged with the theft of the statue, and the *Nataraja* had been sold to Behram. He had kept it at his home in Bombay, where it had been seen over the years by scholars and government officials. While it was in his collection reproductions of the statue appeared in several publications. If Behram had taken possession of the statue through a shady deal, apparently he didn't think he had anything to hide. The Indian government made no attempt to retrieve the statue from his collection, possibly because of an informal agreement or mistaken impression that Behram would bequeath it to the nation. Behram died in 1968. Simon was told, on the one hand, that Behram had sold the piece shortly before his death to an intermediary who in turn sold it to Manu Narang, an art dealer based in Bombay and London, and on the other, that the *Nataraja* was sold after Behram's death.

Narang had the statue flown to New York, where it was passed by U.S. Customs on 24 March 1969, and placed in storage at Hahn Bros. warehouse. He then offered to sell the *Nataraja* to several art dealers in New York. One after another, they demurred or declined because of reports that the Indian government—however belatedly—considered the piece to have been stolen. Officials at the Government Museum in Madras formally declared the *Nataraja* to have been stolen in 1969—after they learned that the work they had purportedly lent to the Sivapuram Temple about fifteen years earlier and hadn't retrieved from Behram was in the United States. Behram's extended ownership of the piece made their claims questionable at best, but most dealers didn't want to handle a piece that had such a cloudy past. Heller was different. He had seen the *Nataraja* in Behram's home and had never forgotten it. In his view the statue had a fascinating story, but no insurmountable problems. In January 1970 he bought the *Nataraja* for five hundred thousand dollars.

Origins aside, Simon's decision about acquiring the statue also depended on the willingness of major American museums to

exhibit it. A show of his Asian art collection was already being planned at the Metropolitan Museum of Art in New York. He thought the Nataraja would make a spectacular centerpiece and the curator agreed. The prospect of introducing his new purchase at the Metropolitan was irresistible. On 13 December 1972 the Norton Simon Foundation purchased the *Nataraja*. Simon sent Heller a check for $1,075,000 of which $900,000 was for the *Nataraja* and $175,000 for the Cambodian head of Surya.

In January 1973 Isley examined the statue at the Metropolitan Museum and reported to Simon that it hadn't been properly cleaned and the bronze disease had not been stabilized. The British conservator Anna Plowden, who had seen the *Nataraja* three months earlier, while Simon was considering its purchase, agreed to treat the piece and it was sent to her in London.

News of Simon's acquisition made the rounds of dealers, but they kept quiet, fearing that, if trouble erupted, the Indian art market would be damaged and their business would suffer. Among them was Wiener, who had spent hours talking with Simon about the *Nataraja* and had indulged his penchant for speculation about every possible scenario that could evolve if he made the purchase. "The last thing I said to him was, 'Norton, you know anything like this that sells for a million bucks and becomes public knowledge is just bad luck.' Sure enough, it got into the papers because it cost a million dollars. And who gave the story to the papers? Norton Simon."

The story broke five months after the sale had occurred. On 11 May—only a week after Simon had earned headlines for Parke-Bernet's auction of impressionist and post impressionist art from his collections that had realized $6 million—the *New York Post* reported: "A priceless, tenth-century bronze statue of the Hindu god Shiva, stolen from a village temple in Southern India and smuggled out of the country, has been bought by Norton Simon, the multimillionaire West Coast art collector, for a price reported to top $1 million.

"The idol, which has been the central figure in an international tale of adventure and intrigue, has been sought by the Indian Government for two or three years."[11]

The following day, the *New York Times* picked up the news: "Norton Simon, the West Coast industrialist and art collector, said yesterday that he had paid $1 million for a bronze sculpture of a Hindu deity that Indian Government officials say was stolen from a South Indian temple and smuggled out of India.

" 'Hell, yes, it was smuggled,' said Mr. Simon in a telephone interview. 'I spent between $15 and $16 million over the last two years on Asian art, and most of it was smuggled. I don't know whether it was stolen.' "[12] The comment about his expenditures on Asian art was an exaggeration—the actual figure was just under $5 million—and the flippant remark about smuggling that was attributed to him turned out to be an embarrassment.

Two days later in a report published in his hometown paper, the *Los Angeles Times,* Simon denied that he had admitted purchasing a smuggled bronze.

> I knew that the piece had been in the possession of a prominent Bombay art dealer who had openly presented it for sale over several years, which he could not have done without the knowledge of the Indian government.
>
> There is no question in my mind that I bought this bronze from its rightful owner and that I have clear title to it.
>
> I have long been interested in the progress of the United Nations' draft treaty that would prohibit countries from importing or exporting suspect works by art. As a collector deeply and emotionally involved in art, I deplore the rape of art treasures of any country.
>
> Should the treaty be adopted and signed by the United States, under conditions that would make governments like the Indian government responsible for barring exportation of smuggled art, while making the country of entry accountable for its art importations, I would seriously consider giving the *Nataraja* sculpture to an Indian national museum. But I will never do so while unfounded claims are being made that I bought a work whose title is clouded.[13]

20

AN EYE FOR THE OLD MASTERS

*When Norton's eyes turn onto a painting, passion develops.
In terms of art, love is priceless.*

JENNIFER JONES SIMON
Los Angeles Times, *24 April 1980*

FROM THE MOMENT HE BEGAN collecting in earnest, Simon did not follow a single, predictable path. He had a natural affinity for French impressionism, but he bought a few contemporary pieces of art, occasionally dipped into antiquities, and amassed a considerable number of old masters before plunging into the Asian art market in the 1970s. Even as he explored the territory of Indian and Southeast Asian art with astonishing vigor during the 1970s, he continued to buy European art. Within his widely varied collection he built significant holdings of monumental figurative sculpture by Henry Moore, Aristide Maillol, and Auguste Rodin. As time went on, his interest in European art shifted from the nineteenth century and early twentieth centuries to earlier periods. Part of the attraction was that older works were often less expensive than the more recently created art was, and, in his view, a better buy. But once he became seriously involved in the old master market, he bought at the high end. In one spectacular deal after another, he landed the paintings from the fourteenth through the eighteenth centuries that have become cornerstones of his collection.

One of these jewels came to him in December 1969 from an impoverished Benedictine community in England. A new monastery was under construction in the village of Prinknash in Gloucester-

shire, but funds had run out. To avoid delaying the project and probably increasing its cost in the long run, the monks decided to sell some of the artistic treasures given to their community over the years. The best piece was *The Flight into Egypt*, an exquisite painting by the sixteenth-century Italian artist Jacopo da Ponte, who is called Bassano after his hometown, near Venice. Influenced by his more famous contemporaries, Titian, Veronese, Tintoretto, and the mannerist Francesco Mazzola Parmigianino, Bassano distinguished himself as an innovative painter of rustic genre scenes. His unusual interpretation of the Biblical story portrays the Holy Family with an athletic angel as a guide. Joseph, surrounded by swirling, orange drapery, leads a donkey carrying the Madonna and Child through a verdant country landscape populated by peasants, chickens, and a dog.

The Bassano had been a gift of H. S. Goodhart Rendel, the architect of the original monastery who is buried in the crypt at Prinknash. The monks knew that the painting was special, but they entirely underestimated its value. Hoping to sell it together with several less distinguished pictures for a total of about $100,000, they consigned the works to Christie's in London. Simon bought the Bassano alone for $655,118. He congratulated himself for getting a bargain, while members of the religious community believed their prayer had been answered, more than sixfold. "This near-miracle means that the monks now have sufficient funds almost to complete the monastery, though not the abbey church," a Benedictine publication reported.[1]

In another case of brilliant opportunism—this time coupled with international tragedy and intrigue—Simon acquired the near life-size paintings *Adam* and *Eve* painted around 1530 by the German artist Lucas Cranach the Elder. Count Alexander Stroganoff, the first president of the Academy of Arts of Russia and a friend of Catherine the Great, founded a celebrated collection and built a palace to house it in St. Petersburg in 1764. His descendants added to the collection, enhancing the trove of paintings, sculpture, tapestries, furniture, and coins, but it was confiscated by the Bolshevik government in 1918 and many of the artworks were transferred to the State Hermitage Museum.

In dire need of foreign currency in the late 1920s and early 1930s,

the Soviet government began to sell off some of its best works of art. About two hundred pieces from the Stroganoff collection were sent to an auction in Berlin in May 1931. The sale at Lepke auction house was publicized as if the Stroganoff family and not the Soviet government had consigned the art. Affronted both by the prospect of having their heirlooms sold for the benefit of the state and by the government's underhanded approach, members of the family protested the auction. They were unable to stop it, but their objections cast doubt on the legality of the sale, and prices were lower than the government expected.

Jacques Goudstikker, the best-known dealer in Amsterdam, purchased the Cranachs and added them to his valuable inventory. The two panels, depicting sensuous, nude figures in the Garden of Eden, were still at his gallery on 10 May 1940, when he died in an accident aboard a ship. He and his family, who were Jewish, were fleeing the Netherlands to avoid being captured by the Nazis. The Goudstikkers were crossing the English Channel, on a ship ultimately bound for South America, when the vessel was attacked by German dive bombers and the men on board were ordered into the hold. Venturing up on deck for some fresh air after the danger seemed to be over, Goudstikker stumbled and fell to his death through an uncovered hatch.[2]

Hermann Göring, a member of Hitler's inner circle who had an upper-class background and a lust for fine art, subsequently appropriated Goudstikker's inventory, including the Cranachs. In 1945, when the United States Army retrieved Göring's collection, the confiscated artworks were sent to a central clearing house in Munich, where attempts were made to return them to their rightful owners. If the owners could not be found, the artworks were sent back to the countries from which the Nazis had confiscated them. The Cranachs were returned to the Netherlands to be held in trust, should the heirs appear.

After the war Goudstikker's heirs did not claim the Cranachs taken from his gallery by the Nazis. Count Paul Stroganoff, the last member of the family that had owned the Stroganoff collection, died in 1923, before the auction in Berlin, but he was survived by an enterprising

nephew, Prince George Stroganoff Scherbatoff. In 1962, seventeen years after the war had ended, Scherbatoff heard of the whereabouts of the Cranachs and attempted to get them back.[3] Scherbatoff had lived quite well on money secreted out of Russia by his uncle and he had supplemented his inheritance with an unusual military career. As a youth, he fought with the White Russians in the Black Sea area, then became a communications expert in England, studied at Oxford, and eventually joined the United States Navy, rising to the rank of commander. But the family money was running out by the time he found the Cranachs. It took four years and the help of an expert in international law for Scherbatoff to establish himself as the legal heir to the paintings. When he eventually took possession of the Cranachs, in 1966, he saw them as a source of income that would secure his comfort for the rest of his life.

Scherbatoff, who moved easily from one country to another, was living in Zurich when the Netherlands honored his claim. He subsequently met and became a good friend of Spencer A. Samuels, an art dealer who began his career at his father's firm, French and Company, and had worked for Edward Fowles at Duveen Brothers before establishing his own gallery in New York. Curious about the value of the paintings and concerned about their authenticity, Scherbatoff asked Samuels to look at them. He agreed and asked Scherbatoff to have them sent from Amsterdam to Zurich.

"I went over there and I remember it was a very tense moment," Samuels said. "The life-size paintings by Cranach were in large crates that looked like coffins. We finally got the customs officers to open the crates for us. I looked at the paintings and I knew immediately that they were right. I was absolutely overjoyed in seeing them myself and overjoyed for my great friend who did not have a lot of money. We were very happy. I remember we dined very well that night."

Samuels undertook to sell the Cranachs for Scherbatoff. The paintings were kept in storage in Zurich for awhile, then transported to the dealer's gallery in Manhattan where he installed them as star attractions on a paneled wall in his back office, covered by a curtain. When special clients stopped by, he would invite them into his inner

sanctum and pull back the curtain. Simon was among the first clients to whom Samuels mentioned the Cranachs, but it took more than four years to consummate the deal.

Samuels first offered the Cranachs to Simon in September 1966 for $1.2 million, but got no encouragement until the following May, when Simon's secretary, Angelina Boaz, called to inquire about the paintings. Samuels was negotiating with another client by then, but when their talks reached an impasse he began to pursue Simon again. While considering the purchase—at an excruciatingly slow pace, from Samuels's point of view—Simon became concerned about the condition of the paintings, areas of which had been restored. In addition, some art historians were wondering whether they really were the work of Cranach or simply a product of his workshop. Samuels reluctantly sent Simon X-rays of the paintings so that he could examine their condition, and he passed them on to Ben Johnson, the conservator at the Los Angeles County Museum of Art. Johnson was not impressed. In February 1969, James M. Brown, director of the Hunt Foods & Industries Museum of Art, wrote to Samuels saying, "After inspecting the photographs and the X-rays, we feel that the past restoration and apparent additional required work makes it necessary for us to decline your offer since we feel that the price of the paintings is considerably higher than warranted."[4]

Samuels shot back a letter describing the pitfalls of judging artworks by X-rays and arguing that the best qualities of the Cranachs were not apparent in either X-rays or photographs. He urged Brown and Johnson to see the actual paintings in New York, and added that the price was negotiable. They did not make the suggested trip, but discussions continued and early in March 1970, Samuels sent the paintings to Simon for his inspection. In the meantime, Simon had raised the possibility of trading one or more works in his collection as partial payment for the Cranachs, should he decide to buy them. Samuels agreed to consider that option, but said the transaction— regardless of how it was done—must be completed by March 27.

Pushed to make a decision, Simon took an option to buy the paintings, but at the substantially reduced price of $800,000. Samuels drew up a letter of agreement providing for payments amounting to $300,000 in cash and the balance in promissory notes

to be paid over five years. Samuels was beginning to think he was achieving a sale, but Simon decided that he wanted to restructure the sale so that he could trade paintings as partial payment. Six weeks after writing the first agreement, Samuels drafted a new one calling for $200,000 in cash payments, $250,000 in the form of five early twentieth-century French paintings from Simon's collection (three paintings by Édouard Vuillard, one by Georges Rouault, and one by Albert Marquet), and the balance, $350,000, in promissory notes.

In January 1971, the five paintings to be traded were shipped to New York. But even then Simon hadn't stopped tinkering with the transaction. A year later, he decided that he wanted to buy up the promissory notes at a 10-percent discount. "I'm not sure I would have given it to him," Samuels said, "but George was getting along in years. He wanted the money, and he wanted it now, so he agreed. He used it to buy a house and horses in Litchfield, Connecticut, and lived there very happily for the rest of his life."

Some of Simon's delays can be chalked up to a daunting schedule of daily activities, overloaded with the demands of his business, political ventures, and public service. He also stalled to give himself and his staff time to research potential purchases and to wear the dealers down, so they would sell at a reduced price. Although the reasons for postponing any particular decision varied, he had a reputation among dealers as a relentless negotiator and reluctant deal-closer. Yet he was capable of making extremely quick decisions at auctions and in other situations when he knew he had a serious rival. The dealers who knew him best occasionally used Simon's competitive streak to their own advantage. In one spectacular case, involving Francisco de Zurbarán's *Still Life With Lemons, Oranges and a Rose,* an elegant Spanish painting that is one of the most admired works in his collection, Simon considered buying it for months but agreed to the purchase only when Eugene Thaw and his colleague, Stanley Moss, a dealer in New York, deceived him into believing that the Louvre was about to buy it.[5]

The painting, which was in storage in Zurich, was being sold in the spring of 1972 by heirs of the Italian collector and dealer Alessandro Contini Bonacossi, who had provided Samuel Kress with many of the old master works now in the National Gallery of Art in Wash-

ington. Part of a cache of rare works that remained in private hands after thirty-five other pieces in the estate had been donated to Italy for display at the Uffizi Gallery in Florence, the Zurbarán had caught the interest of several prominent museums and collectors. "Norton had been toying with that picture for ages. So had the National Gallery in Washington. A lot of people had been playing with it," Thaw said. When a rumor arose that the chief curator at the Louvre was planning to go to Switzerland to see the painting and arrange to buy it, Thaw and Moss decided to present the rumor to Simon as if it were fact. "We got him on the phone on a Sunday and told him that the Louvre's representatives were going to Zurich the next week," Thaw said, "and sure enough, we got Norton and Stanley on planes the next day, and Norton bought it. I used a friend of mine who was a banker in Zurich for the financial transaction. It was done virtually overnight—but only by telling him that the Louvre was going to try to get it. That's what pushed him over the line. He was able to be very decisive when he felt that there was that wind at his back."[6]

Simon had considered buying the Zurbarán still life off and on during the turbulent months when he was running for election to the Senate, his son committed suicide, and he was being divorced by Lucille. He bought the picture in April 1972 for $2.75 million, about ten months after he had married Jennifer Jones. The Hollywood gossip columnist Joyce Haber heard about the new acquisition three months later, when the painting was being lent to the Metropolitan Museum of Art in New York. Although the Zurbarán had been purchased by Simon's foundation for public display, Haber informed her readers that "multimillionaire art collector Norton Simon finally found a suitable wedding present for Jennifer Jones. It's a seventeenth-century still life by Spanish court painter Francisco de Zurbarán."[7]

Simon took great pride in the Zurbarán, once he had it. When he unveiled another spectacular old master acquisition, Raphael's *Madonna and Child with Book*, late in 1972 at Princeton, he told reporters: "For a long time it has been my great desire to have a masterpiece from the High Renaissance in our corporate collection. I am gratified that we could acquire the painting in time for the Princeton

exhibition. I consider the Raphael, along with the Zurbarán still life and the Rembrandt *Titus* as the greatest acquisitions in twenty years of collecting."[8]

It was a very good year for Simon and old masters. Although 1972 was also his first full year of collecting Asian art—during which he purchased eighty pieces—he spent more than $8 million on old masters. In addition to the Raphael, which cost $3 million, and the $2.75-million Zurbarán, he bought *David Slaying Goliath* by the Flemish master Peter Paul Rubens for $500,000 and Guariento di Arpo's masterpiece, *The Coronation of the Virgin Altarpiece,* for $631,214.

In the Guariento, Simon acquired an impressive composition of Biblical scenes executed in tempera and gold leaf on wood panels. Measuring seven feet tall and nearly nine feet wide, it's the only fourteenth-century polyptych of its size and quality in the United States. But he overpaid. The Guariento had been consigned to the Colnaghi gallery in New York in previous years and had at the time been offered to Simon and to J. Paul Getty. Both men had turned it down. Getty was interested, but he told his curator in Los Angeles that he didn't want to spend several hundred thousand dollars to buy it. Simon had the painting shipped to California on approval, but sent it back to New York. Unknown to the other, both Simon and Getty changed their minds in July 1972, when the altarpiece went on the auction block at Christie's in London. Their representatives bid against each other, with Simon winning.

When Getty's curator, Burton Fredericksen, learned that Simon had bought the Guariento, he was appalled to find that he had bid against another collector from Los Angeles and unwittingly run up the purchase price. Fredericksen told Darryl Isley that he had been the underbidder and that Simon had paid a hundred thousand dollars more than he should have. Because Simon had already taken the painting on approval and returned it, Fredericksen had assumed he wouldn't bid on it at auction. To avoid unnecessary competition in the future, Fredericksen suggested that he and Simon improve their lines of communication. They did not bid against each other again.

Although Simon liked to attend important auctions and bid for himself or in cooperation with dealers, he sometimes assigned the

starring role to his wife, Jennifer Jones. She was in an international spotlight in April 1980 at Sotheby Parke Bernet in London, when she was credited with making the winning bid of $3.7 million for a rare example of the work of the fifteenth-century Flemish painter Dieric Bouts. *The Resurrection,* delicately painted on linen, depicts Christ stepping from the tomb. Works by Bouts so rarely come on the market that the auction house didn't know what to expect from the sale. The painting commanded the highest price ever paid at Sotheby Parke Bernet at the time and more than seven times its estimated value.

Although newspapers reported the sale as a coup deftly managed by Jones, the whack of the auctioneer's gavel actually signaled the end of frantic, behind-the-scenes activity, with David Bull, the director of the Norton Simon Museum in the hot seat. "The sale was on a Wednesday in London," Bull said. "On Monday I got a call to come to Simon's house in Malibu prepared to fly to London, but he didn't know whether I would actually go or not. He had made reservations for me on a bunch of consecutive flights and he had booked a reservation for Jennifer Jones. I sat around for hours until he eventually decided I should go. When I asked him what I should bid, he said he wouldn't know until he found out how the pieces he was selling in the same auction did. My instructions were to call him after I had seen the painting in London."[9]

Bull flew to London, got a few hours sleep, and saw the painting. When he called Simon he received permission to bid on the Bouts, but the plan was far from straightforward. "We're going to have some fun," Simon said. Then he instructed Bull to get three plain envelopes and label them *A, B,* and *C,* as if they contained three different sets of instructions. Simon said he would be on the phone with Tim Llewelyn, the assistant to Derek Johns, the auctioneer. Bull would have the envelopes in his pocket. Simon would tell Johns which envelope to open and Johns, in turn, would signal Bull, who would open the proper envelope and follow the instructions.

When Johns was told of the plan he was furious. "We can't play games like that," he told Bull. "It's hard enough to hold an auction without this nonsense." It was only a ruse. The envelopes were empty and they weren't used. Instead, Johns took directions from Simon

over the phone. Bull was instructed to continue bidding by making eye contact with the auctioneer as long Johns held the phone to his left ear. If he moved the receiver to his right ear, Bull was to stop. As the competition neared its climax, Julian Agnew, on behalf of the National Gallery in London, was bidding against Simon. When Simon got the Bouts, Llewelyn announced, as planned; "Sold to Jennifer Jones Simon on behalf of the Norton Simon Museum."

Derek Johns heaved a sigh of relief when the sale ended and Bull gave him the empty envelopes as a souvenir of a tense night. Simon had conceived the wacky plan to be sure he got maximum publicity at the sale, no matter how it turned out. With Jennifer Jones in the audience, everyone knew that Simon would be bidding on the Bouts. "If he didn't get the painting and he used the envelopes, he would get publicity for that," Bull said.[10]

Reached by telephone in Los Angeles after the sale, Simon told a reporter that he was delighted. "I don't know of a Northern Renaissance picture of this quality that has come on the market in all the years I've been collecting," he said. "The National Gallery in London has the companion piece. They were bidding against us. We went close to the last mile on the price. If you take the fees and whatnot into account, the price was really about $4.2 million. I think it's thrilling. We should have something besides cowboys here in the Far West."[11]

The auction houses were a public forum that Simon loved to use to the hilt. But buying at auction entailed risks. It was sometimes difficult to determine the condition of works offered for sale. In the case of old masters, which had accumulated several centuries of wear and sometimes had been clumsily restored, the dangers were compounded. He took a chance on the condition of Giovanni di Paolo's painting *The Branchini Madonna,* a fifteenth-century altarpiece commissioned for the Branchini family chapel in Siena. Simon bought it for $923,500, the highest price paid at Sotheby Parke Bernet's celebrated auction of Baron Robert von Hirsch's estate, held in 1978 in London. But the gamble paid off. Indeed, his purchase turned out to be something of a bargain. The Madonna's blue robe had been overpainted so completely that conservators couldn't determine whether the underlying painting were intact. Marco Grassi,

who was Baron von Thyssen's conservator in Switzerland but had set up a workshop in New York in the early 1970s, cleaned and restored it beautifully, and Simon gained a masterpiece. "That was one of the bravest things he did," Agnew said of Simon's purchase. "He bought the painting for not an enormous amount of money at the time because everybody else was too scared to buy it. It turned out that most of the original blue was there underneath. It was a major coup to have bought that painting."[12]

Grassi also worked miracles on a large painting by Giovanni Battista Tiepolo that came from the Contini Bonacossi collection and was purchased from Thaw in 1972 for more than $1 million. Designed for a ceiling in the Palazzo Manin in Venice, the frothy confection of airborne characters portraying *The Triumph of Virtue over Ignorance* is an Italian rococo canvas that had been hideously overpainted. "That was a difficult project because I was working in my house at the time, and that ceiling was so big, I had to do the work in a warehouse," said Grassi, one of several prominent conservators who worked for Simon and found him an unusual and time-consuming collector. He took a great deal of interest in their work on his collection, but he also picked their brains. Grassi described his methods:

> I spoke with him frequently by telephone. He would call me
> in Europe when I was still working in Lugano. If I was in
> London, he would ask me to look at things in the sales there.
> On a number of occasions he came to see me. With Simon
> there was always the personal aspect. He always established a
> kind of personal rapport, which was very winning, especially
> for someone for whom he could be an important client.
> He didn't treat you like trade. He was someone who took
> an interest in your life, and kind of got involved, which was
> very nice. He would invite you to his house.
> I never got involved in negotiations with him, or the
> kind of conflict you would get into negotiating with him.
> But in the end, everything was a negotiation. He was always
> trying to elicit information and weigh what he got from
> you against information he got from others. This was what
> always came across in his manner, and his personality made

you a part of his process. He didn't deal with you at arm's length. He was very, very close to you when you were with him. That inevitably gave you the impression that you were really his adviser or his fount of information. And of course it wasn't true at all. He would simply factor your information in with all the information he got from others. It was his manner that elicited all this information, and he was brilliant at that.[13]

Simon was concerned about the condition of his entire collection, but his increasing interest in old masters inevitably called for more and more conservation. In addition, work on pieces that he had acquired in the Duveen inventory continued for many years in an effort to sort out questionable attributions and preserve the best works. Visiting conservators were frequently asked for advice, and sometimes pressed into service on artworks that were squirreled away in storage. "Once," said Mario Modestini, a conservator who worked in New York, "when I was at the museum in Pasadena he said, 'Mario, I have a painting left over from those I bought from Duveen. It was a completely repainted painting that looked like the school of Botticelli, painted in the nineteenth or twentieth century.'" Listed in the Duveen inventory as a Botticelli, it was valued at $82,682.66 in 1964. Simon had exhibited it at the Los Angeles County Museum of Art, in the rush of excitement over the museum's opening and his acquisition of Duveen Brothers, but the painting had long since been relegated to storage.

Modestini scoffed at the notion of wasting time on something so obviously worthless. "I said, 'Norton, it's a fake. It's nothing. Forget it.' But Simon said, 'There must be something underneath. Do me a favor and clean it.' So I took the painting to New York. I cleaned it and indeed there was a real Botticelli. He was absolutely right. When I removed the painting that was on top, it came out, not in good condition, but beautiful and absolutely a Botticelli. It was a real discovery, to find a real painting under the restoration."[14]

Unknown to Modestini, Simon had had good reason to believe there was a genuine Botticelli under the suspiciously bright, Christmas card-like painting. Before Modestini paid his visit to Pasadena,

Selma Holo, Simon's curator, had received a call from a conservator who was coming from the East Coast to the Getty Museum to look at the Billy Suhr archive, a record of the restorations done by Suhr, a prominent conservator. The name meant little to Holo at the time, but Simon became extremely excited when he heard that the archive was in Los Angeles. From past conversations with Ric Brown who, in New York during his tenure at the Frick Collection, had consulted with Suhr, and Simon's own experience when Suhr cleaned Rembrandt's *Portrait of Hendricke Stoeffels,* he knew the man as a brilliant conservator who had worked on Renaissance paintings for many prominent clients. He had restored paintings in some of the nation's best museums, but his work sometimes obscured the original artist's hand, particularly in Italian pictures. Following a tradition of restorers who reinterpreted artworks made hundreds of years earlier to suit the taste of their times, he had been criticized for creating "a Billy Suhr look."

"He's the greatest Renaissance painter that ever lived," Simon told Holo, repeating a comment about Suhr that had made the rounds of the art world. Simon insisted that she go immediately to the Getty and see what was in the archive. As she sifted through the material, she came across photographs and documentation on Simon's Botticelli that explained its artificial appearance: Suhr had repainted it so extensively that much of the original work was hidden. Modestini proved the point by removing Suhr's additions and giving Simon a thinly painted but well-drawn Botticelli that deserved a place in his museum.[15]

21

WEEDING OUT AND CASHING IN

*The Sotheby Parke Bernet auction of "Important Nineteenth-
and Twentieth-Century Paintings, Drawings and Sculptures" on the
evening of May 2 is remarkable in that it includes a substantial number
of works collected by Norton Simon, the most stylishly
egocentric of our major collectors.*

STEPHEN SPECTOR
Art in America, *May/June 1973*

CONSTANTLY CHURNING through an ever-increasing volume of hold-
ings, Simon established himself as an aggressive buyer of art and a
major seller. Some pieces he sold quietly or traded; others went to
highly publicized auctions. In 1971, a year after he and Lucille were
divorced and about a month before he married Jennifer Jones,
Simon consigned 317 pieces to Parke-Bernet auction house in New
York. The most valuable works, a group of 74 paintings, went on the
block at a glamorous evening sale early in May. They brought in a
total of $6,506,300, reportedly the highest sum ever for an art auc-
tion in America. The auctioneer, Peter Wilson, called the event "a
real shot in the arm for the art market."[1]

Simon was selling works by thirty nineteenth- and twentieth-cen-
tury artists, including nine pieces by Honoré Daumier, eight by
Edgar Degas, and five each by Eugène Boudin, Aristide Maillol, and
Pablo Picasso. Vincent van Gogh's *St. Paul's Hospital at Saint-Rémy,*
an expressionistic landscape depicting the institution where the artist
had spent a year before he took his own life, brought the top price of
$1.2 million. Another collector in Los Angeles, the magnate Armand

Hammer, was the buyer. Simon had bought the painting ten years earlier for $380,000, so he was pleased with his profit. Later, as prices for Van Gogh's paintings escalated wildly—reaching $82.5 million in May 1990, when the Japanese industrialist Ryoei Saito paid that for the *Portrait of Dr. Gachet*—Hammer congratulated himself on snapping up a bargain.

Saito's bid only added to Hammer's pleasure about the private sale of another late Van Gogh that had made front-page news a couple of months earlier. The purchase by the J. Paul Getty Museum of *Irises,* a painting depicting a bed of flowers in St. Paul's Hospital garden, was the final chapter in a saga that seemed to epitomize the heady rise and precipitous fall of the art market in the late 1980s. Two and a half years before the Getty acquired the painting, it had been sold by Sotheby's in New York to the Australian businessman Alan Bond for the then-unthinkable price of $53.9 million. Soon after the sale it was revealed that the auction house had lent Bond money to buy the Van Gogh, using the painting itself as collateral. Critics charged that Sotheby's had rigged the sale to inflate the price of the painting. Auction house officials defended the financing scheme, but Bond defaulted on the payments and returned the painting, leaving Sotheby's to unload a world-famous picture without sullying its own reputation or devaluing the piece itself. After many months of behind-the-scenes negotiations, Sotheby's and the Getty struck a deal for an undisclosed sum. While art aficionados speculated about whether the Getty had paid more or less than $53.9 million for *Irises,* Hammer boasted that the value of his own Van Gogh had appreciated to hundreds of millions of dollars because it portrayed the entire hospital and its grounds, not merely a corner of the garden.[2]

In the sale of Simon's holdings of 1971, Hammer also bought Paul Gauguin's painting, *Self-Portrait with Palette,* (1891) for $420,000. The sale established an auction record for Gauguin's work and gave a tidy profit to Simon who had bought the portrait in 1964 for $275,000. When the auction ended, Simon had more than doubled his money on several other items. He had purchased Paul Cézanne's tiny painting, *Bathers,* in 1962 for $56,000, a high price at the time for so small a piece—it measures only 13¾ by 8¾ inches; it was sold for $120,000. A much larger painting of waterlilies by

Claude Monet, bought by Simon in 1968 for $100,000, fetched $320,000. He also did well with *Danseuses Basculant (Danseuse Verte)*, a pastel and gouache bird's-eye view of twirling ballerinas by Edgar Degas. Simon had paid $303,165 for the work in 1963 at Arthur Tooth & Sons, Ltd. in London. Baron von Thyssen Bornemiza purchased it for $530,000 at the auction.

The remaining 243 items, consisting of old master drawings and decorative objects, most acquired in the Duveen inventory, were sold for a total of $1,039,980 in a two-day extravaganza a few days later. Selling prices ranged from $80 for a Sèvres milk jug to $190,000 for a set of four eighteenth-century Gobelins tapestries based on drawings of mythological characters by François Boucher and Maurice Jacques.

The following year Simon consigned several works to Christie's in New York, including a scene of Argenteuil by Claude Monet, which was sold for $411,500. Simon had purchased the impressionist landscape in 1964 for $134,000. Two other French impressionist paintings, a Renoir and a Degas, failed to meet the minimum bids that Simon had established, so he kept them.

In another effort to prune his collection while raising money to buy more art, Simon offered forty-seven impressionist and post-impressionist works for sale in 1973 at Sotheby Parke Bernet in New York. Ten works—two each by Cézanne, Degas, and Renoir, and one each by Braque, Daumier, Forain and Géricault—came from his private collection; the remaining thirty-seven were consigned by two of his foundations. The auction, which was open only to those who had tickets, attracted an array of international collectors and resulted in $6,782,900 in sales, a record for a auction of paintings at the time.[3] But accounts in the newspapers didn't tell the whole story. The actual total was about $4 million because the two most expensive items were not actually sold.

Cézanne's painting, *Tulips in a Vase,* was reported to have been purchased by Wildenstein & Company of New York for $1.4 million; certainly the gallery's representative made the last bid. But, as sellers often do, Simon had stipulated a reserve, or minimum, selling price. For this painting, it was $1.5 million. To avoid embarassing publicity, should the Cézanne fail to reach the expected price, he had mailed Wildenstein a

check for $1.5 million to be used for bids on his behalf, if competition for the painting stopped before it reached that sum. After the auction, Wildenstein returned the check along with the Cézanne.

According to the press, a second painting, Édouard Manet's *Still Life with Fish and Shrimp* purchased by Simon in 1959 for $110,000, was also sold to Wildenstein for $1.4 million at the auction. Once again, a Wildenstein representative had apparently made the last bid. But the painting actually had been "bought in" by the auction house, which had guaranteed Simon a minimum selling price of $1.5 million. Unlike the more commonly used reserve system, the guarantee provided that, if the bids for the Manet didn't reach $1.5 million, the auction house would pay Simon that sum, take possession of the painting, and try to recoup its investment by selling it privately.

As months and then years went by, Sotheby Parke Bernet offered the Manet to various dealers and collectors. Agnew took it on consignment for awhile in London, Thaw showed it to some of his clients in New York and several other dealers tried to find a buyer, to no avail. Simon was watching from the sidelines with increasing interest. He began to make bids to buy the painting back, but at a vastly reduced price. At first the auction house officials declined his offers. But after five years had passed, they still had the painting and few prospects of selling it without taking a considerable loss. Eager to conclude the extremely frustrating and wearisome affair, they made a deal—with a typical twist of Simonesque complexity.

When *The Branchini Madonna* by Giovanni di Paolo was scheduled to come up for sale in June 1978, as the star attraction of an auction of Robert von Hirsch's holdings at Sotheby Park Bernet in London, auction house officials agreed that, if Simon bought that painting or was even the underbidder, placing the next-to-last bid, he could buy the Manet back for $400,000. He bought the Madonna for $923,500 and reacquired the Manet for less than the guaranteed price that the auction house had paid him for the Manet alone. "He was never happier," said Sotheby Parke Bernet's impressionist specialist and director David Nash, recalling the strange turn of events.

When the Manet and the Cézanne turned up in the 1973 auction, some art critics and journalists who were unaware of his arrangements

with Wildenstein and Sotheby Parke Bernet wondered why Simon would sell such important pieces. He claimed that he was refining and broadening his collections. "I like more kinds of art now than I used to. I like things from different countries and periods. I want the best of them represented in my collections." Simon said he still liked impressionist and post-impressionist paintings of the kind he had sold, but now preferred to buy Asian art and old masters. Noting that he had spent $20 million on art the previous year, he insisted he was not slowing down or liquidating his art holdings. "My buying has been far greater than my selling," he said. "I think I have bought better than I have sold. You don't always sell at the right point, and you don't always buy at the right point. My batting average is, however, better than fair, I think."[4]

Indeed, many items that really were sold at the auction in 1973 yielded a considerable profit for Simon. He had purchased Dégas's gouache and pastel *Répétition de Ballet* in 1965 for $410,000; Sotheby's sold it to Marlborough Fine Art for $780,000. Cézanne's *Still Life with Blue Pot,* for which Simon had paid $406,000 in 1967, was sold for $620,000 to an unidentified private collector in Switzerland. The watercolor went on the block again at Sotheby's in London in 1980 and was sold to the French actor and collector Alain Delon. Three years later the much-traveled Cézanne returned to southern California and is in the collection of the J. Paul Getty Museum.

Prices were important to Simon, who sometimes seemed fanatical in his compulsion to get a good deal. He would pay top prices when the occasion demanded it, but he could be so mercurial that his associates never knew what to expect. He took a chance in buying *The Branchini Madonna,* but the gamble paid off. Sometimes he was more cautious. Hammer Galleries of New York, of which Armand Hammer was president and co-owner, bought a badly soiled painting, *Tahitian Woman and Boy* by Gauguin, in 1964 for $252,000. Offered in a million-dollar sale of impressionist and modern paintings at Sotheby's in London, the Gauguin was in the last shipment the artist sent from the South Pacific to his dealer in Paris. The painting had been hidden away in a Scottish castle for forty years and it was the subject of great deal of interest when it was described in the auction catalogue, but Simon declined to bid on it. Less than two months

later, after Hammer had had the painting cleaned, he shipped it to Los Angeles and personally delivered it to Simon, who immediately agreed to buy it for $365,000. Simon thought himself frightfully clever; Hammer was pleased to be able to turn a quick profit at the expense of a knowledgeable competitor.[5] Of the painting, which depicts two dark-eyed figures who look directly at their audience, their quiet poses and placid expressions seeming to belie their inner feelings, Simon said, "I loved the picture because it's different. It has a highly emotional theme, but at the same time there's an emotional calm about it."

To aesthetic purists and to dealers who thought they had spent too much time with Simon for too little return, it often seemed that Simon's passion for art was tempered—if not entirely governed—by his keen awareness of its market value. "He knew the price of everything and the value of nothing."[6]

Simon himself fanned the flames of doubt about his commitment to art from time to time when he declared that he could sell his entire collection and never look back. "The thing that amazed me is that if he got a good enough price he would have sold anything," Nash said. "There was a time around 1973 when there was a huge amount of money in Iran and the Shah was buying art, or so we heard. I was sent to get the Shah interested in buying paintings at auction. As a foot in the door, Peter Wilson and I went to see Norton and said, 'What would you sell?' And he said, 'Hell, I'd sell anything.' So he gave me a bunch of transparencies and a price list and off I went to Iran to induce the Shah into buying. There were very few paintings that Norton wouldn't have let go." The trip was made in vain. Nash was turned away without even meeting the Shah, much less making him an offer, so none of Simon's art wound up in Iran.[7]

Items did however, move from his collections to other museums and galleries. E. V. Thaw & Company of New York was one of Simon's primary sources of art; the owner, Eugene Thaw, was also a major buyer. He bought Cézanne's *Portrait of a Peasant* in 1973 for $1 million, giving Simon a huge profit on a painting that he had purchased seventeen years earlier for $70,000. In 1974 Thaw paid Simon $1 million for *Open Window in Paris,* an important cubist painting by Picasso, and

$350,000 for Matisse's painting of an elaborately costumed woman in an interior, *The Small Blue Dress, Before a Mirror,* produced in 1937. Simon had bought the Picasso in 1966 for $225,000 and the Matisse in 1968 for $130,000. On another occasion Thaw bought a painting from Simon at a vastly appreciated price, and when it turned up at another gallery in New York three years later, Simon bought it back for a lower sum. The painting was Pissarro's *The Poultry Market at Pontoise,* which Simon acquired in 1967 for $140,000. Thaw bought it in 1981 for $950,000 and sold to another client. In 1984 the picture was back on the market at Acquavella Galleries, where Simon reacquired it for $750,000, making an additional $200,000 profit on a painting he now had back in his collection. In 1982 Thaw bought Renoir's *Girl in Yellow Hat* for $1 million; in 1969 Simon had paid $425,000 for it. An avid collector himself, Thaw also bought many old master drawings from Simon and later donated them to the Pierpont Morgan Library in New York.[8]

Working with Thaw as the buyer's agent, Simon sold part of a collection of drawings to Thomas Agnew & Sons of London. He had bought an album of sixty drawings by the seventeenth-century French landscape painter Claude Lorrain in 1970 for $1 million. In 1980 he decided to sell most of the collection because it was impossible to display the entire group satisfactorily and the drawings, although important to scholars, excited little public interest. Agnew agreed to pay $4.42 million for fifty-three of the drawings, but then Simon had great difficulty deciding which seven to keep. "We went on for about six months, juggling back and forth over whether he should keep this one instead of that one," Thaw said. "He was worried that he wasn't going to keep the right few, and he had to feel that he was outfoxing me in some way or the deal wouldn't have had the satisfactory resonance. He finally wears you down, so you say, 'All right. Take whatever you want.' In the end he got a nice little assortment of Claude drawings, which he needed because he was weak in Claude paintings."[9]

In yet another multimillion-dollar sale of a significant art asset, Simon in 1982 sold Picasso's 1906 painting *Nude Combing Her Hair* to the Kimbell Art Museum in Fort Worth, Texas. Edmund P. Pillsbury, the director of the Kimbell, described the acquisition as "one of

the most important events" in the museum's ten-year history and the painting as "a work of incomparable beauty and force, certainly equal in quality to the finest old masters in the collection." In a press release the painting was said, rather vaguely, to have come from "a distinguished art collection of a corporate foundation in Southern California," but the painting was so well known that reporters immediately supplied the missing name. Once again, Simon had sold an important piece at an enormous profit. He had purchased the Picasso in 1968 for $680,000; the Kimbell bought it for $4 million.

Some of these transactions baffled art professionals who couldn't understand why he would let such good things go, even at an enormous profit. Simon was also criticized for behaving more as a dealer himself than as a collector engaged in the accepted practice of refining his holdings. "One part of him knew there was almost no price that was out of the question for something great and rare," said John Walsh, the director of the J. Paul Getty Museum. "But once he had something and got used to it, he could think of selling it. He was constantly looking over the balance sheet."[10] Indeed, Simon would weigh his short-term aesthetic losses against what he believed would be long-term gains. He argued that relatively modern pieces that were expensive because they were in demand were often less important than were works that were older, rarer, and comparatively cheap. His logic often defied conventional wisdom, but he won qualified respect for his business acumen from people in the trade. "I think the amazing thing is how much Norton bought with how little money," Nash said. "He bought a lot with recycled money."[11]

Asked, several years after he had stopped collecting, if he regretted the loss of any works he had sold, Simon replied: "I'd have to look at what I did with the money to answer that. I usually sold to buy something else, and you have to measure what you get against what you paid for it. But if you are asking me to make up a sorry list, that's a different story."[12]

22

A SUITABLE HOME

*The transformation in Pasadena puts a great deal at stake in the
contemporary art community—dealers' commissions, artists'
reputations, curators' jobs, and the feeling that the entire philosophical
apparatus behind [the Pasadena Museum of Modern Art] languishes
along with the institution. Yet not even those with most at stake
wanted to knock the virtue of Simon's princely collection's finding
a permanent base in the Southland.*

WILLIAM WILSON
Los Angeles Times, *29 April 1974*

DURING THE DECADE between the mid-1960s and the mid-1970s,
Simon's collecting career was at its most frenetic. He was not only
buying enormous numbers of artworks in widely diverse fields, but
also carrying out an ambitious program of exhibitions and long-term
loans to museums and university galleries across the nation. In 1966,
when Simon gave up his plan to build a home for his collection in
Fullerton, he said he would use the money he had planned to spend
to acquire more art and display it in other institutions. That's exactly
what he did. But, as he sent more and more of his acquisitions on the
road—to satisfy requirements for his tax-exempt foundations and his
own need for public recognition of his achievement and professional
validation of his taste—questions inevitably arose about the future of
the collection.

Given the cost and risk of transporting fragile works of art, as well
as the time, energy, and diplomacy required to arrange exhibitions in
far-flung locations, Simon's museum-without-walls seemed unlikely

to continue indefinitely. Knowledgeable observers—particularly those with vested interests—believed that at some point he would surely seek a permanent home for the collection. But what and where would it be? Would he build his own museum and keep the collection intact? Give his entire art holding to another institution that filled his needs and met his demands? Parcel out the artworks to various museums that had proved themselves worthy? Or would he live up to his reputation as a hard-nosed, astute businessman and cash in on his art investment?

Such questions were rarely asked directly of the man who had the answers, but he knew they were in the air. More important, he knew that having a highly coveted homeless collection served him well. As long as he had valuable art assets to lend—and possibly give away—he could demand that they be treated with respect and exploit them to the hilt. If directors of museums that displayed his loans thought their institutions might eventually receive donations of art from him, they would be all the more eager to show his collection to its best advantage and use it in educational programs and public events. He made no promises he didn't keep, but his penchant for probing every possible relationship and leveraging every transaction inevitably raised false hopes.

Simon's tactics were not new to the art world, but he certainly sharpened the contest. He had so much to offer that the stakes were unusually high. Collectors and museums are perpetually engaged in courtships that may or may not lead to marriage and often involve a tenuous balance of power. The better the collection, the more demanding the collector can be. As one of the world's wealthiest collectors, Simon had tremendous clout. He quickly learned that he could provide museums with a desirable public attraction and an educational asset in return for tax benefits, recognition, and exhibitions in prestigious institutions that would enhance the value of his art.

He had a good thing going in his museum-without-walls and—despite speculation in professional circles—he claimed to have no intention of cutting it off. In the spring of 1973, when the exhibition *Three Centuries of French Art: Selections from the Norton Simon, Inc. Museum of Art and the Norton Simon Foundation* was at the Califor-

nia Palace of the Legion of Honor in San Francisco, he told a newspaper reporter that he was helping to correct an endemic problem in America: an oversupply of museums with an undersupply of first-rate art on their walls. "I started to plan a museum at the site of our corporate headquarters in southern California," Simon said. "As things went on, I decided there were too many museums already, all with too many problems. They are too busy building up crowds, acting as travel agents, and adding to their collections even if a lot of what they buy ends up in storage in the basement."[1]

After more than a decade of wrestling with the Los Angeles County Museum of Art and establishing relationships with dozens of other institutions, the lure of having his own museum, the possibility of having his collection in one place, where he could exercise absolute control, proved irresistible. The opportunity arose in Pasadena, a conservative community just north of Los Angeles, distinguished by lovely residential areas and well known to the nation's television audience as the site of the Rose Parade and Rose Bowl football game on New Year's Day. Pasadena was also the unlikely home of an avant-garde art museum that had captured national attention when it opened a new building in 1969. In the new Pasadena Art Museum, the Los Angeles area had, at last, a real museum primarily devoted to new art, but it was doomed even before it opened its doors.

The museum was conceived in 1922 by a group of local citizens who had acquired the title to a city-owned estate known as Carmelita Park. Situated at the corner of Orange Grove and Colorado boulevards, the verdant site was on the edge of an exclusive residential district. The museum was founded as the Pasadena Art Institute in 1924 and housed in an old wood building on the estate. In 1942, the institute moved to downtown Pasadena and began operating in a Chinese-style structure that had been the home of Grace Nicholson, a collector of and dealer in oriental art.[2] Visitors entered the museum through an ornate gate and pleasant courtyard, where flagstone pathways led to a series of galleries. The facility on Los Robles Avenue offered easier access and a distinctive—if eccentric—building, but the museum's trustees did not view it as a permanent location. They had made a pact with the city of Pasadena to retain rights to Carmelita

Park for about twenty years, provided they raised funds to build a permanent museum there.

The Pasadena Art Institute had grown up as a provincial institution, largely staffed by volunteer women's groups, and its programs were little known beyond the immediate community. But the windfall of the Galka E. Scheyer Collection, including about 450 works by the Blue Four—Wassily Kandinsky, Paul Klee, Lyonel Feininger, and Alexei Jawlensky—and other modern artists, together with a cache of eight hundred documents, engendered new respect. The collection was placed at the institute in trusteeship for the people of the State of California on condition that a catalogue be published. What Scheyer requested was simply an "illustrated catalogue of the collection with as many color and photographic reproductions of the pictures as possible, and a minimum of written descriptive matter."[3]

The trusteeship of the Scheyer collection heightened the ambitions of the Pasadena Art Institute's staff and trustees. They changed its name to the Pasadena Art Museum in 1954 and presented an exhibition of the collection, accompanied by a preliminary publication with brief essays, a checklist of the Blue Four's works, and a promise to publish a definitive catalogue at a later date.

In an introduction to the exhibition checklist, the museum director, W. Joseph Fulton, wrote:

> Since Mme. Galka E. Scheyer first introduced *The Blue Four* to the West Coast in 1926, the world-wide esteem for these artists has risen steadily until they are now accepted as being of top significance in the history of twentieth-century art, the works are eagerly sought after by collectors, and the recognition of their artistic stature is such as to more than justify Mme. Scheyer's early appreciation of their worth and to fulfill her pioneer efforts to bring attention to them. The Pasadena Art Museum is honored to have been selected to receive Mme. Scheyer's fine private collection of *The Blue Four,* especially rich in the works of Alexei Jawlensky and Paul Klee.

Around the same time, the museum's most ambitious supporters began to think more seriously about erecting a new building in

Carmelita Park, but progress was slow. The major obstacle was that the museum was not a professionally operated institution. A series of directors left in frustration after being unable to wrest control from the volunteer groups or effect changes that would have updated and streamlined operations. Fulton departed in 1957, and his successor, Thomas W. Leavitt, resigned in 1963 to direct the Santa Barbara Museum of Art. The board of trustees was itself split between members who had a strong interest in contemporary art and members who favored more traditional material, particularly oriental art. But the museum reacquired title to the Carmelita Park property in 1961, and the move for a new museum was on.

Among the few energetic individuals rallying to the cause was Eudora Moore, who conceived of the new museum as part of a cultural complex including theater, symphony, and chamber music groups. Moore stepped down as president of the board in 1962, but continued to push for the building. Retaining her place as a trustee, she established a department of design and served as its curator. At the same time, she founded a corporation within the museum that produced *California Design* exhibitions, celebrating the state's designers and craftspeople and attracting large crowds to the museum. These popular events were criticized as tasteless and parochial by members of the avant-garde fine-arts crowd. The detractors' interests were, however, well served by Walter W. Hopps, a brilliant young curator who had been a major force behind the Ferus Gallery, in Los Angeles, a seminal showcase for contemporary art. He joined the museum's staff as a curator in 1962 and staged an international coup the following year, when he organized and presented a retrospective of Marcel Duchamp's work. Within a few years Hopps had compiled a distinguished exhibition record at the museum, including a show of pop art and timely presentations of the work of Alberto Burri, Jasper Johns, Larry Rivers, Frank Stella, and Joseph Cornell. When Leavitt resigned in 1963, Hopps became acting director of the museum and then director from 1964 to 1967.

Hopps was skeptical of the building plans and suggested a more modest expansion on the Los Robles site, but he was overruled. Harold S. Jurgensen, a successful, self-educated businessman who had established a chain of gourmet wine and grocery stores,

succeeded Moore as president of the board of trustees in 1962. He had already launched a crusade for a new building, which became the focus of his reign. In a variation of the architectural debacle at the Los Angeles County Museum of Art, Jurgensen secured a pledge of five hundred thousand dollars from Wesley Dumm, a reclusive millionaire who never attended the Pasadena museum's board meetings but had a definite idea about who should design the new building. His choice was none other than Edward Durrell Stone, the popular but conservative architect whom Howard Ahmanson had championed unsuccessfully at LACMA. Stone was hired to design a preliminary plan. He conceived a huge Egyptian revival-style complex including performing arts facilities as well as galleries. The scheme was far too costly for the Pasadena group to build or maintain. Stone eventually revised and scaled back his proposal, but Jurgensen then rejected him along with a slate of more adventurous architects suggested by Hopps. Instead, Jurgensen settled on a local journeyman, Thorton Ladd, and his partner, John Kelsey, because Ladd's mother lived in Pasadena and had offered to donate a sum double her son's fee if he were chosen for the job.

The mission of the Pasadena Art Institute, as stated in 1924 in its articles of incorporation, was "To establish and maintain a museum and library of Art, Painting and Sculpture; also to encourage and develop the study of the Fine Arts and to advance the general knowledge of kindred subjects, and also to do any and all things incidental, accessory or advantageous to the carrying out of such purpose or purposes." When the institute's name was changed to the Pasadena Art Museum, its mission was not redefined. If the trustees even considered the matter, they probably thought it best to maintain a broad statement that would encompass interests of all potential supporters. When Jurgensen launched the fund-raising campaign for the new building, brochures given to prospective donors described the museum's collection of oriental art and a plan to provide a wing for it, the museum's old master print holdings, and its goal to begin its permanent collection with the art of the French impressionists and post-impressionists.

Jurgensen was succeeded as board president by Robert Rowan, an enthusiastic collector of contemporary art whose wealth came from

his grandfather's real estate empire. Rowan took charge of the project in 1965, with a vision of transforming the Pasadena Art Museum into a major showcase for contemporary art. The timing seemed right because Los Angeles was becoming a center of contemporary art. Southern California claimed a large population of creative artists, many of whom were achieving national and international recognition, and they needed a museum to show their work. Although the County Museum of Art had opened that year, modern and contemporary art was only one component of its encyclopedic collection and exhibition program.

Indeed, every gain on behalf of the contemporary scene was less than the level that was needed, and some of the most promising developments evaporated. *Artforum* magazine had been established in San Francisco in 1962 as a monthly publication devoted to art on the West Coast, but it soon adopted a broader outlook and a sophisticated style. The magazine moved to Los Angeles in 1965, taking up residence above Ferus Gallery on La Cienega Boulevard and evolving into a leading journal of current art. But, to the consternation of contemporary art aficionados, *Artforum* packed up and took off for New York in 1967, the year the Pasadena Art Museum broke ground for Ladd & Kelsey's building in Carmelita Park. In another blow, Hopps, far more effective as a curator than as an administrator, was becoming increasingly disturbed over the building plans and resigned as the museum's director in 1967.

James Demetrion, whom Hopps had hired as curator, became acting director and then director, presiding over the building's completion and first year of operation. He soon became discouraged by the museum's lack of financial resources to build a significant collection and present a vigorous program. In a letter to Frederick Weisman, a trustee of the museum (and Norton Simon's brother-in-law), late in 1967, Demetrion stated the facts bluntly: "Ours is the only 'museum' of modern art which I know of which doesn't own a Pollock or a Rothko or a Still or a Newman or a Gorky or a Motherwell or a Guston or a Tomlin or a Tworkov or a Reinhardt or a Johns or a Rauschenberg." Complaining bitterly about the Pasadena museum's inability to compete with the Los Angeles County Museum of Art and

its exhibitions, he issued a challenge: "Give us the ammunition. Then we can fire the guns."[4]

Plans for a new building went forward anyhow. The trustees had planned a $3-million building, but costs escalated and they ended up with a $5-million structure they could not afford to program and maintain, in addition to a $1.5-million debt on the building. The new facility was opened in November 1969. The eighty-five-thousand-square-foot, H-shaped building was designed with four wings extending from a central lobby. The upper level held galleries, a four-hundred-seat auditorium, a tea room, and a bookshop. The lower floor accommodated classrooms, administrative offices, storage, a library, and facilities for shipping, receiving, and preparing of artworks.

Designed with curves instead of corners, dead-end corridors, and makeshift lighting—by architects who had no museum experience—the building presented serious challenges for curators. Nonetheless, they managed to win critical accolades for presenting major exhibitions on the Bauhaus, Andy Warhol, Frank Stella, Carl Andre, and Claes Oldenburg. The museum served the community by offering a wide variety of art classes for adults, teenagers, and children. But, despite appearances of vitality, the museum suffered from serious maladies. Professional leadership was a perpetual problem. Demetrion bailed out in 1969, and Tom Turbell, a local banker and vice chairman of the museum board, was drafted as acting director until a qualified person could be found. He served until 1971, when William Agee, who had joined the museum staff the previous year, was appointed director. Another chronic problem was that the museum had neither a large enough audience nor sufficiently dedicated a group of patrons to maintain it—much less dig it out of debt. Dumm withdrew his pledge because he didn't approve of the architecture, and other promised gifts failed to materialize. Donors who had given money expecting a gallery of oriental art and curator to go with it were understandably disappointed. Trustees who favored contemporary art donated much more money than they had planned and several pieces from the collection were sold to pay operating costs, but the museum always ran a deficit.

By early 1971, when Alfred E. Esberg, a retired businessman in

Pasadena, succeeded Rowan as president of the board, it was clear that other sources of revenue had to be found. Rowan persuaded his old friend Gifford Phillips to rejoin the board. A nephew of Duncan Phillips, founder of the Phillips Collection in Washington, D.C. Gifford Phillips had been a major supporter of the museum in its earlier days. Phillips, Esberg, and Rowan became a triumvirate, united in an effort to save the museum.

The first big step was to try to join forces with another museum or get financial support from the County of Los Angeles. Among other efforts to balance the books, Esberg explored a possible contract with the museum corporation. The idea was for the county to pay most of the museum's $1-million annual operating budget, while the museum corporation retained ownership of the $6.5-million art collection and controlled programming.

In May 1971, Esberg called a special meeting of the museum's executive committee and fourteen key representatives of support groups and staff to discuss the implications of the museum's financial problems and review the status of negotiations with the County Board of Supervisors. Before the meeting Esberg had provided participants and board members not in attendance with an outline of four financial planning options. "First: We can elect to continue as we have by covering our operating deficits by sale of deaccessioned paintings, emergency loans, special gifts, etc." But he didn't advise that approach. Despite raising more than one hundred fifty thousand dollars in contributions and art sales during the past fiscal year and borrowing one hundred twenty thousand dollars from trustees, much of which had been repaid by selling paintings from the collection, the museum was still struggling. It was sustaining an operating deficit of between ten and fifteen thousand dollars a month, and an interest burden on loans of six thousand dollars per month.

Second: "If we can find some way to clear or substantially reduce our capital indebtedness of over $1 million we can seek operating support from the County of Los Angeles under a format similar to that now in force with the County Art Museum." That would allow the Pasadena museum to establish a self-perpetuating board of trustees or governors instead of being subject to a board appointed by the County Board of Supervisors, as was the case with the plan

under negotiation. Either way, the museum would gain operating funds from the county and museum employees would become civil service employees. But Esberg doubted that it would be possible to come up with major new financial backing to reduce the museum's capital indebtedness.

Third: "We can push ahead with our current plan to obtain both capital and operating funds from the County of Los Angeles." The problem here was a probable loss of control. The initial board of governors would be drawn from the current board, but the County Board of Supervisors would appoint subsequent governors who, in turn, would appoint a director. The governors would be eligible to succeed themselves, and they would not be in charge of day-to-day operations, but there was no guarantee that the supervisors would not ultimately rule the museum.

Last: "We can reinstitute discussions with the County Museum of Art." That offered the advantage of retaining the Pasadena museum's board of trustees and comingling it with the County Museum's board. The Pasadena museum might also be able to get capital funds from the county. Franklin Murphy had promoted this plan, suggesting that the Pasadena museum could be the County Museum's modern art wing and the curator, Maurice Tuchman, could be transferred there.[5]

In a follow-up board meeting, Esberg informed trustees that striking a deal with the county similar to that of the County Museum was "legally possible but not politically viable under present conditions."[6] His talks with county officials about this possibility were so discouraging that the second option would have to be dropped. After a two-and-a-half hour discussion, the trustees voted unanimously to negotiate with the county, as outlined in the third option. Several trustees had argued persuasively that the county supervisors would not interfere as long as the museum were well managed. Because that approach seemed to be the most effective way to get financial help and negotiations were already underway, the third option easily won the full board's support.

The trustees' painful deliberations were kept quiet until two weeks after the vote, when the story broke in the local press. The *Los Angeles Times* reported that John Phillips, the city manager of Pasadena,

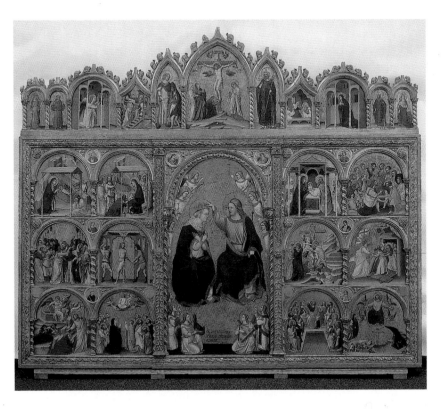

Unwittingly, Simon bid against the curator of the J. Paul Getty Museum at auction in 1972 for a fourteenth-century masterpiece, *The Coronation of the Virgin Altarpiece* (1344) by Guariento di Arpo (see page 185). (Norton Simon Art Foundation, Pasadena, Calif.)

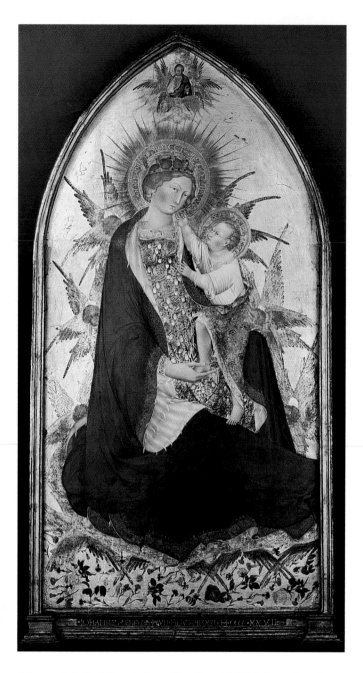

Giovanni di Paolo's painting, *The Branchini Madonna* (1427)
(see page 187), was the star attraction of an auction of Robert
von Hirsch's collection in 1978. (The Norton Simon
Foundation, Pasadena, Calif.)

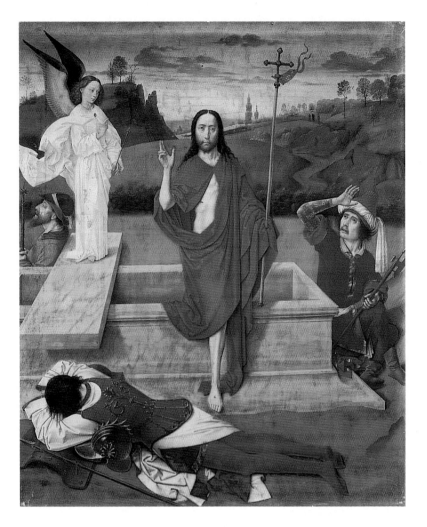

"Sold to Jennifer Jones Simon on behalf of the Norton Simon Museum,"
an auctioneer announced, ending the bidding for *The Resurrection* (c. 1455),
a painting by the fifteenth-century Flemish painter Dieric Bouts (see page
186). Of it Norton Simon said, "I don't know of a picture of this quality
that has come on the market in all the years I have been collecting."
(The Norton Simon Foundation, Pasadena, Calif.)

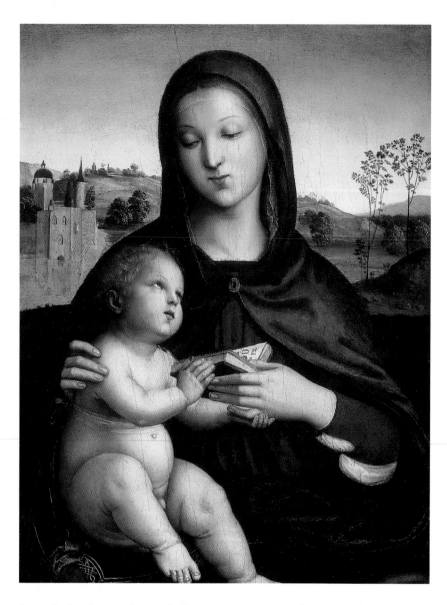

In a calculated move that made front-page news across the nation, Simon revealed his purchase, for $3 million, of a masterpiece of the High Renaissance, Raphael's *Madonna and Child with Book* (c. 1502-03) (see page 128), just before the opening of an exhibition of his collection at Princeton University. (Norton Simon Art Foundation, Pasadena, Calif.)

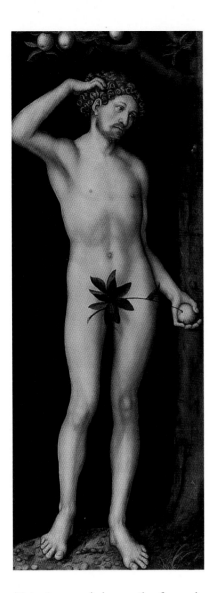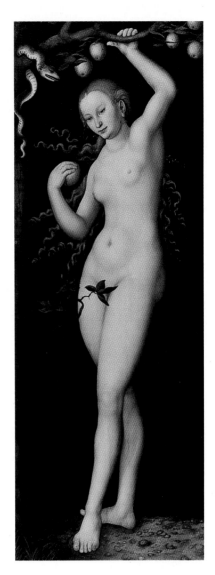

Twice impounded as spoils of war, the pair of near-life-sized paintings, *Adam* and *Eve* (c. 1530) by Lucas Cranach the Elder (see page 179) was confiscated from a collector in St. Petersburg by the Bolsheviks in 1918 and sold at auction in 1931 by the bankrupt Soviet government. The buyer was a dealer in Amsterdam whose stock ended up in Adolf Hitler's possession during World War II. A nephew of the Russian collector reclaimed the pictures in 1966 and sold them to Simon in 1971. (Norton Simon Art Foundation, Pasadena, Calif.)

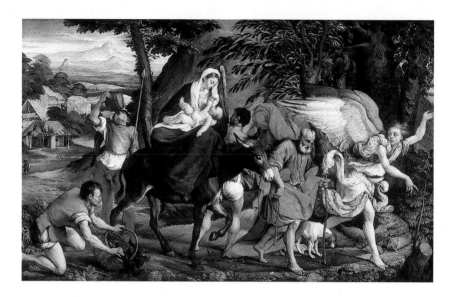

To raise funds for a new monastery, a Benedictine community in England decided to auction its greatest treasure, *The Flight into Egypt* (c. 1544–45) by the sixteenth-century Italian painter Jacopo da Ponte, called Bassano, along with a few less valuable works (see page 179). Hoping to raise $100,000 from the sale, the monks perhaps felt as if they had witnessed a near-miracle when Simon paid $655,118. (Norton Simon Art Foundation, Pasadena, Calif.)

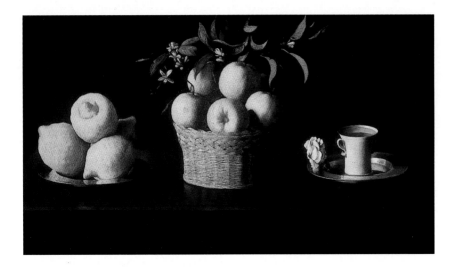

Francisco de Zurbarán's masterful painting, *Still Life with Lemons, Oranges and a Rose* (1633) (see page 183), is one of the most admired pieces in Simon's collection. He procrastinated about the purchase for so long that the frustrated dealer decided to fool him into thinking that he had some competition. (The Norton Simon Foundation, Pasadena, Calif.)

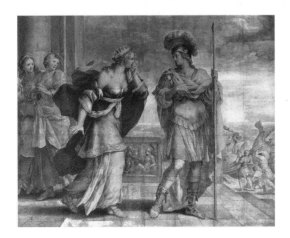

In a 1969 auction, Simon bought only four of six tapestry cartoons by Giovanni Francesco Romanelli depicting the story of Dido and Aneas. Later, Simon decided that he had to have the entire set, including this one, *Aeneas Leaving Dido* (c. 1630–35) (The Norton Simon Foundation, Pasadena, Calif.)

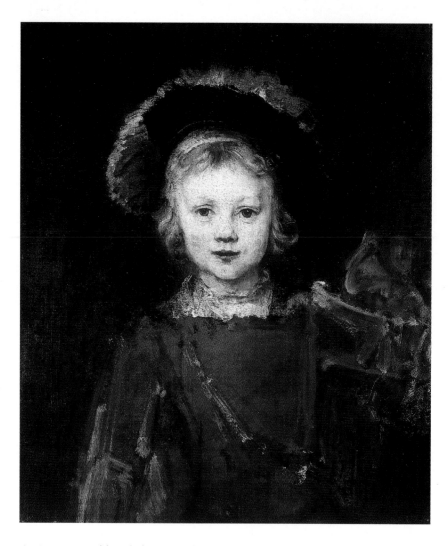

An international brouhaha erupted in 1965, when Simon purchased Rembrandt's painting, *Portrait of a Boy, Presumed to be the Artist's Son, Titus* (c. 1645–50), at an auction in London (see page 2, and page 86). When the auctioneer, confused over Simon's complicated bidding system, sold the painting to a dealer in London, Simon demanded that the bidding be re-opened. (The Norton Simon Foundation, Pasadena, Calif.)

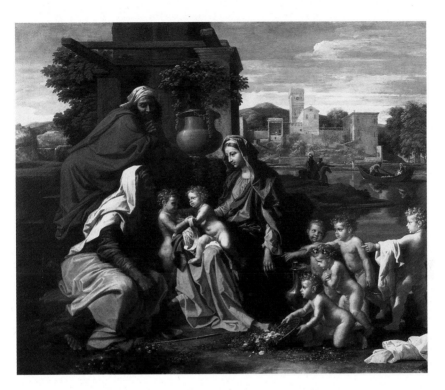

Nicolas Poussin's painting, *The Holy Family with the Infant Saint John the Baptist and Saint Elizabeth, with Six Putti Carrying a Ewer and Basin, in a Classical Landscape* (1650–51) (see page 256), was the first of two joint purchases made by the Norton Simon Museum and the J. Paul Getty Museum. The purchase evoked speculation that the two museums might merge. (Owned jointly by the J. Paul Getty Museum, Los Angeles, and Norton Simon Art Foundation, Pasadena, Calif.)

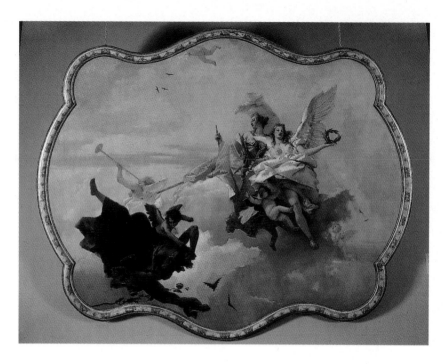

Giovanni Battista Tiepolo's painting, *The Triumph of Virtue and Nobility over Ignorance* (c. 1740–50) (see page 188), acquired by Simon in 1972 from the collection of Alessandro Contini Bonacossi for $1 million, was designed for a ceiling in the Palazzo Manin in Venice. (The Norton Simon Foundation, Pasadena, Calif.)

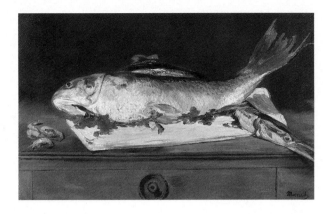

Having guaranteed a price of $1.5 million in an auction in 1973 of works from Norton Simon's collection, Sotheby's was obliged to take possession of Edouard Manet's painting, *Still Life with Fish and Shrimp* (1864) (see page 194), when it failed to sell. Five years later, Simon bought it back in conjunction with his purchase of *The Branchini Madonna* (Norton Simon Art Foundation, Pasadena, Calif.)

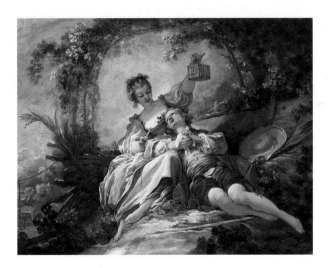

Jean-Honoré Fragonard's rococo fantasy, *The Happy Lovers* (c. 1760–65), is one of the jewels Simon acquired with his purchase in 1964 of Duveen Brothers (see page 73), a legendary art dealership in New York. (The Norton Simon Foundation, Pasadena, Calif.)

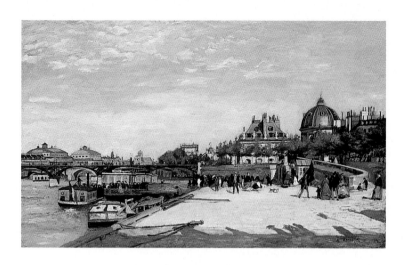

Stephen Hahn bid at auction on Pierre-Auguste Renoir's early painting,
The Pont des Arts, Paris (c. 1867–68) (see page 63), but stopped at $1
million to give the impression that his famous client had reached his
limit. Simon took over behind the scenes and bought the Renoir for
$1.5 million. (The Norton Simon Foundation, Pasadena, Calif.)

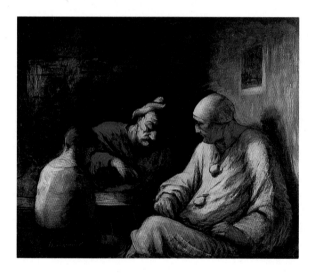

Mountebanks Resting (1870) was the first of many works
by Honoré Daumier to enter Simon's collection (see
page 42). (Norton Simon Art Foundation, Pasadena,
Calif., Gift of Mr. Norton Simon, 1976)

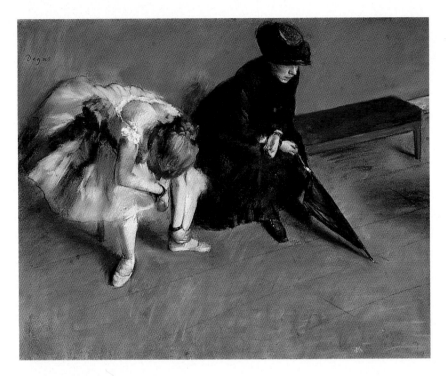

In 1983 the Simon and the J. Paul Getty Museum jointly purchased *Waiting (L'Attente)* (c. 1880–82), a pastel by Edgar Degas, from the estate of Henry O. and Louisine Havermeyer (see page 259). The price paid set an auction record for an impressionist work of art. (Jointly owned by Norton Simon Art Foundation, Pasadena, Calif., and the J. Paul Getty Museum, Los Angeles)

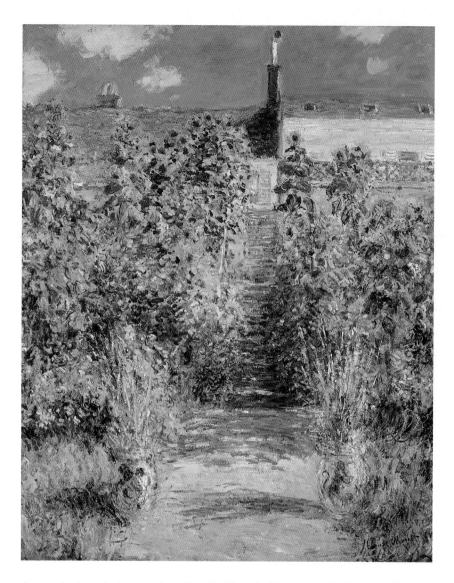

Impressionist paintings, such as Claude Monet's shimmering landscape, *The Artist's Garden at Vétheuil* (1881) (see page 43), had a strong appeal for Simon throughout his long collecting career. (The Norton Simon Foundation, Pasadena, Calif.)

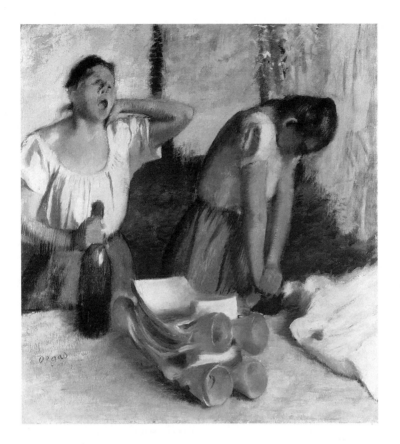

In one of his earliest purchases of works by Edgar Degas, Simon bought *Women Ironing* (c. 1884) in 1959 (see page 41), just as it was about to be consigned to auction by the collector Chester A. Beatty. (Norton Simon Art Foundation, Pasadena, Calif.)

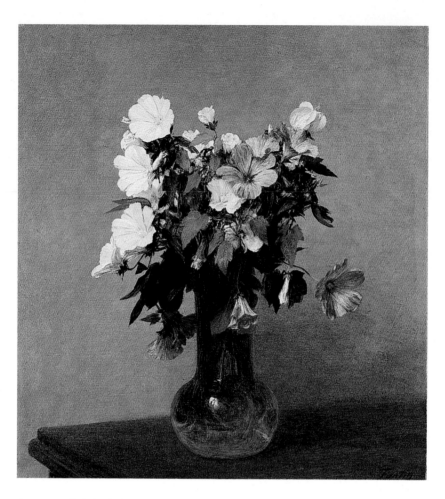

Simon traded the building that had housed Duveen Brothers in New York to
the dealer William Aquavella for two French paintings, a portrait by Renoir and
Henri Fantin-Latour's still life, *White and Pink Mallows in a Vase* (1895) (see page
76). (The Norton Simon Foundation, Pasadena, Calif.)

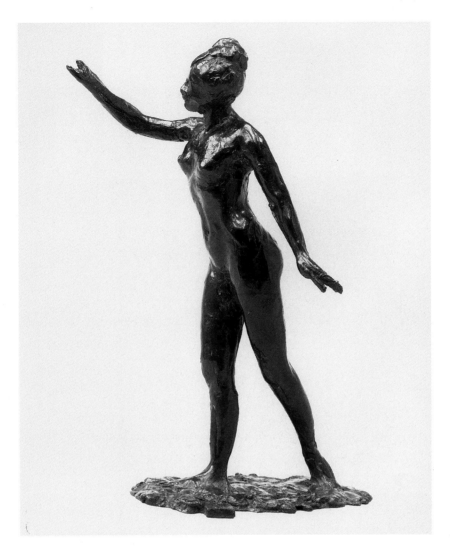

Simon couldn't believe his ears when, in 1976, a dealer in London offered him a recently unearthed set of seventy-two bronze *modèles,* or master casts, of sculptures by Edgar Degas (see page 232). The dealer immediately flew to Los Angeles with a sample, *Grande Arabesque, First Time* (1885–90), so that Simon could compare it with a cast of the same subject already in his collection. (Norton Simon Art Foundation, Pasadena, Calif.)

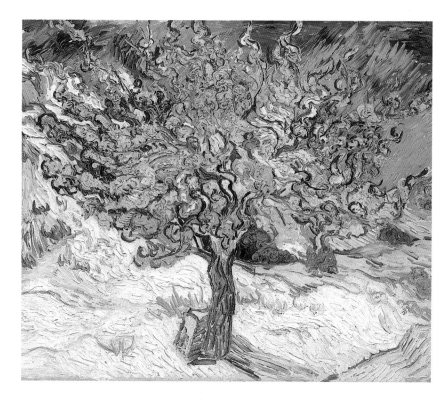

While on a trip to Los Angeles in 1961, a dealer from New York offered
Vincent van Gogh's painting, *The Mulberry Tree* (1889), to Simon (see page 44).
Discovering that the collector might, instead, buy some paintings by Degas that
were about to be offered at auction, the dealer instructed his assistant to circum-
vent Simon's intentions and acquire the Degases for the gallery's inventory. The
strategy worked: Simon bought this painting for $300,274. (Norton Simon Art
Foundation, Pasadena, Calif., Gift of Mr. Norton Simon, 1976)

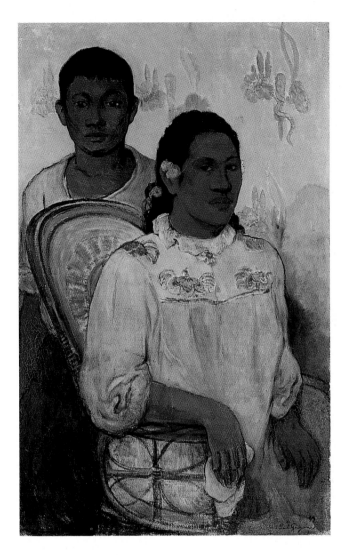

Simon was attracted to Paul Gauguin's *Tahitian Woman
and Boy* (1899), but did not bid on it when it was auctioned
in 1964 because it was so badly soiled (see page 195). Armand
Hammer, also an industrialist in Los Angeles, bought the
painting, had it cleaned, and, less than two months later,
sold it to Simon. (Norton Simon Art Foundation, Pasadena,
Calif., Gift of Mr. Norton Simon, 1976)

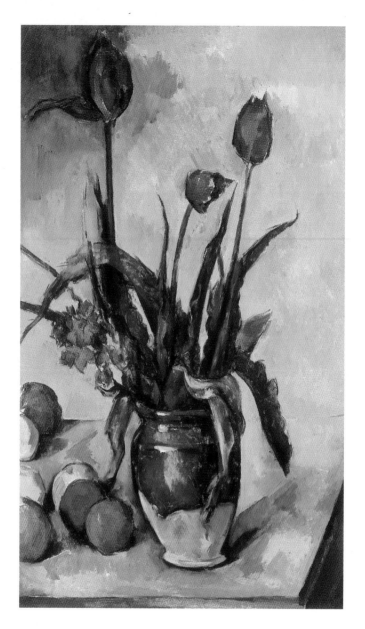

Wildenstein & Company, dealers in New York, apparently bought Cézanne's *Tulips in a Vase* (c. 1890–92) for $1.5 million at an auction of part of Simon's holdings in 1973 (see page 193). But Wildenstein had been bidding on behalf of Simon himself to ensure that the painting was not sold for less. After the auction both the check and the Cézanne were returned to Simon. (Norton Simon Art Foundation, Pasadena, Calif., Gift of Mr. Norton Simon, 1976)

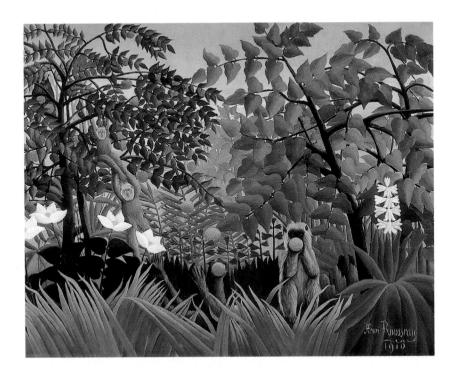

Henri Rousseau's painting, *Exotic Landscape* (1910) (see page 62), is among the major works that Simon purchased at auction through Stephen Hahn, a dealer in New York. (The Norton Simon Foundation, Pasadena, Calif.)

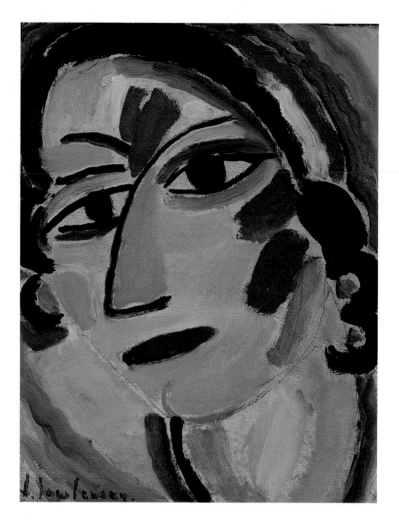

Simon purchased Alexei Jawlensky's painting, *Mystic Head, No. 21: Galka* (1917) in 1968 (see page 33). Six years later, when he took charge of the Pasadena Art Museum, he came into possession of the collection made by Jawlensky's subject, Galka E. Scheyer. (Norton Simon Museum, Pasadena, Calif.; ©1998 Artists Rights Society (ARS), New York / VG Bild-Kunst, Bonn)

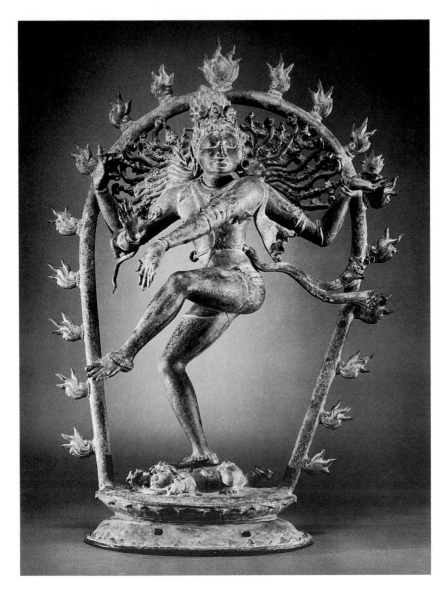

Simon's purchase of this statue, *Shiva Nataraja (Lord of the Dance),* in 1972 led to a celebrated court case in which the government of India claimed that the bronze, made about 1000 A.D., had been stolen from a temple and smuggled out of the country (see page 171). (The Norton Simon Foundation, Pasadena, Calif.)

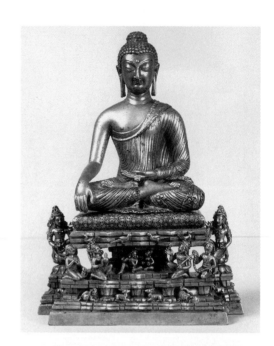

Altarpiece with Adoration of the Buddha, an eighth-century bronze altarpiece from Kashmir, India, or possibly Gilgit in Pakistan, depicting Buddha seated on a three-tiered mountain, is the most highly prized piece of Himalayan art in Simon's collection. (The Norton Simon Foundation, Pasadena, Calif.)

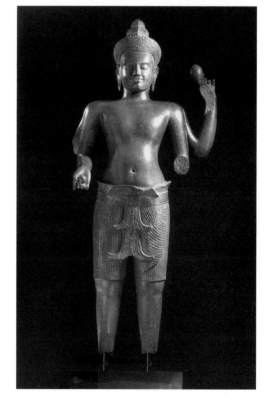

This life-sized granite statue of the Indian god Vishnu, made in the tenth century A.D. at Koh Ker in Cambodia (see page 171), is among the monumental Asian sculptures acquired by Simon during the early 1970s. (The Norton Simon Art Foundation, Pasadena, Calif.)

had recommended the transfer of museum operations to Los Angeles County. The issue was scheduled for discussion on June 1.[7] Shortly after the meeting Esberg released a statement: "Preliminary indications are that a satisfactory arrangement can be negotiated which will protect the interest of the Pasadena Art Museum, the City of Pasadena and the County, but no firm commitments have been made and no agreements signed."[8]

Members of Pasadena's City Board of Directors, who had been asked to increase their support of the museum but had not been informed about the quest for county support, were taken aback by the news. Jurgensen, then serving as chairman of the museum's funding and development committee, explained that the plea for help from the county had been submitted in a hurry to meet the 7 June deadline for budget requests. Placated by Jurgensen and eager to resolve the problem, the city directors voted to support the museum corporation's request for a $758,000 allocation from the county for operating expenses. At the same time, the directors voted in favor of a proposal to create a joint-powers authority, comprising the City of Pasadena and the County of Los Angeles, to take over the museum's land and buildings. According to the plan, Pasadena would convey the museum land to the authority, which would buy the building from the museum corporation. The authority would then pay the corporation $1.5 million to retire the building debt and the museum property would be leased to the county. The corporation would retain ownership of the art and make it available for exhibition.

At a meeting of the county board on 8 June 1971, Kenneth Hahn, a supervisor, claimed that the museum would be "a white elephant" that would set a dangerous precedent, and he tried to force a vote. The decision was delayed, but on 22 June the supervisors rejected the proposal "without prejudice," thus leaving door open for revised offers. Of the supervisors, Warren Dorn and Frank G. Bonelli were in favor of the proposal; Hahn and Burton Chace had opposed it from the start and voted against it. The museum trustees were counting on Ernest E. Debs as the swing vote, but he let them down. "In its present form, I can't support the proposal—not by a long shot," Debs said. "They have the right to wheel and deal with the art, [but] that shouldn't be done without some restrictions. It's too loose. We

got the building on Wilshire Boulevard [the County Art Museum] without a nickel of taxpayer money. If the Pasadena people want to give us a building, they ought to come back with the same terms and conditions."[9] Esberg was discouraged, but he maintained a hopeful public image. "We feel confident we can keep the elephant alive, although we may have to go on a restricted diet while we look for more hay."[10]

The museum limped along for three more years, cutting back on its operating costs and repeatedly approaching the County of Los Angeles, the City of Pasadena, and various people in the private sector with appeals for funds. In June 1973 Esberg proudly reported to his fellow trustees that the museum's operating loss had been reduced from $460,000 in fiscal 1971 to $215,000 in fiscal 1972 to $195,000 in fiscal 1973. In addition, the building debt had been trimmed to $850,000. But these gains had taken a toll in programs, staff, and trustees' resources, and they still hadn't resolved the museum's fiscal crisis.

Meanwhile, Esberg, Rowan, and Phillips were pursuing another potential savior: Norton Simon. They first approached him for a donation in 1971, through Frederick Weisman. At the time, Simon had no interest in paying the museum's bills. During the following year, as the Pasadena museum's trustees struggled to find a solution to their financial problems, Simon investigated a variety of ways to house his collection. He paid a visit to the museum early in 1972 with Robert Macfarlane, who had recently joined his staff as an administrator of the foundations' funds and programs. Simon's appearance raised hopes that he might be persuaded to support the museum after all. Rowan, an enthusiastic collector who admired Simon as a connoisseur, told him he should support the art of his time as well as impressionists and old masters. Again, Simon failed to come to the rescue, but he began a different kind of relationship with the museum a few months later. In summer 1972 the Pasadena facility opened a year-long exhibition of thirty-five pieces of modern sculpture from the Norton Simon, Inc. Museum of Art and the Norton Simon Foundation. Major works by Henry Moore, Barbara Hepworth, David Smith, Wilhelm Lehmbruck, Jacques Lipchitz, and

Auguste Rodin, among many other artists, filled two large galleries and the spacious foyer.

Phillips become president of the board of trustees in 1973 and inherited the job of courting Simon. But before he made a move, he received a call from Weisman, who said that Simon was still looking for a home for his collection and advised Phillips to contact him immediately. Taking the tip seriously, Phillips called Macfarlane. Over lunch, Macfarlane informed Phillips that the only partnership that might interest Simon was one in which he could take charge of the entire museum and then allot a portion of the space to the Pasadena museum's own collection. "I rejoined that I was sure our board would not be interested in any arrangement that did not allow us at least half the space," Phillips said. "I had no doubt that I was accurately portraying the board's sentiment, but I wondered silently what we would do if Simon turned down such a proposal. I was painfully aware of our dismally weak bargaining position."[11]

Phillips called a special board meeting to discuss the possibility of an arrangement with Simon. But, with no concrete proposal in hand, he could only guess what the arrangement might be. The trustees raised dozens of questions that would have to be resolved. But, because there were no viable alternatives, the board authorized Phillips and Esberg to explore the situation without making a commitment. Phillips communicated frequently with Macfarlane for about a month without getting any closer to understanding what Simon had in mind. Eventually Macfarlane said Simon was interested in taking charge of the museum, paying off its deficit, and allocating a yet-to-be-negotiated amount of space to the Pasadena museum's permanent collection. Phillips thought Simon intended to buy the museum, but Macfarlane informed him that was not the case. What Simon wanted was for the museum trustees to vote themselves out of office and instate a new set of trustees chosen by him.

The trustees were not enthusiastic about Simon's offer, but they felt they had no choice. Yet, when they tried to pursue it, they made no progress. "We kept pressing him (always through Macfarlane) for a definite proposal, but he obviously preferred our making the

proposals, all of which he promptly turned down," Phillips said. "Macfarlane always seemed to begin our telephone conversations with the observation that 'Norton was very disappointed in your proposal.' We proposed various contractual arrangements, but clearly, Simon didn't want a contract. We proposed that half the museum space be allocated to PAM's collection; then a third of the space—again rejected."[12] Exasperated, Phillips told Macfarlane that the museum couldn't accept less than one-third of the space, and that that was the final offer. A month passed with no response. At last Macfarlane called Phillips with a new proposition: Simon agreed to allocate one-quarter of the museum space to the museum's collection for five years. Phillips relayed the offer to Esberg, who said: "Take it, it's the only game in town."[13]

After three months of negotiations, Phillips, Esberg, and Coleman Morton, the museum's treasurer, eventually met with Simon himself. Entering his office in shirt sleeves and appearing rather disheveled to his nattily attired guests, Simon wasted no time with formalities. Speaking in a low voice, he simply reiterated the conditions laid out by Macfarlane. Simon would take charge of the museum, assume financial responsibility for it, and pay off the debt. In exchange, he would move his collection into the museum, get the lion's share of exhibition space and—as he had so frequently done in business— take control of the board.[14]

On 22 April 1974, Simon drafted a letter outlining an agreement to combine his collection with the museum's collections. "We would expect to utilize 75 percent of the exhibition space and we would expect the Board to commit to an average use of 25 percent of the exhibition space for five years for exhibiting modern and contemporary art from the permanent Pasadena Museum collection, the Galka Scheyer Collection, and other modern and contemporary art loaned to the Museum for exhibition," he wrote. Additionally he laid out a plan to reduce the number of trustees from thirty-five to ten, only three of whom would represent the Pasadena group.

Four days later Simon and the Pasadena trustees formally announced "a long-term program of joint exhibitions, mutual cooperation and aid." The museum's name had been changed to the Pasadena Museum of Modern Art on 1 March 1973, in an effort to

clarify its mission and identity, but its former name was now more appropriate, so it was readopted with the agreement. Disappointed and wary of Simon, but immensely relieved to have unloaded a burden, the trustees voted unanimously for the merger. "I am extremely pleased that the Board of Trustees of our museum has voted approval of a proposal to expand dramatically the scope of our Museum, by exhibiting our collection with the world-renowned collections gathered by Mr. Simon over the past twenty years," Esberg said in the joint press release.

Simon also put his best face forward: "Basically I see this program as adding two positives together," he said in the press release. "The Pasadena museum has a fine building and a collection that is modern and contemporary. The Foundation's collections, while having some of the same period, are primarily pre-twentieth century. By jointly exhibiting the collections, we will be able to offer the public a broader sweep of the evolution of art. We see the Pasadena Museum as an additional part of a national consortium of museums where parts of our collections are currently on long-term loan."[15]

Many people who had been involved with the museum took a far less sanguine view of the news. Agee, who had served as the museum's director from 1971 until a few weeks before the agreement was final, castigated the trustees. "I would call it all good if this deal had given the trustees some getaway money to open a more modest operation," he said. "It is the death of the museum no matter how they couch it. It was a great museum serving a unique and important function in the wrong town. The trustees neither cared for nor wanted the museum. Institutions only last as long as people care for them and want them." Hopps concurred: "Any careful, objective examination of the records over the years could clearly determine that PMMA had a succession of the least responsible, least thoughtful boards of trustees I've ever encountered as they acted as boards. Their collective activities are a sorry record leading from one disaster to another."[16] Claes Oldenburg, an artist whose work had been the subject of a retrospective exhibition at the museum, also interpreted the merger as a disaster, but a predictable, provincial one: "It's just another step in the disappearance of L.A. as a contemporary art scene."[17]

The trustees argued that they had done all they could. "It is a great

solution for many of our problems," Esberg said. "The original purpose in building a museum is to provide a home for a great collection and the benefit of all the people in the community. It must be a secure home. This merger will do that. We've given the contemporary community a major try to support the museum. Its supporters and sympathizers did not rise to the occasion. A great experiment didn't work."[18]

Phillips also supported the decision in public statements. "Pasadena was always an unfortunate choice as the site for a large, costly museum emphasizing avant-garde art," he said. "Pasadena is a conservative community in its art tastes, and with few exceptions PMMA's contemporary art exhibitions, as splendid as they have been, drew only small attendance. The museum could have survived without a large paying attendance only if it had had either adequate endowment or county financial assistance. But it had neither. A small number of patrons and support groups have kept the museum alive for the past several years, doubling their normal efforts and contributions in the expectation that a permanent solution would be found. But they had reached the end of the road, and if Norton Simon had not rescued it, the museum would have probably closed down within the year."[19]

23

THE BANKRUPT MUSEUM

The financial collapse of the Pasadena Art Museum, and its subsequent takeover by Norton Simon, an exceedingly rich and powerful Southern California industrialist, raises issues that extend far beyond the problem of survival of this particular museum. It poses acute questions about the power and accountability of museum trustees, the lack in many American art museums of carefully thought-out policies within their local communities, and the general role a museum should assume within the community of art museums throughout the country.

<div align="center">

JOHN COPLANS
Artforum, *February 1975*

</div>

IN TAKING OVER THE Pasadena Art Museum, Simon gained a home for his collection, which had grown to about five thousand pieces, and added an even larger though far less valuable holding of modern and contemporary art comprising seven thousand paintings, sculptures, drawings, and prints. He also established a tenuous relationship with the art community that would grow increasingly acrimonious as he was portrayed as an opportunist or a villainous savior. Simon's arrival was greeted with joy and relief by relatively conservative members of the art community, but the museum's financial failure was a bitter disappointment to artists, critics, and supporters of contemporary art. For them, the arrangement with Simon symbolized the pathetic inability of Los Angeles to develop into a serious center for cutting-edge art. Modern and contemporary art would now play a relatively minor role at the Pasadena Art Museum and space would not be available for major traveling exhibitions. Aware of Simon's lack of interest

in contemporary art, many artists and collectors who had donated art-works to the original museum felt betrayed and objected to having their gifts go to Simon.

Criticism of both Simon and the museum's former management raged through the art world, providing a source of feverish gossip in social circles and fodder for reporters and critics. The most thorough account and one of the most biting assessments of the museum takeover was the article "Diary of a Disaster," written by John Coplans and published in *Artforum*.

> We are not dealing with Carnegie, Ford, Frick, Mellon, or Rockefeller, in the Eastern United States, or a Mark Hopkins (California School of Fine Art), or Leland Stanford (Stanford University) in Northern California.[1] No matter how tough and vicious these men may have been in conducting their business affairs, their concept of public responsibility and the manner in which they approached the institutions they founded and funded derived from an ethic of public charity entirely different from that of Norton Simon.
>
> Simon operates within the tradition of the Southern California eccentric, of extraordinary cranks such as William Randolph Hearst became in time, of the lone wolf, crazily furtive and secretive, such as Howard Hughes. The art world for Simon is a theater existing mainly to dramatize his own will and ego: this unhindered mobility becomes the vehicle for this willfulness, disguised as philanthropy. Simon, I think, has some obsessive dream of himself as a superman, surely gained from his triumph as a corporate raider during the conglomerate era of American business in the early 1960s, a role he is now playing out in the art world.

Coplans's portrayal of the Pasadena museum's trustees was equally scathing, and he did not blame Simon for their faults. But he concluded that Simon's record of selling works from his collection proved that he treated works of art "not as esthetic objects, but as securities, the equivalents of stocks and bonds, to be manipulated to produce profits in much the same manner as an art investment

trust." The Pasadena Art Museum was destined to become "Simon's warehouse for these speculative operations," he wrote. "What was intended to be a museum is to become the private economic plaything of a rich man."[2]

Despite the optimism Simon expressed about the museum in public statements, he was advised by Macfarlane that he had acquired "a can of worms" over which "no one has been exercising leadership or assuming overall responsibility for some time."[3] And indeed, as Simon's aides delved into the museum's operations, they discovered that pledges from patrons had not been paid and the books didn't balance. In a dubious effort to recruit new members to the museum, artworks from the collection had been lent to various public and private institutions and never returned. The building, although only five years old, was also in need of repair—the variety and extent of its problems not immediately apparent.

Simon closed most of the museum in June 1974 for renovations and the installation of his collection. The old regime's last exhibition, of works by the sculptor John Mason, remained on view to its scheduled ending, 23 June. The last slate of art classes ended on 21 June, to the dismay of volunteer supporters who had developed a lively community art program but suddenly found themselves unwanted and homeless. Despite his professed belief in the educational value of art and his longstanding habit of contributing generously to educational programs, Simon had no interest in maintaining a school at his museum. Neither did he want unnecessary vestiges of the former leadership. What he had in mind was an efficient operation that would present his collection to the best advantage with the help of a trusted, hard-working staff. To that end, he discharged most of the museum's employees and installed his own curators, Darryl Isley and Sara Campbell, at the museum. Andrea Clark, who had started her career as a registrar at the Los Angeles County Museum of Art, under the direction of Frieda Kay Fall, and moved on to the Pasadena Art Museum, was one of the few staff members retained by Simon.

George T. Peters, an administrator and fund-raiser from Princeton, New Jersey—and, like Macfarlane, an ordained Presbyterian minister—was brought in as executive director. Like his predecessors

both at Simon's museum-without-walls and the Pasadena Art Museum, Peters had a brief tenure. On 1 March 1976, the board of trustees formally appointed Darryl Isley, curator of Simon's collections, as the museum's new director. Isley was only thirty-three, but he had worked for Simon for nearly eight years, in Fullerton, Los Angeles, and Pasadena.

Simon had expected to paint the interior of the building, relocate the bookshop, and build partitions to accommodate a new installation of art. But he soon found that he had acquired a million-dollars-worth of problems in a building that had been neglected. The roof and the storage vault leaked, rainwater had swollen the ground floor, the air-conditioning system malfunctioned, and humidity controls didn't work at all. Instead of the projected three or four months, it took nine months to complete repairs, carry out a facelift, and install the collections. To inform the public that a new day was dawning for the museum, Simon issued a press release on 21 October announcing that his foundations would invest $1 million "to assure the rebirth of the fifty-year old institution." The statement also announced the receipt of a grant of four hundred fifty thousand dollars from the Harry G. Steele Foundation and an appropriation of twenty-five thousand dollars from the Board of Directors of the City of Pasadena, in addition to the city's undertaking to continue the maintaining museum grounds.

In yet another move, designed to ensure the museum's public status for tax purposes, the museum's board was restructured to include more so-called public members. On the new slate, Simon and Macfarlane represented the Simon foundations, the newscaster Tom Brokaw, the retired army general and film producer Frank McCarthy, the Pasadena businessman William E. Forbes, and the actress Dorothy McGuire Swope were the "public" members, Barbara Steele Williams represented the Steele Foundation, and Esberg, Phillips, and Rowan were retained from the museum's original board.

Phillips found the board meetings "bizarre," completely unlike the gatherings of the museum's former governors:

As befitted a group of very important persons, there was frequent picture taking. Agendas, vague to begin with, were often disregarded completely. Policy questions were rarely submitted for board decision. The feature of the meetings and the only matter deserving of particular attention was a long monologue by Simon himself, delivered with head bent and in a low monotone. He would discuss plans for gallery installations and matters related thereto. One could hardly describe these rambling reports as inspirational. Still, I thought it was to Simon's credit that he was talking about art and not about finances, which is often the sole concern of businessmen on museum boards. I suppose since he alone was meeting the deficit, there was really no need for financial discussions. Simon's total stewardship of the museum likewise does much to explain the passive posture of board members during this period. Undoubtedly, they were loath to assert themselves in any way that might have increased the budget beyond Simon's commitment. To be able to sit on a prestigious board without having any more than a nominal financial obligation is a circumstance dear to any trustee's heart. No move should be made that might jeopardize such a comfortable arrangement.[4]

Because of Jennifer Jones's Hollywood connections, many members of the film community eventually served on the boards of Simon's museum and foundations. It was a memorable experience. "Cary Grant I and would drive to Pasadena for board meetings," said the film director Billy Wilder. "We always had a very good lunch with a nice group of people. Then there would be a meeting, but no discussion. Norton Simon ruled. If you disagreed with him, he made you feel like an ignoramus. He had to be in control, so every issue passed unanimously. He would say he bought something at $1.2 million and sold it at $3 million. He was always concerned about money, but he couldn't help himself. He was both an art lover and an art dealer. He loved art and the art of the deal equally."[5]

The Pasadena Art Museum reopened in March 1975, with no fanfare but a stunning new look. "CHRIST! Lookit those floors, like

glass! There must be $10,000 worth of urethane here," exclaimed the critic Peter Plagens of the renovation. "Sure looks expensive— official, deep brown and gold. Like a real museum, at last. (Omigod. What if I like the place? What if Simon's corporate-raider know-how actually transforms the ol' Pasadena? Wouldn't that be embarrassing for all us bleeding hearts? Well, Mussolini made the trains run on time.)"[6]

In the museum's reincarnation, the former lunch room had become a bookshop. A members' lounge was transformed into a gallery displaying sculpture by Isami Noguchi, Henry Moore, Jean Arp, Constantin Brancusi, and Barbara Hepworth. Asian sculpture occupied the space that had been used for the old bookstore. Tapestries, old masters, and impressionist paintings from Simon's collection were installed on the south side of the building, and the cream of the Pasadena holding filled galleries on the north side. Temporarily placating those who feared that they had seen the last of modern art in Pasadena, the opening installation emphasized twentieth-century art, including works from the Galka E. Scheyer Collection.

Still smarting from the failure of southern California's highly touted forum for new art, some contemporary art aficionados could not bear to set foot in the museum. But press response to the revamped institution was predominantly encouraging. "Leaving aside—for the moment—the dismaying manner in which its former board allowed the museum and its five-year-old building to drift into disarray and the manner in which industrialist-collector Norton Simon gained control of the multimillion-dollar facility and its rich content, it must be reported in all fairness that the opening display is of the highest quality."[7]

Devotees of old masters and the French impressionists were impressed with Simon's transformation of the Pasadena institution. *Connoisseur,* a British magazine, devoted an entire issue to the museum, describing its contents as "one of the most remarkable art collections in the world" and pronouncing the institution "a port of call for scholars in many fields." Noting that controversies inevitably follow public figures, the editors rose to Simon's defense in an introductory essay: "The successful businessman-turned-art collector is a favourite target, and has been since the time of Croesus. There is

something about huge American foundations, multifaceted as they tend to be, which baffles, even exasperates, Europeans. It was probably easier to be King of Lydia than it is to be Norton Simon."[8]

The new chief of the Pasadena museum kept his promise to show contemporary art in 25 percent of the space for a period of five years, but it became increasingly clear that the man who paid the bills was in charge. If any doubt remained, it disappeared on 23 October 1975, when the institution became the Norton Simon Museum, to "clarify unmistakably that the museum is to become an institution of the type of the Frick Collection" and to lessen its identification with contemporary art. Six of the board members he had appointed voted in favor of the change. The three holdover trustees, Robert Rowan, Gifford Phillips, and Alfred Esberg, who were appalled by the prospect of becoming even more irrelevant, voted against it. Robert Macfarlane had attempted to win their support before the meeting and effect a unanimous decision, but they refused it. Barbara Steele Williams, who was absent from the meeting, voiced her disapproval upon hearing the news. Audrey Steele Burnand, president of the Steele Foundation, also wired objections: "Hundreds of citizens of Pasadena and Southern California have contributed to the establishment and support of this museum over the years with contributions of money, volunteer efforts, and donations of art. A change of name will destroy valuable rights acquired in the existing name of the museum and its public identification with citizens of Pasadena. While the Norton Simon Foundations have generously supported the museum, such support has not been exclusive. The proposed name change would falsely represent that the museum is solely supported by the Norton Simon Foundations."[9]

Simon said he expected "some static" but hoped that his past supporters would stay with him. The Steele Foundation, however, filed a breach of contract suit, claiming that the change deprived the City of Pasadena of recognition and seeking court permission to break off the foundation's financial commitment. Two hundred-thousand-dollar installments of the four hundred fifty thousand dollars promised had already been paid, but the foundation withheld the third payment, which was due shortly after the board approved the name change.

As the controversy intensified, it was revealed in the press that Simon's rationale for the renaming was that Norton Simon, Inc., the billion-dollar consumer products company that funded his foundations, would be more likely to make gifts to a museum named for Simon than to one named for a city. Because he controlled both the company and the foundations, his line of reasoning was disingenuous. But he knew money would talk to the trustees, and he quickly delivered assurances that they had made the right decision. In November 1975 Mortimer J. Matthews, the mayor of Pasadena, announced that two grants totaling $2.75 million would be made to the museum by the Norton Simon, Inc. Foundation and the Norton Simon Foundation, with the objective of expanding the museum "into an institution of international stature."[10]

Esberg, Phillips, and Rowan had threatened to resign from the board in 1975, when the museum was renamed, but they relented in the hope that, by maintaining a presence, they would have a voice in the institution's policies. They eventually resigned in the spring of 1978, citing frustration in trying to give contemporary art its due and dissatisfaction with the museum's reluctance to lend art from its collections.[11] One of the final blows was Simon's refusal to lend a painting by Richard Diebenkorn to a retrospective exhibition of his work being organized by the Albright-Knox Art Gallery in Buffalo. The incident particularly rankled supporters of the former Pasadena Art Museum because Diebenkorn had given the painting to the museum in 1960 as an expression of gratitude for its organizing his first retrospective exhibition, before he had achieved international recognition.

The departure of Rowan, Esberg and Phillips formally ended a chapter of transition at the museum. But their removing themselves from the museum did not resolve the three trustees' disappointment and resentment, which festered for two more years before erupting in a widely publicized lawsuit.

24

THE *NATARAJA* AFFAIR

*There may yet be a happy ending to the international adventures of the
dancing Nataraja. The bronze idol smuggled out of India and
eventually sold in the U.S., to West Coast industrialist Norton Simon
for $1 million has been the subject of a series of ultra-tactful
negotiations at the Indian Embassy in Washington.*

FERN MARJA ECKMAN
New York Post, *20 June 1974*

THE NATARAJA AFFAIR continued to smolder. Once the statue from
Sivapuram became the subject of international headlines, the Indian
government could no longer ignore it. Losing the sculpture to a for-
eign country, after it had been so long ignored at home, was a public
embarrassment. The loss seemed to symbolize India's lowly status in
the international art market and its inability to protect its cultural
heritage. The return of the *Nataraja* became a high priority.

For Simon, trouble began to brew at the Metropolitan Museum of
Art in New York, which had planned an exhibition of his Asian art
collection before he was offered the *Nataraja*. He had been assured
the statue would be added to the exhibition if he purchased it and
that an image of the *Nataraja* would be used on the cover of the cata-
logue. Once he actually had acquired the extraordinary bronze, he
was eager to give it a spectacular introduction in a prestigious show-
case. The Metropolitan Museum was the perfect setting, Simon
thought, but progress on the exhibition was excruciatingly slow. When
he grumbled about the sluggish pace of museum operations, he was
told that it took time to prepare proper, scholarly presentations. In

November 1973, just as the exhibition was beginning to shape up and the catalogue was nearing completion, he got wind of interference from the Indian government. Eric Gonsalves, India's Minister of Culture, had written a letter to the museum inquiring about the exhibition and stating that the *Nataraja* had been stolen from the temple in Sivapuram. When Simon heard about the letter, he dispatched one of his attorneys, Helen Buckley, to look into the matter. She met with Gonsalves on 3 December 1973 at the Indian Chancery in Washington. He told Buckley that, under the Indian Antiquities Act, the statue was considered to have been stolen though under United States law it was not. After discussing the matter and gathering as much information as possible to take back to Simon, she left Gonsalves having asked him to send her a written explanation of the problem and its legal basis. As winter turned into spring, she renewed her request repeatedly, but did not ever receive an accounting of fact supporting the contention that the *Nataraja* was stolen.[1]

Meanwhile, under pressure from representatives of the Indian government and the U.S. State Department, officials at the Metropolitan became increasingly uncomfortable about the planned exhibition of the *Nataraja*. Behind the scenes in New York, dealers in Asian art also lobbied against exhibiting the statue. They feared that publicity surrounding an exhibition of the statue would raise questions about other Indian artifacts in their inventories and damage the market. From their point of view, the best thing that could happen was for the controversy to fade away as quickly as possible. Showing off the *Nataraja* at the Metropolitan was likely to have exactly the opposite effect. As they saw it, to stage an extravaganza with this particular Lord of the Dance as the star attraction was to court disaster.[2]

For Simon an exhibition of his Asian art collection without the *Nataraja* was unacceptable, and tantamount to an admission of wrongdoing. Some sort of resolution was clearly needed, so he took the matter into his own hands and scheduled a meeting with the Indian ambassador, T. N. Kaul, at his official residence in Washington. On the evening of 20 March 1974, Simon arrived at the embassy with his associate, Alvin Toffel, and his attorney, Theodore Weisman, the brother of Simon's brother-in-law, Frederick Weisman.

They were greeted by Kaul and Gonsalves and Dennis Kux of the U.S. State Department.[3]

After exchanging pleasantries over cocktails, the ambassador got to the point of the meeting. He told Simon that he hoped they could reach an understanding that the *Nataraja* would be returned to India after the American people had a chance to see it. Simon said he shared that hope, but there were many factors to be considered and several obstacles to overcome. Furthermore, he said, the Indian government should be happy the statue was in his foundation's possession because it had paid for extensive conservation that was essential but had been neglected previously. The dancing figure would have sustained serious damage from bronze disease if action hadn't been taken. Kaul acknowledged India's debt for the treatment, but guided the conversation back to the return of the statue. Taking over from Kaul, Gonsalves explained that getting the statue back was important in itself but it was also part of a larger objective: India had a problem with smuggling and many artworks had left the country illegally. Retrieving such a significant piece as the *Nataraja* was the key to the repatriation of many other artworks.

Holding his ground, Simon agreed that smuggling should be stopped but objected to the hypocrisy that was endemic to the international art market. Museums all over the world were full of objects that might, at some time, have been improperly removed from their home countries, he said. But illicit trade in art usually required the complicity of citizens of the very countries that complained about the loss of their national heritage while doing little to protect it. Simon said he had behaved honorably by taking an option on the *Nataraja* and investigating the piece before buying it. Yet, despite these precautions, his reputation had been harmed by the controversy. The assurance given by the Metropolitan Museum that the statue would be exhibited if he acquired it had been a decisive factor in his purchasing the statue, he said. But now, the museum was retreating and leaving him in an embarrassing situation.

Kaul, in an attempt to placate Simon, offered to try to correct injustices done to his reputation in the press. He invited Simon to travel to India so that he could be presented an award at a public ceremony in a show of international good will. Annoyed that the

ambassador seemed to think he could be bought off so easily, Simon said he was not interested in an award; he wanted justice. And that meant solving his problem at the Metropolitan Museum. The director of the museum, Thomas Hoving, and the president, Douglas Dillon, had become uncooperative and needed an attitude adjustment, he said. That's where the ambassador could help. Kaul protested that such differences had to be worked out between Simon and the museum officials, but Simon insisted India's support was a prerequisite for the *Nataraja*'s return.

Wearying of Simon's persistence, Kaul eventually agreed to try to use the Indian government's influence to ensure that an appropriate show was held at the Metropolitan—but only after they had reached an agreement in principle about the *Nataraja*'s return. Without acceding to Kaul's demand, Simon upped the ante. He told Kaul that he was so upset with the Met, he was no longer certain he wanted the show to be there; the National Gallery of Art in Washington might be more appropriate. The ambassador said the Indian government would help to smooth the way for an exhibition wherever Simon wanted it, if only an agreement in principle could be reached.

Having negotiated as far as he thought he could on that point, Simon said he wanted to give more thought to the location of the show. Then he proceeded to the next item on his private agenda: The *Nataraja* must be given a clean bill of health and all cloud of suspicion about its status as a stolen object must be removed. Once again, Kaul said the government would try to launch a public relations program to remove doubts about Simon's acquisition of the statue.

Shifting to a more philosophical stance, Simon told the ambassador that the real problem with returning the statue was not the money he had spent on it, but that he wanted justice in light of his reputation and his relationship with the Metropolitan Museum. Furthermore, if he returned the statue to India, he wanted the gesture to be meaningful. Perhaps his action could launch a cultural exchange program that would promote better understanding between the people of India and of America. The ambassador agreed with the notion, but said that working out logistics was a separate matter that would require time. He was prepared, however, to make repatriation of the statue an event of major significance.

Taking yet another tack, Simon eventually admitted that the controversy surrounding the *Nataraja* served his interests by publicizing his collection and enhancing other pieces of Indian art he owned. The *Nataraja* wasn't even his favorite piece. Other objects in his collection gave him more aesthetic satisfaction, but he didn't want to give up the statue unless he obtained something in return. Maintaining his diplomatic demeanor, Kaul said he appreciated Simon's candor, and thought he was acting with "enlightened self-interest."

Then Simon revealed his last condition for the return of the *Nataraja.* He told Kaul that he wanted the Norton Simon Foundation's Indian art collection to be given immunity from further efforts by India to seek the return of art. Sensing that this was the true key to the return of the *Nataraja,* Gonsalves readily agreed. The ambassador did not commit himself. The meeting ended without the agreement in principle that Kaul had tried to secure, but he and Simon did agree to try to develop a plan that would lead to the return of the statue. As Simon departed, Gonsalves whispered to Toffel that he was sure that immunity could be arranged.

By the following morning Simon had had second thoughts about his remarks about the Metropolitan. He became concerned about what sort of action Indian officials might take, so he scheduled a meeting with Gonsalves that afternoon to clarify the situation. "Where do we stand?" Simon asked when they met. Gonsalves said that the Indian government, in conjunction with the U.S. State Department, had agreed to exert influence on the museum to proceed with the exhibition, with the *Nataraja* as its centerpiece, or to help smooth the way for a similar exhibition at National Gallery of Art in Washington. In addition, the Indian government would drop criminal charges in the case and develop a public relations program to publicize the significance of the statue's return and remove imputation of culpability in Simon's acquisition of it. He warned Simon, however, that these arrangements would have to be confirmed by the Indian government. Putting himself on equal footing, Simon countered that his decisions must be approved by his foundation's board of directors. The two men agreed that ten years was an appropriate period of time for Simon to keep the statue.

Having achieved what he wanted for the moment, Simon seized the opportunity to turn a potential disaster into a triumph. He told Gonsalves that he hoped the Indian government would become an active participant in the planned exhibition by lending between thirty and forty prime pieces of Indian art. That would create the largest and most complete exhibition of Indian art ever held in the United States, and it could travel—perhaps to Los Angeles and Cleveland. Gonsalves hedged a bit, saying that he thought loans could be arranged but would take several months. They parted with a verbal agreement to negotiate a firm plan.

The plans were never realized. Two months after the meeting in Washington, negotiations had accomplished nothing. Gonsalves repeatedly requested, but did not ever receive, a written confirmation of an agreement to return the *Nataraja*. Simon failed to win the cooperation he had demanded to facilitate the exhibition. As pressure mounted at the Metropolitan to exclude the *Nataraja*, Hoving eventually told Simon that the museum would not display the statue.

"We stand on the grounds that we will not show a work of art that a foreign government has requested us not to show because—to the best of their knowledge—it is stolen property," Hoving reportedly told the *New York Post*, later adding "that the board of trustees decided to follow UNESCO guidelines in not exhibiting any art work to which another government has made claim."[4] Simon was quoted as saying that it was he who had actually taken the initiative and that the entire show was canceled: "Everything from our foundation has been pulled out of the Metropolitan because we couldn't have the show under the peculiar kinds of executive privilege that exist there now."[5] The following day it was reported in the *New York Times* that Simon denied that the museum had refused to show the *Nataraja* and he chastised the Metropolitan for being unable to pull the exhibition together after two years.[6]

Simon lost that particular battle, and the affair disappeared from the public eye until December 1974, when the dispute escalated to an international lawsuit. The Indian government filed charges of fraud against the Norton Simon Foundation and asked for $1.5 million in addition to the return of the statue. The plaintiffs were the Union of India and the state of Tamil Nadu, two so-called trustees of

the statue, Sankara Kanakaraja and Arulmiga Sivagurunathaswamy, and the Sivapuram *Nataraja* itself. In addition to the Norton Simon Foundation in California, the defendants included the dealers Ben Heller in New York and Manu Narang in London and the conservator Anna Plowden, who had treated the statue and put it in a bank vault in London for safekeeping.

"I guess Norton and I are the only people in the United States who have ever been sued by a god," Heller said, more than twenty years after the suit was filed, when he could laugh at his predicament. "We were sued by Siva, whose representative was the keeper of the temple, whose representative was the Indian government."[7]

The suit, filed in the District Court for the Central District of California in Los Angeles, charged that there had been a conspiracy to steal the *Nataraja,* that the Indian government held title to the object, and that it should be returned to India. The plaintiffs sought $500,000 for intentional infliction of mental suffering, $1 million in punitive damages, and costs incurred in locating the idol and litigating for its recovery. The suit also asked for a substitute payment of $4 million ($2.5 million in addition to the $1.5 million for damages and expenses) if the statue were not returned.

Putting his lawyers on the case, Simon declined to comment in the press until a few weeks later, when he told a reporter for the *New York Times:* "If it was their great idol and was in the Behram collection in Bombay, why didn't they seize it then? Why didn't they seize it when Heller had it? But no, they only became interested when they heard how the price had gone up."[8]

In February 1975, the Norton Simon Foundation counterclaimed for willful and malicious disparagement and asked for damages of more than $1 million, punitive damages of $10,000, and court costs. The suit argued that the plaintiffs had no rights or title to the statue, they should have known its whereabouts when it was displayed openly in Behram's collection, and by their failure to try to recover the statue at that time had forfeited their rights. The claim also said Indian law is contrary to United States public policy and should not be applied in an American court.

The case did not go to trial. In May 1975 an out-of-court settlement provided that the Indian government would get title to the statue and

the foundation would retain the right to exhibit it for ten years. While on display, the statue was to be accompanied by a label stating that it was "on loan from the Union of India to the Norton Simon Foundation for a period of ten years as part of an amicable resolution of a dispute as to title between the Union of India and the Norton Simon Foundation." Under terms of the agreement, the Indian government agreed to lend additional artworks to the Simon museum for an exhibition. But, despite repeated requests from the museum over many years, that promise was not kept.

In an important concession to Simon, the settlement also provided that the Indian government could not make claims against the foundation with respect to any art object already in the collection by the time Simon had taken an option to purchase the *Nataraja*. Each party agreed to pay its own legal costs; Anna Plowden's expenses were to be split between the plaintiffs and the defendants. In a separate action, Simon had sued Heller for $1 million to get back the purchase price of the sculpture. The statue was to remain in a bank vault in London until the foundation had arrived at a settlement with Heller.

In May 1975 Heller proposed settling Simon's claim by giving the Norton Simon Foundation a choice of Asian artworks from a list of sixteen pieces, at a total book value of up to $275,000. Heller claimed that the market value of his offer was between $820,000 and $1 million. Alternatively Heller gave the foundation an opportunity to buy all sixteen items on the list for $550,000, and receive $175,000 in cash. In addition, Heller offered to sell the foundation a fifty-two-piece holding of Asian art amassed by the Swiss collector Samuel Josefowitz for $1.1 million.

Simon refused both proposals. After nearly a year of negotiations, he worked out a variation that suited him. In April 1976 Heller agreed to give Simon fifteen Asian artworks, at a book value of $900,000, and to give him a cashier's check for $100,000. Three of the pieces had already been sent to Simon on approval; the remaining twelve were to be shipped to the Phoenix Art Museum, where they would be displayed long enough to avoid California taxes.

"Norton made a gorgeous Norton deal," Heller said. "Ultimately he got his money back. He gave the sculpture back to the Indians but

only after ten years of possession and he got free rights to everything else in his Indian collection. Everything else was untouchable. I would have loved to have seen the case tried. It becomes a very interesting question of ownership because the piece was openly held in a private collection and it wasn't illegally brought into this country, by our laws."[9]

On 14 May 1976, Simon received the *Nataraja* from Anna Plowden, packed and double crated. Nearly three months later, on 2 August, Mr. Kaul, the ambassador for India, and Simon held a joint press conference at the Norton Simon Museum to announce the settlement and to inaugurate an Asian art wing and a display of fifty major sculptural works and small artifacts, with the Sivapuram *Nataraja* as the centerpiece. Indian government officials expressed the hope that Simon would return the sculpture before the prescribed decade had passed, but he stuck to the agreement and sent it back to India in 1986.

Simon and his associates discussed the possibility of staging a special exhibition or reception to mark the return of the statue, but attorneys counseled Simon to conclude the affair quietly. Despite his agreement with the Indian government, they feared that publicity might raise questions about the return of other pieces in his collection or lead the public to think he had lost the legal case.

A contingent from India arrived at the museum on 5 May 1986, and officially took possession of the *Nataraja*. Nagaraj Rao, the director general of the Archaeological Survey of the Government of India, accepted the statue. The world's most famous Indian bronze was then packed and shipped to India, where it has been all but forgotten.

25

A SECRET CACHE OF DEGAS BRONZES

*There can be no question but that it is a genuine set made at
the time when the other series were cast.*

JOHN REWALD
The Complete Sculptures of Degas, *1976*

You go from piece to piece mumbling, "I don't believe it."

WILLIAM WILSON
Los Angeles Times, *May 14, 1978*

IN SEPTEMBER 1976 SIMON took a call from Martin Summers, a
charming young dealer from the Lefevre Gallery in London, who
claimed to have a full set of Edgar Degas's bronzes for sale. The claim
sounded preposterous because the only complete or nearly complete
sets of the bronze ballerinas, female nudes, and race horses were
known to be in the collections of the Metropolitan Museum of Art
in New York, the Louvre in Paris, the Ny Carlsberg Glyptothek in
Copenhagen, and the Museu de Arte in São Paulo. Other castings of
the same sculptures were scattered in collections throughout the
world. Even more incredible was that, according to Summers, the
sculptures comprised a long-forgotten, recently unearthed group of
pieces that were unique and superior to all other editions of Degas's
work. The bronzes he offered to Simon were *modèles*, or master casts,
from which all the other, authorized casts had been made.[1]

Summers and his partner, Desmond Corcoran, had chosen their
mark well. The mere mention of Degas's name was enough to get the

attention of Simon, who counted the French artist among his personal favorites. An aficionado of several French impressionists, Simon was particularly drawn to Degas who was the most difficult and complex member of his circle of artists. Interested in observing Parisian life—at ballet studios, race tracks, and in mundane settings where women groomed themselves or performed domestic duties—rather than in painting landscapes and momentary effects of light, he was more of a realist than the other impressionists were. A master of awkward grace, he found arresting beauty in the offhand gesture, the unposed stance, the unguarded moment, and the oddly cropped composition. His work lacks a veneer of cosmetic perfection but pulses with life and resonates with an awareness of flawed humanity. Perhaps for those reasons it had always attracted Simon, who probably saw something of himself in Degas's subjects.

Simon had purchased his first two works by Degas, *Dancer Rubbing Her Knee,* and *Dancer in Green,* in 1955. Subsequently, he bought one or more works by Degas nearly every year. His first purchase at the Lefevre Gallery, in 1958, was a Degas, and several others later made their way from London to Simon in California. Summers, who had become a partner at Lefevre in 1967, began in the art business at Arthur Tooth & Sons and knew that Dudley Tooth, his former employer, had sold *Women Ironing,* a prized painting by Degas, to Simon in 1959, two years before Summers joined the firm.

As Simon had built his collection, Degas had become a major presence. By the late 1960s, when Simon was still married to Lucille, some two dozen of the impressionist's drawings, paintings, and sculptures—more works than by any other artist—were installed in their house on Hudson Avenue. Friends and groups of visitors who perused the Simons' personal collection saw examples of Degas's work in the foyer of the house, the living room, the gallery, the office, and even a closet. Other pieces by Degas, owned by Simon's foundations, often went on the road as loans to museums and educational institutions. A painting and a drawing of dancers were among twenty-three pieces exhibited in *Recent Acquisitions by the Norton Simon, Inc. Museum of Art,* at the Portland Art Museum in 1968. *The Star: Dancer on Point,* a gouache and pastel on paper, appeared on the cover of the catalogue for the exhibition of *Three Centuries of French Art: Selections from the Norton*

Simon, Inc. Museum of Art and The Norton Simon Foundation, at the California Palace of the Legion of Honor in San Francisco in 1973. A year-long loan made to the Los Angeles County Museum of Art in 1972 also included works by Degas.

The artist was known during his lifetime as a painter and draftsman, but he spent a great deal of time modeling figures in wax and during the last decade of his life concentrated on sculpture. He did not, however, have any of his waxes cast and he exhibited only one of them, *The Little Fourteen-Year-Old Dancer,* a thirty-seven-and-one-half-inch tall ballerina dressed in a real net tutu and with a satin hair ribbon. At his death, in 1917, about 150 wax statuettes were found in his studio. They were taken to the foundry of Adrien A. Hébrard in Paris, where seventy-four of them were cast in bronze. The rest were broken or crumbled and beyond repair. A contract between Hébrard and Degas's heirs stipulated that twenty-two casts would be made of each work: one complete set for the heirs, one for the foundry, and twenty sets for the market. An Italian craftsman, Albino Palazzolo, was commissioned to do the job, an intricate, painstaking process accomplished between 1919 and 1932.

As the attentive owner of several Degas bronzes, Simon was familiar with the history of the artist's sculpture and its posthumous casting, as far as it had been known, so he greeted Summers's news with skepticism and a torrent of questions: "What's the story? Where did they come from? Whose are they?" When Summers said that the bronzes had been found in the cellar of Hébrard's house on the Île de la Cité in Paris, Simon sputtered, "They must be fakes."

"No, they are not fakes," Summers said, informing him that John Rewald, the foremost Degas expert and author of the catalogue raisonné of the artist's sculpture, had seen the bronzes and intended to publish an article attesting to their veracity as *modèles.*[2]

This was the second major discovery that shed new light on Degas's sculpture for Rewald and other scholars. It had long been assumed that the original waxes were destroyed in the casting process, but they had been found in 1955, in the same cellar where the bronzes were later discovered. The waxes were exhibited at Knoedler and Company in New York in 1955 and purchased by the American col-

lector and philanthropist Paul Mellon, who gave several of the stat-
ues to the Louvre. Rewald confessed in an essay written later in 1976
for the Lefevre Gallery's exhibition of the bronze *modèles* that, when
he had studied the waxes in Hébrard's cellar, he had "noticed the set
of bronzes now being shown, but paid no special attention to it and
thus did not realize that it bore a mark different from the others with
which I was familiar."

As Rewald noted in his essay, Jean Adhemar, Degas's biographer,
had alluded to the *modèles* in an interview with Palazzolo that was
published in *Art News* in November 1955. In the article Hébrards'
decision "to make a bronze master cast of each figure, checking it
meticulously against the original," was mentioned but no further ref-
erences to the master casts had appeared in print thereafter and the
possibility of their existence had apparently been forgotten.

"It is quite obvious that the set which is shown here represents
these *master casts,* since this is consistent with its marking:
MODÈLE," Rewald wrote. "It is regrettable that, through sheer neg-
ligence, no mention was ever made of this set. It is true that it was
not for sale and has remained in Hébrard's cellar for more than half a
century. Nevertheless, there can be no question but that it
is a genuine set made at the time when the other series were cast."[3]

As it turned out, the *modèles* were indeed unique. Degas's waxes were
too fragile to be used repeatedly to create an edition, so Palazzolo care-
fully made gelatin molds of the sculptures and used each mold to
make one very fine wax cast. The wax casts in turn were used to pro-
duce the master set of bronzes, or *modèles*. All subsequent casts were
made from the *modèles*.

Although Degas's *modèles* are marked as such, there are other
ways to distinguish them from second-generation casts. The *modèles*
have more surface detail and evidence of the artist's hand, and there
is a difference in size: They are between 1½ to 3 percent larger than
later editions, an effect of the contraction of metal during the casting
process. Degas's *modèles* also have marks where gelatin molds were
cut away, which can be seen under magnification, and traces of
gelatin and clay can sometimes be found in the crevices of the sculp-
tures and under the base.

"How much do you want for them?" Simon demanded of Sum-

mers after hearing his tale of the *modèles*. Summers named a price in excess of $2 million and got a quick response: "That's crazy."

"Well," Summers said, "it sounds crazy without seeing them. Why don't you come to London and see them? We're going to have an exhibition, but that won't be for a bit. I'm planning to tell a few other people about them, but I'm telling you first and you ought to come and see them."

"I'll call you back," Simon said.[4]

During the following month, Simon's curator, Darryl Isley, kept in touch with Summers and updated Simon on the complicated transactions required to get the sculptures out of France. French authorities initially denied export licenses for the large figure, *The Little Fourteen-Year-Old Dancer* and three smaller pieces, but the delay was temporary and in late October the whole group was finally assembled in London.

Meanwhile, discussions about the impending deal proceeded in a typical fashion, with Simon stalling and Summers threatening to offer the *modèles* to other clients. The dealer and the collector had a tentative verbal agreement, but no firm commitment, on a price of $2 million, which allowed Lefevre a fair profit. When Simon hedged, Summers told him he would ask $2.25 million from other clients if Simon turned him down.

"He is not in the mood to play chicken," Isley said of Summers in a memo to Simon. "Martin does not want to get into negotiations on this. If we come up with a ridiculous or insulting offer he said they would just blow us out the window." Summers told Isley he had to have Simon's decision by 1 November.

One morning as the deadline approached, Summers's phone at home rang before dawn. "You've got every single one of them?" Simon asked.

"Yes, save the two that have been lost for years," Summers responded, assuring Simon that he had seventy-two relatively small figures and the larger one, *The Little Fourteen-Year-Old Dancer.*

"You have bronze number eighteen?" Simon persisted, referring to a 19¼-inch-tall figure, *Grand Arabesque, First Time,* one of which he already owned.

"If you go to the airport now, you can catch the 8:15 flight to Los Angeles," Simon said. "Bring number eighteen with you. I'll meet

you in the Polo Lounge at the Beverly Hills Hotel at 8 o'clock tonight."

Grabbing his passport and packing the sculpture with a change of clothes in a carry-on bag, Summers headed toward the airport. His flight was delayed, but he reached the hotel only about five minutes late. He found Simon waiting with Isley. They were sitting in a booth with Simon's number eighteen on the table. Simon ordered a round of drinks and guacamole, and got down to business.

When Summers lifted the statue out of his bag, Simon grabbed it and thrust his bronze at Summers. "They don't even compare," Simon said derisively, insisting his was better.

But he was only being contrary. When Summers called his bluff and said, "No, they don't compare at all because yours is a fake," Simon soon backed down. He could see that his own sculpture lacked detail that gave the *modèle* a far greater sense of life. Indeed, as he learned later, the figure he owned wasn't even a second-generation cast. It was an unauthorized cast of a second-generation sculpture and thus of little or no value.

"I returned to London and we did the deal," Summers said. "Sometimes he had to act sharply, when he didn't want to miss an opportunity. He didn't want to commit too much, too quickly, but he knew this was something quite out of the ordinary."[5]

The exhibition opened at the Lefevre Gallery on 18 November, and Simon announced his purchase of the *modèles* the same day. The collector who loved to negotiate and hated to close a deal had acted relatively quickly on the *modèles*. But, before committing himself, he had solicited the advice of Charles Millard, an art historian and expert on Degas, formerly a curator at the Los Angeles County Museum of Art and now at Harvard University, who had gone to London to look at the bronzes, and Arthur Beale, a conservator at the Fogg Art Museum at Harvard, who had done considerable research on bronzes with Millard. "Simon had a way of ferreting out who were the people who were most on top of whatever area he was collecting in, and consulting with them," Beale said. "I guess he always wanted the very best advice."

The show at the Lefevre Gallery closed on 21 December, and the *modèles* were shipped to the Fogg Art Museum, where they were put on exhibition and studied by Beale and other scholars. In April 1977

the sculptures were the subject of a symposium at Harvard that attracted leading Degas scholars from the United States and Europe.

> We had hypothesized technically that it was likely that there was a master set of models for the Degas sculpture. Charles and I had traveled to Europe, looked at pieces there and actually visited with the foundryman in Italy. Also, I was involved in an exhibition and a study called "Metamorphosis in Nineteenth-Century Sculpture," which was concerned with some of these issues. We realized by studying the art of Antoine-Louis Barye, the French animal artist, that this was common nineteenth-century and early twentieth-century practice. When a production series was going to be done, a model would be made in bronze, particularly if the original models were fragile, whether they were plaster or, as in the case of Degas, they were wax and plastiline. And that master bronze model would be the one used subsequently either for mold making or actually in the foundry process. In this case, the editions were all cast in the lost-wax process. So the bronze was used to make the waxes.
>
> We were unaware of the existence of the casts until Simon was offered them, but, when we examined them, we knew exactly what they were because all the tell-tale signs of the mold making were on them. We could see the cut lines. We also measured and weighed them and compared them to known edition series. We were able to prove conclusively how important they were.[6]

With their reputation intact, the sculptures eventually traveled to California. They were installed at the Norton Simon Museum in Pasadena in May 1978. Reviewing the exhibition, the art critic William Wilson wrote: "It's the kind of news that should cause us to crumple in an ecstatic faint. It is too good to be true, except, of course, it's true." After telling the story of the creation of the sculptures and describing Simon's new acquisition, Wilson marvelled about the effect of the display:

> The Simon Museum's Degases aren't simply fulfilling. They are enthralling. You go from piece to piece mumbling, "I

don't believe it." Has anyone ever known the anatomy and gait of a horse so well that a small, casual-looking wax could function like a series of X-rays that reveal successive layers of bone, sinew, muscle, flesh, coat, movement, and finally even *character?* Has anyone ever seen woman so wryly unglamorous and yet discovered there such grace, dignity, and charm? Degas's willingness to let people be human puts him in a class with Rembrandt. His unwillingness to force his feelings upon us puts him in a class by himself.[7]

Although Degas himself did not have the works cast and may have disapproved of having his laboriously reworked waxes reproduced in bronze after his death, the seventy-two *modèles* were what they had been purported to be. *The Little Fourteen-Year-Old Dancer* was a different matter.

"Several months after we had shipped the sculptures, I got a rather pained telephone call," Summers said. "Simon wanted to let me know that, delighted as he was with the whole set, the fourteen-year-old girl was a problem." That particular figure had always existed in a gray area, as Summers knew all too well. Twenty-two sets of the smaller bronzes had been cast and marked with letters of the alphabet or inscribed with *HER* and *HER.D* for the foundry and for Degas's heirs; twenty-eight versions of the larger figure had been created, eleven of which are not marked.

But Summers, who believed that he had sold Simon the master cast of the ballerina, could hardly believe his ears. "You're saying it's not genuine? You want me to sell it for you? We did a deal six months ago. We're not backtracking now," he told Simon.

"Well, we'll have to work it out. I want my money," Simon said, reminding him that he had paid $450,000 for the large figure.

Summers refused to refund Simon's money but told him to send the sculpture to London so that he could look into the matter. On 25 May 1977 Simon shipped the bronze to Lefevre and demanded that Summers find a new buyer for it. It sat in the gallery's office for nearly five months, "forlornly looking for a new home," Summers said. "I was really quite upset by it."

"One day Desmond and I were having lunch in the dining room above the gallery and trying to resolve what to do," Summers said.

"We actually had rather too much to drink and we went downstairs and we were sort of fooling around. I remember thinking, 'I'm going to undress the girl.' Now this isn't something you do, but I looked at the tutu and the little knickers underneath, and saw that the tutu was sewn up on one side. There were quite definitive holes where the needle had gone through the cloth."

Emboldened by frustration and alcohol, Summers loosened the thread that held the clothing in place, examined the bronze underneath and discovered the word *"modèle"* on the figure's upper left thigh. Thrilled that he had proved *The Little Fourteen-Year-Old Dancer* was consistent with the rest of the set, he called Simon with the news and returned the bronze to Pasadena.[8] But the affair wasn't settled to Simon's satisfaction.

Hearing that Beale was traveling to Los Angeles on business a few days later, Simon called him in Boston and asked if he could stay an extra day to compare his version of *The Little Fourteen-Year-Old Dancer* with others in local collections. Beale agreed to extend his trip. He had previously studied other bronze castings of the figure at museums and private collections on the East Coast. In Los Angeles, Simon had arranged for him to study two works in private collections. At the end of the day the visiting conservator dined with the Simons at their home in Malibu, where they picked his brain about various artworks on display there. A few days later he sent the collector a written report of his Degas research.

The results bore out Simon's concerns and discounted the *"modèle"* marking that Summers had found on the figure. The dancer was either cast from another bronze or made from a sculpture composed of some other material. "It was a truly inferior cast," Beale said. "So not only was it not the master *modèle,* it wasn't even as good as the run of the mill. I knew on a comparative basis that it was quite incorrect." Unlike actual *modèles,* which are larger than second-generation casts, this one was smaller than other versions he had examined. Having thicker walls, it also was heavier than its counterparts.

Intrigued by his findings, Beale wanted to take his research further by studying a plaster sculpture of the same figure at the Joslyn Art Museum in Omaha, but Simon had no interest in funding that effort. "That was frustrating for me," Beale said. "I'm a perfectionist. I want

to get the last answer. I don't want to just say, 'This is wrong.' I want to know why, and where the real one is and carry it to the logical conclusion. Simon treated me very well, but he had no interest in supporting scholarship beyond his collection. He wanted to learn everything he could about the pieces he was acquiring. He was not interested in acquiring anything that wasn't of the highest quality or what it was reputed to be, but his scholarship had bounds."

Several years later Beale did study the plaster figure in Omaha, and concluded that it probably is the model for the other casts of *The Little Fourteen-Year-Old Dancer.* "It's a model used to make gelatin molds," Beale said. "That's what the bronze *modèles* were used for. When the foundrymen took a knife to cut the gelatin molds away, they left a cut line that can be seen under magnification. In this case they used a plaster model instead of a bronze one, and it has all the tell-tale marks. It also has nice detail. The bronzes are all smaller than it is, showing that the bronze shrank."[9]

Despite Beale's report, Simon kept his version of *The Little Fourteen-Year-Old Dancer* and displayed it in a gallery of works by Degas, selected from the more than 100 drawings, paintings, and sculptures by the artist in his collection. Had the collector foreseen his acquisition of the *modèles* and the little ballerina, he might have held on to an earlier purchase. In 1965 he bought the version of *The Little Fourteen-Year-Old Dancer* that had been made by the Hébrard foundry for $115,000 from Marlborough-Gerson Galleries in New York. Six years later, in 1971, in a $6.5-million sale of works from his collection at Parke-Bernet's auction house in Manhattan, Simon sold the statue for $380,000. The widely heralded price set an auction record for sculpture. It seemed an extraordinary sum for an artwork that is not unique. However charming and beloved the figure may be, it is merely part of an edition—and one that was cast posthumously. But on 10 May 1988, while the art market was rising to dizzying heights, the same cast of *The Little Fourteen-Year-Old Dancer* that Simon once owned set a much more astonishing record. It was sold at Sotheby's in New York for $10.12 million in an auction of fifty-five artworks that rang up $94.4 million in sales.

26

THE ETHICS OF DEACCESSION

*A California lawsuit by former trustees charges Simon with
"cannibalization" of the collection of the Pasadena museum whose
control he assumed in 1974. "It's a cleaning up of the mess
they left behind," replies Simon.*

PATRICIA FAILING
ArtNews, *October 1980*

AFTER FIVE YEARS OF operating under a new regime, the Norton
Simon Museum had become a valued fixture in the cultural land-
scape in Los Angeles. Even bitter opponents of Simon's governance
had to admit that having much of his art collection under one roof
where the public could see it enhanced the city's artistic resources
enormously. Housing what had become known as the best private
collection assembled since World War II, the Norton Simon
Museum was the West Coast's version of the Frick Collection in
New York. With the periodic addition of rare items such as *The Res-
urrection,* by the fifteenth-century Flemish painter Dieric Bouts,
The Branchini Madonna, an alterpiece by Giovanni di Paolo, and
the *modèles* by Degas, the Simon museum was no mausoleum. It
offered an astonishing array of new acquisitions.

The museum also had a new director, Darryl Isley, who had
worked for Simon since graduating from California State University
at San Jose. Charismatic and popular among his peers, he seemed
to have a gift for getting along with his difficult boss. Simon
demanded a great deal of Isley, as he did of all his employees, but
treated him as a favored son. Once Isley became director, however, it
was only a matter of time until he clashed with Simon, who was in

charge of the museum no matter who had the title. One day when they got into an argument, Simon threatened to fire Isley, who retorted that he would quit. They patched up their differences, but only long enough for Simon to flaunt his authority. In a display of power calculated to humiliate Isley, Simon fired him in August 1977 during a meeting of the museum staff. Isley subsequently worked as a dealer and died of a heart attack in April 1990 in London.

The next person to occupy the hot seat was Alvin Toffel, who had no training in art but had been an administrative assistant to Simon since 1973. Toffel served as the museum's chief administrator until 1980, when he resigned to pursue business ventures. Then came David Bull, a British conservator who had met Simon in London and had worked on paintings the California collector later purchased. Bull left England in June 1978 to become head of conservation at the J. Paul Getty Museum in Malibu, but Simon was pursuing him even before he began his new job. "I wanted to give my family time to settle into a new country, so we moved about three weeks before I was scheduled to begin at the Getty," Bull said. "I had told no one I was in Los Angeles, but as soon as the telephone man connected the phone in our rented house, it rang. It was Selma Holo saying that Norton Simon had a painting he wanted me to work on. He knew my telephone number before I did."

Such capers persuaded many people that Simon had spies, but his tactics were effective. During Bull's first year at the Getty, he frequently spent afternoons at the Simon Museum looking at paintings with Simon and Holo and being seduced by intellectually challenging conversation. One day when he was accompanied by his associate, Simon gave them a "taste test." He had set out some sixteenth-century paintings of tulips that he owned, along with another group he was considering buying. Simon asked his visitors to tell him which group was better. "It was difficult, but fortunately I picked the right ones," David Bull said. The surprise exercise in connoisseurship led to another unexpected encounter. Simon asked to have a private word with Bull, took him into the museum's empty auditorium, and offered him the position of museum director. "I was flattered, but I told him I had never thought of being a museum director," Bull said. "He said he thought I would be the

perfect person for the job. But, in typical Simon style, nothing was settled. We just agreed to continue the discussion."[1]

During the ensuing months Bull met Simon at his house in Malibu a couple of afternoons each week. "I always sat facing the beach. He always sat with his back to the ocean. Then he began the Gestapo grilling. For an hour and a half while the sun was setting we would talk about paintings in the collection. The sun would get in my eyes. He would ask if it bothered me and I would always say no. But it did. Meanwhile, his face would recede in darkness. It was a deliberate ploy and it was brilliant." Increasing Bull's discomfort, Simon would press him about fine points of works in his collection, which Bull didn't know well. "Part of the time I was lying," he said, "but I never knew if he knew I was lying, or if he somehow admired me for that."

Despite his ominous introduction, Bull couldn't refuse Simon's offer. "He said, 'When you become director, I will step back and you will step forward and you will inevitably step on my toes.' And of course I did," Bull said. "I took the job because I admired the man so much and I thought the collection was so good. Every single person I knew said I was a fool. The staff placed bets as to whether I would last six months or a year." He stayed almost exactly a year, from 1 April 1980 to 5 April 1981. Having resigned from both the Getty and the Simon museums, Bull went into private practice in Los Angeles for three years. In 1984 he became a conservator at the National Gallery of Art in Washington. Simon threw Bull's career off track, effectively stealing him from a coveted position at the Getty, two years before it received its benefactor's fortune and became one of the world's wealthiest museums. But many years after he had left California, Bull said that his time with Simon had been "a great year. I don't regret it for a single second. He was the most remarkable man and the greatest collector I have ever known."[2]

Bull was the last person Simon hired as director of his museum. "I think we'll no longer have a director," he said when Bull left. "From now on we'll work with consultants. I find it much more comfortable working with them, even financial consultants. They get you away from being trapped with someone. You don't get tied to a single thought."[3]

One consultant he had already employed was David Steadman, who left Princeton University in 1974 to consolidate the galleries of the Claremont Colleges, east of Pasadena. From about 1976 to 1980, he spent one-quarter of his professional time working for Simon. "It was fabulous training," Steadman said. "The thing that fascinated me was the process. He was always comparing, and thinking of the collection in its totality. I think he cared a lot about how people would respond to the work. Basically his impulse was to ask why a work of art was important and how to get people to respond to it."

Steadman left southern California to become director of the Chrysler Museum in Norfolk, Virginia, shortly after Bull took his short-lived position with Simon. By then, the passage of time had healed some wounds caused by the Pasadena Art Museum debacle. But another development speeded the process. Early in 1979 patrons and aficionados of contemporary art who had supported the Pasadena museum found a new place to direct their energy. They joined an effort to form the Museum of Contemporary Art in Los Angeles. Founded by a group of collectors, artists, business people, and civic leaders, the project was publicly endorsed in the spring 1979 by Tom Bradley, the mayor of Los Angeles, who played a key role in securing a downtown site for the institution. In June 1980 in an ingenious arrangement intended to revive and gentrify a dilapidated section of the city's center, the museum was incorporated into a master plan for Bunker Hill by the Community Redevelopment Agency, as the centerpiece of a cultural, commercial, and residential complex. Those who had seen all the money raised for the Pasadena Art Museum consumed by building costs, with nothing left for operations and programs, must have envied a crucial aspect of the Bunker Hill deal: The developer was required to assume the entire cost of the new museum building.

To prove their seriousness and actually get the free building, backers of the planned museum had to raise an operating endowment of $10 million. It was a daunting challenge, but the idea caught fire and the fund-raising goal was met—and exceeded by $1 million—within a year. Some of the campaign fuel was provided by a burning desire to prove that Los Angeles could and would support a museum for

contemporary art. Among the museum's evangelical founding trustees were two people who had worked for the defunct Pasadena Art Museum, Robert Rowan and Norton Simon's sister, Marcia Weisman, who, with her husband, had built a contemporary art collection and was trying to make her own mark as a patron of the arts and a self-styled teacher of classes on collecting new art.[4]

Once again, a new day seemed to be dawning for contemporary art's support structure in Los Angeles. It appeared that the projected museum would play the role once assigned to the Pasadena Art Museum, but in a more appropriate, less conservative setting. Some starry-eyed enthusiasts even dared to dream that Simon might eventually give the planned museum the $3-million modern and contemporary art collection he had acquired with the institution that now bore his name.

But old antagonisms erupted in May 1980, while the museum was still in its formative stage. Flipping through a catalogue of pending sales of contemporary art at Christie's auction house in New York, Rowan discovered two paintings that he himself had donated to the Pasadena Art Museum—Franz Kline's *Composition, 1948,* bearing an estimated price of between thirty-five and thirty-eight thousand dollars, and Richard Diebenkorn's *Urbana No. 1,* which was valued at between forty and fifty thousand dollars. They had been consigned anonymously, but Rowan had no doubt about the seller's identity. It had to be Norton Simon. Rowan considered the advertised sale an egregious breach of trust and an intolerable personal affront. Simon's plan to sell off pieces from the museum's collection of contemporary art symbolized his lack of concern for what Rowan and his colleagues had tried to accomplish in Pasadena and intensified the pain of their failure.

Rowan immediately notified Alfred Esberg and Gifford Phillips of the sale, and the word soon spread throughout the art community. As the former trustees and several prominent artists looked into the matter, they discovered Simon had consigned five works to an auction on 16 May. In addition to the Kline and the Diebenkorn, there was a 1958 gouache by Sam Francis, valued at between twenty-five thousand dollars and thirty thousand dollars; Willem de Kooning's 1964 painting, *Grumman,* with a predicted sale price of between fifty and sixty thou-

sand dollars; and Wayne Thiebaud's 1962 painting, *Refrigerator Pies*, estimated to fetch between fifteen and twenty thousand dollars. And that wasn't all. Twelve other works from the Pasadena collection had been consigned to a less prestigious sale at Christie's East on 10 June. The most valuable among them was *Leaf in the Wind*, a painting by Agnes Martin that was expected to bring between thirty-five and forty-five thousand dollars when it went on the block. It had been given to the museum by Nicholas Wilder, one of the most admired and respected contemporary art dealers in Los Angeles.

A group of artists called a meeting at a studio in Venice to protest the auctions and during the following weeks, several artists, the three former trustees, and other donors to the Pasadena Art Museum raged against Simon, while he responded to their charges in telephone calls from reporters.

"On a moral, aesthetic basis, he is totally out of whack," the artist Robert Irwin said of Simon's plan to sell one of the artist's own paintings, which he had donated to the museum in 1969, when the market value of the piece was about twenty-five hundred dollars. "I didn't ask the Pasadena Museum to exhibit my painting—they came and asked for it and it was a major gift from me. Now Simon stands to make twenty thousand dollars to twenty-five thousand dollars on its sale. Why can't he give it to another institution as I gave it to Pasadena?" Irwin asked. "It would be no more of a strain for him than it was for me at that time." As a founding trustee of the Museum of Contemporary Art, Irwin suggested the planned museum as the most appropriate recipient. If Simon followed his advice, "He would come out a hero, smelling like a rose, and the city would benefit," Irwin said.[5]

Simon had a quick answer to Irwin's solution: "That museum is only a dream still. We're supposed to sit around and wait for their dream?"

Angrily defending himself against his accusers, Simon claimed he was behaving responsibly by pruning the collection.

> Former officers and members of the board of the Pasadena Museum are chagrined because of the disastrous management of the museum. Just because they couldn't run it

capably, they are inspiring the artists to cause all this trouble.

Maybe we [the Norton Simon collection] don't belong in L.A. I don't know if our art is appreciated—the bulk of people around the world realize we have built a great museum. This is preposterous. Preposterous. I'm at my wit's end with these selfish people who didn't know how to run a museum and are only interested in their personal pocketbooks and self-image.[6]

The dealer Nicholas Wilder also weighed in, pronouncing himself "outraged" over the sale of the Agnes Martin. "I gave that painting in memory of a wonderful friend, not as a tax deduction or to support the museum. At least they could offer to sell it back to me," he said.[7]

The former trustees voiced their objections in broader terms. "We would never have made the merger—given over the paintings and the building—if we hadn't felt they were reasonably secure," Esberg said. "The only condition of the transfer was that the collection be shown or lent for exhibition elsewhere. But to auction them off, convert them into cash, and use the money for other purposes, is clearly a violation of the trust."[8]

Simon said he had no intention of using the sale proceeds for purposes other than upgrading the collection, in accordance with nationwide ethical standards for museum deaccessioning. Furthermore, every dollar received from the auctions would be used to purchase other works of twentieth-century art, rather than from the earlier periods he generally preferred. It was all part of a rational, deliberate process, he said. "We're deciding whether to sell each work on the basis of the quality of the work, its appropriateness in the museum, and what its market is at the present time," he said.

There were no restrictions on the sale of the items he planned to auction, Simon argued, and he denied committing an ethical transgression. "The people who ran the Pasadena Museum of Modern Art were not able to make a go of contemporary art here—the museum fell of its own weight. Actually, we are doing well by some of these works because when they are sold they will be seen and shared, instead of lying in a vault. And I feel that by selling the works to buy

others more meaningful to the Norton Simon Museum, I am only carrying out my fiduciary duty."[9]

Rowan questioned Simon's commitment to the museum on the basis that his collection belonged to his foundations rather than the institution, then he threatened legal action. "If Norton had given, say, $10 million or $100 million worth of objects to the museum, he'd certainly have the right to upgrade or improve those objects. But he hasn't given anything to speak of, and when he starts selling the only permanent collection at the museum, isn't he wasting its assets? That's one of the things that we intend to look into legally."[10]

The war of words escalated into a lawsuit against the museum, filed by Esberg, Phillips, and Rowan in Los Angeles Superior Court on 15 May 1980, the day before the first Christie's auction. The immediate result was a temporary order restraining sales from the museum's permanent collection. To Simon's consternation, the seventeen pieces he had consigned to the 16 May and 10 June auctions were withdrawn. The plaintiffs' attorney subsequently asked the court to issue a perpetual injunction prohibiting the museum from further sales of art, but the judge issued a much more limited restriction. He ordered the museum to give twenty days notice of any plans to sell works from the collection built by the Pasadena Art Museum, from 20 June until the suit went to trial. However, the plaintiffs had the responsibility of petitioning the court to stop sales. Subsequently the period of advance notice was increased to forty-five days, giving the plaintiffs more time to petition the court but still requiring them to take the initiative. Meanwhile, Simon was allowed to proceed with sales of about two hundred paintings and prints consigned before the ruling took effect.

In establishing the plaintiffs' longtime support of the museum, the court filing stated that Rowan had donated four hundred thousand dollars in money and art and that Esberg and Phillips together had contributed a total of one hundred thousand dollars. Their suit charged that the proposed sales violated terms of the California charitable trust under which the museum held its assets. Alleging that the museum had gradually reduced its space devoted to contemporary work and added no new pieces of art to the permanent collection, the plaintiffs claimed the sales would result in an irreparable loss to

the collection. The suit also alleged that the museum had privately sold other contemporary artworks, including Frank Stella's 1978 protractor-style painting, *Tahkt-I-Sulayman I,* donated to the Pasadena museum in 1971 by Rowan.

While awaiting a court date, the suit was aired in the press. Simon had abided by his agreement to use 25 percent of the museum's space to exhibit modern and contemporary art for five years. But he made no pretense about his lack of interest in the Pasadena museum's collection, telling a reporter he had "walked away from modern art some time before. Once I had a fine de Kooning, two Gorkys, a Hofmann, but I sold them because I found it was tough enough picking good paintings out of the past. I did not want to tax myself with the myriad painters of the present. Probably there are fifty thousand painters in California alone today."[11]

Operating—as always—as a loner and an outsider opposed to any form of "the establishment," Simon ran the museum much more as a private indulgence than as a community enterprise. He had alienated the museum's former volunteers, but he made no apologies for cutting out popular programs and amenities, which to him, were either beside the point or a costly nuisance. "Any museum has to be pseudosocial to a certain extent, but when it gets to a point that the social end or the personal accoutrements mean more than the damned art, I don't see it," he said. "I stopped the auditorium, I stopped the restaurant, I stopped the docents. I stopped a lot of other things that were costing nothing but money."[12] He also stopped lending artworks from the collection, claiming that the probability of damage was too great and, thereby, incurring the wrath of museum directors and curators across the country.

Defending his long-term commitment to the museum, Simon pointed out that his foundations had spent $3.75 million on the institution, retired its debt, and purchased six and one half acres of adjoining land, then occupied by several automobile dealerships. The purchase was a shrewd move that seemed to signal a long-term plan to expand the museum or to develop the property and enhance its value. At the very least, the property provided a steady source of income. But Simon revealed no plans and made no promises about the future of the museum. "Some decades ahead,

it is likely that we might merge with another institution, and then be able to give the paintings to the museum," he said, referring to the Museum of Contemporary Art. "But how do I know that something far more important might not come to pass? Tentative? Everything's tentative."[13]

Deeply offended by the lawsuit, Simon did nothing to endear himself to the public or his adversaries. "It's a frivolous, misguided lawsuit," he said. "We are dealing with people who have come into court with unclean hands. Much of the recent history of the museum amounts to simply a cleaning up of the mess they left behind."[14]

As emotions heated up, the plaintiffs also voiced their complaints in public. "We formed a partnership in the use of the building and the use of the collection which was supposed to remedy our lack of underwriting, you might say. We didn't do it with any idea that it would be one step toward liquidation of the collection," Esberg said. "We did give up all the traveling shows, the activities, the membership—Norton wasn't interested in membership or ladies' auxiliaries. All those went right away, all the infrastructure we'd built up. But we were willing to accept that to find a regular home for our girl. We're not willing to accept the fact that we were consigning her to the permanent junk heap."[15]

The art world's sympathy lay with the plaintiffs, but the former trustees were on shaky ground. They could win in the press, but they had pitted themselves against a man who was furious about being vilified and only too eager to reveal his assailants' culpability. Every charge the former trustees leveled against Simon only exposed their own naiveté, vulnerability, and ineptitude. Simon had not only abided by the five-year agreement, but also had adopted some practices more in line with national museum standards than those of his predecessors had been. When the plaintiffs charged that Simon had sold off works from the collection, he revealed that they had deaccessioned $444,950 worth of art between 1969 and 1974, including a Paul Klee painting from the Scheyer Collection. What's more, Simon had put the proceeds of sales into art acquisitions, as required by nationally recognized ethical standards; they had sold art assets to pay for operations—and still ran a deficit. Rowan's objection to sales of works he had donated to the museum triggered the lawsuit, but as facts of

the institution's troubles came to light, it turned out that three other paintings he had given to the museum in 1961 and 1962 had been sold in 1970 when he was president of board.

At the museum, as in business, Simon was a maverick who got his way by taking control of the board. To insiders, the Norton Simon Museum appeared to be an unorthodox organization run by a dictator whose board of directors—including many Hollywood celebrities—simply rubber-stamped his wishes. But Simon had no difficulty in taking the high ground on issues raised by the lawsuit. The Norton Simon Museum had adopted a strict deaccessioning policy in 1978, in accordance with guidelines of the Association of Art Museum Directors and the College Art Association. In contrast, the Pasadena Art Museum had only an informal, unwritten policy that allowed artworks to be sold after three years—a policy sharply contradicting the former trustees' claim that artworks in the museum's collection must be held in perpetuity.

Repudiating charges that Simon had wrongfully changed the nature of the museum, he pointed out that the Pasadena Art Museum had been founded as a general art museum and was represented as such for fund-raising purposes. Even though the museum had become a showcase for modern and contemporary art, nothing had been done to change the institution's officially stated focus. The statement of purpose written in 1924 was reaffirmed in 1970 and signed by Esberg, then president of the museum.

"We are resigned to the fact that these people are going to cost the museum—and themselves—a lot of money," Simon said of the plaintiffs. "But their reasoning really doesn't make any sense. If they were so upset about the loan policy, for example, why didn't they sue me when they were on the board—when they would have had much better legal standing? The answer is that they really weren't using their intellects. They are basically interested in harassment. What they and their attorney are apparently trying to do now in court is create new law. The way it looks at the moment is that the biggest monument in the Pasadena collection may turn out to be an ill-conceived conceptual artwork put together in court by three old trustees."[16]

But if Simon sounded sure of victory, he was appalled by the

prospect of being told how to manage the museum he had poured so much money into. As he consulted with his attorneys and raged about the plaintiffs' effrontery, he began to worry that the court might actually take control of his collection. In a frantic effort to stave off imagined dangers, he removed some of the most valuable pieces he had collected and sent them out of state. His staff quickly telephoned other museums and offered loans of as many artworks as they could accommodate. David Bull, the museum's director, and the curator Selma Holo asked surprised colleagues in museums scattered all across the United States and Canada, "How would you like a Rembrandt? How many Monets do you want?"[17]

There was no shortage of willing hosts for visitors from Simon's collection. The Zurbarán still life and Degas's *Women Ironing* went to the Philadelphia Museum of Art, Rembrandt's *Titus* to the Art Institute of Chicago, Bassano's *Flight into Egypt* to Princeton University's Art Museum. The Metropolitan Museum of Art got Botticelli's *Madonna and Child with Angel,* Bellini's *Portrait of Joerg Fugger,* Giorgione's *Portrait of a Courtesan,* and Alfred Sisley's *Louveciennes in the Snow.* One night, at the height of Simon's paranoia about what he perceived as a threat to his collection, he dispatched his chauffeur to drive Raphael's *Madonna and Child with Book* and Rembrandt's *Self-Portrait* to the Phoenix Art Museum. With the loan of ten other paintings, the Arizona institution was transformed into a stronghold of old masters including *The Branchini Madonna,* works by Lorenzo Monaco, Bernardino Luini, and Peter Paul Rubens. The collector who had been criticized for his unwillingness to lend artworks from his museum was, when it suited him, eager to have the best of his collection housed elsewhere. During the year in which the lawsuit was pending in court, in addition to the long-planned loan of three dozen pieces to exhibitions at ten other institutions, fifty-one other artworks owned by Simon's foundations were lent on short notice to thirteen museums.

Stung by bad press and feeling unappreciated, Simon approached Dianne Feinstein, the mayor of San Francisco, in July 1981, a year after the lawsuit had been filed, to explore the possibility of moving his collection to her city. She promptly invited him to visit and rolled out the city's official red carpet, hosting a dinner in honor of Simon

and his wife at the museum in the California Palace of the Legion of Honor, a recreation of an eighteenth-century French palace in a spectacular setting overlooking the Golden Gate Bridge. Shortly thereafter, Feinstein and a contingent of museum trustees from San Francisco paid a visit to the museum in Pasadena.

The news created a furor in the press. Citing the legal conflict and Simon's allegiance to his boyhood home as logical reasons for a gift of his collection, San Franciscans speculated about what the collection would mean to the city and where it might be displayed. There was talk of building a new Asian Art Museum at the Yerba Buena Center, an urban-renewal area downtown, and installing Simon's Asian collection there. The Palace of the Legion of Honor, the city's most prominent showcase for French and ancient art—and the site of the courtship dinner—was thought to be the best place for the bulk of Simon's art holdings.

According to Alan Temko, the art critic, the Simon collection could turn the Legion of Honor into "a jewel of a museum that would rival the Frick in New York. Every room, the surrounding lawns in Lincoln Park, could be made perfect. The undistinguished objects that now take up space in the Legion, as others do at the de Young, simply because San Francisco has nothing better to show, could be weeded out.[18]

Meanwhile in Los Angeles, William Wilson sounded a dire warning. "The worst piece of cultural news to emerge here in many a long, logy summer is the prospect of the Norton Simon Museum removing its treasures from Pasadena to a museum in San Francisco." Adding official weight to Wilson's assessment, Earl A. Powell, director of the Los Angeles County Museum of Art, said: "It would be an incalculable loss. It is the greatest collection of old-master art in the Western United States, a testament to individual taste and discrimination."[19] The affair turned out to be nothing more than a summer sideshow, but Simon had made his point.

The trial of the case brought by Rowan, Esberg, and Phillips against the museum began Monday, 14 September 1981. Judge Julius M. Title conducted the nonjury proceeding for five days, concluding on Friday with a visit to the museum to see how the collection was being handled. On 22 September he issued an eleven-page memo-

randum of intended decision, absolving Simon and his trustees of any wrongdoing and dissolving the preliminary injunction requiring forty-five days notification of sales of artworks.

Citing the "broad discretion" given by law to boards of trustees, Title declared that "the evidence overwhelmingly demonstrates that the members of the board of trustees of the museum have at all times properly performed their fiduciary duties to the museum and have reasonably exercised the discretion given to them by law in the discharge of their obligations as trustees." Emphasizing that the plaintiffs had not "acted in bad faith or for selfish purposes in attempting to impose their views upon the board of trustees," Title wrote:

> The basic difficulty is that plaintiffs have overlooked the fact that it is the present trustees who not only have the right, but also the legal and fiduciary duty to make the decisions concerning the operation of the museum. Plaintiffs have seen fit to voluntarily resign from the board of trustees, and by that action they have taken themselves out of the management and decision-making process of the museum. If the present trustees were to permit them by this lawsuit or otherwise to make and dictate a policy of the museum, this would in itself constitute a violation of the fiduciary duty of the board of trustees. It is indeed unfortunate and even tragic that a museum which must be one of the finest museums of its kind in the world of art would become the center point of a controversy such as has been brought by this action because former trustees simply disagree with the policies of the present board of trustees, particularly where the present board consists of reputable and leading members of the community with unimpeachable reputations for remarkable public service and who have unselfishly devoted many hours of their valuable time to the affairs of the museum.[20]

On 23 September the museum released a brief statement to the press: "We fully appreciate the court's complete recognition of the propriety of the actions of the Museum and the dignity of its Board of Trustees."[21]

27

THE CLOSE OF A SPECTACULAR CAREER

We have so many exceptional pictures. The question is, how far do you go?

NORTON SIMON
Los Angeles Times, *24 June 1990*

SIMON'S ACQUISITIVE instincts were temporarily stifled by the lawsuit lodged against him by former trustees of the Pasadena Art Museum and by fears that their legal action could loosen his control over his collection. After he was vindicated, he did not purchase art as voraciously as he had done in the 1960s and 1970s, but he didn't stop buying. Neither did he become a conventional collector. His tactics continued to baffle those who watched the evolution of his vast, ever-changing holdings.

In 1981, Simon allied himself with a powerful buying partner, the J. Paul Getty Museum. In an auction of old master paintings at Christie's in London in April, a painting by the French artist, Nicolas Poussin, *The Holy Family with the Infant Saint John the Baptist and Saint Elizabeth,* was sold to Wildenstein & Co. for the record price of £1.8 million (about $4 million). The artwork had been expected to bring between $4.5 million and $6.5 million but the auction house withdrew the Poussin when bidding stopped at $3.8 million. Within fifteen minutes Christie's announced a negotiated sale of the painting to Guy Wildenstein, a dealer who had been the underbidder. About two weeks later it was revealed that Wildenstein had been bidding for the Getty and for one of Simon's foundations, which had acquired the seventeenth-century masterpiece as a joint purchase.

Executed in Poussin's late classicizing style, the painting presents the Holy Family in the company of Saint John the Baptist and his mother, with the children embracing and their parents forming a loving circle around them. The figures are artfully arranged on the left side of the canvas, in front of an architectural ruin in a verdant, classical landscape. On the right, six putti carrying a ewer, a towel, and a basin of water are thought to refer to Saint John's later baptism of Christ in the Jordan River. The biblical scene was painted in 1650–51 for the duc de Crequi in France but was subsequently sold to the duke of Devonshire in England. He installed it at Chatsworth, his family's grand home, in 1761, and it remained on display there for more than two hundred years. In 1980 the current duke of Devonshire needed funds to endow a trust to run the estate, so he decided to sell the valuable painting. He offered to sell the Poussin to several British museums, but they declined, so he consigned it to auction. His action was of great interest to Poussin lovers. Two other versions of the painting are in the collections of the Louvre in Paris and the Fogg Art Museum at Harvard University, but the Chatsworth picture is considered the finest of the three. Indeed, the painting was the best Poussin to have come on the market in more than three decades. Among other would-be suitors, the Metropolitan Museum of Art in New York wanted to buy it but didn't have sufficient funds.

News of the acquisition was heralded in the press. "The joint purchase of the painting and an agreement for its alternate showing is a significant occasion for the two museums and for the California art scene. Old master paintings of this quality are rare in West Coast collections, with the strongest representation at the Norton Simon Museum. While the Simon museum is given top rating by professionals in the field, the Getty's collection of European paintings is perhaps its weakest area, and the Poussin is a strong addition."

Simon was pleased with his latest acquisition, but he appeared to be more excited by his new partnership. "Even more important" than the painting itself "is the fact of the new leadership at the Getty that made it quite easy to facilitate a joint acquisition of this significance," he said.[1] Simon was referring to his old friend and former business associate, Harold Williams, who had been appointed

head of the wealthy organization that was to become the J. Paul Getty Trust.

Despite Simon's apparent rejection of Williams in 1969, when he chose David Mahoney instead of his long-time associate to head Norton Simon, Inc., the two men remained friends. At the time that the Poussin was consigned to Christie's, Williams had accepted his new position at the Getty but hadn't yet moved back to California. The Getty Museum, which was in a period of transition while its fortune was settled and the trust was being formed, hadn't been actively involved in the art market for a year, but when Simon proposed the joint purchase to Williams, he decided it was a good idea. "It was a signal that we were back [in the art market] and that we had a relationship with the Norton Simon Museum," he said.[2] Williams proposed the joint purchase at the first meeting of the Getty board that he attended and won the board's approval. An export license for the painting was delayed until September to give British museums a chance to raise sufficient funds to match the selling price and keep the Poussin in the country, but the money was not forthcoming. In due time, the painting arrived in California and began traveling between the two museums at regular intervals.

In 1982, Simon did much more selling than buying. Having emerged victorious from the lawsuit that challenged his right to deaccession works from the Pasadena Art Museum's collection, he sold several of the contested paintings at auction, including Richard Diebenkorn's *Urbana No. 1* for sixty-five thousand dollars, an untitled Sam Francis for forty-five thousand dollars, Wayne Thiebaud's *Refrigerator Pies* for thirty-eight thousand dollars, Willem de Kooning's *Grumman* for thirty-one thousand dollars and James Rosenquist's *Win a New House This Christmas (Contest)* for fifteen thousand dollars. In two larger private transactions during the same year, Simon also sold works from his foundation collection: Claude Monet's classic 1894 impressionist painting, *La Cathédral de Rouen, La Tour d'Albane, Le Matin,* to Galerie Beyeler in Basel for $1.5 million and Picasso's 1906 painting, *Nude Combing Her Hair,* to the Kimbell Museum in Fort Worth, Texas, for $4 million.

In 1983, Simon reappeared on the auction scene as a highly visible

buyer in a closely watched sale of sixteen works from the estate of Doris D. Havemeyer, the daughter-in-law of Henry O. and Louisine Havemeyer, legendary collectors of old masters and the impressionists, who had bequeathed about two thousand artworks to the Metropolitan Museum of Art in New York. The Havemeyer sale, scheduled for 18 May at Sotheby Parke Bernet in New York, had created immense excitement in art circles. All the pieces were desirable, but the best was Degas's pastel, *Waiting, (L'Attente)*. Dramatically composed and in pristine condition, it's a bird's-eye view of a ballerina who is bending down to fasten her shoe and is accompanied by an older woman dressed in black. Epitomizing the contrast between age and youth, the two figures sit on a bench, as they await the girl's audition. Both Simon and the Getty Museum wanted to acquire the pastel, so they agreed to buy it together, as they had the Poussin. The auctioneer, John L. Marion, knew of their plans, but about an hour and a half before the sale Simon walked into his office and asked to set up an arrangement for a bidding signal. Marion agreed, but only for specified items, not throughout the entire sale as Simon had requested. The arrangement was that Simon would be bidding when he had his hand on his chin. It was one of three special signals Marion had accepted for the auction of the Degas. Another client would be bidding when his gold pencil was in his mouth; the third would have his arm around his wife and poke the man next to her when he wanted him to bid. As the battle heated up, Simon feared Marion was not paying attention to him. Keeping his hand on his chin, he stood up and waved his elbow. "He looked like a duck," Marion said of the secretive collector who so obviously blew his own cover.[3] But he and the Getty got the pastel, for $3.7 million, a price that set an auction record for an impressionist artwork. Like the Poussin, the Degas travels back and forth between the two museums, offering silent testimony to Simon's love of complicated arrangements.

Once again, Simon and the Getty had landed a picture that was widely admired, but Simon's motivation was privately questioned. Noting that he had a large collection of works by Degas that suddenly became more valuable after a record price was paid for *Waiting*, some

observers suspected he had manipulated the Getty into sharing the financial burden of enhancing the worth of his own collection; others remarked that the joint purchases of the Poussin and Degas gave Simon two pictures at half the price and double the publicity.

He considered buying yet another piece with the Getty, *The Aldrovandi Dog* by Giovanni Francesco Barbieri, called Il Guercino, an Italian artist of the Bolognese school. Then he decided to purchase it alone. Simon had owned the painting for more than a year, from November 1980 to March 1982, but had returned it to the seller, Galerie Nathan in Zurich, and obtained a refund. By June 1984 it was in the possession of the David Koetser Gallery in Zurich. Deciding he wanted the painting back, Simon purchased it for six hundred thousand dollars, about half the price he had paid the first time.

The painting depicts a large brindle and white dog with the Aldrovandi family coat of arms on its collar. Looming large in the picture, the dog calmly stands by a column. A walled Italian town and a circular castle may be seen in the distance. The painting is thought to have been commissioned around 1625 by Count Filippo Aldrovandi, for whom Guercino also painted a portrait of a favorite horse, among other pictures. *The Aldrovandi Dog* was still in the Palazzo Aldrovandi in Bologna in the second half of the eighteenth century. Then it was transferred to the collection of John Smith-Barry at Marbury Hall in Northwich, England and passed down through the Smith-Barry family until it found a new home in Pasadena.

The Havemeyer sale in 1983 was Simon's last appearance at an auction, and Guercino's portrait of a dog was his last large purchase before he contracted Guillain-Barré syndrome, a neurological disorder that causes paralysis in varying degrees. By then, the Simons had moved from Malibu to Beverly Hills so that Norton could get relief from asthma. He loved to swim and had gone for daily dips in the ocean and in his own pool for many years, but the dampness in Malibu seemed to aggravate his health problems, so he and Jennifer moved inland to try a drier climate. At first they lived in a bungalow at the Beverly Hills Hotel. The change appeared to help, but they were dissatisfied with the bungalow. After trying others,

they found a house with a pool on Kimridge Road in Beverly Hills, on the crest of a ridge between Coldwater Canyon and Mulholland Drive.

During that period Norton typically woke up around 5:30 in the morning and worked at home. A secretary would arrive about 6:30 A.M., when he would turn his attention to the stock market. He rarely got much exercise until the end of the day. But when Jennifer had afternoon appointments or meetings in the city, he would ask his secretary to drive him down Coldwater Canyon on her way home and drop him off at the Will Rogers Memorial Park, a small, triangular green across Sunset Boulevard from the Beverly Hills Hotel. He would walk alone until Jennifer met him; then they would stroll together and drive back up the hill to their home. One day in May 1984 Norton rode to the park with his secretary and took a walk as usual. But by the time Jennifer arrived he was sitting on a bench, feeling extremely tired. The next morning he couldn't move.

The Kimridge house became a makeshift hospital with a team of ten nurses maintaining an intensive care facility; later it was transformed into a rehabilitation unit. The Simons moved to a bungalow at the Beverly Hills Hotel in late 1988. They stayed there until late 1992, when the celebrated hotel was closed for extensive renovations, and they relocated to a comfortable house in Bel-Air. Simon's condition waxed and waned, but he was physically incapacitated and dependent for the rest of his life. The disease was a terrible blow to a man who had been obsessed with being in control. At times he was depressed and almost unbearably cranky, but he regained his spirits and learned to cope with being confined to a wheelchair. He had always been an incessant telephone user. When it became difficult for him to go out, he became increasingly dependent on the phone for information and intellectual sustenance. His illness was kept quiet for awhile. Although word eventually spread through the art and business communities, the nature of his affliction was not announced publicly until September 1985, in conjunction with remarks Jennifer prepared for a benefit reception for the University of Pennsylvania School of Nursing.

In the meantime, Simon had rallied sufficiently to keep tabs on

New York's most important auctions. In the November 1984 sales, he purchased Picasso's *Woman with Mandolin,* a 1926 post-cubist painting from Walter Annenberg's collection, for $1.9 million, Van Gogh's *Head of a Peasant Woman with a White Bonnet,* a study for *The Potato Eaters,* for $220,000; two paintings of boats by the French impressionist Gustave Caillebotte, and four early twentieth-century works by Albert Marquet, a French realist.

Simon did not make many art transactions in the next few years, but an auction at Sotheby's in New York in October 1989 caught his attention. The sale included a wide array of European and American paintings from the estate of John T. Dorrance Jr., a collector in Philadelphia who was the son of the founder of the Campbell Soup Company and had served as the company chairman for twenty-two years. Simon had his eye on Gustave Courbet's painting, *Peasant Girl with a Scarf,* which was valued at between $800,000 and $1.2 million. It was a relatively minor item in the auction, which brought more than $1 million apiece for 29 of the 118 artworks that were sold. Indeed, the Courbet was a disappointment to Sotheby's because it was sold for $550,000, far less than its estimated value, to Acquavella. Simon didn't bid, but he was intrigued with the pensive image of a young girl, seen in profile as she leans forward and, with her elbow bent, rests her head on one hand. After the sale he contacted Acquavella and purchased the picture for $900,000.

The Courbet brought Simon back to the roots of his collection, to the territory of nineteenth-century painting, where he had first found artistic satisfaction. Predating the work of Degas that captivated Simon, the Courbet, which was painted around 1848, is relatively sentimental, but it embodies some of the emotional qualities Simon valued in art. By then he had amassed such a wide array of European and Asian artworks that there seemed to be no pattern to them except for high quality. There were old master paintings with religious themes, seventeenth-century Dutch portraits, landscapes, and still lifes, superb bodies of prints by Rembrandt and Goya, figurative sculpture by Auguste Rodin, Aristide Maillol, and Henry Moore, French impressionist works, cubist paintings by Picasso and Braque, expressionist images by Chaïm Soutine and Oskar Kokoschka, Indian

and Southeast Asian sculpture that expresses Hindu and Buddhist ideals. His takeover of the Pasadena Art Museum had also given him the Scheyer Collection of modern art and a cache of contemporary art, which was of far less interest to him. If a thematic thread of continuity runs through the varied works he selected, it is wrapped around an intellectually restless man's fascination with human images and the uncertainties of life.

28

DANCING WITH IMMORTALITY

*For a man who loves to cut a good deal, what finer thing could there be
than to parlay the greatest art collection of modern times into
the greatest act of philanthropy in the history of American universities?*

WILLIAM WILSON
Los Angeles Times, 1 March 1987

As the years passed and Simon's museum gained international renown, it was increasingly valued by southern Californians as one of the region's cultural jewels. But it was never taken entirely for granted. Simon's mercurial nature, his penchant for selling works from his collection, and his history of considering every possibility and then doing as he pleased led to doubts that the museum would be a permanent fixture. Furthermore, as art-world insiders knew, he had talked about gifts, partnerships, and alliances of various kinds with many institutions, including the Los Angeles County Museum of Art, the Fine Arts Museums of San Francisco, the Huntington Library, Art Collections and Botanical Gardens in San Marino, and the California Institute of Technology in Pasadena.

A public announcement in 1985 that Simon had been stricken with Guillain-Barré syndrome heightened speculation about his ultimate plans for his museum and whether he would, or could, endow it richly enough to ensure its long-term future. In characteristic fashion, he did nothing to quell the gossip. Instead, he periodically added new grist to the rumor mill by discussing possible mergers with other institutions.

Before he became ill his joint purchases of artworks with the J. Paul Getty Museum had kicked off speculation about a merger. The Getty's wealth and the fact that it was managed by Williams, a former employee and longtime friend of Simon, made that possibility seem quite plausible. In due time, both Simon and Williams acknowledged discussing a buyout or partnership. "We used to joke about what we would call it, the Getty-Simon or the Simon-Getty," Williams said. "But there just wasn't a way to do it to satisfy Norton. In some ways I think he did feel burdened by the collection and concerned about its future, but he couldn't quite walk through the door."[1]

Simon persisted, however, in opening other doors. Early in 1987 he conceived another plan for his collection that gained more credence than any of his past schemes had, except for his early involvement with the Los Angeles County Museum of Art. His new courtship was with the University of California at Los Angeles, which his old friend Franklin Murphy had served as chancellor and Simon himself had governed as a regent.

The university campus occupies an immensely valuable swath of land, stretching from Sunset Boulevard southward almost to Wilshire Boulevard in an affluent area of West Los Angeles known as Westwood. In the 1940s the university had been given an additional eighty-acre plot of land by the United States Congress just south of the campus, in the heart of a thriving commercial district. Fronting on Wilshire Boulevard between Veteran and Gayley avenues, the property is just east of a large tract of federal property encompassing the Veterans Administration Medical Center, the Los Angeles National Cemetery, and a federal office building; to the north and east are several blocks of shops, restaurants and theaters adjacent to the campus. The eighty-acre parcel had been deeded to the university for medical use and was restricted to that purpose. Plans initially called for a medical school to be built on the site, but one was constructed in another area, closer to existing university buildings, and the undeveloped land became a parking lot.

Although a few blocks south of the main campus, it is a highly visible property, easily accessible and ideally suited to a public facility

that could heighten the university's presence in the community. The chancellor, Charles Young, had favored the site for development, but had to wait until 1986, when Congress lifted the restriction on the use. The long-awaited change was Young's signal to realize one of his fondest dreams. He envisioned a major arts complex with a museum as its centerpiece. As he wrote to Simon in the early days of their courtship, "The west side of Los Angeles lacks cultural attractions and a cultural center, and the University has been looked to by the community to fill this gap. In the area of the visual arts, however, our present Wight Gallery is inadequate to meet this need. Its location on campus makes it relatively difficult to visit, its size is smaller than desirable for major exhibitions and certainly for permanent exhibitions, and it is, after all, an academic facility that must be primarily dedicated to academic uses. The need for a first-class art exhibition facility on the west side is clear, and I believe UCLA owns the most likely property for its establishment."[2]

With that vision clearly in mind, Young and other university officials had discreetly put out the word that if a first-rate art collection were to be donated to the university, a splendid home would be built for it. The Arensberg debacle was an embarrassing episode in the university's history, and it would not be repeated. When Simon heard the possibility of having the university take over his collection, he called Young. "It was shortly before his eightieth birthday. He was beginning to think about life after Norton, and about what would happen with his collection," Young said. "He asked if we would be interested, and I said of course we were interested."[3]

Simon and Young had known each other for more than twenty years by then. In addition to serving as a member of the Board of Regents of the University of California, Simon had been a patron of the university. In 1963 he had made the lead gift toward the University Art Council's purchase of a sculpture by Jacques Lipchitz, *Song of the Vowels,* to be installed on campus. When Norton and Jennifer moved to Beverly Hills in 1983, he donated their $4.6-million property in Malibu to the university, to be used as a conference center. The Simons also had been major contributors to university projects in medical research.

Talks between Young and Simon started on the telephone in early

January and continued in a series of meetings at Simon's house on Kimridge Road. Young and Alan Charles, an attorney who served as the university's vice chancellor for external affairs, repeatedly drove up Coldwater Canyon, turned off on Cherokee Drive, and proceeded along a succession of narrow, winding roads to the crest of the hill to meet with Simon, who was confined to a wheelchair but mentally alert and only too eager for stimulating company.

"Norton had a hard-bitten businessman's reputation, but he had a very lovely, gracious side," Charles said.

> These meetings always started out in a genteel, socially gracious way. We had to talk about the old days when he was on the board of regents, and discuss who was powerful and who wasn't, who was good and who was bad. Norton would regale us with his stories. Chancellor Young enjoys that kind of repartee with people, so these two powerful men would chat about Norton's Senate campaign and the regents. They could go on for an hour without ever getting to the point.
>
> The issue on the table was Norton's collection. We wanted it badly, and Norton wanted something in return, but it was difficult to figure out what that was. The sands were very shifty and as time went on, they got shiftier. At first though, when he finally got around to it, he wanted to know how his collection would be cared for, how it would be housed, what kind of facility we would build, precisely where it would be located on the property, how grand and visible it would be, and how he or his successors could retain some authority over its management. Those conditions weren't laid on the table, but they eventually came out.
>
> Two of them were really critical, it seemed to me. One was that he didn't want this facility used for anything other than his works, which was a problem for us because we were looking for a place for our collections as well. The other sticking point, which was probably in some ways more significant, was his desire to maintain control through his trustees, or somehow maintain a strong control over how it played out in the years after he was gone.

In short, Charles said, it became clear that Simon wanted the university to take over the financial burden of the museum while he and his trustees maintained control over its collections and operations. That arrangement would preserve the cultural legacy Simon had built, and give him a big bonus. Instead of putting most of his fortune into a museum endowment, he could donate it to medical research and other causes that he and Jennifer had supported.[4]

It took dozens of phone calls and eight or ten trips to Simon's home over the course of five months to reach that point of understanding, however. The initial point of agreement was that Simon would transfer as a gift to the university the various art holdings known as the Norton Simon Museum, together with related property in Pasadena. In return Young would recommend that the regents accept the gift and maintain it in perpetuity as part of the University of California at Los Angeles. Early on in their discussions, Young honored Simon's apparent wish to leave the most valuable part of the collection in Pasadena but urged him to allow loans of artworks to Westwood and patiently explained that he couldn't justify the expense of taking charge of the collection unless the student body and the public had access to it. Hoping that Simon would provide an endowment to maintain the entire collection in both locations, Young also made it clear that support for the proposed facility and program would have to come from the private sector.

Young proposed that they negotiate an agreement providing both parties with assurances on a number of issues. The university, Young said, was prepared to operate the museum in Pasadena if it had a satisfactory agreement with the city, Young said, but must be granted control of the income property that Simon had acquired adjacent to the museum. Simon's primary fear was that his museum would ultimately be subsumed by the university and either forgotten or neglected. His model to prevent that possibility was the Jules Stein Eye Institute at the university, which is operated by the regents as an academic unit of the university but has a separate board of trustees, which has oversight responsibilities, budgetary approval rights, and the authority to challenge the university in case of disputes. Charles had drafted the Jules Stein agreement, so he got to work on a similar

document for Simon. But before a resolution was even remotely in sight, the local press got wind of Simon's proposed gift.

> Seismic shock waves are about to be felt in the local art world as the unofficial word begins to spread that UCLA has entered into negotiations with millionaire Norton Simon to acquire both his art collection and his museum in Pasadena. Simon's collection—noted for its old masters, Asian art, and Degas bronzes—is generally regarded as the best display of its sort West of the Rockies. And since it's also been generally assumed that Simon is not prepared to endow the collection in perpetuity himself, the betting has been that the Simon would eventually fall into the hands of the Getty Museum of Art, where it would prove a most valuable addition in shoring up the Getty's own holdings. But now all bets are off as, apparently, UCLA has moved to the forefront. While UCLA's press office would neither confirm nor deny the possibility, an official announcement confirming that discussions are taking place is expected momentarily. In the meantime, art mavens are already speculating that the crafty Simon may simply be playing the university off against the Getty in a maneuver that would be nothing if not baroque.[5]

Knowing that the news was about to break, Simon said he thought that it was necessary to respond in a press conference. Both Young and Charles were reluctant because no agreement or contract had been worked out, much less signed and approved, so there was little to say. The proposal hadn't even been presented to the regents, they protested. But while privately wondering if Simon himself had leaked the news to gain an advantage or even to get attention, they acceded to his wishes. Young scheduled a presentation of the proposal at the regents' meeting February 19, at the University of California in Santa Barbara, and called a press conference the following morning at the Wight Art Gallery.

Meanwhile, the university's public relations office hurriedly drafted a press release. The first version said that the Simons "have been dis-

cussing and are close to an agreement in principle with UCLA for the transfer of their highly esteemed art collections to the University" and valued their art holdings at more than $500 million. In its final form, dated February 19, the release said an agreement was pending (the value of the collections had risen to $750 million). Otherwise, the three-page document was strong in its praise of the proposed gift but tellingly weak in details.

> UCLA Chancellor Charles E. Young said that serious discussions are in the final stages that could result in the University taking over responsibility for the Norton Simon Museum in Pasadena and for expanding scholarly and public access to parts of the collections not presently on view. The proposed agreement would carry with it the intent to construct an additional museum facility which at a minimum will be approximately the same size as the Wight Art Gallery on campus with appropriate adjacent grounds for future buildings and parking. [The new facility] would not result in a change in the permanent location or quality of exhibitions in Pasadena. Indeed, the Norton Simon Museum would now have two homes.

To the embarrassment of university officials, the news was widely reported as a done deal or very close to it. In fact, it was nothing of the kind. During the next two months drafts of an agreement were repeatedly drawn up and revised. The basic premise was that, in return for Simon's gift, the university was to maintain, preserve, and secure the collection, make it available to the public through display, and use it for teaching and research programs. Five new faculty positions were to be added to the art history department at an annual cost of between three hundred thousand and five hundred thousand dollars. The new museum in Westwood was to consist of at least twenty thousand square feet of interior space, and exterior areas for sculpture, landscaping, and parking. A museum studies center was to be established as an adjunct to the proposed facility. In addition, the university's development office was to launch a $25-

million fundraising campaign for enhancement of visual arts programs through a permanent endowment.

As drafts of the agreement were passed back and forth, the university made more and more concessions to Simon. Initially he was to provide funds to construct the building in Westwood, but later versions of the agreement indicated that the university would raise funds for part of the construction as well as for the endowment. At first, both the Pasadena and Westwood site were to be called "The Norton Simon Museum of UCLA" but Simon insisted that the university's name be dropped, so the two facilities were renamed "The Norton Simon Museum." Simon also demanded an unprecedented degree of independence and authority for his trustees.

Whether the regents would have approved the agreement is uncertain, but they were not presented with the possibility. As Young and Charles continued to pursue Simon's collection, they resolved some differences but their attempts to complete the plan were perpetually frustrated. Always on call, they would visit Simon at his request, usually on weekends and occasionally at great inconvenience. On Easter Sunday, 19 April, Charles received a call at home from Simon asking him and Young to meet with him that day. Charles said Young had gone to Palm Springs for the weekend, but Simon insisted on seeing them. "No one wanted to risk his loss of enthusiasm for the project," Charles said, so he called Young, who interrupted his holiday and drove back to Los Angeles. While he was in transit, Simon called Charles saying he had changed his mind and didn't want to see them after all.

When they actually did meet,

> we never focused on the points of agreement and disagreement. It was not a logical negotiation. Norton always wanted more. He hadn't got enough assurance. Or he would say, "I'm giving you a collection that's probably the most fabulous privately owned collection in the world. What are you doing for me? How am I being appreciated here?" We didn't know what he wanted us to say or do. One day when things weren't going well, Jennifer grabbed Chuck by the arm as we were leaving and said, "Don't worry, Chuck, it's all going to work

out." When we got in the car to go back to the campus, I said to the chancellor, "You know, this is not going to work out. This is never going to happen. It just isn't going to happen." But Chuck, who is one of the more optimistic people I've ever known in my life, said "Don't worry, we're right in there."

Chancellor Young always had the view that things will work out. You take some risks and see what happens. Things will change, or get better somehow or other. But I was very nervous about where this was going because I just didn't see that we were going to get anything out of this, other than that the collection was going to be forty miles closer than where it was before.[6]

As the talks dragged on, university officials did their best to muster their most persuasive forces and consult with those who knew Simon best. Young asked the university president, David P. Gardner, to meet with Simon, but not before Gardner was briefed by Franklin Murphy. To expedite the affair, Charles talked to Murphy and composed a memo to Young conveying Murphy's reading of the situation, so that Young could prepare Gardner for his meeting.

> Norton consciously knows and feels that he must make this transfer to UCLA, but subconsciously does not want to part with the collection until after he dies, and subconsciously does not believe he is going to die, at least in the near future. Therefore, he is ambivalent.
>
> However, he does not want to break off negotiations with us because his alternatives are extremely limited. First, the collection must stay in Los Angeles because Norton would not be able to tend it elsewhere; he is simply too disabled to travel.
>
> Second, he would only sell it to the Getty, and the Getty won't buy it, and certainly won't buy it at the price he wants. Moreover, the Getty would not accept his condition that the whole of their joint holdings be called the Getty/Simon Museum.
>
> Third, the only other non-UCLA alternative is a free-standing museum of the sort he has now, but which he

would have to fully endow. Franklin does not think he has that kind of money, but even so, he has promised Jennifer to use his money for mental health research.

Franklin's conclusion, therefore, is that he needs the university more than we need him."[7]

But astute as he was about Simon, Murphy miscalculated the situation. In retrospect, Young said:

> I cannot tell you what went wrong. I know what Norton said went wrong, but that isn't what went wrong. We were beginning to develop designs for the site and building. Then one day, he called and said, "Chuck, you told me the university owned all that property, the frontage of that entire block on Wilshire from Gayley to Veteran." I said, "Yes." Then he said, "Well there's another little piece." And I said, "Yes, but that piece—where there's a Hertz Rent-A-Car and a Union Oil station—is a diamond that comes down to a point at Wilshire. We own the frontage up to there and we are trying to acquire that last piece and we will be able to acquire it." He said, "You lied to me." I said, "No, Norton, I didn't lie to you. It's inconsequential. It has no impact on the designs, and I assure you, we will acquire the property." That's something that could have been worked out, and it certainly wasn't a lie or in any way misleading, but it was the stated reason for not going on.[8]

Even then, there was no clear end to the deal. "Negotiations just petered out," Charles said. But in answer to queries from the press in mid-June, both Simon and the university issued brief statements acknowledging that the proposal had been dropped. In his statement Simon cited problems "in both the substance of the negotiations and in the manner in which UCLA conducted them" but offered no details. The university simply said it had negotiated in good faith until Simon requested a break and that he had never resumed the discussions.

"My take on it all, at the end, was that this was another flirtation by Norton with some potential repository for his vast and wonderful art

collection, that he was the reluctant debutante, though all the way it was just flirtation," Charles said. "In his heart he never meant for this to be consummated. He may have meant it intellectually because he loved to negotiate, but on an emotional level I don't think he was ever really committed to UCLA or any other suitor that came along. The odd thing was that he was the one who sought out suitors, rather than their just coming to him."[9]

Unpredictable as Simon was, Young views his refusal to follow through on the UCLA proposal as part of a familiar human pattern. "I think there is a point in time when psychologically, subconsciously there is a feeling that your life and the work of your life are related," he said. "And when the work goes, you go. I think Norton knew the best thing that could have happened would have been to enter into the agreement we had worked on. But down deep somewhere, he thought, if I do that, my life is over."[10]

In yet another scheme, never revealed in the press, the National Gallery of Art in Washington drew up a plan to make the Norton Simon Museum its West Coast affiliate. The Simon would keep its name, collection, and identity while gaining government support and loan exhibitions. The plan was the most prestigious of Simon's proposals to provide for his artistic legacy. But before an agreement was reached, he pulled out, protesting that he couldn't trust his country's government. The man who loved to keep his options open couldn't bear to relinquish control of his collection.

Simon's health took a sharp turn for the worse in March 1989, when he resigned as member, trustee, and president of the museum and Jennifer Jones Simon took over as chief executive. Improbable as it seemed, he finally loosened his grip on the museum that he had dominated for fifteen years.

29

A GLITTERING FAREWELL

*Norton Simon, molder of conglomerates, world-class art collector,
candidate for U.S. senator, and a self-created capitalist
who was extremely proud of that description, has died.*

LOS ANGELES TIMES
4 June 1993

IN THE LAST CHAPTER of his life at the museum, a celebration of
Norton Simon's eighty-fifth birthday 5 February, 1992, Simon was
surrounded by an effusively appreciative audience. He may have
been too weak to absorb the full impact of the event and he did fail
to recognize some of his friends and longtime associates, but the
guests—a parade of museum directors and curators, movie and media
stars, political leaders and businessmen who represented nearly every
facet of his life—were struck by the magnitude of his achievement and
touched to be part of a memorable evening. The film director Billy
Wilder, the actor Walter Matthau, and the actress Candace Bergen
were there, with the governor of California, Pete Wilson, the former
governor and childhood friend Edmund G. (Pat) Brown, the news-
caster Tom Brokaw, Eugene Thaw, an art dealer from New York, and
the president of the Getty Trust, Harold Williams. Art professionals,
including the curators George Goldner and Gillian Wilson and con-
servator Andrea Rothe of the J. Paul Getty Museum, and Selma Holo,
who had become director of the University of Southern California's art
galleries and museum studies program, indulged in shop talk and sur-
veyed the celebrities.

Simon had made his last public appearance about three and half

months earlier at the funeral of his sister, Marcia Simon Weisman, who had died on 19 October 1991. The elegant occasion at his museum was likely to be the last birthday for Simon, whose legendary vigor had been sapped by a paralyzing disease that had long since confined him to a wheelchair. His hyperactive mind had been caged in a body that had grown so frail that he could neither shake hands with friends nor feed himself. His memory also had slipped. Once able to identify every object in his museum and reel off details of where and when he had bought it, as well as the price he had paid and the foreign exchange rate at the time of purchase, Simon now struggled to recall names of the artists.

Cameras flashed and champagne glasses clinked as the crowd milled around massive Henry Moore sculptures in the museum's lobby, then filed through a long gallery to the site of the main event. Leaving rooms of French impressionist paintings, Renaissance masterworks, and Asian sculpture, they drifted past other tributes to Simon's collecting acumen: sensitive depictions of Saints Benedict, Apollonia, Paul, and Frediano in a pair of exquisitely detailed paintings by Filippino Lippi, *Saint Ignatius of Loyola,* a larger-than-life-sized portrait, and *David Slaying Goliath,* a dramatic interpretation by Rubens, Manet's monumental painting, *The Ragpicker,* the *Portrait of the Artist's Mother* by Van Gogh, and *Woman with a Book* by Picasso. Entering a grand salon of old master paintings, the guests took their places at round tables laden with fresh tulips, silver, crystal, and china. The Simons sat beneath the gallery's pièce de résistance, *The Triumph of Virtue and Nobility Over Ignorance,* an Italian rococo painting portraying airborne figures as actors in a morality play, created by Tiepolo for a ceiling in a Venetian palace. Then Brokaw took his place as master of ceremonies and the festivities began.

One by one, Simon's friends and associates toasted, roasted, and shed tears over the man they characterized as brilliant, demanding, infuriating, perplexing, and endearing. Brokaw told about being called to Simon's presumed deathbed several years earlier, only to see Simon suddenly emerge from a comalike condition, question him about the current state of the stock market, and offer advice on an investment. Williams recalled his friend's pain on being alone at the top. Pamela Simon, Norton's adult granddaughter, was the family's

designated speaker. Dressed in a long pink satin gown, she concluded a short statement with a simple sentence, "We love you, Grandpa." Simon, whose voice had been reduced to a whisper, spoke not a word to the gathering but his wife later told friends that he said the celebration was the most wonderful night of his life. Sixteen months later, on 2 June 1993, Simon succumbed to pneumonia while sleeping at his home.

Shortly after his death, the position of the Norton Simon Museum was outlined in a press release issued by the museum:

> The person who formulated the collection and inspired the staff is no longer here. However, Mr. Simon put into place a staff he trusted to make the decisions about the museum's operations and its future, and that group of people, working with the board of trustees, will continue to perform their functions. The board and staff are committed to continuing to manage the institution consistent with the philosophy and principles Mr. Simon established over the years. President and chairman of the board of trustees is Mrs. Jennifer Jones Simon. The primary liaison with the board is the chief operating officer, Walter Timoshuk, who has worked with Mr. Simon on foundation affairs and the administration of the museum for ten years. The chief curator of the art collection is Sara Campbell, who has worked with Mr. and Mrs. Simon and the Simon Foundation art collections for twenty-five years, twenty of them at the Norton Simon Museum in Pasadena. The fundamental principle guiding the governance of this collection has been to maintain the highest possible standards of quality in the art collection and in its display. This continues to be our guiding principle. There are no plans for the collection to leave Pasadena.

Simon's obituaries were sprinkled with admiring quotes from museum directors and other cultural leaders. "Since World War II, no one bought pictures more shrewdly than Norton," said John Walsh, the director of the J. Paul Getty Museum. "He used to phone at all hours, often after midnight, to talk about a picture he'd been offered

and the conversation would roam over everything. There was nothing he wasn't curious about, and I always learned something. His collection has dramatically raised standards in Los Angeles."[1]

Looking back on his thirty-seven-year association with Simon, the president of the Getty Trust, Harold Williams declared him a singular collector. "The collection is the result of an inquiring eye and the judgment of one person. The man had an incredible eye and a spirit of inquiry that made the collection what it is. His persistent questioning and challenging of his own and others' judgment is why the collection turned out to be so fine."[2]

Franklin Murphy, who in the 1960s and 1970s had agonized over Simon's involvement with the Los Angeles County Museum of Art, said that he considered Simon "one of the truly great art collectors in American history. He brought together a fabulous collection of works of art in an astonishingly short time."[3]

Speaking from the East Coast, J. Carter Brown, the director of the National Gallery of Art in Washington, praised Simon's collection and said, "He bought low and sold dear, something we all try to do."[4] Philippe de Montebello, the director of the Metropolitan Museum of Art in New York, called the Norton Simon Museum "one of the great collections of our age,"[5] but criticized Simon's reluctance to lend his holdings to other museums.[6]

Long after Simon's death, his art associates continued to assess his achievement. "One of my observations, after reflecting on the man, is that he was the first to pursue collecting in a way that had almost no social overtones," said the conservator, Marco Grassi.

> From time immemorial, certainly in the nineteenth century and, God knows, in the early twentieth century, the pursuit was supposed to ennoble one's person, one's family, one's home. When the great English magnates made a fortune, the first thing they needed was a picture gallery. That pattern was followed by the great industrialists in Germany and, of course, in America. In a way, they all subconsciously wanted to be the duke of Sutherland.
>
> As far as I could tell, that was really never on Norton's mind. He was free of snobbism and social climbing, and therefore able to concentrate on the issue at hand, the art.

Many people in the trade had trouble dealing with that because we come from a tradition where there is an aspect of social interplay. I'm sure many people who dealt with Simon thought that he had the same kind of agenda as other big collectors, but he didn't. He would show up in a double-knit suit. He never really saw art as a social tool.

So what does that leave? Well, he loved the process. He truly loved the process. And I think at the end of the day he must have gotten a tremendous cultural and aesthetic pleasure from these things, although it was difficult for him to enunciate that.[7]

For many art dealers, working with Simon was a unique experience for better or worse. Martin Summers, a dealer in London, remembered him fondly despite his difficult personality and infuriating tactics.

Norton Simon was a predatory animal, a corporate giant and yet with an aesthetic undertone that is extraordinary, and that is something you do not see today. There are collectors who make as much money, but they are less rough and tough, and they don't have the aesthetic underside. They don't have the courage of their convictions.

He didn't buy much after 1980, but we're still talking about twenty-five years of collecting, which is a short time for what he accomplished but a long time for anyone to collect. The normal pattern is eight to ten years, between the ages of forty-eight and fifty-eight. That's when you are at your earning peak and you have settled your family, and you have the conviction of your own genius.

When Norton was buying, it wasn't to make a profit. He was delighted if he thought what he bought was worth more than he paid because it justified what he'd done. But I like to think, if he had been offered a million dollars for an object that wasn't worth that much, he would have said, "No, $1.3 million," and procrastinated because he didn't really want to sell. He was creating his monument. The result is there, at the museum. When I go to the Norton

Simon Museum in Pasadena, I come away thinking, what a remarkable achievement.[8]

From the outside, all appeared to be quiet at the museum in the first three years after Simon's death. Those who had feared that the museum would be closed and the collection dismantled took comfort in seeing it continue. The building, which is owned by the museum's board of trustees, stands on land leased from the City of Pasadena for one dollar a year. The seventy-five-year lease runs until 2059. Most of the art that Simon collected is on long-term loan from the Norton Simon Foundation and the Norton Simon Art Foundation. A few pieces on display have been lent by Jennifer Jones Simon. Works acquired from the Pasadena Museum of Art belong to the museum's permanent collection. Sara Campbell, who was promoted to the position of director of art in September 1993, oversees a twelve-thousand-piece collection, of which about 10 percent is exhibited at any one time. Many of the finest and most celebrated artworks are permanently on view; other parts of the collection are presented periodically in temporary exhibitions.

The Norton Simon Museum settled into operating without its namesake, but the institution was in danger of being perceived as a mausoleum. No substantive changes had been made to the building for twenty years, and it was time for refurbishment. The museum needed to revitalize itself, for the sake of both the collection and public perception. In March 1996, plans were announced for a major renovation of the museum's interior and gardens, under the direction of the architect Frank O. Gehry, a longtime friend of the Simons who serves on the museum's board of trustees. Changes to the interior included improving the artificial lighting, adding skylights, raising ceilings on the main floor, and dividing long hallways into smaller galleries to provide more intimate viewing spaces.

Outside, in a scheme developed by the landscape designer Nancy Goslee Power, the gardens were to be expanded and altered to complement the collection, in a style inspired by the nineteenth-century paintings. The rectangular, tiled reflecting pool would be converted into a large natural pond. Sculptures would be installed among

indigenous plants in an informal environment designed to engage visitors with art and nature. The focal point of the garden would be a tea house, described as a light-filled, one thousand-square-foot pavilion, set on a platform above a meandering pond.

Work on the sculpture garden began in July 1996. The first phase of the interior renovation opened six months later, revealing four handsomely refurbished galleries that made the early Italian and Renaissance paintings look better than ever. Galleries on the upper floor have been finished, and the lower floor is being renovated to accommodate the collection of Asian art. The Norton Simon Museum had begun a new life.

CODA

Wrapping up this project—seven years after first thinking of it, three years after I launched the research, and eighteen months after I began writing—I still don't know Norton Simon. I have learned hundreds of facts about him, heard dozens of stories, and weighed conflicting opinions. Yet, as most biographers discover in the process of exploring the lives of their subjects, the essence of his character is not absolutely clear. Indeed most of the characterizations that seem to suit him—troubled genius, existential control freak, outsider on the inside—are equivocal if not paradoxical. Knowing what he did, and even understanding how, when, where and with whom he did it, does not necessarily explain exactly why he did it.

That said, I come away from the writing with my own opinions and an enormous admiration for Simon's intelligence and accomplishments. He needed a new challenge after he made a fortune in his early adulthood and had grown weary of running a corporate empire. Buying art and learning about every aspect of it, as well as its market, provided him with a reason to acquire an entirely new body of knowledge. Collecting art also gave Simon the satisfaction of using an outsider's tactics to become an insider, just as he had done in business. He always had something to prove, and it was fundamentally, that an uneducated Jewish renegade from modest circumstances could rise to the pinnacle of influence and power in his chosen fields.

What set him apart from many other, similarly aggressive acquisitors is that he did not use his collection to achieve social status or political power. No matter how demanding or unreasonable he may have seemed to his suitors, and despite the extremes of his one-upmanship, his goal was to build a collection of the highest quality possible and to be appreciated for that achievement. Art suited him

partly because it is a commodity; as a businessman he never lost sight of that. Yet he excelled at collecting because he was passionate about the objects he pursued. Buying broadly and always comparing apples and oranges, he sometimes made decisions that were imcomprehensible to others but he always went after the best as he saw it. The resulting collection is not a parade of perfect masterpieces, but it is extraordinary.

In the 1950s, when Simon began buying art, he was in the right place at the right time to make a perceptible difference in the cultural scene in southern California. His subsequent involvement in the founding of the Los Angeles County Museum of Art, his takeover of the Pasadena Art Museum—which, in a roundabout way, resulted in the establishment of the Museum of Contemporary Art—and his long association with Harold Williams, who shaped the programs of the J. Paul Getty Trust, have had a profound effect on the growth and development of art museums in greater Los Angeles. When Simon's unparalleled collection is considered in the context of the institutions he formed or influenced over a period of thirty years, he has no peers. And that's exactly what he wanted, to stand alone.

NOTES

CHAPTER ONE

1. John Herbert, *Inside Christie's* (London: Hodder & Stoughton, 1990), 104.
2. Harold M. Williams, conversation with author, Santa Monica, Calif., 27 July 1994. During Williams's watch, the J. Paul Getty Museum would, among dozens of multimillion-dollar purchases, spend $20 million on a Greek statue of Aphrodite, $35 million on a portrait of a Medici duke by Jacopo Pontormo, and about $50 million on a Van Gogh painting of irises.
3. Herbert, *Inside Christie's,* 105.
4. Julian Agnew, conversation with author, Los Angeles, Calif., 23 May 1994.
5. *Time,* 4 June 1965.

CHAPTER TWO

1. Steven V. Roberts, "Why a 63-Year-Old Tycoon Worth $100-Million Wants to Run for the Senate," *New York Times,* 31 May 1970, *Sunday Magazine,* p. 12.
2. Ibid.
3. "The Corporate Cézanne," *Time,* 4 June 1965, 75.
4. Roberts, "Why a 63-Year-Old Tycoon," p. 12.
5. Evelyn Simon Prell, conversation with author, Los Angeles, Calif., 8 May 1994.

CHAPTER THREE

1. Freeman Lincoln, "Norton Simon—Like Him or Not," *Fortune,* December 1953, 170–72.
2. "Tin Can King," *Time,* 8 October 1945, 87.
3. Lincoln, "Norton Simon," 144.
4. "The Raiders Challenge to Management," *Time,* 25 July 1955, 80.
5. Milton Ray, conversation with author, Laguna Hills, Calif., 29 July 1996.
6. Harold M. Williams, conversation with author, Santa Monica, Calif., 27 July 1994.
7. Evelyn Simon Prell, conversation with author, Los Angeles, Calif., 8 May 1994.

CHAPTER FOUR

1. Norton Simon, conversation with author, Beverly Hills, Calif., 14 June 1990.
2. "65 and Still Growing: Anniversary Annals of the Museum, from the Grand Opening to the New North Wing," *Terra* (Natural History Museum Alliance of Los Angeles County), 16, no. 3 (winter 1978): 1–9.
3. Joseph B. Koepfli, conversation with author, Santa Barbara, Calif., 5 December 1996. Mr. Koepfli had been an active member of the Associates from 1954 to 1976.
4. Naomi Sawelson-Gorse, "Arensberg," *Dictionary of Art,* vol. 2 (London: Macmillan, 1996), pp. 383–85.
5. "U.C.L.A. Gets Art Collection," *Los Angeles Times,* 30 October 1944, sec. 1, p. 1.
6. "Arensberg Art Collection Going to Philadelphia," *Los Angeles Times,* 18 January 1951, sec. 1, p. 7.
7. Galka E. Scheyer, Last will and testament, 27 October 1945, Norton Simon Museum.
8. Norton Simon, conversation.
9. Ibid.
10. Al Stendhal, telephone conversation with author, 12 December 1995.

CHAPTER FIVE

1. "The Corporate Cezanne," *Time,* 4 June 1965, 79.
2. *Masterpieces from the Norton Simon Museum* (Pasadena, Calif.: Norton Simon Museum, 1989), 122.
3. James Elliott, telephone conversation with author, 5 August 1996.

4. David Roell, letter to Edward Fowles, 20 April 1953, Duveen archive, Metropolitan Museum of Art, New York.
5. Norton Simon, telephone conversation with author, 29 June 1990.
6. Eugene Thaw, conversation with author, Santa Fe, N. Mex., 9 June 1995.
7. Simon, conversation with author, Beverly Hills, Calif., 14 June 1990.
8. Ibid.
9. Thaw, conversation.
10. Simon, conversation.
11. Marshall Berges, "Jennifer Jones & Norton Simon," *Los Angeles Times*, 15 December 1974, *Home* magazine, p. 61.
12. Harold M. Williams, conversation with author, Santa Monica, Calif., 27 July 1994.

CHAPTER SIX

1. For a discussion of Dorothy Buffum Chandler's fund-raising efforts, see David Halberstam, *The Powers That Be* (New York: Alfred A. Knopf, 1979).
2. "Board Delays Action on New Museum," *Los Angeles Times*, 2 April 1958, sec. 3, p. 2.
3. Joseph B. Koepfli, conversation with author, Santa Barbara, Calif., 5 December 1996.
4. Jules Langsner, "The Way I See It: An Open Letter to the County," *Beverly Hills Times*, 25 February 1960.
5. "Art Museum Assured on Hancock Park Site," *Los Angeles Times*, 1 July 1960, sec. 3, p. 1.
6. Henry J. Seldis, "62 Start in Hancock Park Set," *Los Angeles Times*, 5 January 1961, sec. 3, p. 8.
7. Norton Simon, conversation with author, 14 June 1990.

CHAPTER SEVEN

1. "Exit Lord Pengo," *Newsweek*, 4 May 1964, 61.
2. Eugene Thaw, conversation with author, Santa Fe, N.Mex., 9 June 1995.
3. Martin Summers, conversation with author, London, 14 September 1994.
4. David Nash, conversation with author, New York, 13 June 1994.
5. Summers, conversation.
6. Stephen Hahn, conversation with author, Santa Barbara, Calif., 27 May 1994.
7. Ben Heller, conversation with author, Dover Plains, Conn., 9 December 1995.
8. Summers, conversation.
9. Alvin Shuster, "A Vincent Van Gogh Is Sold in London for $277,200," *New York Times*, 29 June 1968, p. 25.

10. Nash, conversation.

11. Julian Agnew, conversation with author, Los Angeles, Calif., 23 May 1994.

12. Thaw, conversation.

13. Michael Findlay, conversation with author, New York, 7 December 1995.

14. Agnew, conversation.

15. Findlay, conversation.

16. Nash, conversation.

17. Heller, conversation.

18. Paul Kantor, conversation with author, Beverly Hills, Calif., 21 April 1994.

19. Summers, conversation.

CHAPTER EIGHT

1. For a discussion of Duveen and Berenson, see Colin Simpson, *Artful Partners: Bernard Berenson and Joseph Duveen* (New York: Macmillan, 1986); and S. N. Behrman, *Duveen: The Intimate Portrait of a Fabulous Art Dealer* (New York: Harmony, 1982).

2. Milton Esterow, "Norton Simon Foundation Plans to Buy Duveen Gallery," *New York Times*, 21 April 1964, p. 27.

3. Barbara Roberts, memo to Norton Simon, 1 April 1964, Norton Simon Museum.

4. Molly's last name seems not to have been recorded for posterity.

5. Roberts, to Simon, 30 April 1964, Norton Simon Museum.

6. Milton Ray, conversation with author, Laguna Hills, Calif., 29 July 1996.

7. Jean Fowles, letter to Norton Simon, 6 February 1974, Duveen archive, Metropolitan Museum of Art, New York.

CHAPTER NINE

1. Peter Bart, "Los Angeles Prepares for Museum Opening," *New York Times*, 29 March 1965, p. 42.

2. Henry T. Hopkins, conversation with author, Los Angeles, Calif., 25 July 1996.

3. Alfred Frankfurter, "Los Angeles: The New Museum," *Art News*, March 1965, 61.

4. John Canaday, "Art: New Coast Museum," *New York Times*, 25 March 1965, p. 42.

5. Robert Wernick, "Wars of the Instant Medicis," *Life*, 28 October 1966, 112.

6. Philip Leider, "Who's in Charge Here?" *Frontier*, December 1965, 23.

7. "Drawing the Line in L.A.," *Newsweek*, 22 November 1965, 98.

1. Claude A. Partridge, letter to Norton Simon, 1 April 1957, Norton Simon Museum.
2. Norton Simon, letter to Claude A. Partridge, 9 April 1957, Norton Simon Museum.
3. Edward Fowles, letter to Norton Simon, 21 January 1963, Norton Simon Museum.
4. Simon, letter to Geoffrey Agnew, 8 February 1963, Norton Simon Museum.
5. Geoffrey Agnew, letter to Norton Simon, 17 February 1963, Norton Simon Museum.
6. Simon, to Agnew, 26 February 1963, Norton Simon Museum.
7. Agnew, to Simon, 17 February 1964, Norton Simon Museum.
8. Simon, to Agnew, 18 March 1964, Norton Simon Museum.
9. Agnew to Simon, 22 April 1964, Norton Simon Museum.
10. Simon, to Agnew, 4 May 1964, Norton Simon Museum.
11. Agnew, to Simon, 18 January 1965, Norton Simon Museum.
12. Robert M. Leylan, letter to Norton Simon, 20 January 1965, Norton Simon Museum.
13. John Herbert, *Inside Christie's* (London: Hodder & Stoughton, 1990), 105.
14. Martin Summers, conversation with author, London, 14 September 1994.
15. Lord Robbins, letter to Norton Simon, April 15, 1965, Norton Simon Museum.
16. "East Will See 'Titus' Before It Comes Here," *Los Angeles Times,* 13 May 1965, sec. 2, p. 1.
17. Henry J. Seldis, "'Titus' Display in Capital Reflects L.A.'s Problems," *Los Angeles Times,* 6 June 1965, *Sunday Calendar,* p. 2.
18. "'Titus' Heavily Guarded on Flight to Washington for First Showing," *Los Angeles Times,* 18 May 1965, sec. 1, p. 3
19. "The Corporate Cézanne," *Time,* 4 June 1965, 74.
20. Frieda Kay Fall, conversation with author, Los Angeles, Calif., 6 August 1996.
21. Seldis, "'Titus'—A Good Beginning," *Los Angeles Times,* 2 January 1966, *Sunday Calendar,* p. 28.

CHAPTER ELEVEN

1. "The Abstract Businessman," *Time,* 5 June 1964, 90.
2. Ibid., p. 95.
3. "The Corporate Cézanne," *Time,* 4 July 1965, 80.
4. Henry J. Seldis, "Norton Simon and the World of Art," *Los Angeles Times,* 23

July 1967, *West* magazine, p. 16.

5. Joseph J. Rishel, *Cézanne* (Philadelphia: Philadelphia Museum of Art, 1996), 461.
6. Seldis, "Norton Simon," 12.
7. Ibid., 19.
8. Ibid., 14.
9. William Brice, telephone conversation with author, 27 September 1996.

CHAPTER TWELVE

1. Carl Kalbfleisch, letter to Herman Hiltscher, 10 March 1964, Norton Simon Museum.
2. Ibid.
3. Press release, Hunt Foods & Industries Foundation, 10 March 1964, Norton Simon Museum.
4. John Coplans, introduction to *A Selection of Nineteenth- and Twentieth-Century Works from The Hunt Foods and Industries Museum of Art Collection* (Irvine, Calif.: University of California, 1967), n. p.
5. Henry J. Seldis, "Famed Museum Builder Selected as Hunt Art Director," *Los Angeles Times,* 18 November 1967, sec. 1, p. 1.
6. Ibid., 13.

CHAPTER THIRTEEN

1. Maurice Tuchman, conversation with author, Los Angeles, Calif., 3 September 1996.
2. Joseph B. Koepfli, conversation with author, Santa Barbara, Calif., 5 December 1996.
3. Liz McGuinness, "County Cities Still Hope to Get Valuable Art Collection," *Los Angeles Times,* 11 August 1969, sec. 2, p. 1.
4. Minutes of LACMA board of trustees executive committee meeting, 2 March 1971, Norton Simon Museum.
5. Franklin D. Murphy, letter to Robert Macfarlane, 16 June 1972, Norton Simon Museum.
6. Macfarlane, memo to Simon, 29 June 1972, Norton Simon Museum.

CHAPTER FOURTEEN

1. Robert S. Macfarlane, conversation with author, Santa Monica, Calif., 12 November 1996.
2. Henry J. Seldis, "Simon's 'Museum Without Walls' Expands Nationally," *Los Angeles Times,* 15 October 1972, *Sunday Calendar,* p. 62.
3. David W. Steadman, telephone conversation with author, 6 December 1996.
4. Wen C. Fong, foreword to *Selections from the Norton Simon, Inc. Museum of Art* (Princeton, N.J.: Princeton University, 1972), 9.
5. Norton Simon, introduction to *Selections from the Norton Simon, Inc. Museum of Art* 11.
6. David L. Shirey, "The Norton Simon, Inc. Collection: Distinguished and Eclectic," *Artnews* (December 1972): pp. 23–24; Henry J. Seldis, "Simon Says: 'Under one roof, we'd rank among the top museums in the country,'" *Artnews* (December 1972): pp. 24–28; David W. Steadman, "The Norton Simon Exhibition at Princeton," *Art Journal* (Fall 1972): 34–40.
7. Darryl Isley, memo to Norton Simon, 21 November 1972, Norton Simon Museum.
8. Thomas Hoving, letter to Norton Simon, 6 December 1972, Norton Simon Museum.
9. Eugene Thaw, conversation with author, Santa Fe, N.Mex., 9 June 1995.

CHAPTER FIFTEEN

1. "Simon Says It With a Broad Brush," *Business Week,* 14 May 1966, 64.
2. Richard J. Whalen, "Norton Simon Says Thumbs Down," *Fortune,* June 1965, 147.
3. Ibid.
4. "Simon Says It," 64.
5. Ibid., 63–64.
6. Dan Cordtz, "Antidisestablishmentarianism at Wheeling Steel," *Fortune,* July 1967, 107.
7. Whalen, "Norton Simon Says," 146.
8. "Blast From Simon," *Time,* 25 December 1964, 59.
9. Cordtz, "Antidisestablishmentarianism," 106.
10. Ibid., 107.

11. Arelo Sederberg, "Norton Simon Inc. to Operate Without Its Namesake on Board," *Los Angeles Times,* 2 December 1969, sec. 3, p. 8.

12. Alvin A. Butkus, "Salesman in the Executive Suite," *Dun's,* October 1970, 37.

13. "Dave Mahoney Puts His Imprint on Norton Simon, Inc.," *Forbes,* 15 February 1972, 27.

CHAPTER SIXTEEN

1. Charles E. Young, conversation with author, Los Angeles, Calif., 29 January 1997.

2. Ibid.

3. William Coblentz, telephone conversation with author, 27 February 1997.

4. David Shaw, "High-Roller's Choice," *Los Angeles Times,* 1 August 1971, *West* magazine, p. 23.

5. Young, conversation with author, Los Angeles, Calif., 29 January 1997.

6. Daryl E. Lembke, "Kerr Fired as UC President in Surprise Vote by Regents," *Los Angeles Times,* 21 January 1967, sec. 1, p. 14.

7. "Dismissal of Kerr Called a 'Tragedy' by Ex-Gov. Brown," *New York Times,* 21 January 1967, sec. 1, p. 6.

8. Minutes of the Meeting of the Board of Regents of the University of California, 14 July 1967, p. 2. University Archives, UCLA.

9. William Trombley, "Restore Fund Cuts, UC Regents Urge Reagan, Legislators," *Los Angeles Times,* 15 July 1967, sec. 1, p. 1.

10. Ibid.

11. Trombley, "Regent Simon Assails UC Investment Policy," *Los Angeles Times,* December 1967, sec. 1, p. 1.

12. John Dreyfuss, "Regents Announce Liberalized Policies on UC Investments," *Los Angeles Times,* 18 January 1969, sec. 2, p.1.

13. Trombley, "Angela Davis: A Time of Testing for Young," *Los Angeles Times,* 17 May 1970, sec. 1. p. 1.

14. Shaw, "High-Roller's Choice."

15. Minutes of the Meeting, 17 April 1970, University Archives, UCLA.

16. Trombley, "Regents' 'Hands in Cookie Jar' at UC Irvine, Simon Says," *Los Angeles Times,* 18 July 1970, sec. #1, p. 1.

17. Noel Greenwood, "Two UC Regents Clash Over Land Dealings With Irvine Co.," *Los Angeles Times,* 19 September 1970, sec. 2, p. 1.

18. Trombley, "Angry Reagan in Name-Calling Shoving Clash With 2 Regents," *Los Angeles Times,* 17 October 1970, sec. 1, p. 1.

19. Ibid.

20. Don Speich, "2 UC Regents With 2 Styles Leaving Board," *Los Angeles Times,* 21 February 1976, part 2, p. 1.

21. Minutes of the Meeting, 20 February 1976, University Archives, UCLA.

CHAPTER SEVENTEEN

1. David Shaw, "High-Roller's Choice," *Los Angeles Times,* 1 August 1971, *West* magazine, p. 23.
2. Editorial, *New York Times,* 20 March 1970, p. 46.
3. Gay Scott, "Simon's Reason: To Oppose Murphy," *Citizen News,* 27 March 1970, sec. 1, p. 3.
4. Steven V. Roberts, "Why a 63-Year-Old Tycoon Worth $100-Million Wants to Run for the Senate," *New York Times,* 31 May 1970, *New York Times Magazine,* p. 10.
5. Richard Bergholz, "L.A. Industrialist Norton Simon Will Challenge Murphy," *Los Angeles Times,* 21 March 1970, sec. 1, p. 28.
6. Scott, "Simon's Reason."
7. Ibid.
8. Roberts, "Why a 63-Year-Old Tycoon" p. 12.
9. Shaw, "High-Roller's Choice," p. 21.
10. Angelina Boaz, conversation with author, Tustin, Calif., 26 March 1994.
11. Tom Goff, "Simon Vainly Seeks Reagan's Aid, Criticizes GOP Attitude," *Los Angeles Times,* 1 April 1970, sec. 4, p. 1.
12. Roberts, "Why a 63-Year-Old Tycoon," p. 28.
13. Ibid.
14. Ibid.
15. Shaw, "High-Roller's Choice," p. 23.
16. Ibid.
17. *Los Angeles Times,* 2 June 1976, sec. 1, p. 6.

CHAPTER EIGHTEEN

1. Harold M. Williams, conversation with author, Santa Monica, Calif., 27 July 1994.
2. Mrs. Simon was not available for any interviews.
3. David Shaw, "Norton Simon and Jennifer Jones Wed Aboard Yacht," *Los Angeles Times,* 31 May 1971, sec. 1, p. 21.
4. "Norton Simon and Jennifer Jones on Secret Honeymoon," *Los Angeles Times,* 1 June 1971, sec. 1, p.1.
5. Ibid.
6. Ibid.
7. Shaw, "Norton Simon and Jennifer Jones," p. 3.

CHAPTER NINETEEN

1. Pratapaditya Pal, conversation with author, Los Angeles, 31 October 1994
2. Suzanne Muchnic, "Laboring Under No Illusions," *Los Angeles Times,* 20 November 1994, *Sunday Calendar,* p. 92.
3. Pal, "Collecting Asian Art: Norton Simon Style," lecture delivered at the J. Paul Getty Museum, Malibu, Calif., 12 December 1996.
4. Ibid.
5. Pal, "Norton Simon," *Marg* 38, no. 1 (1985): 54.
6. Doris Wiener, conversation with author, New York, N.Y., 8 December 1995.
7. Pal, "Norton Simon," p. 54.
8. Robert H. Ellsworth, conversation with author, New York, N.Y., 14 June 1994.
9. Ibid.
10. Wiener, conversation.
11. Fern Marja Eckman, "Stolen Statue of Shiva Bought by Simon," *New York Post,* 11 May 1973, sec. 1, p. 2.
12. David Shirey, "Norton Simon Bought Smuggled Idol," *New York Times,* 12 May 1973, sec. A, p. 1.
13. Henry J. Seldis, "Simon Denies He Admitted Buying Smuggled Statue," *Los Angeles Times,* 13 May 1973, sec. 1, p. 3.

CHAPTER TWENTY

1. *Seven* (Ealing Abbey parish magazine) no. 22 (February 1970) 14.
2. Lynn H. Nicholas, *The Rape of Europa* (New York: Knopf, 1994), 84.
3. Spencer A. Samuels, conversation with author, Santa Monica, Calif., 5 January 1996.
4. James M. Brown, letter to Spencer Samuels, 28 February 1969, Norton Simon Museum.
5. Eugene Thaw, conversation with author, Santa Fe, N. Mex., 9 June 1995.
6. Ibid.
7. Joyce Haber, "$3 Million Wedding Gift for Jennifer," *Los Angeles Times,* 5 July 1972, sec. 4, p. 19.
8. Henry J. Seldis, "Simon Museum Buys Raphael Painting for About $3 Million," *Los Angeles Times,* 2 December 1972, sec. 1, p. 1.
9. David Bull, telephone conversation with author, 22, August 1996.
10. Idem.
11. William Tuohy, "Jennifer Jones Bids $3.7 Million for Simon Art," *Los Angeles Times,* 17 April 1980, sec. 1, p. 3.
12. Julian Agnew, conversation with author, Los Angeles, Calif., 23 May 1994.
13. Marco Grassi, conversation with author, New York, N.Y., 6 December 1995.

14. Mario Modestini, conversation with author, New York, N.Y., 7 December 1995.
15. Selma Holo, conversation with author, Los Angeles, Calif., 19 August 1996.

CHAPTER TWENTY-ONE

1. "Ever Upward," *Time,* 5 May 1971, 83.
2. Armand Hammer, conversation with author, Los Angeles, Calif., 2 March 1989.
3. John Goldman, "47 Paintings From Simon's Collections Brings $6 Million," *Los Angeles Times,* 3 May 1973, sec. 1, p. 1.
4. David I. Shirey, "Simon 'Refines' Art Collection by Selling," *New York Times,* 4 May 1973, p. 24.
5. David Nash, conversation with author, New York, N.Y., 13 June 1994.
6. Paul Kantor, conversation with author, Beverly Hills, Calif., 21 April 1994.
7. Nash, conversation.
8. Eugene Thaw, conversation with author, Santa Fe, N. Mex., 9 June 1995.
9. Ibid.
10. John Walsh, conversation with author, 16 April 1997.
11. Nash, conversation.
12. Norton Simon, conversation with author, 14 May 1990.

CHAPTER TWENTY-TWO

1. United Press International, "Simon Says More Art, Not Museums," *The Daily Review* (Hayward, Calif.), 27 May 1973, p. 16.
2. The building currently houses the Pacific Asia Museum.
3. Galka E. Scheyer, Last will and testament, 27 October 1945, Norton Simon Museum.
4. James Demetrion, letter to Frederick R. Weisman, 5 December 1967, Norton Simon Museum.
5. Summary of special executive committee meeting of the board of trustees, Pasadena Art Museum, 4 May 1971, Norton Simon Museum.
6. Summary of board of trustees meeting, Pasadena Art Museum, 12 May 1971, Norton Simon Museum.
7. Hall Leiren, "Pasadena Asks County to Run Art Museum," *Los Angeles Times,* 29 May 1971, sec. 2, p. 10.
8. Alfred M. Esberg, memorandum to members of the Pasadena Art Museum board of trustees, 1 June 1971, Norton Simon Museum.
9. Ray Zeman, "Supervisors Reject Offer to Take Over Pasadena Museum," *Los Angeles Times,* 23 June 1971, sec. 2, p. 1.

10. "Art Museum in Pasadena to Seek Funds," *Los Angeles Times,* 24 June 1971, sec. 2, p. 8.
11. Gifford Phillips, "Depending on the Rich: The Collapse and Takeover of an Art Museum," memoir, p. 32.
12. Ibid., p. 34.
13. Ibid., p. 35.
14. Ibid., pp. 35–36.
15. Pasadena Museum of Modern Art, press release, 26 April 1974, Norton Simon Museum.
16. William Wilson, "Simonizing of the Pasadena Art Museum," *Los Angeles Times,* 29 April 1974, p. 8.
17. Grace Glueck, "Simon Control of Museum Stirs Coast," *New York Times,* 14 May 1974, 38.
18. Wilson, "Simonizing," p. 8.
19. Henry J. Seldis, "Public Reaction to Simon's PAM Control," *Los Angeles Times,* 9 June 1974, *Sunday Calendar,* p. 74.

CHAPTER TWENTY-THREE

1. In a later version of this article, Coplans supplied revised versions of the names: Mary Hopkins and Layland Stanford.
2. John Coplans, "Diary of a Disaster," *Artforum,* February 1975, 45.
3. Robert Macfarlane, memorandum to Norton Simon, 3 May 1974, Norton Simon Museum.
4. Gifford Phillips, "Depending on the Rich: The Collapse and Takeover of an Art Museum," memoir, pp. 42–43.
5. Billy Wilder, conversation with author, Los Angeles, January 18, 1996.
6. Peter Plagens, "Pasadena, Like a Real Museum," *Artforum,* May 1975, 67.
7. Henry J. Seldis, "Pasadena Museum Gets It Together," *Los Angeles Times,* 16 March 1975, *Sunday Calendar,* p. 1.
8. "The Norton Simon Museum of Art at Pasadena," *Connoisseur,* November 1976, 161.
9. Henry J. Seldis and William Wilson, "Pasadena Art Gallery Renamed," *Los Angeles Times,* 24 October 1975, sec. 1, p. 1.
10. Bert Mann, "Museum to Get 2 Simon Grants," *Los Angeles Times,* 19 November 1975, sec. 1, p. 3.
11. Barbara Isenberg, "Simon Board Holdovers to Quit," *Los Angeles Times,* 12 June 1978, sec. 4, p. 12.

CHAPTER TWENTY-FOUR

1. Helen A. Buckley, affidavit, 28 February 1975, Norton Simon Museum.
2. Doris Wiener, conversation with author, New York, N.Y., 8 December 1995.
3. Alvin Toffel, memorandum for the record, 25 March 1974, Norton Simon Museum.
4. "Statue Dispute Cancels Simon Show at Met," *Los Angeles Times,* 3 June 1974, sec. 4, p. 3.
5. Fern Marja Eckman, "The Curse of the Dancing God," *New York Post,* 30 May 1974.
6. Grace Glueck, "Met Suspends Simon's Show of Asian Art," *New York Times,* 31 May 1974, p. 22.
7. Ben Heller, conversation with author, Dover Plains, Conn., 9 December 1995.
8. Grace Glueck, "Simon and India: Battle on Idol Widens," *New York Times,* 30 December 1974, p. 36.
9. Heller, conversation.

CHAPTER TWENTY-FIVE

1. Martin Summers, conversation with author, London, 14 September 1994.
2. Ibid.
3. John Rewald, "The Complete Sculptures of Degas" (London: Lefevre Gallery, 1976), 8.
4. Summers, conversation.
5. Ibid.
6. Arthur Beale, conversation with author, Boston, Mass., 22 February 1996.
7. William Wilson, "Degas Bronzes: Dance of Life at Simon Museum," *Los Angeles Times,* 14 May 1978, *Sunday Calendar,* p. 1.
8. Summers, conversation.
9. Beale, conversation.

CHAPTER TWENTY-SIX

1. David Bull, telephone conversation with author, 22 August 1996.
2. Ibid.
3. Grace Glueck, "Art People," *New York Times,* 6 March 1981, sec. C, p. 20.
4. The other founding trustees were Leon O. Banks, Eli Broad, Robert Irwin, William A. Norris, and Max Palevsky.
5. Pamela J. King, "Artist vs. Norton Simon," *Los Angeles Herald Examiner,* 9 May 1980, sec. A, p. 10.

6. Ibid.
7. Grace Glueck, "Simon Museum Sale of Art is Charged," *New York Times,* 9 May 1980, sec. C, p. 18.
8. "Lawsuit Halts Norton Simon Deaccessions," *Art Letter,* May 1980, 1.
9. Grace Glueck, "Simon Museum Sale."
10. Ibid.
11. Walter McQuade, "Norton Simon's Great Museum Caper," *Fortune* 102 (25 August 1980) 79.
12. Ibid., 81.
13. Ibid, 84.
14. Patricia Failing, "Is the Norton Simon Museum mismanaged? Or are the former trustees misguided?," *Artnews,* October 1980, 136.
15. Ibid., 138.
16. Ibid., 142.
17. Bull, telephone conversation.
18. Alan Temko, "Will Norton Simon Move His Art Here?" *San Francisco Examiner & Chronicle,* 30 July 1981, p. 46.
19. William Wilson, "Losing Our Art to San Francisco?" *Los Angeles Times,* 5 August 1981, sec. 6, p. 1.
20. Memorandum of Intended Decision, 22 September 1981, Norton Simon Museum.
21. Norton Simon Museum, press release, 23 September 1981, Norton Simon Museum.

CHAPTER TWENTY-SEVEN

1. Grace Glueck, "Poussin Work Bought by Getty and Simon Museums," *New York Times,* 29 April 1981, sec. C, p. 17.
2. Harold M. Williams, telephone conversation with author, 20 May 1997.
3. John L. Marion, telephone conversation with author, 14 June 1994.

CHAPTER TWENTY-EIGHT

1. Harold M. Williams, conversation with author, Santa Monica, Calif., 27 July 1994.
2. Charles E. Young, letter to Norton Simon, 27 January 1987, Chancellor's Communications, University of California at Los Angeles.
3. Young, conversation with author, Los Angeles, Calif., 29 January 1997.
4. Alan Charles, conversation with author, Los Angeles, Calif., 19 February 1997.
5. Gregg Kilday, "Page 2," *Los Angeles Herald Examiner,* 19 February 1987, sec.

A., p. 2.

6. Charles, conversation.
7. Charles, memo to Young, 30 April 1987, Chancellor's Communications, University of California at Los Angeles.
8. Young, conversation.
9. Charles, conversation.
10. Young, conversation.

CHAPTER TWENTY-NINE

1. John Walsh, statement issued to the press, 3 June 1993.
2. "Industrialist, Art Collector Norton Simon Dies at 86," *Los Angeles Times,* 4, June 1993, sec. A, p. 20.
3. Ibid.
4. J. Carter Brown, telephone conversation with author, 3 June 1993.
5. "Industrialist, Art Collector."
6. Philippe de Montebello, telephone conversation with author, 3 June 1993.
7. Marco Grassi, conversation with author, New York, N.Y., 6 December 1995.
8. Martin Summers, conversation with author, 14 September 1994.

INDEX

Rubens, Peter Paul, 6, 100, 101, 253; *David Slaying Goliath*, 185, 276; *Saint Ignatius of Loyola*, 276

Russell, Stella, 161

Saarinen, Eero, 56

Saint Anthony Abbot, fresco of, 79

St. Louis Art Museum, 115

Saito, Ryoei, 192

Salz, Sam, 40

Samuels, Spencer A., 181–83

Savoldo, Giovanni, *Shepherd with Flute*, 65

Schapiro, Meyer, 113

Scherbatoff, Prince George Stroganoff, 181

Scheyer, Galka E., 33, 202

School of Rheims, 73

Schreiber, Taft B., 85, 113

Schwitters, Kurt, *Construction for Noble Ladies*, 79

sculpture, NS's collection of: Asian, 71, 168, 176, 220, 263; at the Pasadena Art Museum, 210–11, 220; Western, 101, 106, 107, 108, 124–25, 178, 263; *see also* Degas, bronzes of; *Shiva Nataraja*

A Selection of Nineteenth- and Twentieth-Century Works from The Hunt Foods and Industries Museum of Art Collection (exh.), 107

Seldis, Henry J., 55, 93, 94–95, 99–100, 108

Selections from the Norton Simon Inc. Museum of Art (exh.), 127–29

Selznick, Mary Jennifer, 162

Selznick, David O., 162

Selznick, Jennifer Jones. *See* Jones, Jennifer

Selz, Peter, 35

Sesnon, William T., Jr., 37, 85

Settignano, Desiderio da, *The Beauregard Madonna*, 79

Sèvres, 193

Shapiro, Michael, 115

Shattuck, Edward, 150

Sheets, Millard, 56, 85

Shiva the Bull-Rider (Vrishavahana) (ill.)

Shiva Nataraja (Lord of the Dance) (ill.), 171–77; considered to have been stolen, 175, 176–77, 223, 224, 229; exhibition of, at the Metropolitan Museum of Art, 176, 223–24; lawsuits about, 228–30; negotiations for return of, 225–28; as

plaintiff, 229; provenance of, 172–75; purchase of, 176

Sigma Delta Kappa, 149

Silver, Alec, 74

Simon, Donald, 17, 159, 160, 161

Simon, Douglas, 160

Simon, Eric, 160

Simon, Jennifer Jones. *See* Jones, Jennifer

Simon, Lillian Glickman, 9, 11

Simon, Lucille Ellis, 17, 96, 98, 132, 160, 161–62, 191; divorces NS, 161; interest of, in art, 29, 34, 36, 52, 100, 233; and NS's political campaign, 153

Simon, Lucille Michaels, 13, 14, 29, 161

Simon, Myer, 9, 10–12, 14–15, 16, 26, 27

Simon, Norton W.,
—life and character: appearance of, 4, 14; appointed to LACMA board, 52; birthday celebration for, 275–77; celebrity and, 4, 23, 86, 96–97; childhood of, 9–10; contracts Guillain-Barré syndrome, 260–61, 264; death of, 5, 277; divorce of, 161; donations by, 50, 92, 103, 150, 151, 266; education of, 12, 13; employees of, 25–26, 108, 109, 157, 242–43; family of, 9–10, 11, 13, 15, 17, 26, 159–62; as a father, 17, 159–60; Jewishness and, 140, 155–56; lawsuits involving, 65–66, 221, 228–30, 249–52, 254–55, 256; marriages of, 17, 163–64; modus operandi of, 4–5, 45–46, 59–62, 188–89, 243–44, 267–69, 271–72; personality of, 4–5, 24–25, 153–54, 282; reputation of, 20, 52, 58, 91, 112, 132, 138, 139, 146, 216–17; residences of, 17, 34; resigns from LACMA board, 119; Robert's suicide and, 160–61; self-perceptions of, 4–5, 10, 24, 155–56; "the three Ps" and, 5, 79, 123, 149; trusteeships held by, 124, 126, 137; visits India, 165–67
—art collection of: Asian, 6, 168–71, 185, 231; *see also Shiva Nataraja;* at LACMA, 50, 52, 79–81, 111, 115–21, 283; compass of, 43, 73, 79, 97–98, 99–101, 106–107, 108–109, 262–63; conjectured disposition of, 111, 116–20, 123, 131, 200, 246, 253–54, 264–74; corporate, 102, 108; deaccession and, 248–49; donations from, 35, 52, 78; and importance of public appeal, 2, 123, 128–29; and the J. Paul Getty Museum, 256–58, 259–60;

loans of, 36, 79–81, 106–107, 120, 125, 199–201, 222, 234, 253; origins of, 34–36; personal, 96–101, 233; sales of artworks from, 119, 120, 162, 191–98, 246–52; scholarship and, 241; sculpture, 6; security for, 79–80, 94, 99; size of, 215; value of, 108; *see also* museum-without-walls;

—businesses of, 7, 17, 19–20, 21, 24–25, 130; acquisitions of, 18–19, 21–22, 23, 130–32; advertising by, 19–21, 155, 158, financial position of, 16, 17–18, 23, 24, 28, 93, 135; foundations of, 16–17; retirement from, 136, 137; youthful enterprises of, 12, 13–14

—as a collector, 5, 6–7, 28–29, 46, 170–71, 178, 183, 278–80, 282–83; and the art market, 61–62, 196, 216–17; bidding strategies of, 2, 3, 62, 63, 90–91, 186–87, 259; manipulativeness of, 67–68, 114–15, 200; motivation for, 122–23, 128–29, 223, 259–60; and the naming of buildings, 52–53, 78; purchasing arrangements and, 44, 63–64, 68, 182–83, 194; self-education of, 37, 42, 45–46, 63, 169, tastes of, 39–40, 43, 97, 99, 106, 167, 196, 233; use of options by, 44, 65–66, 72, 173, 182

—opinions of: on art, 122, 127–28; on art smuggling, 177, 225; on business, 131–32; on collecting art, 46–47, 100, 122, 129, 184, 195, 198; on psychology, 156

—in politics, 149–58; politics of, 141–42, 145, 149, 156–57, 158

—as a regent of the University of California, 137–48, 150, 151–52; and university finances, 142–44, 145–56, 147–48, 152

Simon, Pamela, 160, 277
Simon, Robert, 17, 101, 159, 160
Simon Sells For Less, 10, 11
Sisley, Alfred, *Louveciennes in the Snow*, 253
Sivagurunathaswamy, Arulmiga, 229
Sivapuram (Tamil Nadu, India), 172, 175
Smith-Barry, John, 260
Smith, David, 82, 211
Smith, William French, 146
Solomon R. Guggenheim Museum (New York), 52, 112

Somaskanda, 172, 173
Somerset, David, 3, 91
Sotheby Parke Bernet, 163, 186, 194, 259
 NS's sale of artwork through, 193, 194
Sotheby's, 59, 119, 192, 195, 241, 262
Southern California Academy of Sciences, 29
Southern California Symphony Association, 51
Southwest Museum (Los Angeles), 31
Soutine, Chaïm, 263
Spencer, Lord, 87
Spink & Sons Ltd. (Zurich and London), 170
Sproul, Robert G., 33
State Hermitage Museum (St. Petersburg), 179
Steadman, David W., 126–28, 245
Steele Foundation. *See* Harry G. Steele Foundation
Steele, William A., 133, 134
Stella, Frank, 203, 206; *Tahkt-I-Sulayman I*, 250
Stendahl, Al, 36
Sterling and Francine Clark Art Institute (Williamstown, Mass.), 76
Stevens, Wallace, 32
Sthapathi, Raja Swami, 174–75
Stone, Edward Durrell, 56, 204
Storke, Thomas B., 138
Stroganoff, Count Alexander, 179
Stroganoff, Count Paul, 180
students: access of, to NS's collections, 100–101, 107, 109, 126; activism of, at the University of California, 140–41
Suhr, Billy, 44, 190
Summers, Martin: and Degas's *modèles*, 232–34, 236–37, 239–40; on NS, 59, 60, 61, 69, 91, 279
Surasundari (Beautiful Woman of the Gods), 169
Swope, Dorothy McGuire, 218

tapestries, 73, 79, 193; *see also* cartoons
taxation, NS's art collections and, 105, 106–107, 122, 124–25, 218, 230, 231
Technicolor Inc., 136, 151
Temko, Alan, 254
Thaw, Eugene, 45, 46, 65, 106, 129, 183–84, 188, 194, 196–97, 275; on NS, 58–59, 64, 184

Compositor:	Seventeenth Street Studios
Text:	12/14.5 Garamond
Display:	Perpetua
Printer and Binder:	Edwards Brothers